THE SAVVY SPHINX

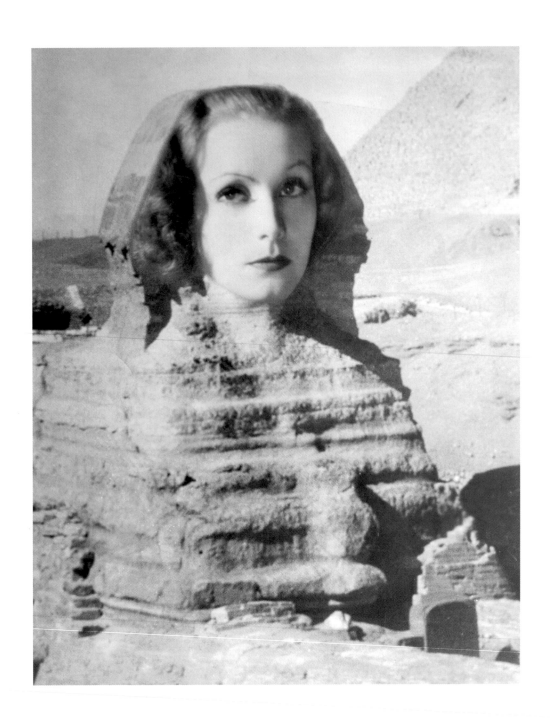

THE
SAVVY
SPHINX

How Garbo Conquered Hollywood

ROBERT DANCE

UNIVERSITY PRESS OF MISSISSIPPI / JACKSON

The University Press of Mississippi is the scholarly publishing agency of
the Mississippi Institutions of Higher Learning: Alcorn State University,
Delta State University, Jackson State University, Mississippi State University,
Mississippi University for Women, Mississippi Valley State University,
University of Mississippi, and University of Southern Mississippi.

www.upress.state.ms.us

Designed by Peter D. Halverson

Frontispiece: Clarence Sinclair Bull, *Garbo as the Sphinx*, 1931

The University Press of Mississippi is a member
of the Association of University Presses.

First printing 2021
∞

Library of Congress Cataloging-in-Publication Data

Names: Dance, Robert, 1955– author.
Title: The Savvy Sphinx : how Garbo conquered Hollywood / Robert Dance.
Description: Jackson : University Press of Mississippi, 2021. | Includes
bibliographical references and index.
Identifiers: LCCN 2021023924 (print) | LCCN 2021023925 (ebook) | ISBN
978-1-4968-3328-0 (hardback) | ISBN 978-1-4968-3656-4 (epub) | ISBN
978-1-4968-3657-1 (epub) | ISBN 978-1-4968-3658-8 (pdf) | ISBN 978-1-4968-3659-5
(pdf)
Subjects: LCSH: Garbo, Greta, 1905-1990. | Motion picture actors and
actresses—Sweden—Biography. | BISAC: BIOGRAPHY & AUTOBIOGRAPHY /
Entertainment & Performing Arts | SOCIAL SCIENCE / Popular Culture
Classification: LCC PN2778.G3 D36 2021 (print) | LCC PN2778.G3 (ebook) |
DDC 791.4302/8092 [B]—dc23
LC record available at https://lccn.loc.gov/2021023924
LC ebook record available at https://lccn.loc.gov/2021023925

British Library Cataloging-in-Publication Data available

DEDICATION

In memory of my teachers: Arthur Mayer, Maurice Rapf,
Stanley Kaufmann, and King Vidor

CONTENTS

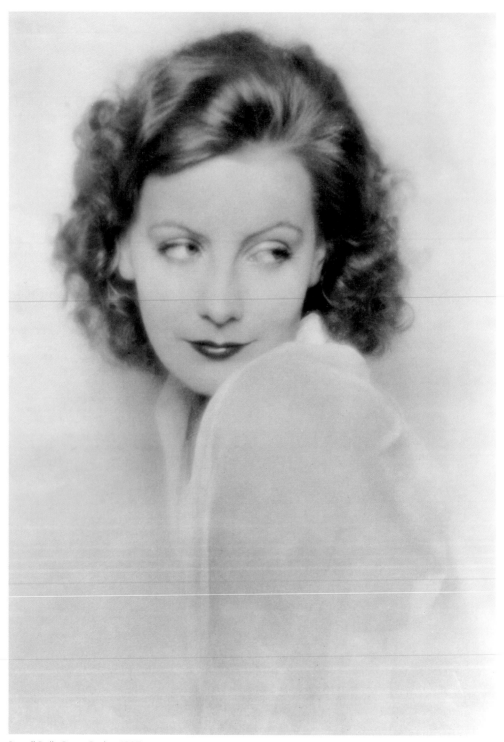

Russell Ball, *Greta Garbo*, 1927

PREFACE

THIRTY YEARS AGO, ON EASTER SUNDAY 1990, NEWS CAME OVER RA-
dio and television that Greta Garbo had died earlier in the day in New York City,
at the age of eighty-four. Although she had not made a film in forty-nine years,
she remained a vital, if peculiar, presence in her adopted hometown. She was a
particular sort of New York denizen, an ultrafamous public figure seeking a de-
gree of anonymity and privacy in the teeming metropolis. Until her last months
Garbo could shop contentedly along First Avenue and take the long walks she
loved around Manhattan without being bothered. Yes, she was often recognized
when she was out on the street, as she had been for the previous sixty-five years.
But only the brashest of the paparazzi confronted her. Otherwise she was left
alone, finally accorded the one request she had made of her fans (and almost
everyone else) during her working years. She had learned decades before how to
ignore the stares of passersby, that man or woman who might gasp at the sight
of perhaps the city's most famous resident.

This book charts the rise of Garbo from ingenue in Sweden to her zenith as
Hollywood's star of stars. In the decades after she stopped working at the age of
thirty-six, when by right she should have faded into a quiet oblivion, she became a
twentieth-century legend. Garbo's fame endured, yet the woman remained elusive
and mysterious, like the Great Sphinx to which she had once been compared.

Movie history annals are filled with the names of great performers who mes-
merized and delighted audiences, made fabulous amounts of money for them-
selves and their producers, and left behind a body of work that continues to
entertain. We all have our list of favorites, and the internet age has made a minor
industry of ranking everything, film stars included. Those rankings—best film,
greatest actor, finest western—all reflect twenty-first-century judgments of what
remains fresh and vibrant today. Garbo ranks high in those polls, never at the top
but usually not far from the apex. How delighted Katharine Hepburn would be
to know that she often comes out in the first position. If she could come back to

comment, however, the ever-frank Hepburn might well remind us that during her long working career she never achieved more than a fraction of the fame accorded the glamorous Scandinavian actress working at MGM. Hepburn would not be alone. Not even Gloria Swanson, Mary Pickford, Rudolph Valentino, or Clark Gable, stars of the highest order, could compete with Garbo for worldwide recognition and frenzied adulation. Charlie Chaplin could, and Elizabeth Taylor might come close, but by the time of her ascent in the 1960s, new matrices defined fame.

The stature of the fortunate few who defined Hollywood stardom in the last century rivaled that of the most illustrious women and men on the planet, whether world leaders, musicians, athletes, or adventurers. Motion pictures were the last century's new entertainment, and during the 1920s and 1930s, as the industry matured and saturated nearly every corner of the earth, the fame of movie heroes spread and deepened, developing a potency hardly equaled since and perhaps impossible to replicate today in a world where media content is so vast and diffuse.

THE SAVVY SPHINX

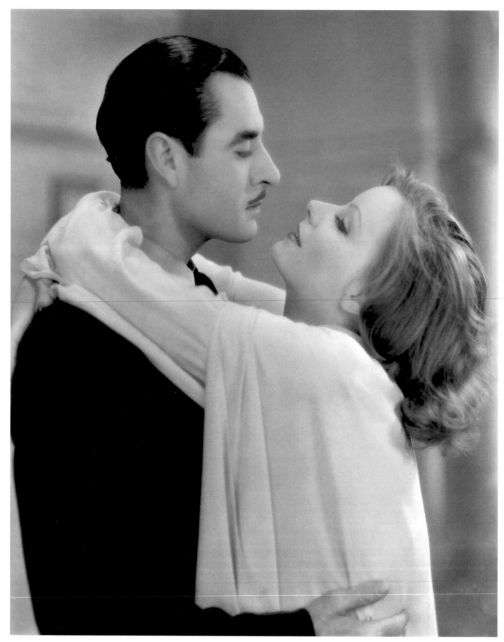

When cinema's reigning king was paired with Hollywood's young princess in *Flesh and the Devil* (1926), John Gilbert and Garbo thrilled moviegoers with their ardor, both on-screen and off. Photograph by Ruth Harriet Louise for *A Woman of Affairs* (1928). Courtesy John Kobal Foundation.

The Garbo Legend

SHE WAS KNOWN SIMPLY AS GARBO. ONE WORD. LONG BEFORE CHER, Madonna, or Beyoncé marketed their professional brands with a single name, Garbo was first, without forethought or a clever publicity team. "Garbo Talks" was the tagline for her first sound picture, *Anna Christie*; "Garbo Laughs" was enough slogan to bring audiences to her 1939 comedy, *Ninotchka*. Only five letters above the title. It was enough.

She did not like the name Greta. From her earliest days, Garbo used her given name only as an official form of identification. Contracts and checks were signed Greta Garbo. Family and childhood friends called her Kata or Gurra. After Garbo came to America, she was known to friends as "G" or "GG," and she often signed personal correspondence with one or both initials. Harriet Brown was her favorite name for traveling incognito, usually unsuccessfully. Derived from Harriet, another favored signature was Harry or "H" or even Harry Boy.

Born Greta Gustafsson in 1905 in Stockholm, Garbo was the third and youngest child of working-class parents. She abandoned her first name as a youth; her ancestral name disappeared when she was eighteen at the very beginning of her film career and was replaced by the surname that would soon identify the world's most famous woman.

Stardom came quickly. Shortly after her twenty-first birthday and eighteen months after she arrived in Hollywood in September 1925, Metro-Goldwyn-Mayer Studios released her third American picture, *Flesh and the Devil*, with Garbo costarring alongside box-office favorite John Gilbert. The promise shown in Garbo's first two Hollywood films was fully realized in her latest. Here was a new sort of screen siren. Blond, beautiful, irresistible to men, and irresistible to audiences, Garbo displayed an overt sexuality that was revolutionary. Never before on screen had a woman been depicted as an equal romantic partner. In her first film, *The Torrent*, director Monta Bell placed Garbo slightly above costar Ricardo Cortez when filming a passionate embrace. The power dynamic between the screen lovers

changed; a woman could now be seen to take control of lovemaking. It would be forty-five years before the feminist revolution of the late 1960s would further radicalize the depiction of screen women.

When Garbo entered movies, the medium was silent; live music, generally a piano or an organ, set the mood; lips moved but voices were never heard. Features, films of more than sixty minutes, had been the standard for little more than a decade. Those years saw tremendous technological development as cameras and film continually improved. With no need to sync voice to image, cinematographers could move cameras eloquently. Narrative itself became increasingly sophisticated. The movies looked to popular fiction for content, and contemporary stories were adapted to the emerging medium. The postwar boom in literature saw the advent of writers such as F. Scott Fitzgerald, whose first novel, *This Side of Paradise* (1920), captured the new license that defined much of the 1920s. New voices appeared as well, such as Anita Loos, whose *Gentlemen Prefer Blondes* (1924) presented modern independent women, and Fannie Hurst, whose many magazine articles and novels, including *Star-Dust: The Story of an American Girl* (1921), advocated an almost feminist model.

Garbo's supercharged eroticism was perfectly suited to the social climate of the mid-1920s. Movies, especially those directed by Cecil B. DeMille in the late teens, presented adult themes. Adultery and divorce were catnip to post–World War I audiences. Gloria Swanson and Norma Talmadge were but two actresses who specialized in portraying women whose reputations might be outside normative middle-class notions. Garbo continued this tradition, her characters pushing even harder against the censors' wrath, and she presented on screen acutely realized portraits of young, contemporary women. Contrary to conventional beliefs about much silent screen acting, Garbo performances were natural. Sex came easy to her, or at least it appeared so, as her roles came to constitute an encyclopedia of strong, secure women.

Garbo rarely got the man in the end. Screenwriters preferred her characters to die, as they do in *Flesh and the Devil*, *Woman of Affairs*, *Mata Hari*, *Anna Karenina*, and *Camille*. In other films such as *Romance* and *Inspiration*, she rejects her suitors and chooses to live alone. It was not until her last two films, *Ninotchka* and *Two-Faced Woman*—both comedies as MGM attempted to update her screen image—that Garbo's character ended up in a clichéd boy-gets-girl ending. Actor Melvyn Douglas was the lucky fellow in both films. But it was too late. Garbo was always a vamp. It was impossible to transition her screen persona into a vaguely exotic version of Irene Dunne or Greer Garson. Nor was there a Spencer Tracy waiting to soften her character in middle age, as he did for Katharine Hepburn. Garbo is rumored to have said late in her career, "No mamas, no murderers." She was right. Better to retire early, wealthy, famous, with a distinguished list of films, than to confront Hollywood's unwillingness to fashion films around older actresses except as mothers and, later, killers (or their victims). The cruel reality

is that Garbo left the screen at only thirty-six, still beautiful, at the top of her ability as an actress, but without the support of the industry that she represented as the paradigm of glamour and sophistication. And to whose revenues she contributed mightily.

From the winter of 1927 through the fall of 1941 Garbo reigned as star of stars, Hollywood's most glorious product. *Flesh and the Devil* made her a household name, and through each subsequent screen appearance—there would be twenty-two more—her allure grew regardless of the quality of the film or its box office success. Garbo appeared during those fourteen years to be largely immune from both censorship and the tight financial controls otherwise imposed on the Depression era studio system. So famous was she that MGM rewarded her with an unprecedented series of lucrative contracts, finally obligating her to make but one film every second year and to receive a guaranteed minimum salary of $250,000. Moreover, Garbo had complete control over script and costar, a consideration accorded no other Hollywood performer during the heady days of the studio system, a moment when eight large studios competed for audiences by presenting a thrilling array of screen personalities. The only condition imposed was that all Garbo's films be made at MGM, one that was acceptable as she never seems to have given a serious thought to leaving the protective cocoon of the studio that brought her to America and nourished her career in its early days.

Though it is easy to look back at Garbo's first year and a half at MGM as a time when she developed into a first-rate actress and then a movie star, she remembered those months as a time of strife and anxiety. She was only nineteen when she came to America and spoke no English. She had been hired by MGM to appease her mentor director Mauritz Stiller, who told MGM boss Louis Mayer when they met in Berlin in the fall of 1924 that he would not accept the studio's offer unless there was a contract for Garbo as well. Stiller, Sweden's top film director and internationally known, was the prize. Garbo was the tagalong. She expected to be directed by Stiller in her American debut, but her studio's economy and Stiller's slow working methods saw her cast in another film, *The Torrent*, practically the moment she set foot on the Culver City lot. Since she was being paid every week, Mayer saw to it that she earned her oats. Only in her second film, *The Temptress*, would Garbo be directed by Stiller, but he was fired hardly a month into the production and replaced by Fred Niblo. Garbo's older sister died back home in Sweden at the same moment, and the actress suffered from severe homesickness and a self-inflicted loneliness stemming from shyness and a refusal to acclimate to the carefree way of life that permeated Hollywood. She liked neither the weather nor the people, especially the loud and kinetic movie set. Nevertheless she came to the studio every day and learned her craft. Absolute focus and perfectly wrought strategy that propelled a Swedish girl with little formal education and childhood dreams of movie stardom into a brilliant and successful screen actress were her constant companions.

How did it happen? Her appearance comes first. When the designation "world's most beautiful woman" was first ascribed to Garbo is unknown, but by her fifth film, *Divine Woman* (1927), her place at the head of the line of Hollywood beauty was fixed. Like faith, those who adhere to Garbo's preeminence do not need, nor will accept, any analysis. Those who claim Vivien Leigh or Hedy Lamarr or Katharine Hepburn as Hollywood's ultimate goddess may rest assured they will always have supporters. But, from about 1927 until the release of her last film in 1941, it is indisputable that the world's press accorded the title to Garbo alone.

Hollywood was and still is filled with beautiful women. In addition to her extraordinary good looks Garbo developed into a superlative movie actress. Maybe the best. Acting in front of the camera is different from working on stage. Few performers have found top success in both film and the theater. Paramount offered Tallulah Bankhead a huge contract in 1931, and although she was good on the screen, the dazzling fire she created on stage was lacking in her movies. Garbo was trained at the Swedish Royal Academy, but aside from roles assigned when she was a student, she never acted on stage. It would be fruitless to speculate what sort of theatrical actress Garbo might have become. Her genius was how she registered in front of the motion picture camera. Garbo learned quickly the intricate technical skills necessary to be a successful movie actress. The lessons began under Stiller's tutelage in Stockholm and continued with G. W. Pabst, who directed her second feature, *The Street of Sorrow*, in Berlin. Once in America the frantic pace of filmmaking—three films in slightly more than twelve months, and with different directors—forced Garbo to perfect her skills on the job. Had she not been able to thrive under this tremendous pressure, MGM would have dropped her contract. Stars were coddled by the front offices, but newcomers simply had to improve every day. Of the thousands of women and men who have passed through the front gates of Hollywood studios with hopes of success, only a small fraction have seen their dreams come true. Later, Hollywood studios set up in-house schools where prospects were taught acting and singing and dancing.[1] But, in the late 1920s, you needed to be a success practically the first time out. Joan Crawford appeared in eight films in her first nine months at MGM before scoring the role of Irene in *Sally, Irene and Mary* (1925). She figured out quickly, and on the job, how to become an actress; two years later MGM anointed her a star. Garbo, slightly younger than Crawford but with a bit more experience, was asked to carry a film as leading lady in her American debut. *The Torrent* holds up well today, and not just because of our ongoing fascination with Garbo. She gives a compelling performance in a finely made production. The vast literature devoted to Garbo studies has scrutinized all her films but perhaps none more than her early silents, in which we can chart her ascent as an actress. In her first three films, Garbo's performances evolve from good, to better, to best. During those early months, she learned first how to be an actress and then a star; over the subsequent fifteen years, she refined and redefined the meaning of both.

To looks and talent must be added Garbo's magic. Something happens in the space between the faces projected on the shimmering silver screen and the eyes of the patrons filling movie theater seats. A studio army, consisting of actors, directors, writers, camera operators, costumers, scenic artists—the dozens of men and women responsible for bringing a movie to life—works together in the hope of creating meaningful entertainment. Some films work, others don't. Some actors garner audience approval, while many more are ignored. Even the brilliant film moguls Louis B. Mayer and Adolph Zukor counted misses among their many hits. The coins of contented audiences fill box office coffers, and those same audiences make stars. Garbo registered well with her new American public when *The Torrent* was released in February 1926. Eight months later *The Temptress* debuted successfully. On December 26, 1926, *Flesh and the Devil* premiered in New York and Los Angeles. Lines formed at the box office. The film was held over week after week. Garbo was now twenty-one and old enough to sign her own contracts. MGM rushed her into yet another film, a potboiler called *Women Love Diamonds*. Garbo said no. The studio suspended her without pay. The lines to see *Flesh and the Devil* continued. The moviegoing public found in that magical ether of the great movie palaces a character, a woman, and an ideal that summed up the aspirations of many in the ebulliently prosperous years following the end of the First World War. Garbo was the screen incarnation of a new type of woman, independent and confident. No longer did a cinema vamp need to be a raven-haired caricature. She could now be blond.

"From the moment *The Torrent* went into production," wrote Louise Brooks in her 1982 memoir, *Lulu in Hollywood*, "no contemporary actress was ever again to be quite happy in herself."[2] It's doubtful that Brooks or anyone else was prescient enough to make that claim in 1925, but her point, made more than a half-century later, is easily understood if we look ahead two years following the release of *Flesh and the Devil*. Brooks continued: "Garbo created out of the stalest, thinnest material the complex, enchanting shadow of a soul upon the screen. And it was such a gigantic shadow that people didn't speak of it." Garbo and Brooks were a year apart in age, and during the summer that Garbo passed through New York on her way to Los Angeles, Brooks was starting her film career in New York working at Paramount's Astoria Studios appearing in small roles. While Garbo was championed from the start, the legend surrounding Brooks was not created until decades after her film career ended, when film historians such as Kevin Brownlow and James Card insisted that her magnificent German films under Pabst's direction be once again considered. Brooks achieved only minor leading-lady status in Hollywood, where she lived and worked between 1927 and 1929 before heading to Berlin. There she found stardom, and later film immortality. A fairly reliable chronicler, she claimed to have met Garbo. What the two shared is thrilling beauty, perhaps the two most modern faces to come out of the early Hollywood period. Until she worked for Pabst, however, Brooks must be considered a so-so

actress, although she was a fine subject for Eugene Robert Richee, Paramount's top portrait photographer.

Marlene Dietrich also spoke glowingly about Garbo in a 1971 television interview she gave in Copenhagen following a concert. "Nobody was ever a competitor with Garbo," she said when asked if she felt rivalry with Garbo in the years after her 1930 arrival in Hollywood. "She was a unique person." Dietrich's professional trajectory differed from that of Brooks. Where Brooks went to Berlin to find success and fame, both had largely eluded Dietrich in Germany until she was cast by Josef von Sternberg in *The Blue Angel*. The film was a joint venture between Germany's UFA and Paramount, and the film was shot simultaneously in both German and English. Watching early rushes convinced Paramount executives that Dietrich might have potential in America, and late in the evening of the film's Berlin premiere, Dietrich left husband and child behind and sailed to New York. Even before *The Blue Angel* was released in America, Dietrich was cast in *Morocco* costarring Gary Cooper. Von Sternberg directed as he would for six of her first seven American pictures, all for Paramount. Unlike Garbo, Dietrich had the opportunity to work extensively with her mentor, who shaped her into Paramount's avatar of screen glamour. The Garbo-Dietrich "rivalry" was a creation of the fan magazines, even if looking back today at each actress's roles between 1930 and 1935 at competing studios we see the possibilities; mostly, however, the films were made in the quest of audience dollars. Garbo portrayed Mata Hari, and Dietrich also played a spy, in *Dishonored*, both films released in 1931. But how do we compare *Queen Christina* with Dietrich's take on Catherine the Great in *The Scarlet Empress*? In 1932 Garbo made a film of a Pirandello play, *As You Desire Me*, while Dietrich was playing Shanghai Lily in *Shanghai Express*. Best to savor the work of both actresses. While Dietrich went on to have a long, successful film career, her legend stems from something bigger that included performing decades of concerts, and a time spent in Europe during the Second World War heroically entertaining American troops. As the war began, Garbo vanished, from the movies and from the public eye. But her position as the unassailable screen goddess never diminished.

From the start Garbo lived her life almost completely apart from the social whirl of late Roaring Twenties Hollywood. In this she was singular. Arriving in Los Angeles, Garbo took a room at the ocean front Miramar Hotel and stayed there happily (and quietly) for three years. How transgressive she must have seemed to those who cautiously watched her rise. Unlike Clara Bow, her name was not associated with wild and lavish parties, or an endless stream of glamorous lovers. And unlike Mae Murray, Garbo seemed immune from the volatile temperament that fame often inflicts upon the suddenly anointed. Nor did she seek the prestige of a noble match with a Russian pseudo-prince (Mdivani), as did Murray. The great, glamorous Paramount star Pola Negri married another Mdivani brother, suggesting that for some, top-line motion-picture stardom was not quite sufficient

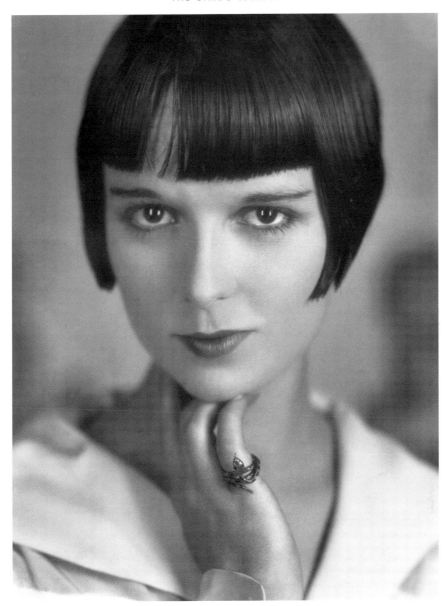

Louise Brooks began her film career at Paramount in 1925, but it was not until G. W. Pabst invited her to star in two German films, *Pandora's Box* and *Diary of a Lost Girl*, that she became a star, and later a twentieth-century icon. Photograph by Eugene Robert Richee.

fame. To all this Garbo was indifferent. Filmmaking kept her busy and perhaps content once she forced MGM to tear up her original contract and produce a new one that promised her a star's salary and script approval. She never made *Women Love Diamonds* but instead was rushed into a prestigious film, a contemporary version of Tolstoy's *Anna Karenina* titled *Love*, and was once again paired with John Gilbert. The new deal gave MGM five years of her services, and they got in

After a decade of acting in her native Berlin, Marlene Dietrich was cast in 1929 as Lola in Josef von Sternberg's *The Blue Angel*. Released the next year, it became an international hit, and Paramount Pictures offered Dietrich a Hollywood contract.

return fifteen films. Garbo became wealthy and internationally famous. But she never went to parties and never married a prince or anyone else.

On-screen Garbo mesmerized audiences. And unlike many of the great female glamour goddesses, she appealed to both men and women. One of the earliest articles about Garbo was published in *Motion Picture* in August 1926, where she was described as possessing "a strangely seductive magnetism. Men are perhaps more susceptible to this quality in her personality than are women."[3] But women had the most to learn from Garbo—like how to smoke, how to wield a cigarette. For women, smoking in public was new. Garbo was far from the first actress to smoke on-screen, but she did it with authority. And women learned how to simplify their appearances, ironic though this might seem: Garbo was often costumed in spectacular gowns designed by Max Rée or Adrian. But even in films where she sported outlandish costumes such as *Wild Orchids* or *Mata Hari*, there are long sequences where Garbo is dressed simply, often in black, without jewelry, and with her hair flowing naturally, barely touched by curling irons, or, in the case of *Mata Hari*, with her hair combed back severely, giving her head the quality of a marble bust. For just the simple way she wore her hair, shoulder length and parted at one side, she might be her century's most influential figure for female style.

Women did not, however, learn about conventional romance from Garbo, as they did in films featuring Joan Crawford or Bette Davis. Garbo's stories generally ended badly. Crawford specialized in portraying the young career woman, often

from the wrong side of the tracks, who through grit and determination (and a spectacular wardrobe) finds the man of her dreams before the closing credits. Davis played a more sophisticated version of the type, usually respectably middle class, heading for matrimony with one of the Warner Brothers stable of leading men, often George Brent. Sex was always subtly on the surface of a Crawford film, especially if she was costarring with Clark Gable, and just slightly under the surface of a Davis film. For Garbo's characters, sex was a banquet, and her characters did not bow to stuffy American mores. Marriage in a Garbo film was often irrelevant to the story. Yes, she sometimes played a married woman but usually to an older man, and she was invariably in an adulterous relationship. In films such as *Romance* and *Inspiration*, where decent young men actually want to marry Garbo's character, the prospect is impossible, and the heroine gallantly leaves these fellows with their memories. In *Camille*, Armand Duval asks Marguerite Gautier to marry him, and the proposal adds to the story's dramatic center. But in mid-nineteenth-century France, a respectable man without a fortune, just beginning a career, could not seriously consider marrying a notorious courtesan. Still, Armand's plaintive words fire the romance of this illicit love affair and turned up the heat for the audience. *Camille* provides Garbo one of her best roles, and her performance has sometimes been cited as the finest acting by a woman in American cinema.

But *Camille* did not win Garbo an Academy Award, although she was nominated. The 1937 Best Actress Oscar went to Luise Rainer for *The Good Earth*, her second win in two years. Irene Dunne was also nominated for *The Awful Truth*. If Garbo gave arguably American film's greatest dramatic performance in *Camille*, and Irene Dunne's bravura comedic performance represents the pinnacle of that genre, what should be said about Rainer's improbable win? Garbo was nominated for three other films, *Anna Christie* and *Romance* both in 1930, and *Ninotchka* in 1939. Norma Shearer took top honors for 1930, and Vivien Leigh, deservedly, for *Gone with the Wind* in 1939. Garbo never won a competitive Oscar; neither did Dunne (or her costar Cary Grant). Yet more than eighty years later, *Camille* and *The Awful Truth* have come to represent the best of American films and film acting. The Academy does not always get it right.

Garbo and Chaplin share honors as the subjects of the greatest number of books that came out of the early film world; it is hard to determine who wins the final count. The first for Garbo, *Greta Garbos saga*, was published in Sweden in 1929. In English the floodgates opened with *The Private Life of Greta Garbo*, which hit the bookstores in 1931. Written by Rilla Page Palmborg, a popular writer for fan magazines, the book relied heavily on the indiscretions of a couple whom Garbo had hired as cook and gardener when she rented her first house in Los Angeles. Later decades saw the publication of dozens more biographies spiking at anniversaries or to mark her death. In the contemporary celebrity-obsessed world, it might not seem unusual for a twenty-six-year-old actress to be the subject of a

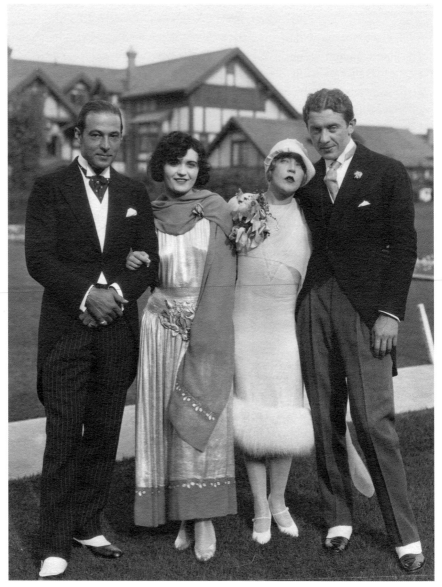

Mae Murray married "Prince" David Mdivani in a June 1926 ceremony witnessed by Pola Negri and Rudolph Valentino. The next year Negri married David's brother Serge. Both marriages ended in divorce after the brothers successfully squandered their wives' fortunes. Left to right: Valentino, Negri, Murray, Mdivani.

full-length biography, but in 1931 it was without precedent. Only Chaplin, from the early generation of performers, was anthologized beginning in his twenties. Not even the likes of Mary Pickford and Douglas Fairbanks, a couple whose every move filled newspaper and fan magazine columns, were the subjects of biographers until much later. And never to the extent of Garbo and Chaplin.

From the ballyhoo days of Hollywood publicity, more ink was likely spilled in the fan magazines celebrating Garbo than any other performer. Joan Crawford might come a close second, but she worked the publicity machine diligently, making herself constantly available to studio portrait artists for new pictures and to reporters for fresh copy. After a few bumpy interviews when she started at MGM, Garbo spoke rarely to the press. And she refused to pose for photographs other than those directly related to her films after the spring of 1926, when MGM's publicity office sent her to USC to pose with athletes, and to the zoo to be pictured with a lion. Such noncooperation was against her contract, but the lady said no. Soon studio officials saw the wisdom in allowing an enigmatic aura to surround their young Swedish leading lady.

Mystery (or was it simply the refusal to play the game?) became one of Garbo's defining features. Stubborn refusal to meet the press seemed churlish, so MGM promoted it as alluring, although some journalists took Garbo to task for unsporting behavior. But she was consistent, and from the winter of 1927 until the end of her life she never sat for a proper interview. She might meet briefly with a fan magazine or newspaper writer, and she consented to a few quick shipboard greetings with the press as she arrived in America or Sweden after one of her Atlantic crossings, but nothing more. If a camera turned its lens on her, she denied the photographer the prize. Over sixty years only a tiny number of grab shots depict Garbo smiling or engaging with a photographer in any way. Thousands of other pieces of film show her head down, frowning, perhaps hand or tissue covering her face, but always insisting on her privacy when she was not working. And since she never worked after 1941, there were almost five decades in which the only photographs she permitted were a small number of private sessions with friends such as photographers Cecil Beaton or George Hoyningen-Huene. These few precious images were parsed out to fancy magazines like Vogue or Bazaar, likely with her tacit if not explicit approval.

As great as Garbo's fame was during her working years—on screen rivaled only by Chaplin's—some perspective is in order. Nothing could challenge the explosive media coverage of and worldwide enthrallment over Charles Lindbergh's 1927 nonstop flight from New York to Paris. Probably only the Armistice concluding the First World War, the bombing of Pearl Harbor on December 7, 1941, and the moon landing drew more attention in the twentieth century, though as a human interest story, Lindbergh's landing might be the biggest of all. *The Spirit of St. Louis* took off from Roosevelt Field on Long Island on May 20, 1927, and landed in Paris the next day. Trying to describe Lindbergh's glory in the years following this achievement is nearly impossible, as he became its perfect embodiment. Everyone on the planet knew his name. Everyone was dazzled by what he had done.

A few miles away from Roosevelt Field stands Yankee stadium, and at the moment Lindbergh lifted off the ground, Babe Ruth might have been America's most famous personality. The legendary 1927 Yankees, regarded by some as baseball's

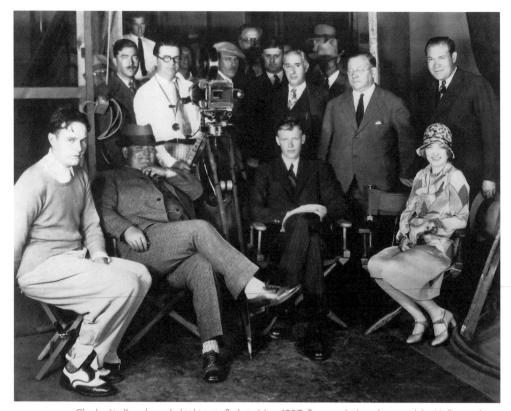

Charles Lindbergh made his historic flight in May 1927; five months later he visited the Hollywood
set of *West Point*, directed by Edward Sedgwick (seated, wearing hat) and starring William Haines
(seated left). Others included Marion Davies (seated right), producer Harry Rapf (standing behind
Lindbergh), and studio executive Eddie Mannix (standing behind Davies).

best team ever, counted The Babe among its roster, and as he scored one home
run after another, fans screamed and Ruth's fame was out of the park.

Movies, adventure, baseball—Americans were enjoying a postwar prosperity
and created heroes reflecting the newly found self-confidence. Motion pictures
might not have been invented in the United States—the French fairly lay claim
to getting there first—but most of the industry's striking technical developments
were American. In addition, a small group of movie moguls created the studio
system, which made and marketed films at home and abroad. So efficient was
the studio system that by the early 1930s, the top eight studios combined released
more than three hundred features a year and many hundreds more short subjects
and cartoons. American films saturated the world's market, and the faces of those
pictures' stars were recognizable any place that had a movie theater.

By May of 1927 when Lindbergh made his famous flight, Garbo had taken her
first steps toward worldwide acclaim. *Flesh and the Devil* made her a movie star,
and her native financial acumen and business sense found her besting Louis B.

Mayer at the negotiating table; she secured a new contract that promised $2,000 a week immediately, with annual increases that over five years brought the number up to $6,000. Still, she was not a top earner; Mary Pickford, Norma Talmadge, John Gilbert, and Charlie Chaplin were among those who drew larger salaries at the time. But Garbo was the first performer whose weekly pay under the strict conditions imposed by the studio system jumped fivefold—from a paltry $400 a week to $2,000—in eighteen months, and soon would rival the great stars of the recent past. Within Hollywood's new regime, Garbo had accomplished the nearly impossible. MGM bosses wanted the terms of the new contract kept private lest other performers try similar tactics. Garbo said nothing, but Hollywood is a small town, and soon the papers and magazines were reporting, sometimes accurately, sometimes not, her new deal with MGM.

When Garbo disembarked in New York in the summer of 1925, the very notion of a movie star had been current scarcely for a decade. But during those ten years, a small group of women and men had invented and defined motion picture stardom as it would be known for most of the twentieth century, and they reached, seemingly overnight, a level of fame hardly matched since. Garbo's legend was built on the foundation laid by her predecessors. Clark Gable, Cary Grant, and later Elizabeth Taylor were similarly indebted. Motion picture producers cultivate performers' careers and place them before audiences for approval. But ultimately the public—never wrong, though sometimes fickle—decides who will be a movie star. There is a valley below Parnassus filled with the dry bones of talented and beautiful men and women who seemed positioned to become the next favorite. Only a few reach the pinnacle of fame and endure long enough to become legends. Is there a better example than the career of John Gilbert, Garbo's frequent costar, to demonstrate soaring heights followed by a sudden plummet from favor into near oblivion?

Garbo was one of many aspiring actors who came to Hollywood in 1925. MGM producers, though willing to give her a chance, cannot have had the sense that a major new star was in the making. Mauritz Stiller was the first true believer in the Garbo religion, but few at the studio paid much attention to his prophecies. It was only after the cameras began to roll and the first rushes were viewed that the bosses saw something remarkable. Her first film was released, and then quickly her second. She was a success. In January 1927, a mere ten months after *Torrent* opened, her third film, *Flesh and the Devil*, was screened. Audiences acclaimed her a star. When Garbo died in 1990, forty-nine years after making her last film, her fame was still white-hot.

Movie Stardom before Garbo

THE STARS

MOVIE STARDOM IS ALMOST AS OLD AS MOTION PICTURES, BUT NOT quite. The earliest film that most knowledgeable aficionados can name is French director Georges Méliès's *A Trip to the Moon*, made in 1902. Plenty of pretty young women therein, scantily clad, but their names have not come down in film history. A half-decade later Florence Lawrence, working for D. W. Griffith at Biograph Studios in Manhattan, was designated "The Biograph Girl." Veteran of a hundred or more short films, her face was becoming recognizable to moviegoers, who wondered about her identity. Carl Laemmle founded the Independent Moving Picture Company in 1909, and she joined the roster of his players. The prominently positioned IMP logo on all advertisements featured a drawing of a devil whose pointed tail wrapped around the letter "I." A publicity stunt, one of the movies' first, released news of Lawrence's death in a streetcar accident on February 17, 1910. Advertisements for *The Broken Oath* (released March 14, 1910) shouted, "We Nail a Lie," and revealed that "Miss Lawrence . . . is in the best of health." Publicity for her subsequent films often included the IMP devil holding a portrait of the actress's face, although she is rarely mentioned by name. After Laemmle's creation of Universal Pictures in 1912, Lawrence's name was prominently displayed in posters and advertisements. Florence Lawrence is generally accorded the title of film's first movie star. She may well deserve it, but in most ways Lawrence does not embody the twentieth century's notion of what that meant.

A better candidate is Theda Bara, who burst on the film scene in early 1915 as star of William Fox's *A Fool There Was*. While advertisements announced the leading player as "Vampire," within days of the movie's opening, Bara's identity was widely known, and the type of the sultry, magnetic female mantrap, or "vamp," originates with her. Promoting Bara, Fox's publicists ushered in an era of extravagant movie star promotion, exemplified in a 1917 ad appearing in *Motion*

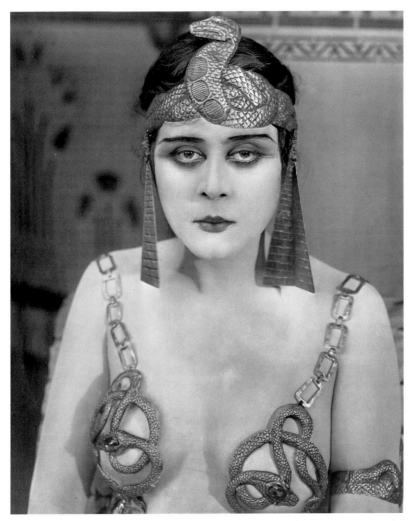

Early screen sensation Theda Bara had a short but spectacular run after her smash hit *A Fool There Was* (1915) made her the screen's first vamp. Photographer Albert Witzel photographed her in costume for *Cleopatra* (1917).

Picture News for *Camille*, exclaiming above the title: "A MASTERWORK OF BARA ART."[1] Virtually all her films have been lost to neglect, and history relies principally on the survival of *A Fool There Was* as cinematic evidence of her appeal. Perhaps more significant is the photographic record, the portraits, and scene stills of Bara at work. Original prints by Albert Witzel and Walter Frederick Seely, the first of the photographers who followed cinema's westward migration to Hollywood, are aggressively sought after by collectors and fetch high prices at auction. Here we see the heavy make-up and hypnotic, heavily darkened eyes that defined cinema's first femme fatale, costumed in spectacular, outrageous, and often risqué costumes appropriate to roles such as *Camille*, *Cleopatra*, and *Salomé*. Yet

despite this overlay, Bara reveals hints of a self-deprecation that belies a ponder-
ous screen persona. Her career lasted hardly four years before the public tired of
her overwrought acting. Still, so indelible was her image that a century later her
name alone evokes the moment in time when glamour was born in the movies,
and film scholars and fans hold out hope that in some still-to-be-mined archive,
one more Bara film will yield another glimpse of the original vamp at work.

While Bara was emoting behind heavy-lidded eyes and cavorting around film
sets setting the template for future wicked women on the screen, a very different
sort of actor was gaining popularity playing simple souls up against the tyranny
of early twentieth-century life. Charlie Chaplin started making shorts for Mack
Sennett in 1913. Two years later he moved to Chicago-based Essanay Studios,
where he made the aptly titled *His New Job* (1915). Already a cinema attraction,
the comic was tempted by Essanay with the promise of a princely salary of $1,250
a week. Chaplin may have liked the money, but Chicago must have reminded him
unhappily of London; he soon decamped to Essanay's newly built West Coast
production facility in Niles, California, just north of San Jose. There, in April 1915,
he made *The Tramp*. No sonic boom was recorded the first time the title character
in the film's final fadeout walked down the street away from the camera, but both
the Tramp and his creator were heading into the sort of fame likely never before
experienced by one who was not an emperor, queen, or pope.

Chaplin was not Hollywood's only star comedian, of course. Buster Keaton
and Harold Lloyd were pretenders to his throne. Both were wildly popular and
tremendous moneymakers, as their films could be made cheaply and quickly.
Keaton began his career in 1917 working with Roscoe "Fatty" Arbuckle, another
top comedian who made mostly popular short subjects before his career came
abruptly to a halt after a 1921 scandal. By 1920 Keaton was directing and starring
in feature films, many of which today are indisputable masterpieces (*The Nav-
igator*, 1924; *The General*, 1926). Lloyd entered films around the same time and
made a series of now-classic comedy features (*The Freshman*, 1925; *Speedy*, 1928).
The twenties were unquestionably the golden age of motion picture comedy, but
regardless of how popular the comedians were, with the exception of Chaplin,
the "serious" actors, the dramatic gods and goddesses, came first in the pecking
order of early Hollywood royalty.

Mary Pickford had made hundreds of short films by the time Essanay released
The Tramp (1915) and, months, earlier had signed a robust contract with Artcraft
Pictures, whose films were released through Paramount. She began her career in
New York in 1909 at the age of seventeen and by the next year was one of Carl
Laemmle's IMPs. The December 24, 1910, issue of *The Moving Picture World*
features Pickford with long blond curls in a full-page photograph where she is
identified possibly for the first time. In that first year, she developed a screen
character, or range of characters, that relied on her petite size, golden locks (a
symbol of virginity), and fresh-faced innocence. In whatever role she played, her

character prevailed against long odds. Audiences adored Pickford and insisted that her character not change—only the situations in which she found obstacles. Could this popularity survive longer films? Receipts following the release of one of Pickford's first features, *Tess of the Storm Country* (1914), directed by cinema pioneer Edwin S. Porter, made clear that the blond waif was worth her hefty weekly salary. Two years later the ever-frugal Adolph Zukor at Famous Players-Lasky (Paramount) signed Pickford to an unprecedented contract guaranteeing her not only $10,000 a week but full control over the selection, casting, and script of her productions. Star power was steadily growing, exerting its newfound influence both before the public and in studio board rooms.

Unlike Chaplin and Pickford, Douglas Fairbanks became a movie star rapidly and apparently with little effort. Success on Broadway led to a contract with the newly formed Triangle Film Corporation, the triangle consisting of D. W. Griffith, Thomas Ince, and Mack Sennett. Moving to Los Angeles in mid-1915, Fairbanks starred in two features directed by Christy Cabanne. The first, *The Lamb*, was a hit. After a year with Triangle, he set up his own production company with Artcraft/Paramount distributing. What set Fairbanks apart, aside from his dashing good looks and terrific body—which was often on display (have a look at *The Half Breed*, 1916)—was his athleticism. Here was an actor who appealed to both sexes and to young and old, one comfortable in drawing-room comedies, westerns, or kinetic adventure films. It was the last that catapulted Fairbanks from star into legend.

Following America's entry into the First World War, Chaplin, Pickford, and Fairbanks joined forces to sell war bonds, perhaps the first demonstration of the power of motion picture stars outside the walls of cinemas.[2] Surviving newsreels and a large quantity of press photographs record the three on a sales drive beginning on April 6, 1918, in Washington and ending in New York City two days later. The day before, the US Treasury had formally announced the Third Liberty Bond Issue to raise revenue for the war effort in Europe. Purchasing war bonds was considered a patriotic duty, and the three were enlisted to help launch the campaign. In Washington they traveled in horse-drawn open carriages, cheered by huge crowds anxious to see their film idols close up. "We paraded through the streets like potentates," Chaplin wrote in his autobiography.[3] At the Treasury Department, they got out and addressed the adoring multitude. On Wall Street two days later, twenty to thirty thousand people were said to have turned out to greet them. Photographs of Chaplin standing on Fairbanks's shoulders under the statue of George Washington in front of Federal Hall capture the jovial spirit of the occasion, with every inch of the street below crowded with fans.

Three years earlier Chaplin had made his first film at Essanay, *His New Job*. In the opening scene he enters a business office and greets a secretary who is seen quietly typing near the door. Gloria Swanson—for it was she—was working as an extra for Essanay and occasionally getting small parts. With Mack Sennett the next year, she was featured in many two-reel shorts where her comic abilities

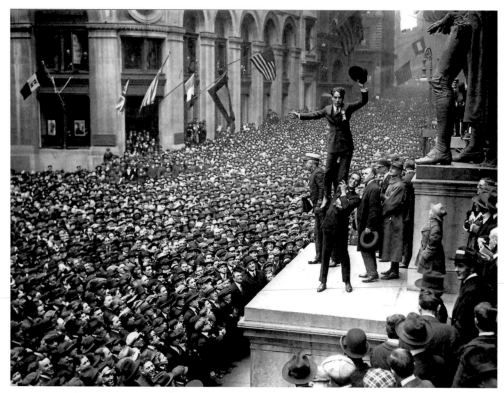

Cinema's two great male attractions, Charlie Chaplin and Douglas Fairbanks, joined forces to sell war bonds in April 1918. A crowd estimated at 30,000 gathered at New York City's Federal Hall to catch a glimpse of the dynamic pair.

were on display. It was not until Swanson signed with Triangle in 1918 that she began to develop into a serious actress. When Triangle dissolved later that year, Cecil B. DeMille offered Swanson an Artcraft/Paramount contract and cast her immediately in *Don't Change Your Husband* (1919). In less than five years, De-Mille had become one of Hollywood's most successful—certainly in terms of box office—directors giving his public a mixture of westerns, war pictures, and boudoir melodramas. Most made money. DeMille, it seemed, could direct any sort of picture, but the racy films featuring adulterous married couples, divorce, and other "adult" plots were becoming his specialty. Opulent sets created by top designers, magnificent, gorgeous gowns sewn by the best couturiers, and the luxurious bathroom, previously ignored in the movies, all became hallmarks of DeMille's films. Over the years he had worked with many excellent actresses but had never found exactly the right leading lady to convey the glamorous, wealthy, world-weary sophistication he wanted to present, especially to female audiences who counted more at the box office. Then he cast Gloria Swanson as Leila Porter festooned in brilliant sumptuous costumes created by Mitchell Leisen. The artist had his muse, who would soon outshine even the mighty DeMille.

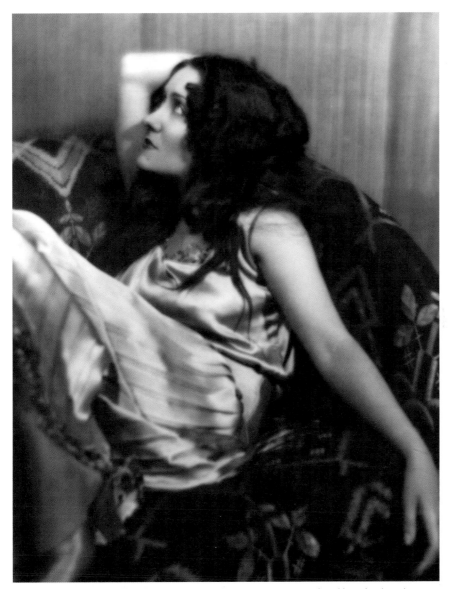

Gloria Swanson's first film with Cecil B. DeMille, *Don't Change your Husband* (1919), ushered in a new screen type, the glamour goddess, and she played this role perfectly for the balance of her screen career. Photograph by Russell Ball.

What made Bara, Chaplin, Pickford, Fairbanks, and Swanson so popular with audiences? Superficially they each became associated with a strongly identifiable type: Vamp, Tramp, Waif, Swashbuckler, and re-Vamp. Theda Bara's career ended shortly, but the others' endured. Audiences insisted on strictly defined screen images, and Mary Pickford better than her peers resisted the temptation to play characters outside limited fan expectations. But, while blond little-girl lost may

have made sense when she started acting at seventeen, by the age of thirty, these roles started to wear poorly. Pickford cut her curls and sought out adult parts as silents turned to talkies. *The Taming of the Shrew* (1929) met with some success, and she won an Academy Award for *Coquette* (1929) before retiring in 1933. She was rewarded financially for keeping her well-established brand alive so long, and who could blame her for having waited to try more imaginative roles? Still, it was better to retire in splendor at the top of Hollywood society than chance antagonizing the fickle audiences that had made her one of the most popular players in the world.

Gloria Swanson's characters were the antithesis of Pickford's. At the dawn of the Roaring Twenties, film audiences increasingly demanded more-subtle and contemporary stories; they also began to look at actors as something more than shadows on the silent screen. Cowboy Tom Mix became a hero to a generation of boys. Not the roles he played, but the man himself. Mabel Normand's cheerful comedic antics endeared her to young women. In perhaps half of her more than two hundred film appearances, her character was even named Mabel. Mix and Normand were the brand. Although remembered mainly by silent-film devotees today, they were screen archetypes during their active careers. When Swanson under DeMille's direction synthesized the characteristics of the confident urbane and glamorous 1920s woman into a coherent screen persona, she created a vogue for fashion and manners that was followed around the world. While the exotic and overly dramatic Swanson mannerisms may strike us as parodic today, the unforgettable screen characters she created have been preserved forever in the rich amber of the best silent pictures.

Chaplin's genius as creator, writer, director, and star of his films has never been matched. Perhaps most astonishing was his ability to invent stories that are happy, sad, or poignant, or ironic, critical, or political—sometimes in the same film—while always playing only slight variations on the little tramp. When in 1936 he made *Modern Times*, the tramp became a factory worker; four years later in *The Great Dictator*, a barber. Chaplin's character, unlike Pickford's, frozen in her youth, could evolve.

Close contemporaries and best of friends, Douglas Fairbanks and Chaplin shared nothing on the screen except the adulation of fans. Fairbanks's dashing hero was cultivated through many films and finally coalesced into a trademark in *Reaching for the Moon* (1917). Modern-day America melded with European aristocracy as he fought up and down a medieval circular staircase and engaged in what must have been his first screen swordfight. For more than a decade, he kept up his physical antics and was still a star of the first rank when he released his last silent film, *The Iron Mask*, in 1929, playing a still spry and only slightly aging cavalier. *The Taming of the Shrew* (1929) came next, costarring Pickford, his wife, inaugurating what might have been a successful career in talking pictures. But age (he was nearing fifty), being forced to work with a new technology, and a

broken marriage conspired to undermine Fairbanks's confidence, and after three more films he retired. Like Pickford he must have wanted fans to remember past triumphs.

The only man not a comedian who challenged Chaplin and Fairbanks at the box office in the early 1920s was Italian-born Rudolph Valentino. He drifted around Hollywood in the mid- and late teens taking bit parts and later leading roles in five- and six-reel features (fifty to sixty minutes), often appearing under the name Rodolfo di Valentina (a slight variation of his birth name). Sounding slightly feminine, it was not a promising marquee name for a male actor in post–World War One America. *Four Horseman of the Apocalypse* (1921) at Metro marked his real emergence, using the slightly anglicized Rudolph Valentino; a Famous Players-Lasky contract followed, along with the lead role in *The Sheik* (1921). Valentino was now a star. A hundred years on, Chaplin's performances even in silent and choppy black and white seem fresh. Fairbanks's easy masculine manner, the glint in his eyes, and tongue-in-cheek approach to moviemaking keep his films vivid. Valentino's appeal is harder to gauge. He was something new in Hollywood. Handsome, even a bit pretty, he was the first Latin romantic star to challenge the sturdy Anglo-Saxon notion of the ideal man. His heavily pancaked charm was directed strictly to women; he was perhaps the first male movie star to set off something approaching a sexual frenzy. As a trained and famous tango dancer, he moved eloquently and when well directed (*Beyond the Rocks*, 1922; *The Eagle*, 1925) is a pleasure to watch. Valentino was a very big star for a very short time. Nine films followed *The Sheik*, and the last, a rehashing of the old chestnut titled *The Son of the Sheik*, premiered only weeks before his sudden death from peritonitis in August 1926 at thirty-one. Such was Valentino's star wattage that motion picture's two most important producers, Adolph Zukor and Marcus Loew, led the procession preceding his coffin as it left Frank Campbell's Funeral Chapel in New York.

How important was appearance for the early movie stars? Certainly by the 1930s the studios were selling beautiful women and handsome men, sometimes at the expense of any acting talent. Hedy Lamarr, Ava Gardner, and Robert Taylor landed on the screen because each possessed a dazzling face. This was not true in the early days. Faces with great character drew audiences to fill theater seats—faces that corresponded to the idea of the role being portrayed. An actor playing a rugged cowboy did not need to be handsome, just convincing as cowboy. Of the early great film stars only Fairbanks could be classified as enormously attractive. Valentino in portraits often registers as somewhat bland and unaffecting. He is better in motion, with those soulful eyes burning deeply into his leading lady's soul. Chaplin's tramp defied characterization other than winsome, although the actor was rather good-looking off-screen. Pickford was pretty but her looks were artfully disguised to avoid the appearance of late adolescence. Bara's glamour was strictly the result of tremendous personality. Swanson's was owing to an

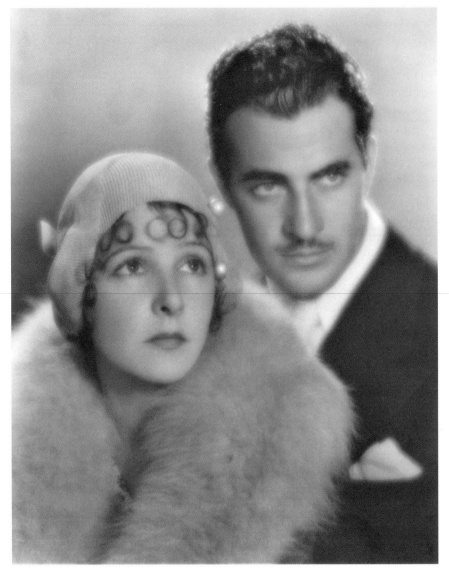

Top Hollywood star Norma Talmadge began a professional and personal relationship with Gilbert Roland, who was eleven years her junior, in 1925. They costarred in four films, including *Camille* (1925), before splitting up four years later. During the Second World War, Roland would have a brief affair with Garbo.

electrifying screen presence the equal of Garbo and Dietrich, but while handsome she did not possess the beauty of either. Movies were slow to speak, and not until the studio system did they depend on beauty to sell tickets.

Sure, silent pictures could boast dozens of attractive screen faces. Norma Talmadge was even thrillingly beautiful, a top star who drew one of Hollywood's biggest salaries and came to fame just before glamour was deemed one of the

industry's guiding principles. An actress of great range, in a career harking back to 1915, she effortlessly made both comedies and dramas, and the best of her surviving work (*Kiki*, 1926; *The Woman Disputed*, 1928) reveals Talmadge as one of most gifted performers in the silent era. She also produced her own films with her husband Joseph Schenck. Two talkies, however, *New York Nights* (1929) and *Du Barry, Woman of Passion* (1930), made clear that Talmadge did not have a voice for sound, ending her career. Alas, today her silent films are hard to find even on DVD, so enthusiasts of the medium have few opportunities to see her at work. She was an exceptional screen personality but played to a narrow market niche that left her stranded just below the summit of Hollywood's Mt. Parnassus, where her contemporaries—Pickford, Chaplin, Swanson, and Fairbanks—are likely to abide forever.

Leading men were expected to be good-looking but not too handsome, which might arouse suspicions of unmanliness. John Barrymore was the exception; the "Great Profile" photographed as beautifully on-screen as he must have appeared on stage. Yet he was never really a top movie star, although he came close during the mid-1920s with films such as *Beau Brummell* (1924) and *Don Juan* (1926). He was an artist, principally of the theater, the youngest of three remarkable siblings who always, it was assumed, saved their best for the stage. Thomas Meighan and Wallace Reid were two Famous Players-Lasky stars who also never quite reached the top ranks. Both were masculine and ruggedly handsome, just the type to work for Cecil B. DeMille and not take too much attention away from the leading ladies. Meighen reached the height of his fame costarring with Swanson in two DeMille potboilers, *Male and Female* (1919) and *Why Change Your Wife?* (1920). Reid, veteran of hundreds of film performances in a career than lasted only a dozen years, also worked with Swanson in a DeMille film, *The Affairs of Anatol* (1921). Slightly softer versions of the Clark Gable type, they were both appealing (to women) but with hardly a trace of menace. Born in 1879, by the mid-1920s Meighan was aging out of the top leading-man department and continued to work in increasing less distinguished films before retiring in the early 1930s. Reid's career ended in 1923; he died of a drug overdose at thirty-one.

One sure sign that movie stardom mattered in post–World War One America was the enormous press coverage of the scandals that rocked Hollywood. The biggest came first. Fatty Arbuckle was a huge comic star with a million-dollar-a-year salary from Famous Players-Lasky. Rivaling Keaton and Chaplin in popularity, Arbuckle was the fat opposite of the lean and slight Keaton, and the two were a team in two-reel shorts in the late teens. Kids adored Arbuckle and his films were staples of Saturday-afternoon movie fare. On the night of September 5, 1921, Arbuckle was hosting a party in his suite at the St. Francis Hotel in San Francisco. The critical facts of what happened that evening have never been adequately explained. The party was rowdy, with many guests, one of whom, the actress Virginia Rappe, died four days later of peritonitis as a result of a ruptured bladder (or so said the

record). Was Arbuckle responsible? The press and the courts decided yes, and he was tried not just once but three times over the next six months. Despite acquittal, his career was ruined. This was sensational international news, and no newspaper worked harder to keep the story in the headlines than those belonging to William Randolph Hearst. He more than anyone must have understood the damage such a scandal could cause the film industry—he also owned Cosmopolitan Pictures, which at the time of Rappe's death was producing the pictures of his long-term mistress, Marion Davies, but apparently newspapers were worth more to him.

A second outrage was the murder of director William Desmond Taylor in his home in Los Angeles on February 1, 1922. The crime was never solved, but over the past century it has continued to fascinate, providing the source material for an extensive blog and at least two interesting books on the subject.[4] Star actress Mabel Normand was with Taylor early on the evening of his death. Although she was never actively considered a suspect, the intense questioning by police led to the common belief that she was a cocaine addict; even a popular young female star's career could not endure the intimation of the one combined with the unsavoriness of the other, and hers did not. A second popular actress, the nineteen-year-old Mary Miles Minter, was also implicated in the scandal, as the press bruited stories of a romance between the former child actress and the forty-nine-year-old director; by the next year, she too was washed up. Taylor and Minter both had been under contract to Famous Players-Lasky, and studio chief Adolph Zukor did not want the attention, especially as the second Arbuckle trial was in process when Taylor was murdered.

There was more. On January 18, 1923, Wallace Reid died of a drug overdose at thirty-one. The screen favorite had been injured during filming in 1919 and was prescribed morphine for his pain; soon the patient was an addict. The studio still managed to work him unmercifully. In the year before his demise, he starred in eight pictures, now unfortunately all lost. If the rumor of Mabel Normand's drug use was a spark in Hollywood's night, Reid's death was a fire. Unwanted scrutiny from authorities outside the producers' offices was looming. The sordidness of Hollywood needed cleaning up. Soon the films did too.

Stars could sell movies, especially good movies, and stars could sell newspapers—even more of them if the news was bad. There is no telling whether movie scandals drove circulation as robustly as political scandals, but it is certain that in the early 1920s, movie news was national news, and movie news meant star news.

THE PRODUCERS

When in late spring 1912 the producer Adolph Zukor decided to name his new company Famous Players in Famous Plays, he was gambling that popular stage actors could attract film audiences ready for more sophisticated and longer

entertainment. The right material was important too, but Zukor placed players before plays. Why? The short answer is Sarah Bernhardt, the legendary stage actress who had made a four-reel, forty-minute film in France titled *The Loves of Queen Elizabeth*. Zukor had decided to quit his partnership with theater owner Marcus Loew and set up a new company to release the film in the United States. He predicted accurately that her fame would ensure financial success for his new venture, called simply Famous Players Film Co. when the papers were drawn up. Sixty-four years later Zukor died, at the age of 103, holding the title chairman of the board emeritus of Paramount Pictures, the corporation that had evolved, after a series of mergers, out of his simple but novel idea to release a film based on the presumption of star power.

Zukor's early success was one of few victories among scores of small companies that entered the film business in the first two decades of the twentieth century. This chaotic film production world straddled the country with legs principally set in New York and California, although limited facilities were also to be found in New Jersey, Illinois, and Connecticut, as well as other locales. All jockeyed for dominance, and success was predicated on a complicated mixture of wise decisions and good luck. The opposite meant failure. Triangle Film Corporation allied the collective talent and wisdom of Griffith, Sennett, and Ince, yet lasted merely three years. Few remember Jesse Lasky, but the Jesse L. Lasky Feature Motion Picture Company, the small outfit he established in 1913 in New York at 234 West Forty-Eighth Street, merged in 1916 with Famous Players to become Famous Players-Lasky. Along with Zukor and Lasky, the studio's controlling triumvirate included Cecil B. DeMille. Purchasing a successful Colorado film distribution company called Paramount Pictures in 1919 enabled Famous Players-Lasky to be one of the industry's survivors. Lasky himself lasted at the top as production chief for almost two decades, a good long run in Hollywood.

Biograph, Essanay, Selig, and Lubin are among the names of early studios that did not survive, but a few of the early pioneers rose to great prominence in the massive consolidation that took place beginning in the early 1920s. The year 1912 was significant not only for Zukor but also for Carl Laemmle, who founded Universal Pictures by consolidating several small companies. Louis B. Mayer, who would go on to rival Zukor as Hollywood's top mogul, was then managing a string of theaters in Haverhill, Massachusetts. In 1914 he negotiated successfully for the New England distribution rights for Griffith's *The Birth of a Nation*. The tremendous profits that ensued led Mayer to move to Los Angeles and try his luck at producing.

The new Louis B. Mayer Productions immediately signed a popular leading lady, Anita Stewart, to a contract giving her co-producing credit. Even in the infancy of one of Hollywood's must successful producing careers, Mayer recognized the financial dependency between movie players and movie producers. Though Stewart is little remembered today, the success of her films helped make Mayer's

career. Perhaps his shrewdest early move was luring Irving Thalberg away from Laemmle at Universal in 1923. Thalberg became Mayer's production chief and was part of the business package that must have appealed to Marcus Loew when he decided to broaden his stake in film production. Loew, one of the richest and most successful of the movie moguls, owned a New York–based theater chain that was among the country's most profitable. To expand he wanted to control product as well as theaters, so in a brilliant assemblage of acquisitions in early 1924, he amalgamated his Metro Pictures with Goldwyn Pictures and Louis B. Mayer Productions under the control of Loew's Inc. Metro-Goldwyn (later Metro-Goldwyn-Mayer) was born, with Mayer as vice president in charge of production.

By April, Mayer was suddenly head of a large motion picture enterprise, inheriting films already under production, such as Goldwyn's epic *Ben-Hur*. Thalberg and Harry Rapf were the senior producers responsible for MGM's ambitious program of releasing one film a week to keep Loew's theaters well supplied. Later, Mayer would assume a largely administrative role at his studio, but in the mid-1920s he was involved with day-to-day activities helping to oversee films in production and taking an active hand in shaping MGM's star roster.

Successful studios, harking back to Laemmle at Independent, counted on having marketable stars under exclusive contract. DeMille might have been able to open a film under his name alone in 1920, but he was unique. With the exception of Chaplin, Pickford, and Fairbanks, who joined forces (along with Griffith) in 1919 and formed United Artists, most actors relied on studios for jobs. Swanson and Talmadge each had a production company and in the late 1920s released their pictures through United Artists, but they were the last of the ancient régime; by 1930 Talmadge was retired, and the next year Swanson was working with Samuel Goldwyn. Even the great comics lost full artistic control of their films. Lloyd went to Paramount in 1926, and Keaton to MGM in 1928. Neither was happy. As the 1920s progressed and studio consolidation continued unabated, most Hollywood actors forfeited their independence.

Marcus Loew's creation of MGM under the command of Mayer was a vital step in establishing what later would be known as the Hollywood studio system. This practice enabled large motion picture corporations to control all aspects of filmmaking under their own roofs and brands. This included having a stable of producers, directors, and actors under long-term contracts. Under the studio system, the bosses did not have to worry, at least for seven years (the length of a typical studio contract), that an up-and-coming Mary Pickford would suddenly demand $10,000 a week. Universal Studios and Famous Players-Lasky (Paramount) were the first to work under this model; others soon followed. MGM's consolidation was complete in 1924. Warner Bros. would acquire Vitaphone (1925) and First National (1928) and with early success in sound become an industry leader. To the names Paramount, Universal, MGM, and Warner Bros. soon would be added RKO, Twentieth Century-Fox, Columbia, and United Artists. All but

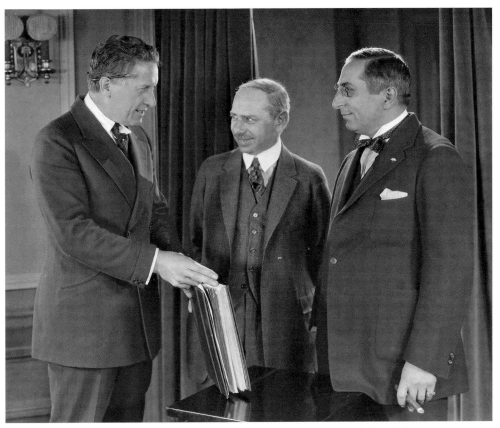

Marcus Loew (center), owner of a successful theater chain, bought Louis B. Mayer's (left) small film
production company and combined it with other properties to create Metro-Goldwyn Pictures, a new
studio to be operated by Mayer. The two are shown in a 1924 photo with Fred Niblo, who would
direct Garbo in her second film, *The Temptress*.

Universal, Columbia, and United Artists owned theaters. The eight controlled
virtually all of America's movie output by 1930.

Silent pictures had made the world domination of and saturation by the Hol-
lywood product possible. If only translated intertitles (or title cards) needed to
be changed, all films, whether comedies, westerns, or dramas, could be exhibited
anywhere. The public might have liked the idea of singing and spoken dialogue
in *The Jazz Singer* (1927), but surely Mayer, Laemmle, and Zukor hated what those
Warner brothers foisted on their successful businesses. Talking meant retooling
studios and theaters with expensive new equipment. It meant finding actors who
could speak well on film—something that turned out to be more difficult than
originally expected. It meant figuring out what to do about the lucrative world-
wide market. Germans did not want pictures in English, nor did the Japanese.

From 1924 to 1928, the calm years between the first wave of consolidation and
the advent of sound, when the twenties were roaring loudly and money was in

ample supply, Mayer set out to have MGM rival Paramount as Hollywood's most profitable studio. *Ben-Hur*, the film he had inherited, based on a hugely successful book, followed by a play that ran on Broadway and in subsequent venues across the country for more than twenty years, was among the most prestigious projects under way. MGM not only had tremendous financial resources invested but was under pressure to bring out an entertaining and crowd-pleasing film to satisfy eagerly awaiting audiences. Throughout 1924 *Ben Hur* was shooting in Rome under the direction of Charles Brabin and starring George Walsh. This was the largest production that MGM had taken on with the merger, and, plagued by one problem after another, expenses were soaring. In November, accompanied by his wife and two daughters, Mayer journeyed from Los Angeles to Europe, with Rome as the first destination. He was resolved to figure out how to finish this increasingly costly film successfully.

 Ben-Hur was but one of many topics on Mayer's mind as he crossed the ocean. With his ambitious plan to release a feature each week to feed Loew's many theaters, he needed to increase his stable of directors. Although the domestic supply was ample, films made in Europe were perceived to have a quality and stylishness often lacking back home. The Swedish director Victor Seastrom had come to America in 1923 to work for Goldwyn, and his contract passed to MGM after the merger. In late 1924 his film *He Who Gets Slapped*, starring Lon Chaney, opened to tremendous public response. Seastrom recommended to Mayer that he might consider another of his countrymen, Mauritz Stiller, for a job in America. Stiller had an international reputation and was celebrated for his film *Erotikon* (1920). Seastrom may have known that Stiller was working on an epic, *The Saga of Gösta Berling*, based on Selma Langerlof's Nobel Prize–winning novel. Perhaps Mayer could meet with Stiller while he was in Europe.

Sweden

GRETA GARBO WAS BORN GRETA LOVISA GUSTAFSSON ON SEPTEMBER 18, 1905, in Stockholm, Sweden, at the Södra Maternity Hospital. The third child of Anna Lovisa and Karl Alfred, she had an older brother, Sven, and sister, Alva. Her father was a laborer, and they lived in a modest apartment at 32, Blekingegatan (Blekinge Street) on the island of Södermalm, one of the fourteen islands that together form the capital city. Writers discussing Garbo's childhood disagree on whether the apartment was two or three rooms, but whatever the size, it was tiny for five people. A childhood friend, Ebba Antonsson, recalled that Garbo and Alva "slept in the kitchen, while their parents slept in the living-room."[1] Garbo's many biographers have had to describe her early years based on scant evidence and virtually no comment from the subject herself. We know that her father died on June 1, 1920, when she was fourteen, which corresponds with the end of her formal education. She had already worked as a barber's assistant,[2] and now she needed to find more permanent employment to assist her mother with household expenses. On July 26, 1920, Garbo began working at the Paul U. Bergström (PUB) department store in central Stockholm, an easy streetcar ride from home. Her employment application survives along with a photo.[3] She worked selling women's hats, and within six months the now fifteen-year-old could add "print model" to her accomplishments, as she was featured in PUB's spring catalog sporting five different hats. Just barely, but in a couple of the photographs, one gets the first hint of the face that would later enthrall the world.

At the same time, Garbo made her first attempt in front of the motion picture camera. Attractive and enthusiastic, she was asked to appear in an industrial short produced for PUB, *Herrskapet Stockholm ute pa inköp* (*Mr. and Mrs. Stockholm Go Shopping*), released in December 1920. The thirty-minute film survives; it takes viewers on a tour through the department store. Garbo appears in the middle, modeling dresses and coats. In a bit meant to be humorous (and commonly described as "How Not to Wear Clothes"), she is filmed trying on a series

of unattractive (or at least mismatched) outfits, at one point putting one on top
of the last. Stockholm-based Captain Ragnar Ring directed.[4] Garbo made her
second film, also directed by Ring, the next year, this time for the Stockholm Con-
sumers Cooperative Association.[5] In *Konsumtionsföreningen Stockholm medom
neijd* (*Our Daily Bread*) (released September 1921), Garbo and three other young
women enjoy coffee and pastries on the rooftop café of the elegant waterfront
Strand Hotel; later, we see them lakeside similarly engaged. While at the Strand,
Ring pans his camera at one point from Garbo and her companions to a nearby
table where actor Lars Hanson is seated with a male companion. Hanson was one
of Sweden's most notable stage and screen stars and was famous internationally
from his leading role in Mauritz Stiller's *Erotikon*. Two years later he would costar
with Garbo in her first feature, and in Hollywood they worked together at MGM.
Our Daily Bread survives only in fragments, most of which feature Garbo. Her
third film, *Sverige och svenska industrier* (*Sweden and Swedish Industries*, released
1922), was filmed in five parts and survives in its entirety.[6] Garbo appears in the
first three parts, each time standing in front of a map of Sweden pointing out the
featured locations. Opening part 1, she shows a map of the country and points to
the capital, Stockholm. In part 2 Garbo is seen first pointing to the port city of
Göteborg (Gothenberg) on the west coast, and later to the city of Malmö on the
south coast. The third shows Garbo identifying the Göta Kanal, which crosses
Sweden, and later the city of Västerås. The film gives us only a few of seconds of
Garbo, but in each section she turns toward the audience, occasionally smiling.
All told, nothing in these early films suggests that young, slightly plump Greta
Gustafsson is headed for motion-picture stardom, and thus far she reveals her
potential more in still photographs. Nonetheless, these are significant bits of
footage, as they give us the first glimpse, however unsatisfactory, of the future
actress at work.

At about this time. Garbo likely worked as an extra in two feature films, both
frustratingly lost. The first, *En lyckoriddare* (*The Gay Knight*) *premiered in March
1921, and the second Kärlekens ögon* (*A Scarlet Angel*) in October 1922—both
directed by the pioneering Swedish director John W. Brunius. Scott Reisfield,
Garbo's grandnephew, believes he can identify his great-aunt Alva in one or more
of the surviving stills for *En lyckoriddare* and presumes that Garbo was also in
the crowd scenes.[7]

Many of Garbo's biographers and her family agree that it was a chance meeting
at PUB with Erik Arthur Petschler, comic actor and occasional director, in early
summer 1922 that led to her first featured role in a film. From hats, apparently,
Garbo had moved to the women's clothing department, and there one day she met
Petschler, who was buying costumes for an upcoming film, *Luffar-Petter* (*Peter
the Tramp*). He himself was the lead, as well as the producer, writer, and director,
and the cast was to include three young women playing sisters. Accounts vary,
but whoever took the initiative, they met soon after, and a single audition secured

While working at Stockholm's PUB department store, sixteen-year-old Garbo met director Erik Petschler, who immediately cast her in his short subject film *Peter the Tramp* (1922). At left, with her arms raised, stands Garbo in her screen debut.

Garbo a role as one of the sisters. The now almost seventeen-year-old aspiring actress resigned her job, "to enter films" as she told her employers.[8]

Only fragments of *Luffar-Petter* survive, but those that do largely feature Garbo. Records at the Swedish Film Database list the original running time at seventy-five minutes, and the length approximately two thousand meters. Filming took place in and around Stockholm in late July or early August 1922. With a modest budget, Petschler had to work both quickly and efficiently.[9] The script supplied ample opportunity for the actresses to show off their attractions and to sport the latest bathing suits—the last a public display apparently forbidden in Stockholm, forcing Petschler to shoot at least one day in the more accommodating coastal town of Dalarö, about twenty-fives south of the capital. Surviving footage shows the three sisters off to an island by boat for an afternoon's picnic. None is seen swimming (though stills show them in the water), but they do walk daintily on the rocks just off shore. Petschler gives Garbo her first close-up—nothing more than a comely teenager mugging a bit self-consciously for the camera.

Nonetheless, Garbo was hooked. She wanted parts in more films. Petschler later claimed that he advised her to get training if she really hoped for a professional career. In 1922 Stockholm that meant securing a place in the Academy of the

Royal Dramatic Theatre. Contrary to the director's recollections, while filming *Luffar-Petter* Garbo was already planning to audition for the Academy's fall term. Over the course of the summer she studied with Frans Enwall, a former director of the Academy, who was assisted by his daughter Signe. Garbo prepared three scenes. In 1928, speaking with journalist Ruth Berry, she recalled, "I couldn't see a person. They were down in front. All I could see was that black pit—that black open space. All I could hear was whispering. I was so shy! I had never tried to act."[10] Her effort succeeded, and on September 18, 1922, her seventeenth birthday, Garbo joined eleven other students, the class evenly divided between men and women, and began what was meant to be a two-year program of study and training. The Academy was state sponsored, so tuition was free and came with a small stipend.

We do not know what sort of career Garbo was after at this point. Did she want to be a stage actress, or was her small filmmaking experience enough to draw her toward movies? So far no magic had been detected in her performances. Up to the day she enrolled in the Academy, she was merely one of thousands of young women the world over with aspirations to a life in the theater. Nor is there evidence when she was assigned her first stage roles that she performed especially well. Garbo was not a prodigy. Admission to the Academy signaled definite promise, but its fulfillment was not assured.

What is clear is that Garbo possessed great ambition and self-assurance, two qualities critical for success. Because her tremendous fame in America came all at once when she was just twenty, biographers have tried to see it coming. Perhaps all one can discern, though it's remarkable enough, is that from the time she was hardly a teenager she managed to make a series of wise adult decisions that determined her future trajectory. Working at PUB was a great chance for a fourteen-year-old with little education. Using the job to gain experience in front of a camera, and then deciding to quit two years later when a film prospect appeared, showed an impressive maturity. If the Academy hadn't worked out, Garbo would have tried something else. But in a few short months, after admission an introduction came her way that would forever change the course of film history.

Garbo made her stage debut on Saturday, November 4, 1922, in a small role in the French comedy *Le belle aventure*.[11] The premiere of *Luffar-Petter* followed soon after, on Tuesday, December 26, and she received her first print publicity when the local magazine *Swing* singled her out: "Greta Gustafsson. May perhaps become a Swedish film star. Reason—her Anglo-Saxon appearance."[12] It is not clear what the writer meant by this comment, but it suggests that her face was in some way normative to what was then considered ideal for a female actress, at home but also seen in films coming from America.

Stockholm was not a world cultural capital in 1923. In no way could it rival London, Berlin, or Paris. Nonetheless, Sweden had a vibrant film industry, and the best of Swedish films were distributed internationally. Among the most notable

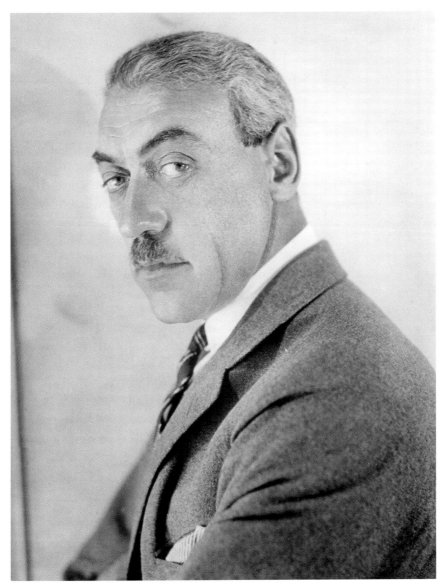

Mauritz Stiller was responsible for casting Garbo in her first feature film, *The Saga of Gösta Berling*, and later she accompanied him to America. Russell Ball made this portrait in New York in 1925.

of its directors was Finnish-born Mauritz Stiller (Garbo called him Moje), who had been working in Sweden since 1912. *Erotikon* was already an international hit, and in the spring of 1923 Stiller was preparing *The Saga of Gösta Berling*. The lead role of Gösta Berling would be played by Sweden's top leading man, Lars Hanson. Among the supporting roles were a pair of sisters-in-law, and to cast for these parts Stiller turned to the Academy's director, Gustaf Molander, to recommend suitable actresses. Molander suggested Garbo and her classmate Mona Mårtenson.

Shortly after the school's Easter break in April 1923, Garbo and Stiller met, and later she auditioned at Stockholm's Råsunda Studio.[13] Garbo won the featured role of Elizabeth Dohna, and Mårtenson was cast as her sister-in-law, Ebba. Garbo signed the contract on July 23, 1923, which her mother cosigned because her daughter was a minor. Filming would commence late summer.

Much has been made of Stiller's enormous size (although he seems to have been only about six feet tall), his looks, and his extraordinarily ebullient personality. Irene Mayer Selznick, Louis B. Mayer's daughter, remembered "a frightening looking man."[14] Sven Hugo Borg, who was Garbo's first translator in Hollywood, and later an actor, wrote about Garbo in 1933. He described Stiller as "a strange man, an intelligent, cultured gentleman of exotic tastes and artistic passions," but also as "ugly, almost hideous in physical appearances. His body was ungainly, his features heavy, lined, gnome-like. His feet were so enormous as to be almost deformed, and his hands, huge, prehensile paws, fitted for the plough."[15] While the view has stuck, it is not borne out in photographs, where he seems an average-looking middle-aged man. Twenty-two years older than Garbo, he mesmerized her from the start. Did she see in him her first real shot at the movies? A series of men had aided the teenaged Garbo in her quest forward—Bergström, Petschler, Ewall, Molander. With Stiller she had positioned herself for the possibility of a film career before her eighteenth birthday. If she hadn't shown any particular distinction as an actress, as a strategist she was brilliant.

It was Stiller who first saw Garbo's potential. Often repeated is his command that Garbo shed some weight before filming, and she seems to have dutifully done so. Stiller conceived *Gösta Berlings saga* in two parts to be filmed consecutively with a month hiatus in between. Production began in September 1923 and continued through the fall. After a Christmas break, filming started up again in January for the sake of the snow scenes crucial to the film's narrative. It is not clear whether Garbo went back to the Academy at any point that fall, or even after the film was completed in February.

In the midst of filming part 1 of *The Saga of Gösta Berling*, Greta Gustafsson made the decison to change her name. On November 9, 1923, accompanied by her mother and her friend and *Gösta Berlings* costar Mona Mårtenson, she went to Stockholm's town hall and made the formal application. As she was still underage, Anna Gustafsson needed to sign as guardian; Mårtenson witnessed both signatures. The original document is stamped as approved on December 4, 1923. She was now Greta Garbo.

Where did the name come from? Mimi Pollak, classmate and best friend, took credit for christening her Garbo. Stiller apparently had suggested to the former Miss Gustafsson that she come up with a better last name. The two young actresses tried out many, and in a sudden fit of inspiration Pollak came up with Garbo. According to Pollak, Garbo's immediate reaction was, "I won't even have to change the initials on my towels."[16] The story sounds like a late invention, as

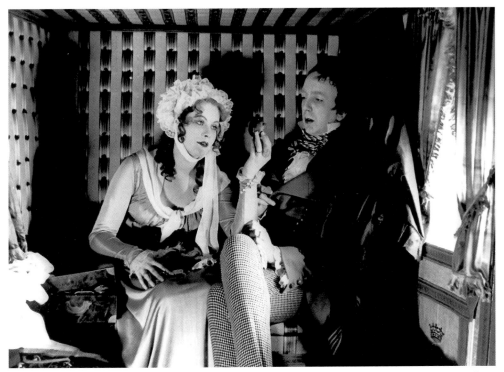

The initial glimpse of Garbo in her first important picture, *The Saga of Gösta Berling*, was riding in a carriage with Torsten Hammarén, who played her husband. The pair gleefully eat sweets as they make their way back home to Sweden after an Italian honeymoon.

it is doubtful that eighteen-year-old Garbo had ever thought about, much less possessed, monogrammed towels. John Bainbridge, in his 1955 biography, *Garbo*, says that Stiller asked his manuscript assistant, Arthur Nordén, to come up with a name for his unrecognized but already "visualized international star," and that "Garbo" was his coinage.[17] The genesis of the name Garbo remains one of the most intriguing mysteries of the Garbo story.

Although *The Saga of Gösta Berling* is best known today as Garbo's first serious film appearance, she was not its star; in fact, Garbo does not appear for almost forty minutes. Lars Hanson—handsome, gentle, and charming—utterly dominates the film. He went to Hollywood at the same moment as Garbo and enjoyed a successful career at MGM until talking pictures sent him back home. Garbo has what is best described as the third female lead. Her portrayal of Elisabeth is important to the narrative, but she really has only one extensive scene in each of the two parts. Still, it is impossible to underestimate the importance of *The Saga of Gösta Berling* as the film that launched Garbo's career.

The picture opens in the early nineteenth century at the grand estate of Ekeby, where we find the so-called knights, a band of a dozen men, mostly former soldiers, living under the protection of the lady of the manor. Among this cohort is

Gösta Berling, a minister who has lost his living because of a fondness for drink. Flashback shows how Berling arrived at Ekeby. Needing employment, he was hired as tutor for Countess Dohna's stepdaughter, Ebba (Mona Mårtenson). The countess hatched a scheme whereby Ebba would marry Berling, a commoner, thereby forfeiting her inheritance in favor of the countess's son, Count Henrich, married to Elisabeth (Garbo). We meet Elisabeth riding in the back of a grand carriage accompanied by her husband and gluttonously eating from a large box of chocolates. At a party welcoming them back from Italy, Ebba overhears her stepmother regaling Elisabeth with her cruel plan and rejects Berling. Miserable, having given up her great love, Ebba soon dies. Berling goes offf to Ekeby to join the knights.

Part 2—winter—opens with the knights having taken over Ekeby after a scandal forces the mistress of the manor to flee. Young Count Dohna is informed that the formal documents certifying his marriage to Elisabeth in Italy were never signed and now must be executed immediately to validate the marriage. Enraged by the unfair circumstances that caused her to be banished from her home, the Lady of Ekeby returns to her estate and burns the magnificent home to the ground, driving the knights, including Berling, out of their beds and into the cold winter night. Forty minutes into part 2, Garbo returns to the screen. Having gone to watch the fire, Elisabeth meets Berling, who takes her into his sled; the two race across the frozen landscape. Smitten, Berling suggests that he and Elisabeth run away together. As dawn arrives, reason prevails and they part. Faced with the decision to sign her marriage covenant, or not, Elisabeth decides no, perhaps she really does love Berling. In the meantime, Berling, with no apparent source of money, rebuilds Ekeby. Predictably, as spring approaches, Elisabeth and Berling end up happily-ever-after, as the new Lord and Lady of Ekeby.

The Saga of Gösta Berling is one of the masterpieces of silent cinema, not because of Garbo's debut, but rather because of Stiller's flawless dircction of a compelling story, beautifully photographed with a top cast. The transformation of Garbo between part 1 and part 2 is radical. In the early scenes, she is pretty but vapid. Stiller and his cinematographer, Julius Jaenzon, figured out quickly that with careful lighting and direction, Garbo could be beaufiful and hold the screen with her presence. She dominates the final thirty minutes of the film. A Swedish star was born.

When author Selma Lagerlöf met Garbo, she described her as "beautiful with sorrowful eyes. Very quiet and withdrawn."[18] Upon the film's release, one Swedish critic wrote, "In a few years, I expect, the name of Greta Garbo will be known all over the world. She has the gift of beauty, unique beauty."[19]

Either during the filming, or soon after it was completed, Garbo was photographed by Stockholm's two finest portrait artists, Olaf Ekstrand and Henry B. Goodwin. Although we have many photographs documenting her childhood, such as those made for her first communion and at school, as well as the PUB

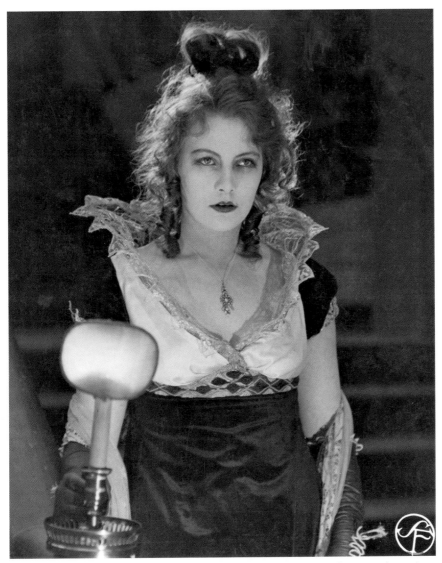

Garbo played the supporting role of Countess Elisabeth Dohna in *The Saga of Gösta Berling* under the direction of Mauritz Stiller. Her performance heralded the arrival of a major new international screen player.

images, the portraits by Ekstrand and Goodwin are the first times she sat for professional photographers interested in revealing her youthful beauty in support of a nascent film career.

One of the surest signs that Garbo was now poised for movie stardom was Ekstrand's photo on the cover on the May 4, 1924, issue of *Film-Journalen*, Sweden's most important film magazine. Was it was arranged by Stiller, or by the photographer? Or perhaps the magazine's editors were taken by her performance and ready to accord the rising actress this important promotion boost? Whatever

the genesis of this prestigious accolade, it would be the first of the thousands of covers she would grace over the next decade.

Garbo's first brush with Hollywood stars was at the sumptuous Grand Hotel Saltsjöbaden, located a few miles from Stockholm, where Mary Pickford and Douglas Fairbanks were entertained at a ball when they visited Sweden over the summer solstice in June 1924. It must have been one of Stockholm's memorable evenings that summer for all who attended. Garbo was squired by Stiller, but no record survives that she was introduced to the reigning king and queen of international film.

The Saga of Gösta Berling premiered in Berlin on August 21, 1924. Garbo, along with Gerda Lundequist, who portrayed the Lady of Ekeby, accompanied Stiller; it was her first trip abroad. Soon she was back in Stockholm to begin what was technically her third year at the Academy, although it is difficult to assess how much time she spent at her studies the previous academic year. Over two months that fall, she appeared in five productions at the Royal Dramatic Theatre, always in small parts.

There are only a few instances during her lifetime in which Garbo's face is tied to a commercial product (other than film). Print advertisements for YvY soap appeared in 1925, one of which ran an image of Garbo from *The Saga of Gösta Berling*, and another with a portrait of her sister, Alva. Garbo is touted as a typical Nordic beaty. The advertisement in which her sister appears names her Alva Garbo, and she is described as one of the Swedish film finds of the season. Alva had a small part in the 1925 film *Två konungar* (*Two Kings*), which must be the work referenced. The circumstances under which Alva assumed her sister's new last name are unknown, and as the film is lost, we can't even get a glimpse of Garbo's sister. Alva died in 1926.

Garbo's studies and stage appearances were cut short once again when Stiller cast her in a new film, *Odalisken från Smolna* (*The Odalisque from Smolensk*), that he intended to film in Constantinople beginning in late December. He had received a commitment for financing from the Berlin-based film company Trianon Film A-G in September as part of a two-picture deal negotiated the previous spring. Trianon had bought the German distribution rights to *The Saga of Gösta Berling*, and its success was a windfall for both Stiller and his new partners. *The Odalisque from Smolensk* was approved in August as the first project, and during the third week of November 1924, Stiller and Garbo returned to Berlin, where he would finalize preparations for the upcoming picture. It was not his only motivation for the trip.

Stiller had been in communication with Louis B. Mayer, vice president and production chief for MGM. As mentioned, Mayer was in Europe principally to evaluate what was happening in Rome with *Ben-Hur*, behind schedule and over budget. He was also always on the lookout for new talent, both behind and in front of the camera. Word of Stiller's successes had reached him; maybe the

director should be recruited. Mayer and his family reached Berlin from Italy in late November. He arranged a screening of *The Saga of Gösta Berling* followed by a meeting with Stiller at the Adlon Hotel, where the Mayers were staying. Garbo accompanied Stiller.

Along with her name change, the second mystery of the Garbo legend is whether Mayer wanted to engage her or whether Stiller insisted that she accompany him to California. Over the past ninety years, writers have remained split, but claims made by Irene Mayer Selznick, who states in her autobiography that she was present at the meetings, says her father wanted Garbo more than Stiller. But Irene Selznick seems determined by the potency of the later Garbo mystique.[20] The truth was likely the opposite. The actress herself said, "Mr. Mayer hardly looked at me the first time I met him."[21] Whatever the veracity of memories, Stiller successfully scored a contract for them both. He would be paid $1,000 per week, Garbo $350. Shortly after the meeting on November 27, Mayer wired Stiller, "This is to confirm our oral contract of November 26, 1924" (there was no mention of Garbo in the cable).[22] Mayer expected the two in Culver City, the home of MGM, the following spring.

Stiller was a clever manipulator who always looked to ensure the best deal for himself. At the moment he agreed to Mayer's terms, he was also under contract with Trianon to direct two films, a fact undoubtedly he did not share with Mayer (Garbo was also included in the Trianon deal). He would weigh both opportunities, signatures be damned, and in the end chose what he felt was most beneficial. Garbo's fate was tied to that of Stiller. What he decided, she would do, doubtless without having been consulted.

The Odalisque from Smolensk went ahead, and Garbo was cast in the leading role, as Countess Maria Ivanovna Galevitsch, a White Russian fleeing her home country and heading to Turkey to find her fiancé. On the way she is captured and sold into slavery, eventually making a brilliant daring escape. Costarring with Garbo were to have been Einar Hanson and Conrad Veidt. Director, crew, and cast left Berlin for Constantinople in late December 1924 and stayed at the luxurious Pera Palace Hotel, built in the late nineteenth century to accommodate passengers traveling on the Orient Express. Garbo was beginning to experience for herself the perquisites of the glamorous life accorded to film success. It was her first Christmas away from her family; Stiller gave her a fur coat as consolation.[23]

What had promised to be a lucrative deal for Stiller fell apart just before Christmas. Expected funds from Trianon failed to appear. Cables went unanswered. Stiller left the others in Constantinople and returned to Berlin, where he discovered the company had been brought down by the disastrous postwar inflation that had bankrupted many businesses. No further funding would be forthcoming. As Stiller had spent all previously advanced money on preparations for his film, Garbo and the others were stranded. It would take the director several weeks before he was able to wire the funds to bring them back to Berlin.

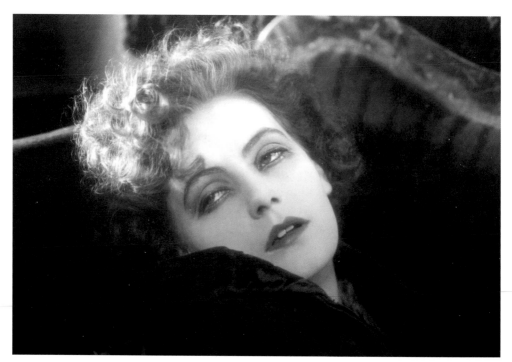

In *The Joyless Street*, Garbo's second feature, audiences saw hints of the face that would enthrall the world after she began working in America.

Where did this money come from? With a firm offer of employment in America, and Mayer's expectation that his two recruits would soon be sailing to New York, the logical plan would have been for Stiller, now free of any obligation to Trianon, to immediately secure passage to America. Wheeling and dealing was too much a part of Stiller's character to take that simple course. Instead he sought employment for Garbo and other members of his cast and crew in Berlin. As Garbo prepared to depart Constantinople at the end of January 1925, she wrote her mother, "In two days I shall be back in Berlin and we'll see what happens then. But it will be all right—it's been a good beginning, in spite of everything."[24] Upon her return, she found that Stiller, without consultation, had cast her in a film to be directed by G. W. Pabst, *Die freudlose Gasse* (*The Joyless Street*). Produced by Hirschel-Sofar-Film-Verleih GmbH, the company was still solvent and made films at least through the 1920s. Stiller scored Garbo a good salary of 15,000 kroner as well as a featured role for Einar Hanson; he demanded, unsuccessfully, that Pabst also find work for his cinematographer. Cameras would start to roll in three weeks. Stiller used the 6,000 kroner advanced by Hirschel-Sofar against Garbo's salary to repatriate his team from Turkey.[25]

Keeping their options open, Stiller advised Garbo to sign the letter of agreement with MGM that awaited her in Berlin; she signed on January 30. Two weeks later she was preparing for her new role for Pabst portraying Greta Rumfort, a

young woman in contemporary Vienna living in a working-class neighborhood and confronting the bitter realities of postwar life, where low wages, food shortages, and squalid living conditions were the norm.

Among her first duties for Pabst was to have her portrait taken. Especially for an attractive young actress, a steady supply of new photographs was essential to building a career. She soon grew weary of spending time before the portrait camera, and once in America dramatically curtailed her availability for this important promotional tool. But on February 16, Garbo reported to Alexander Binder's studio, Atelier Binder, located on the elegant Kurfürstendamm. Binder was the leading portraitist for Berlin's film and theatrical community. Garbo posed in several outfits, all seemingly taken from her personal wardrobe. In one she models an elegant black coat; in others she wears a low-cut white evening dress exposing her shoulders. Stiller came along, and Binder made at least one portrait of him too.

Filming of *The Joyless Street* continued for five weeks. The film follows two women who live on different floors of the same tenement, Garbo as Greta Rumford and Asta Nielsen as her neighbor Maria Lechner. Garbo shares her apartment with her widowed father and younger sister. Nielsen, the real star of the film, plays a "younger" woman living at home with her parents, though she was forty-three years old. The lives of Greta and Maria are dominated by the quest for basic necessities in short supply, especially food, which required waiting in long lines. Maria finds a young man she hopes will marry her and take her away from their squalid neighborhood but believes mistakenly that he has been unfaithful and murders him in a jealous rage, for which she is ultimately arrested. Greta has an office job that ends abruptly when her employer makes a pass at her and is rejected. Meanwhile, her father takes an offer to voluntarily resign from his job as a civil servant in exchange for a lump sum payment. This he invests in a speculative mining operation and is soon wiped out financially. The family becomes destitute, and the nearby brothel becomes Greta's only possible employment until she is saved at the last minute by a visiting American soldier who boards at her family's apartment. Lieutenant Davies is played by Einar Hanson, who would also soon find work in Hollywood.

Although Stiller had little involvement in the production of *The Joyless Street* (and may finally have been banned from the set by Pabst), at the beginning he made an important technical contribution, insisting that the Kodak film stock be used be rather than Agfa, more common in Europe. Kodak was more expensive but was considered to produce better results. Moreover, there is evidence that Garbo developed a slight facial tic noticeable in close-ups. Stiller may have been the one to suggest speeding up the film to address the issue, although credit has also been given to cinematographer Guido Seeber. It worked; Garbo photographs well in her many close-ups, and there is no evidence that this problem continued in the United States.

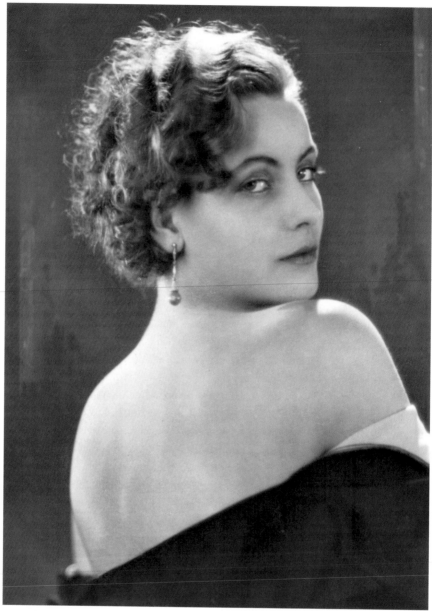

During the production of *The Joyless Street* in the spring of 1925, Garbo sat for Berlin portrait artist Alexander Binder.

It is often said that when Mayer met Garbo in Berlin, he demanded she lose weight, as American audiences preferred slimmer actresses. This story is likely apocryphal, as Garbo is slim in *The Joyless Street*. It might have become conflated with Stiller's instructions two years before or perhaps was invented to make Mayer seem in charge of shaping his new hire's image from the start.

Pabst directs Garbo beautifully, apparently having taught her how, quietly, to let the camera come to her. It is an elegant performance but passive. In America she would master the art of screen acting by engaging with the camera fully to create a three-dimensional character, but Pabst seemed to like his actresses more subservient.

In four years' time, he would bring to Berlin Louise Brooks, who had shown modest promise at Paramount, and direct her in two riveting and never-repeated performances, *Pandora's Box* and *Diary of a Lost Girl* (both 1929). Magnificent films both, and Brooks is a delight to watch. Although her potential for becoming a great screen actress is transparent, after one more leading role in France in *Prix de beauté* (1930), she returned home and appeared only in secondary roles sporadically through the 1930s. Pabst's careful direction and the splendid photography reveal Brooks at her best, but he never taught her to act. She would wait nearly four decades before these European films ignited her fame, making her, finally, a screen and style legend.

The Joyless Street opened in Berlin on May 18, 1925. How financially successful the film was in its initial release is an open question, but over time it has proven to be one of the finest cinema works from the Weimar period. Pabst's film is among the first to show the transition in 1920s German filmmaking from expressionism to realism, reflecting the increasingly dire economic conditions that anticipated the Great Depression. The film suffered severe censorship editing as it was released in different markets. A radically truncated version was released by the British company New Era National Pictures Limited, in the 1930s running only sixty minutes and edited to tell only Garbo's part of the story (and to capitalize on her international fame). It is still the primary version available on DVD in the American market, although in 2009 the Filmmuseum München remastered a 151-minute version that must closely approximate Pabst's original intention.

Stiller returned to Sweden before Garbo was finished with her work on *The Joyless Street*. It wrapped up at the end of March, and she was home by the first of April. She did not attend the Berlin premiere and might never have seen the film in its original version. Instead she waited while Stiller deliberated their next move. On April 20 the German film company UFA offered Garbo a two-year deal starting at $450 a week and increasing to $650 the second year.[26] Mysteriously, the contract was made out in the name of Greta Gabor; it was never signed. Officials at MGM expected her and Stiller in California and were frustrated by his delays. On May 27 Mayer wired him, getting straight to the point, "We have a contract with you." A month later the two took a train 280 miles to the western port city of Göteborg, commencing the long journey to New York and ultimately to Hollywood.[27] "I am traveling to the other world," Garbo wrote to her friend Mimi Pollak shortly before departing. "I don't think I have the energy to join the battle over there but I must try."[28]

The Studio System

NEW YORK

THE *SS DROTTNINGHOLM* DEPARTED GÖTEBORG ON FRIDAY, JUNE 26, 1925. With one stop in Halifax, Garbo and Stiller reached New York eleven days later, on July 6. By all reports New York was in the midst of a heat wave, and Garbo complained about the unexpected high temperatures.

MGM's parent Loew's Inc. was based in New York, with an active press office serving the studio. Howard Dietz, who had joined Goldwyn Pictures in 1919, stayed on after the merger, served as the New York director of publicity, and is credited with coining MGM's motto, "More Stars than There Are in Heaven." His office sent out notices of new talent, and Garbo's first American press coverage was on the front page of the *Film Daily* for Thursday, July 8, under the small headline, "Foreigners Arrive." Among the duties of Dietz's office was to greet new MGM employees. He assigned his assistant Hubert Voight to meet the ship at the Swedish Line pier at the west end of Fifty-Seventh Street; Voight wrote several times of his early encounters with the pair, who were accorded the most minimal welcome—little information about them had reached the publicity office in advance. Voight hired a photographer, James Sileo, who he recalled was paid ten dollars to make three pictures of the newcomers. A translator, Kaj Gynt, was also engaged. Before disembarking the ship, Garbo and Stiller were greeted by the three on the ship's deck. Four photographs survive, not three, one of Garbo with Stiller, the others of Garbo alone. Garbo is dressed in a smart checked suit and light-colored hat; in the photo together they smile happily, leaning against the ship's railing looking more like a father and daughter returning from a vacation abroad than a promising film star with the director who will fix her in the American firmament.

Gynt, brought along because she was bilingual in Swedish and English, was probably known to Dietz's offices from her stage work in New York, and she had

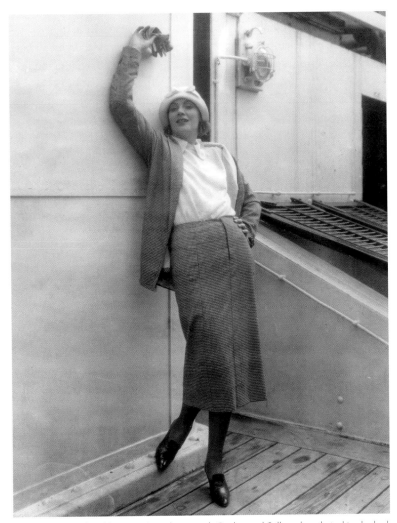

James Sileo was hired by MGM to photograph Garbo and Stiller when their ship docked in New York in July 1925. Garbo playfully mugs for the camera moments before disembarking. Courtesy John Kobal Foundation.

also appeared in Metro Pictures as early as 1917.[1] Trained at Stockholm's Royal Dramatic Academy, she appeared on stage for three years before emigrating. She later claimed to be an old friend of the Gustafsson family, which is possible, but since she was in New York by 1917, she would have known Garbo only as a child. The two women did spend time together in New York that summer, and she may have served both as interpreter and teacher, as Garbo seems to have spoken no English when she arrived. "Mr. Stiller, he is a great director," said to be her maiden utterance, may have been memorized to feed the press.

Voight's first meeting with Garbo and Stiller is recorded in an article in *New Movie Magazine* from February 1934 (boldly titled "I Loved Garbo"); it was love

at first sight, he said."[2] Whatever his amorous feelings might actually have been on July 6, what is known for certain is that Voight escorted his two charges to the fashionable Commodore Hotel recently constructed adjacent to Grand Central Terminal on Forty-Second Street and boasting "the most beautiful lobby in the world." This would be their residence for the next seven weeks as contract disputes between Stiller and MGM held up the transcontinental train voyage that would take them finally to Culver City. Voight also claims over the summer to have kept Garbo company at the theater, sight-seeing around New York, and visiting Coney Island.

He arranged as well both Garbo's first New York interview and portrait sessions with the husband-and-wife team of Gladys Hall and Russell Ball; she was a leading contributor to fan magazines, and he a well-regarded New York photographer who worked mostly for the film industry. According to both Voight and Hall, they met in in Garbo's (or Stiller's) room at the Commodore. Hall, under the pseudonym Faith Service, wrote the earliest article on Garbo to appear in English for *Movie Magazine* (September 1925). In "Greta Garbo: Find," she filled more than two pages with a sketch of the highpoints of the career that brought Garbo to America. Even with the language barrier between author and subject, Hall had the insight to write, "We have the suspicion that Miss Garbo is *not* the ingénue type." She also described Garbo's "expressive eyes and hands, her beautifully toned voice." Hall dutifully reported the hot New York weather and condescendingly recorded the newcomer's accent: "American men are 'beeg and st-rong," the American hotels were "oh, so laaaarge," the American women dressed so well and looked "so preety"; Fifth Avenue was "lovely."[3] This one interview might have put Garbo off the press for the rest of her life.

Russell Ball's photos were the first glimpse Americans had of the Swedish discovery. Although his studio was located nearby at 9 West Forty-Ninth Street, he accompanied his wife to the hotel with camera in tow. Interview and photo session, Garbo may have thought, get them all out of the way together. Hall turned out a worthy article based on almost no information and hardly a story to tell—not even the name of Garbo's first Hollywood film had been determined. Ball had an even more difficult time. Perhaps it was the New York humidity, or simple willfulness, but Garbo seems not to have bothered combing her hair. He managed the best he could, and at least ten photographs from the session ended up in the MGM publicity files. Ball posed Garbo in a manner hoping to bring out some of the sexiness desired by the studio publicity office for attractive young starlets. In some photographs she wears an elegant black suit; in another a fur-trimmed leather jacket. She also modeled a black sleeveless dress, and in at least one shot, she shows an exposed shoulder. It is surprising that Stiller, who would have been present every minute, did not try to coax out something of the beauty his star revealed in *The Saga of Gösta Berling*. But Garbo, who soon learned how to exert the most precise control over her face and image, on that July afternoon

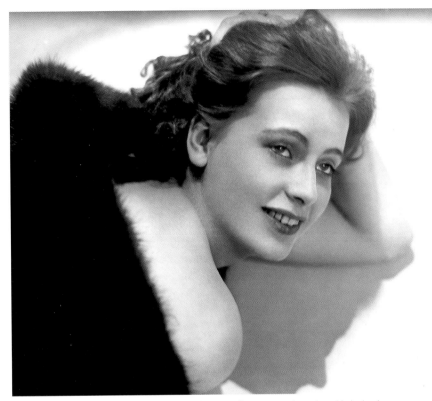

Russell Ball photographed Garbo soon after her arrival in New York, and it is likely that her room at the Hotel Commodore on Forty-Second Street served as the impromptu studio. Courtesy John Kobal Foundation.

clearly did not care. A simple profile shot accompanied Hall's article in *Movie Magazine*, along with a portrait of Stiller made the same day. The best photograph from the session was published full-page in *Motion Picture Classic* in October 1925. Not quite Garbo, but a lovely young woman who might just have a chance in the movies.

Was Garbo showing early disdain for the publicity process, or was she just indifferent to Ball? They would meet one more time at MGM, two years later. Again, it was a short session, with only two outfits, and fewer than ten exposures. In 1927 the now-professional actress met the professional photographer; this time the results were sensational.

A second documented press interview arranged by Voight was with W. Adolphe Roberts, writing for *Motion Picture*. In the November 1925 issue, he announces the arrival of Garbo and Stiller in New York and describes Stiller as "wilting under our torrid rays." Garbo spoke to Roberts "thru an interpreter, from bed." Following decorum, he asked his questions standing at her door. "And the interview? It ran something like this: 'Miss Garbo says she adores America—but is it always so hot as this summer? She looks forward to her work in Hollywood—if she survives

the heat . . . Marvelous skyscrapers here . . . the world's best movies—but heat, *heat*, HEAT!'" [4]

Writers considering Garbo and Stiller's time in New York often focus on a perceived neglect by MGM. It would seem to be true that neither Dietz nor Nicholas Schenck, who was Loew's top executive, had any interest in meeting Garbo. Stiller, on the other hand, was in regular communication with the New York office negotiating and renegotiating their contracts, and the delays were likely mostly his fault. The expense of the summer at the Commodore would be paid by MGM but charged back to them after contracts were signed.[5] It was up to Stiller to move the process forward, but constant haggling over details kept the two in New York through July and well into August. In dispute were money and length of the contract. There would not be much budging by the studio on salary, but Garbo was adamant that she wanted as short a commitment as the studio would grant. Seven-year contracts were standard. Back in Berlin they negotiated for five years. But before leaving New York, Stiller prevailed further, and Garbo signed for only three years.

The wait did result in one of Garbo's most spectacular portrait sessions. In 1925 Arnold Genthe was in one of America's top photographers. His early fame rested on his historic photographs of San Francisco's Chinatown and later documentation of the 1906 earthquake. Moving to New York in 1911, he established himself as one of the city's premier portrait artists. Swedish actress Martha Hedman had lived in New York for a dozen years and had been a subject of Genthe's as well as known him socially. He recalled that Hedman and Stiller had worked together in Sweden under August Strindberg and renewed their acquaintance in New York. Hedman made the introductions, and on July 27 Stiller and Garbo visited Genthe's atelier at 41 East Forty-Ninth Street.

Genthe describes the occasion in his 1936 memoir, *As I Remember*. "I would love to have you make some pictures of me sometime," he recalled Garbo saying to him, speaking in German. "Why sometime?" he responded. "Why not now? You're here and I'm here and I must make some photographs of you to have visible proof that you are real." [6] Even as seasoned an artist as Genthe had evidently fallen under the spell of the Garbo legend when he wrote these words eleven years after they met. More likely is that the tepid results of the Russell Ball session may have made Stiller anxious to have a set of good new portraits. Moreover, not only was Genthe well established, and well connected, he had a contract with *Vanity Fair* magazine. Any aspiring (or established) player wanted that exposure.

Something on the order of twenty portraits were taken that afternoon, most of Garbo, though at least one of Stiller. Nothing that she had ever done professionally on the screen or in photo shoots anticipated Genthe's glorious images, which captured her in a wide variety of moods. He probably started with the three-quarter-length pose in which Garbo, standing, looks directly into his camera lens. Then he moved closer. Looking almost angry, she placed her hand defiantly

on her shoulder, bare arm exposed. Two profile shots showing her long, extended neck reveal an elegance never quite captured before; the magical Garbo of the silver screen is suddenly present.

Genthe did offer these pictures to Frank Crowninshield, *Vanity Fair*'s editor. Whether it was Garbo's charm, Genthe's insistence, or perhaps most likely an arm-twist from MGM's New York publicity office, Garbo was accorded a full page in the November 1925 issue under the title "A New Star from the North—Greta Garbo." The caption includes a reference to a recently signed contract: "The officials of Metro-Goldwyn in America, attracted by her rare promise, proposed a contract for a series of pictures to be made in Hollywood." Genthe took credit for placing the photograph and, having done so, claimed a central role in the studio's decision to bring the actress to Hollywood. His fine work, of course, had nothing to do with igniting Garbo's career. Her destiny was set when she left Sweden. MGM had made a financial investment in both Stiller and Garbo, and it was only a matter of settling the details before she would be in front of the movie camera. Sophisticated *Vanity Fair* readers saw Garbo for the first time that November, but it would be the MGM publicity machine working from Los Angeles that would determine her image, and the one finally marketed to the public would be radically different than that recorded by Genthe's lens.

Voight also arranged a commercial photo shoot for Garbo. Performers at MGM, like the other studios, could be sent off to promote products whether they used that product or not, and with no additional compensation. She modeled coats for the New York shop Weingarten, and judging by the results, she seems to have enjoyed the fun of putting on one soigné coat after the next. The photographer has never been identified, although given the studio connection it might be Russell Ball. MGM's New York publicity department included the photos as part of the initial fanfare about the newly arrived actress and distributed them to the press through World Wide Photos. Typed on the back of many was the claim that Garbo's outfits were part of the wardrobe she imported from Sweden.

Growing up in Stockholm, Garbo had the chance to see many movies made at home, on the continent, and in Hollywood. In Berlin the offerings would have been even more extensive, but nothing would compare to what was available in New York in the summer of 1925. The biggest film news was the opening of Chaplin's *The Gold Rush*, two weeks after Garbo and Stiller arrived. Also playing were films starring soon-to-be MGM colleagues Lon Chaney (*The Unholy Three*) and Marion Davies (*Zander the Great*), and MGM heartthrob John Gilbert was drawing long lines for *The Merry Widow*. Norma Talmadge opened *The Lady*, and Douglas Fairbanks headlined his latest in swashbuckling entertainment *Don Q, Son of Zorro*. We don't know what shows Stiller and Garbo caught, though they must have watched many (and would have been the guests of MGM at any Loew's theater). Similarly we have no sense of how Garbo thought of herself as an actress in comparison with her contemporaries. Yes, she slightly resembled

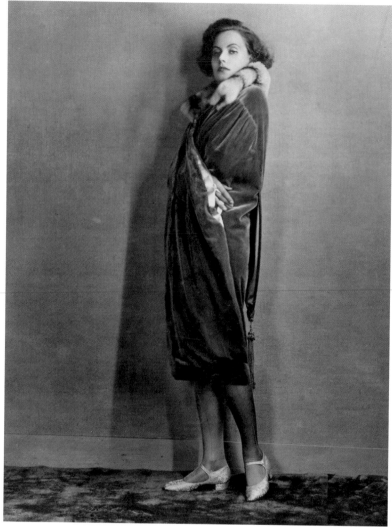

Hubert Voight, MGM's New York–based publicist, claimed that he arranged a modeling session for Garbo in the summer of 1925 for Weingarten's, a Fifth Avenue store that specialized in ladies' coats. Photograph attributed to Russell Ball.

Norma Talmadge and must have registered her screen-acting skills. Voight recalls taking Garbo to the theater but is quiet on the subject of movies.

Finally, contracts were ready to be signed, and Garbo and Stiller could head for California. On August 26, accompanied by Kaj Gynt, Garbo went to Loew's offices above the magnificent three-thousand-seat Loew's State Theater at 1560 Broadway. As desired, she signed on for three years' service to MGM at a salary of $400 per week with two annual raises if her contract were renewed yearly by the studio. MGM's lawyers must not have been aware that Garbo was only nineteen and not legally able to execute a contract on her own behalf.

HOLLYWOOD AND GARBO'S FIRST AMERICAN FILMS:
TORRENT AND *THE TEMPTRESS*

Garbo's datebooks from 1925 reveal that she and Stiller took a northern route to Los Angeles. Leaving Chicago they traveled to Canada, stopping at Lake Louise, majestically situated in the province of Alberta in the midst of the Canadian Rockies. Reaching the Pacific Ocean at Vancouver, they traveled south via San Francisco and Santa Barbara, arriving at Union Station in Los Angeles on September 10. Photographer Don Gillum had been sent by MGM publicity chief Pete Smith to record the moment. Gillum and Garbo would have a few memorable days together later that fall and the next winter, when he was assigned the task of making "candids" of the Swedish import to supply to fan magazines and newspapers.

Garbo and Stiller were met enthusiastically by a dozen or more Scandinavians working in Hollywood. In a group shot next to the train, Garbo, wearing the same suit she wore when disembarking in New York, stands at center holding at least two bouquets, with Stiller smiling broadly beside her. Two little girls, one dressed in a traditional Nordic costume, must have presented Garbo with the flowers. Perhaps missing the photographer's cue, in one photograph Garbo looks away from the camera, and her eyes are closed, although there is a trace of a smile. Stiller's brother Wilhelm was on hand to greet them, along with MGM actors Gertrude Olmsted and Karl Dane (Victor Seastrom was at the studio filming). Smith took Garbo and Stiller to the Biltmore Hotel to spend their first night in California.[7] That evening Erik and Irma Stocklossa invited their newly arrived compatriots to supper at their home.[8] He formerly acted in Sweden and was now working as an interior designer in Los Angeles.

The next day Garbo and Stiller were taken to MGM, where they no doubt paid a courtesy call on Louis Mayer and were introduced to the studio's production heads Irving Thalberg and Harry Rapf. Garbo moved into an apartment at the Miramar Hotel in Santa Monica. The Miramar had originally been an elegant oceanfront residence high on the bluff overlooking the Pacific, but it was converted into a hotel in 1921. Adjacent to the main house was a small building containing rooms for long-term residents. Stiller eventually settled in a house nearby on Eighteenth Street. Both residences were relatively convenient to MGM in Culver City, located about six miles away. Well before the traffic congestion that now rules Los Angeles life, the commute back and forth between work and home would have been easy.

Garbo and Stiller were now MGM employees, and their lives were wholly dominated by the studio. Stiller surely was full of ideas about films that he and Garbo would make together, and she must have been comforted by the security associated with working under the wing of her mentor. Aliens though they were, they had each other. We do not know many details about Garbo's first weeks at MGM. She turned twenty on September 18. A new contract was sent to her mother

for signature. Screen tests were arranged. She was photographed by Ruth Harriet Louise, who commanded MGM's portrait studio. She must have continued being tutored in English. Garbo and Stiller were among the extras seated in the stands, wearing togas, during the October filming of the chariot race in *Ben-Hur*.[9] One thing certain was that MGM would not allow Garbo to be idle. Four hundred dollars a week was not a star's salary, but it was enough that studio bosses wanted as quickly as possible to determine what sort of investment they had made. Within nine weeks the cameras started rolling; Garbo's debut would be nothing like she expected.

In the small coterie around Garbo of those who authentically forwarded her career, the first position is occupied by Stiller. Second place should be cinematographer William Daniels. Daniels photographed Garbo's first American film, *Torrent*, and third, *Flesh and the Devil* (and had a role in her second, *The Temptress*). In total he was behind the camera on twenty-one of Garbo's twenty-five films at MGM. Daniels came to MGM with director Erich von Stroheim, serving as an assistant cameraman on *Greed* and *The Merry* Widow. When Garbo arrived at MGM, he was working the second camera on *Dance Madness*. On a Sunday in late September, his day off, Daniels was called into the studio to shoot some tests. "I didn't like working Sunday too well," he recalled. "But I came in, of course. I made a few simple close-ups of her. She couldn't speak one word of English and was terrifically shy. She didn't enjoy it any better than I did. It was an ordeal for both of us. But they had to have the record of what she could do."[10] Daniels never revealed how his tests were received; the first encounter between the two doesn't sound good. Things would change later in the fall.

Stiller was not invited to direct these tests. Although he must have traveled with a print of *The Saga of Gösta Berling*, MGM's camera department wanted to figure out how to photograph Garbo on film independent of Stiller's earlier results. Thalberg deemed further tests necessary and asked cinematographer Henrik (or Hendrik) Sartov to work with Garbo. Sartov's career spanned more than a decade, and he had earlier worked as a cinematographer for D. W. Griffith. Now he was working at MGM at the request of Lillian Gish, who joined the studio that May with a contract guaranteeing her $800,000 for six pictures.[11] Gish was the first major artist signed by MGM following the merger, and Sartov was part of the Gish deal. *La Bohème* was the first of her pictures to go into production, but the pace of a Gish picture was always slow, owing to her demand that meticulous care and scrupulous attention to detail be taken during the making of her films. During down times, Sartov's talents could be used for other tasks. He had developed a camera lens that was especially flattering to leading ladies. It was this lens that was used for the Garbo test. In a 1964 interview with him, film historian Kevin Brownlow recalled the moment: "Garbo's first test . . . had been badly lit, failing to bring out her depth. 'I had the reputation, [said Sartov,] on account of this lens, that I could make anybody beautiful—or seem to bring out their beauty.' Sartov's

lens and neat ability to 'clean out' the face through spot lighting did exactly that for Garbo."[12] Sartov's tests satisfied Thalberg that Garbo was ready for the camera. What remained was to find a suitable project.

Studio portrait photographers worked in close harmony with cinematographers and from a special studio rather than on the set. Often lighting and camera angles would be figured out in the portrait gallery and repeated on the film sets. MGM's portrait photographer in September 1925 was Ruth Harriet Louise. Like Garbo, Louise was new to MGM, having started her job only two months earlier. Also like Garbo, Louise was young, just twenty-two, and the only woman to work as a photographer in Hollywood. Youth and relative inexperience did not hinder her, and from the start she made flattering portraits of all her subjects. Louise's first portrait session with Garbo that September marked the beginning of a four-year collaboration. Only a few photographs survive from that initial session, Garbo with curly hair and wearing a white fur-collared jacket. In one shot, full face, she looks off dreamily to the right; in another, half-length, she raises her head, revealing her long neck. Louise, using a soft focus, carefully lighted Garbo's face and especially her eyes. The results were romantic and suggested an ingénue. Thalberg had something else in mind, so these pictures exist only as a record of the moment and not as a first step in the creation of the image that would explode with the release of her first film.

Announced late summer, Garbo's MGM debut was expected to be *The Temptress*, directed by Stiller. But either he or the studio was not ready to start production in the fall of 1925, so suddenly Garbo was cast in another film with another director. This was her first serious encounter with the studio system. Under contract to MGM, she was expected to do as she was told. Choice of film, much less director, was solely at the discretion of her new producers. *Torrent*, based on the novel *Entre naranjos* by Spanish novelist Vicente Blasco Ibáñez, had been advertised widely as an upcoming vehicle starring Aileen Pringle. Pringle had come to MGM along with Goldwyn Pictures and was a popular leading lady. She was also thirty when *Torrent* went into production and, for reasons never revealed, was replaced by the twenty-year-old newcomer, Garbo.

The 1925–26 season was MGM's second, and the studio continued its ambitious goal of opening a picture almost every week. Before Garbo arrived, forty-five upcoming releases had been announced. Twenty were designated "The Supreme 20," twenty-five were called "The Superior 25." *Torrent*, promoted as starring Pringle, was among the twenty, as was *The Temptress*, with no star attached. When *Torrent* was released, neither Garbo nor leading man Ricardo Cortez was accorded star billing. Both were named below the title, Cortez preceding Garbo. Even without certified stars, MGM had a great deal invested in *Torrent*. Had Garbo not been thought capable of carrying a prestige picture, she never would have been cast. She would get two chances, *Torrent* followed by *The Temptress*. There was no sentimentality at MGM; success was measured only at the box office. If those

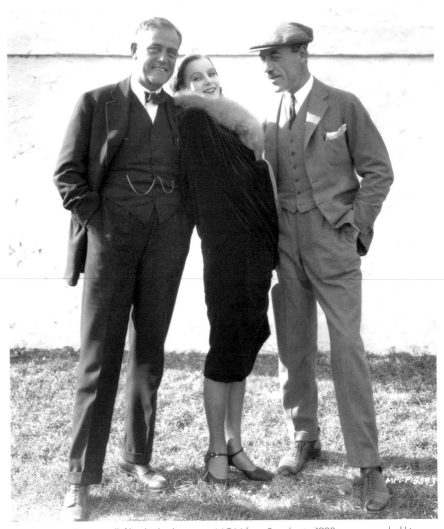

Director Victor Seastrom (left), who had come to MGM from Sweden in 1923, recommended his friend Mauritz Stiller to studio boss Louis B. Mayer. Photograph by Ruth Harriet Louise. Courtesy John Kobal Foundation.

first two films were unsuccessful financially, MGM would not renew her contract for a second year.

A contemporary story set in Spain, *Torrent* features Garbo playing the peasant girl Leonora, who soon becomes the international opera star La Brunna. The loves of La Brunna constitute the narrative, the climax of which is, predictably, the dramatic flood of the film's title. Cortez, one of the pretenders to the Rudolph Valentino Latin-lover crown (although in truth he was Jewish, born Jacob Krantz in Vienna), had been borrowed from Paramount, as MGM lacked the sort of leading male actor who could convincingly play a Spanish grandee. Ramon Novarro,

who was perhaps Valentino's sole serious rival, was under contract to MGM but was busy that fall completing *Ben-Hur*. Paramount was paid $1,000 per week for Cortez's services, and besides his salary the leading man was entitled to "first class transportation, meals and lodging on location work" and also "first name in all advertising."[13] Cortez had a long and successful career, and is probably best remembered for playing suave heavies in the 1930s.

The first of many problems that MGM would have to solve in their long professional relationship with Garbo was what to do about her inability to speak English. During her first weeks at the studio, she was generally accompanied by Stiller, whose own command was poor but who seems to have been able to communicate successfully as they navigated through the various studio departments. Once *Torrent* began, Stiller was not welcome on the set, so MGM provided her with an interpreter. Swedish-born Sven Hugo Borg was a decade older than Garbo and had come to Hollywood, as did so many, with the hope of finding fame in films. MGM turned to the local Swedish consul for suggestions, and Borg, known to some of his compatriots there, was recruited. He began work in mid-November, serving as translator, as well as performing other duties. Borg, like many who worked with Garbo, could not resist capitalizing on their acquaintance after she became a star. His turn to spill the beans came in an article published in *Screen Play* in September 1933. It is so rife with inaccuracies that much of what he writes must be taken cautiously. Still, a few of his memories merit repeating for what they suggest about Garbo's Hollywood beginnings. "For more than a year after her arrival in Hollywood she did not have a personal maid. It was I who drove her car, dressed her hair, got her out of difficulties, and in fact, performed every duty of a lady's maid, except, of course, to dress her. Garbo's demands upon me for personal service were so exacting that it was really embarrassing to me."[14] What man would write such lines in 1933 if they weren't true? Along with helping her learn English, Borg claims to have taught Garbo to drive and recites a litany of her speeding infractions. Shopping expeditions, he said, were often marred by her annoyance at the cost of goods in America.

Officially, filming on *Torrent* began on November 27, under the direction of Monta Bell and financed by Hearst's Cosmopolitan Pictures, which produced films under the MGM corporate umbrella using the studio's performers, director, and technicians. Dated negatives in the John Kobal Foundation archive show Garbo in costume on the set as early as November 14. They record, presumably, rehearsals and costume tests that took place shortly before the official starting date. The earliest stills are numbered under the Cosmopolitan coding system, and *Torrent* was assigned production number 3088, but by the time filming was under way, MGM had rationalized all productions under its banner, regardless of financing. *Torrent* was reassigned MGM production number 254.

The first sight American moviegoers had of Garbo showed her filmed in a soft lavender hue, praying and then singing. Her hair is dyed a dark brown, and she

wears the costume of a Spanish farmer's daughter. We learn that her character aspires to a singing career, and indeed suddenly she is an opera diva, La Brunna, appearing in Paris bewigged in long blond hair in pigtails. The Garbo of the movies finally appears in a third scene, in a café; with her dark hair now severely combed back and wearing an exotic fur coat and copious jewels, the siren of the screen is revealed for the first time.

Torrent might be considered Garbo's first real scene test. In scene after scene, we see director Bell and his team experimenting with different ways to present her. Watching the film today reveals that Garbo's image was slowly evolving in front of the camera, as was typical for most novice performers of this period. William Daniels with his exquisite lighting was an important ally, and his work on *Torrent* began one of the most significant collaborations in the history of the movies. Gaetano (Tony) Gaudio was scheduled to serve as the cinematographer, but an injury during the first days of shooting necessitated the last-minute switch. *Torrent* was Daniels's first sole cinematography credit, though he had tremendous experience working with von Stroheim and as an assistant on several MGM projects. In a 1935 interview, Daniels recalled: "I think everybody recognized that Garbo had something different from the very beginning. Even though at that time she had not had much training, and didn't speak a word of English, she had a natural ability that was striking."[15]

Physically, Garbo did not at first appear to be an obvious glamour goddess. She was too tall, and although she had slimmed down for Stiller, her weight was average for her height, not movie-star lean. And she preferred simple hair, clothing, and shoes. That look yielded to Danish costume designer Max Rée; his first work in America was at MGM, where he designed Garbo's elegant wardrobe and audiences saw for the first time the sharp sophistication that would become her screen trademark. The dichotomy between the radiant Garbo of the screen and the woman herself was evident during the filming of *Torrent* and continued unabated through the end of her career.

Whatever trepidation Garbo might have had making her American debut without Stiller as director seems to have evaporated under Monta Bell's guidance. While it is certain that Stiller coached her, he was, as noted, not allowed to be on hand for filming. With a relatively quick shooting schedule and working six days a week, "from seven o'clock . . . until six every evening," remembered Garbo, director Bell deserves much credit for guiding her American debut so skillfully.[16] Much has also been made of her tense relationship with Ricardo Cortez, but watching the film reveals strong chemistry between them. Garbo's third film, *Flesh and the Devil*, is frequently named as among the first in which the leading lady is filmed above her partner in a romantic horizontal embrace, but here we find her and Cortez already reclining in a garden in exactly this manner. Their romantic scenes are overtly erotic; the innocent young woman at the beginning of the film has evolved into a beautiful seductress. Bell and MGM's team of scenarists,

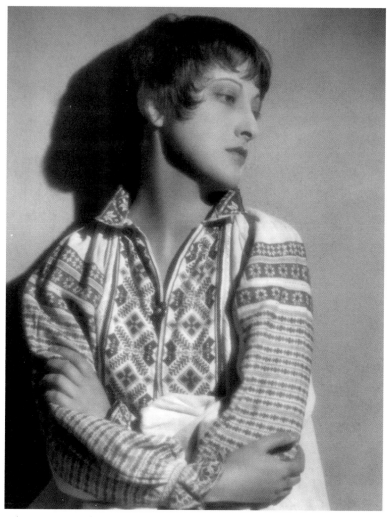

Ruth Harriet Louise, shown in a self-portrait, was twenty-two when she was hired as MGM's chief portrait photographer in 1925. Garbo was among her first subjects.

technicians, and producers created "Garbo" in her first American film. Over the next two pictures, her screen persona would be carefully refined. Makeup and lighting would change; strict dieting would melt the last of the adolescent weight. After *Flesh and the Devil*, the image of Garbo that MGM would present to the moviegoing public would be set forever.

Ruth Harriet Louise had a critical role in shaping this image. She photographed Garbo and Cortez alone and together in the portrait session for *Torrent* (portrait sessions typically were arranged as soon as principal photography completed on a film), and these new works along with the initial photos of Garbo taken in September were used to promote the film in magazines and newspapers. On the last day of December 1925, Garbo and Max Rée went up the three flights of

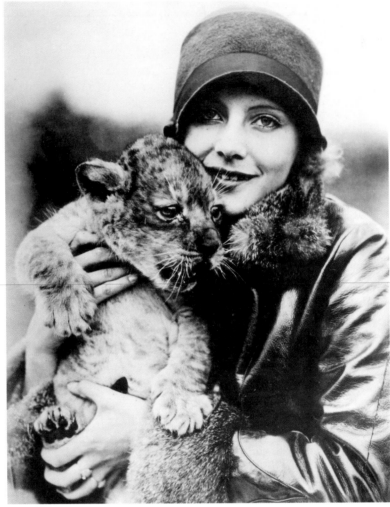

Don Gillum brought Garbo to Gay's Lion Farm in El Monte, just east of Los Angeles. It was photo shoots like this one that encouraged Garbo to refuse publicity gimmicks regardless of her contractual obligations.

stairs to Louise's rooftop studio, where they were photographed together and separately. Garbo is clad in one of the outlandish fur coats her character wears in *Torrent*, but away from the set, without the opulent background and dramatic lighting, the effect is silly rather than glamorous. She would meet with Louise again the following February in a portrait session that heralds the beginning of Garbo as a thrilling portrait subject—not as Genthe saw her, but as the face MGM presented to the world.

Filming of *Torrent* concluded in late December and opened on February 21, 1926, soon after work had begun on *The Temptress*, finally with Stiller directing. Reviews were good, and so were revenues, and the film showed a substantial profit

on the MGM ledger books. *Motion Picture* wrote of Garbo, "Making her début in the film, she registers a complete success. She is not so much an actress as she is endowed with individuality and magnetism."[17] The *New York Times* film critic, Mordaunt Hall, gave Garbo and the film accolades in a long piece that included an interview with the budding star. "Miss Garbo takes full advantage of the numerous opportunities to display her ability as a film actress and easily captures the honors by her performance. She is lithe, quick and graceful."[18] MGM's gamble had paid off. Garbo was worth the $400 a week.

Torrent is a pleasure to watch today, and it is fascinating to witness the development of Garbo as actress, as she still had much to learn. Her movement, contrary to Hall's praise, is sometimes awkward, and she has not yet figured out how to let the camera come to her. Still, MGM knew they had a star in the making. Critic Alexander Walker sums up succinctly the three stages of stardom as newcomer's impact, individuality, and uniqueness. In *Torrent* he observes, "The phenomenon of Garbo's debut is that she did not have to wait: all three stages seemed telescoped into one."[19]

This distinction was not lost on Irving Thalberg, who kept a close eye on all his performers, especially attractive newcomers who might find favor with audiences and create long lines in front of movie theaters. On page 28 of the January 27, 1926, *Variety*, a month before *Torrent* opened, under the headline "Thalberg May Make More Stars," is buried the forecast: "Thalberg it is said also expects this year to elevate to stardom through their work Greta Garbo and Sally O'Neil. Last year Thalberg was responsible for bringing to the fore and stardom, John Gilbert, Norma Shearer and Lon Chaney."[20] The spot must have been planted by MGM's New York publicity office. No mention was made of another ingenue, Joan Crawford, who started at MGM almost a year before Garbo but was still toiling in bit parts. Her chance would come later.

With a film about to be released and a new actress to be introduced to the public, MGM needed to prepare a portfolio of photographs to circulate to newspapers and, especially, the all-important fan magazines. Louise took care of the formal portraits, but still and general publicity photographers were assigned the task of shooting players off the set, typically in locations that served to enhance the image MGM wanted to present. Don Gillum, the photographer who had met Garbo and Stiller at Union Station in September, was recruited to spend time with Garbo and photograph her in interesting, "casual" situations. Someone from publicity director Pete Smith's office had the notion that Garbo, a tall Swede, should be depicted as an athletic outdoors type. Gillum was tasked to bring in a good supply to convey this sort of attitude to magazine readers. He took a series of photographs on December 11, at and around the studio, in which she wears one of her *Torrent* costumes.[21] Somehow a monkey became available, so Gillum dutifully records Garbo seated on the ground and holding the little fellow while she smiles into the camera; shots of her sitting on rocks at the beach were just

slightly more winning. The recently opened Gay's Lion Farm in El Monte out beyond Pasadena in the San Gabriel Valley provided the venue for another afternoon's outing. Garbo posed seated on a chair next to a lion (perhaps the MGM mascot), who glares at her menacingly. In another she holds a cub, and the most ridiculous shot shows her standing behind a chain-link fence feigning terror.

It got worse. Gillum had the bright idea to take Garbo to USC and photograph her with the track team. He was friendly with Cecil "Teet" Carle, USC's director of sports publicity, who agreed to welcome the photographer and his subject on the sports field. Garbo would be costumed, as Teet recalled, "in a track suit (that means brief shorts and tight jersey)."[22] Gillum knew the trainer, Jannes Anderson, was Swedish, so he could interpret. Many photographs survive from that day, as Garbo gamely succumbs to the conditions of the American promotional system; posed next to coach Dean Cromwell as if to sprint off when he fires the starting pistol; standing next to Anderson, who measures the size of her shoulder muscle; and naturally Gillum could not resist asking Garbo to stand under a pole vaulter leaping high overhead. "The girl doesn't look happy," Teet said to Anderson. "She's appalled," came the reply. "She thought she was going to be an actress over here, not a performer."[23]

At MGM, and the other studios as well, work on one film often flowed directly into work on the next. Immediately after Garbo finished *Torrent*, she was preparing for *The Temptress*, slated to begin under Stiller's direction in early March. At last director and actress would be reunited. Again she would be playing a Spanish woman, Elena, the adulterous wife of the Marquis de Torre Bianca, in another Ibañez adaptation from his novel *La tierra de todos*. This time she would costar with an authentic Latin leading man, Antonio Moreno, with whom she would share top billing, although both actors' names would be listed below the title. Lionel Barrymore, Roy d'Arcy, and Marc McDermott would also be captivated by Elena's charms. It was common at this time for virile leading men to take supporting roles in prestigious productions, but another attractive female would seldom be featured in a film alongside a glamorous leading lady.

On February 6, Garbo and Moreno were photographed extensively by Ruth Harriet Louise on what appears to be an abandoned set. They go through dozens of pantomimes, perhaps acting out scenes for their upcoming film. This kind of photograph typically was used for poster art and other promotional material necessary to launch a film once it was completed. In late March, Garbo and Moreno spent another such day, this time accompanied by other male cast members. All leading players were contractually obligated to assist in promoting upcoming films in any way asked. Garbo was learning that these frivolous stunts were routine for studio newcomers and included mild cheesecake for attractive women. On April 19 Garbo was mugging seductively, reclining on a chaise lounge for the portrait camera. Unique among her female peers, Garbo hated this sort of work (at least no others in the 1920s seem to have complained publicly). Men

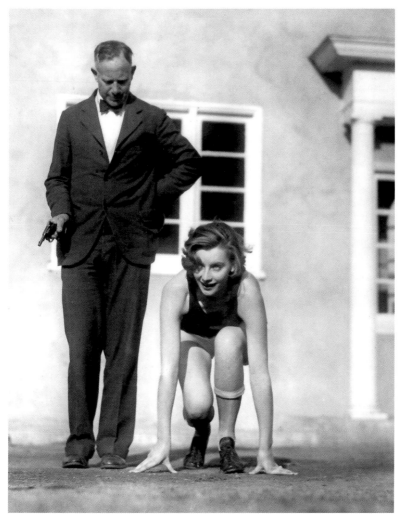

Garbo had an aversion to the sort of publicity stunts demanded of all Hollywood newcomers. Perceived at first to be the athletic type, she was photographed extensively outdoors by Don Gillum, including one day posing with the USC track team. Courtesy John Kobal Foundation

were generally excused from the silliest sorts of demands, a fact likely not lost on Garbo. She told a journalist in an early interview that when she attained the stature of Lillian Gish, "I will no longer have publicity . . . shake hands with prize-fighters and egg-and-milk men so they have pictures to put in papers."[24] Soon she was resisting the calls from the publicity department. A clash with Mr. Mayer was brewing.

In some ways, thematically *The Temptress* picks up where *Torrent* concluded. Garbo, now an experienced woman of the world, is conducting a series of affairs under the nose of her long-suffering husband. Screen intertitles for *The*

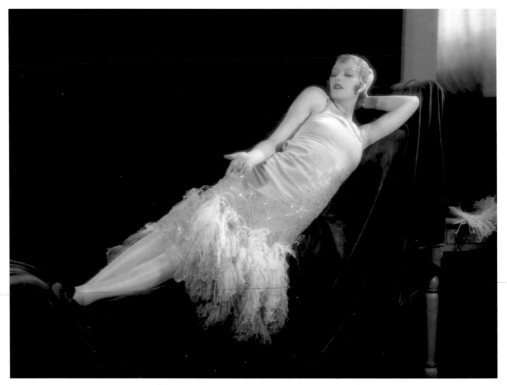

There is only one set of photographs of Garbo in cheesecake poses, and they were taken in April 1926 for *The Temptress*. The photographer was likely Ruth Harriet Louise, although no surviving prints or negatives are credited. Courtesy John Kobal Foundation.

Temptress, written soon after her first film's success, herald the budding star. "You are—beautiful," one title reads as Garbo removes her mask in the opening scene, just in case anyone in the theater missed the breathtaking face. With Moreno watching attentively, she, very slowly, unties her mask before taking it off in an attitude suggestive of a slow strip. There is no more anticipation; Garbo is born.

For more than a month, Stiller attempted to direct *The Temptress*. He was hampered from the start by his own poor English skills as well as a drawn-out European style of working that favored composing scenes on the sets and multiple retakes until the director was satisfied. In her interview with Mordaunt Hall, Garbo attested: "In my country the director is everything . . . Sometimes it takes six or eight months to produce one picture."[25] From the outset it was apparent that Stiller's model of filmmaking would not work at MGM. To make matters worse, he asked Moreno to shave his moustache. Moreno complied but resented the request; he took every opportunity to complain to Thalberg about how slowly the production was progressing. The "Chatter from Hollywood" column in *Screenland* (July 1926) said Stiller's "methods worked like a nutmeg grater on the temper of Antonio Moreno."[26] The columnist continued, "The Swedish director wanted Tony to pad his shoulders, draw in his waistline and pad his feet

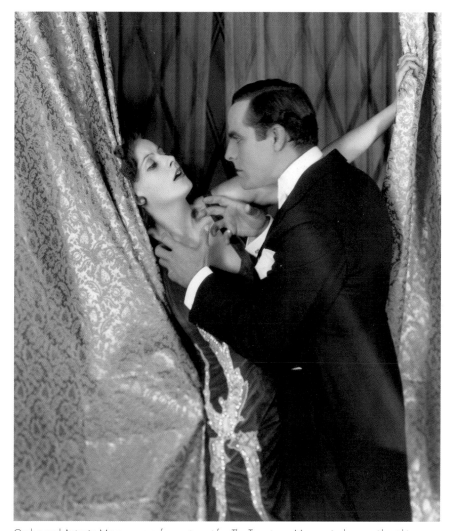

Garbo and Antonio Moreno pose for poster art for *The Temptress*. Moreno is shown without his signature moustache, indicating that the photo was taken when Stiller was still serving as director. Photograph by Ruth Harriet Louise. Courtesy John Kobal Foundation.

to fit number ten shoes."[27] The scorned upper lip may have ended Stiller's career at MGM. Thalberg decided too much time and too much money had been spent on *The Temptress*, and by early May,[28] fired Stiller and replaced him with Fred Niblo, who the year before had salvaged what became a blockbuster for MGM, *Ben-Hur*. "Niblo Directing "The Temptress," ran a headline in *Moving Picture World*. "MGM announced that Fred Niblo, director of 'Ben-Hur,' will relieve Mauritz Stiller, Swedish director of 'The Temptress,' until the latter recovers from his illness to take up the finishing of the Cosmopolitan Picture."[29] Might illness have actually been a factor? By fall there would be strong indication that Stiller was seriously ill with a lung condition.

Weeks before, Garbo had received even worse news. On April 21 her older sister, Alva, had died of cancer back home in Stockholm. Twenty years old, five thousand miles from home, and alone save for Stiller, in a strange land in which she could barely communicate, Garbo somehow managed with only a short break to return to the studio. When she did, life changed again, and she found herself working without her mentor. With only a few days' grace, *The Temptress* would start up again under Niblo, and Garbo would be expected on the set. Did she consider quitting? Did Stiller insist she continue? We know only that she reported for work in early May and completed the film by the end of June. If her experience with *Torrent* had been a rough introduction to the ways of the studio system, it was even worse on *The Temptress*.

Stiller did not stay idle. In an amended contract dated June 9, 1926, MGM lent him to Famous Players-Lasky (Paramount) to direct *Hotel Imperial* starring Pola Negri. His original contract signed back in August 1925 was extended until the completion of that film. As MGM was not going to pick up the first option on Stiller's contract, after *Hotel Imperial* finished he was contractually free of MGM. In the June agreement, Stiller waived all credit to his work on *The Temptress*. As far as MGM was concerned, Stiller had never been at the studio.

In his 1980 book on Garbo, Alexander Walker offers some insight into MGM's termination of Stiller. He quotes a memo dated July 12, 1926, just after the Paramount loan-out was signed, from William Orr of MGM's New York office. Referring to the director's visa and right to stay in America, Orr wrote, "The Department of Labor had heard something antagonistic to Stiller . . . I can only assume it was possibly an anonymous letter sent to the department by someone who wanted to see him out of the country." Walker, evaluating this memo, concludes that "such discretion in the description 'something antagonistic,' and in reference to an 'anonymous letter,' is unusual in a memo of a confidential nature: it tends to be used if morals, particularly sexual ones, come to reckoning."[30] There have been hints over the years that Stiller's secretary, Rolf Laven, who likely traveled from Sweden with the director, was living with him in Santa Monica. MGM kept close tabs on all performers and directors, knowing that the watchful eye of industry morality czar Will Hays, who ran the watchdog MPPDA (Motion Picture Producers and Distributors of America), was scrutinizing any sexual behavior outside of matrimony that might come to light. The studio had cleaned up after popular moneymakers Ramon Novarro and Billy Haines, both gay, whose activities were often less than discreet. Similarly, director Edmond Goulding. The studio would not put out for an actor or director who was not a profit center. Let Stiller become Paramount's problem.

As she had working under Monta Bell, Garbo flourished under Niblo's direction. Stiller's influence on Garbo's performance after more than a month of working together must be significant, but in the end *The Temptress* is Niblo's work, as all of Stiller's scenes were scrapped. Garbo famously rarely signed photographs,

but one survives taken by Ruth Harriet Louise in early 1926, inscribed, "To Fred Niblo with a piece of my heart."[31] With Niblo in command, Moreno regrew his moustache. Cinematographer Tony Gaudio was largely replaced by William Daniels after Niblo took over. He displayed his lighting magic for a second time, making Garbo incandescent.

Not that the star herself didn't do her part. Garbo beautifully inhabited the role of Elena, creating a new model of a screen character—a vamp to be sure, but for the first time a blond, and a woman who is never seen pursuing men. Men are drawn to her; Garbo's characters are victims of their mesmerizing beauty. After a hundred minutes of wreaking havoc on men in Paris and in the Argentine countryside, Elena returns to Europe. The film's conclusion shows her character working as a prostitute on the streets of Paris. In a drunken moment, she seeks salvation and gives her last valuable possession, a ring from one of her earlier admirers, to a destitute man. At the very end, she walks down an alley away from the camera, alone. Preview audiences found this ending too sad, so MGM shot an alternative in which Moreno and Garbo are reunited in Paris, presumably to live happily ever after. The tougher, more genuine original version worked much better and is the one included in most prints, including the DVD.

She also had one or more portrait sessions with Louise during the filming of *The Temptress*, and results were exceptional. Garbo was learning the power of her image, and in collaboration with Louise came to understand the implication of working as hard in the portrait studio as she did in front of the motion picture camera. Garbo shrewdly recognized that if she could look spectacular in photographs, these images would set her apart from her contemporaries when they were reproduced in magazines, and especially on covers.

With its opening on October 10, MGM and Garbo had another hit. Four months of production costs and the expense of two directors made the film inordinately expensive, and it hardly recouped its costs. But when Mordaunt Hall wrote in the *New York Times*, "There are moments when Miss Garbo reflects a characteristic mood by the slightest movement of one of her eyelids,"[32] the Garbo mystique was recognized. In her next outing, MGM would capitalize financially on the promise of her first two films. Thalberg's prediction, found in a few lines in an old copy of *Variety*, would come true.

In the late 1920s, Los Angeles became a beguiling stopping point for illustrious foreign travelers in America. The good weather was a lure, but so too was the chance to see the film industry at work and perhaps meet some of the new American royalty. Authentic royalty made up some of the visitors, and in July 1926 the crown prince of Sweden who later became King Gustav IV Adolf, and his second wife, the former Lady Louise Mountbatten, a great granddaughter of Queen Victoria, visited Hollywood and were entertained for lunch at MGM. Mayer hosted the meal on the Scottish village set of the Lillian Gish film *Annie Laurie*. Garbo was invited to attend and was accorded prime seating at the prince's left.

Sven Hugo Borg, still serving as Garbo's factotum, wrote that Garbo arrived late, as they were off filming on location. After lunch, she said to him: "What a fool I was! Can you imagine? I offered the Crown Prince a cigarette? I am so ashamed, for every Swede knows that he does not smoke or drink. That's why I hate social functions . . . You never know when you will make some awful mistake."[33]

Gaffes in the real world were trying enough, but waywardness on the screen seemed to trouble her too. Speaking just after the opening of *Torrent* with journalist Rilla Page Palmborg, who would write her first full-length biography in 1931, Garbo sighed, "I guess I will always play bad girl . . . Always in Sweden, then here in Ibáñez's 'Torrent,' and now in my next picture, 'The Temptress.' I like sometime to play good girl."[34] That would not be MGM's plan.

FLESH AND THE DEVIL AND LOVE

Garbo was rushed into her third film as quickly as she had been into her second. No sooner had work concluded on *The Temptress* than preparations began on *Flesh and the Devil.* Although both *Torrent* and *The Temptress* were prestige films by dint of the lavishness of the production and the expensive talent involved, *Flesh and the Devil* was of a different order altogether for the simple reason that she would be costarring with MGM's, and perhaps Hollywood's, number one romantic leading man, John Gilbert. Gilbert had scored three triumphs in a row for his studio: *The Merry Widow*, *The Big Parade*, and *La Bohème*. The last was both a financial and artistic success and costarred Lillian Gish; *The Merry Widow*, with temperamental Mae Murray, was a box office bonanza. But nothing compared with the dollars that rolled into MGM coffers following the release of the World War I epic *The Big Parade*, one of the greatest hits of the silent era. Gilbert's popularity was virtually unrivaled; he was a cinema juggernaut like Tom Cruise would become later in the century. Two weeks after *Flesh and the Devil* began filming on August 23, 1926, Rudolph Valentino died in New York City. Hollywood lost a great romantic figure, and Gilbert lost his only real competition.

Casting her with Gilbert was further sign that Thalberg was grooming Garbo to become a star. And, with Stiller now out of the way, he could manage Garbo's career without the older man's interference. The Hollywood pecking order was rigidly stratified. In her first two American films, Garbo was a leading lady. She was credited below the title in both, and in publicity for *The Temptress*, both Garbo's and Moreno's names were printed in smaller letters than that of director Niblo. *Flesh and the Devil* would be the test that if successful could propel Garbo into Hollywood's top ranks. Less than a year after arriving in Los Angeles—grueling months making two films in quick succession—she was thrust into a third without a break as the lead in one of the studio's most important offerings. Nevertheless, when *Flesh and the Devil* was released, Gilbert was accorded sole over-the-title

Garbo met Hollywood's leading male romantic star on the set of *Flesh and the Devil,* and by all accounts they were as enamored of each other as the lovers they played on-screen. Still photographer Bert Longworth captured the couple in a casual moment between takes.

billing, and Garbo was listed secondarily along with Lars Hanson. In the fall of 1926, MGM's female stars were Norma Shearer, Marion Davies, and Lillian Gish. It was not enough to be cast in a classy film; Garbo would have to earn her place in this elite company at the box office.

Thalberg assembled top talent for *Flesh and the Devil* and watched over it with exceptional care. Clarence Brown was hired as a new addition to the MGM directing roster after a string of successes, most recently working with Norma Talmadge on *Kiki* and before that with Valentino on *The Eagle.* Along with Brown, Daniels was on camera, Cedric Gibbons oversaw the sets, and costume designer André-Ani, recently hired to replace Erté, made Garbo's wardrobe. A John Gilbert picture needed the best MGM had to offer, which was the best in Hollywood. Garbo's invitation to join the cast placed her at the summit, but in this heady company, she was still the largely untried commodity.

At first Garbo resisted the call, desiring to break from the mold MGM was pouring for her, that of the beautiful, seductive vamp. Not even the prospect of costarring with Gilbert was enough for her to agree to get back in harness that soon. Garbo wanted different sorts of roles, and a trip home after the death of her

sister. Thalberg said no. In retrospect it is evident that she was keeping a careful tally of alleged slights. She appeared as directed on the set of *Flesh and the Devil*, but next time the studio would not find her so acquiescent.

Garbo and Gilbert became acquainted in late July 1926, during final preparations for the picture. Although Gilbert was not contractually accorded the privilege of approving his costar, Thalberg assuredly would have consulted him. Of Garbo's viewable work, only *Torrent* was then in release, but Gilbert must have watched rushes or an early cut of *The Temptress* to see his new leading lady in action. His response is not hard to guess; he was a notorious ladies' man in movieland.

Frederica Sagor, a screenwriter at MGM in 1926, remembered that the new film was first a title without a story and that she was one of many scenarists who took a stab at the project.[35] She is listed in the *Film Daily Annual* (1926) as working on an adaptation of the novel *The Undying Past* by German writer Hermann Sudermann to be titled *Flesh and the Devil*. In the end it was MGM company writer Benjamin Glazer who successfully pulled it off and received screen credit. The old story and the new title paired nicely. Set at the end of the nineteenth century, it was the tale of best friends, military officers, who fall in love with the same (married) woman, Felicitas von Rhaden. Gilbert and Hanson play the soldiers, and Mark McDermott the cuckolded husband. Gilbert, in a rage fueled by his passion for Felicitas, kills Count von Rhaden in a duel and is forced to flee; Hanson marries the widow; Gilbert returns despondent. In a dramatic conclusion, the heroine falls through the ice and dies, leaving the old friends, now reconciled, behind. A strange ending, and the first of many in which Garbo's character dies just before the final credits. Nevertheless, Clarence Brown managed to film some of the most magnificent love scenes ever recorded in the history of motion pictures.

Cameras started rolling on August 9. Brown told Kevin Brownlow, "Greta Garbo had something that nobody ever had on the screen. Nobody . . . I would take a scene with Garbo—pretty good. I would take it three or four times. It was pretty good, but I was never quite satisfied. When I saw that same scene on the screen, however, it had something that it just didn't have on the set." Bell and Niblo must have understood that something, and Stiller most certainly had. But it was Brown who captured it on film and made it an essential part of *Flesh and the Devil*. "You could see thought," he said of Garbo's acting, "and nobody else has been able to do that on the screen."[36]

Something else happened that undoubtedly surprised no one. Gilbert fell in love with his leading lady. The stories are legion—the love affair that blossomed on the set, first in front of the crew's eyes and soon those of the whole world, and held primacy in Hollywood for decades until finally being supplanted by Elizabeth Taylor and Richard Burton on the set of *Cleopatra* in 1961. Nothing like the Garbo–Gilbert affair had ever so inflamed Hollywood and international press. Mary Pickford and Douglas Fairbanks were tame (and discreet) by comparison.

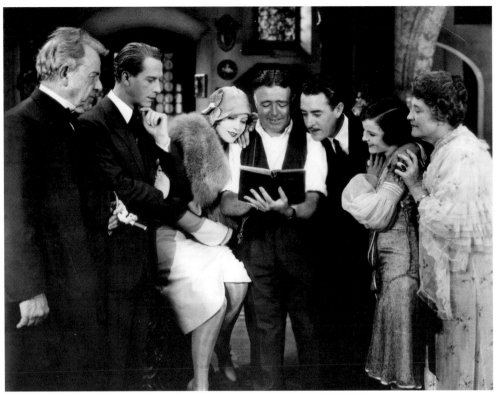

The cast of *Flesh and the Devil* gathered for a group photo with director Clarence Brown (at center with the script). From left: George Fawcett, Lars Hanson, Garbo, John Gilbert, Barbara Kent, and Eugenie Besserer. Photographed attributed to Bert Longworth.

So too was Gloria Swanson's love life, with its long line of husbands and lovers all dutifully reported in the headlines. Through a series of beautifully directed scenes charged by the screen chemistry, Brown created a film that was sure to be hugely popular. The set during the filming of *Flesh and the Devil* must have been explosive, and the love scenes were wonderfully frank and erotic.

Thalberg tracked the connection between them both on screen and off, and new romance became the studio publicity department's dream story that could be marketed endlessly to breathless fans anxiously awaiting the next morsel. In one fantasy scenario of Garbo's life, this could be the fadeout. But nothing in that life was typical, and although Gilbert was desperate to marry her, Garbo was not inclined. Sure, she was interested in him. The trajectory of her ascent from the time she was a shop clerk in Stockholm depended on strategic associations with men who could propel her career forward. What better step than an alliance with the greatest romantic movie star in the world, who commanded an enormous income and all the attendant perks. Looking back from the vantage of nearly a century, what Garbo's amorous feelings about Gilbert might have been seems almost beside the point.

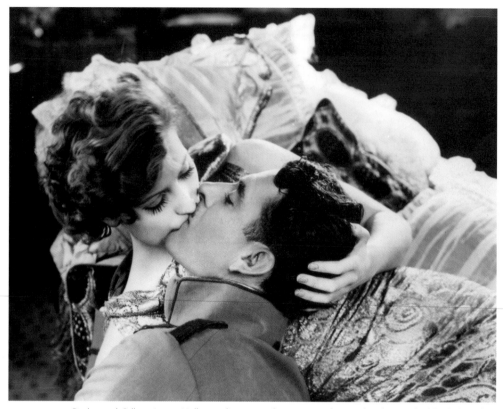

Garbo and Gilbert. It was Hollywood's greatest love story until Liz and Dick ignited tabloids thirty-five years later. This still, taken by Bert Longworth, records one of their smoldering passionate scenes that drew audiences into theaters and made Garbo a film star.

Actress Eleanor Boardman stated unequivocally that her wedding to MGM director King Vidor on September 9, 1926, was meant to be a double wedding with Garbo and Gilbert.[37] According to Boardman, and the lore that has entered the mythology, Garbo stood up her intended groom. Where was she that day? At MGM, working on *Flesh and the Devil*. It is a preposterous notion that the twenty-year-old Garbo, in the midst of her third film, would agree to marry a man she had known for something like six weeks. Do the romantics really believe that she would have gotten dressed that Thursday morning, perhaps stopped by Stiller's house to give him the news, then hurried off to marry Gilbert?

Sufficiently telling is what Garbo wrote to her friend Mimi Pollak in Sweden about him on November 23: "He is sweet, and angry because I don't want to get married. I've been very bad toward him. Without knowing what I wanted, I've promised many things which now make him unhappy because I can't go through with them. He has a very attractive home with everything you could want—tennis, swimming pool, servants, cars and everything to make life easier. But I still return home to my old, ugly hotel room. Why?"[38]

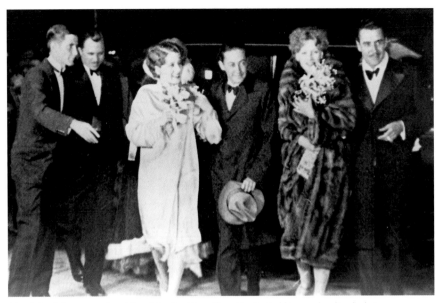

After John Gilbert completed *Bardelys the Magnificent*, he invited his new leading lady to accompany him to the film's premiere in September 1926. Others include (from left): MGM publicist Howard Strickling, director King Vidor, Norma Shearer, Irving Thalberg.

Flesh and the Devil finished filming on September 28, 1926. Ten days earlier Garbo had turned twenty-one; she was now free to sign contracts without her mother's consent. She and Gilbert made a rare public appearance together on September 30, at the Hollywood premiere of *Bardelys the Magnificent*, which starred Gilbert and had wrapped just before *Flesh and the Devil* went into production. His leading lady was the newly married Eleanor Boardman. A bit of newsreel footage survives that shows Garbo and Gilbert arriving at the theater along with the Thalbergs, the Vidors, and MGM publicity chief Howard Strickling. Garbo wears a brown mink coat, carries a bouquet of flowers, and smiles happily. There is no record of a Los Angeles gala premiere for *The Temptress*, which was released in New York on October 10, making it possible, even likely, that the film was released without fanfare. Stars, directors, and producers often saw their new films for the first time in sneak previews, usually hastily announced, at neighborhood theaters. If so, Garbo and Stiller might have watched *The Temptress* together, anonymously, and safe from the klieg lights.

Should any twenty-first-century reader think that Garbo deserved a break after working almost consecutively for twelve months on three films in a foreign land and simultaneously learning a new language, her producers had a different idea. The Mayer–Thalberg team saw Garbo as an increasingly lucrative revenue source, especially in view of her minimal salary relative to the money her films made at the box office. After a year in Hollywood, her contract did gave Garbo a slight pay raise, to $600 weekly, but since she had stubbornly refused to extend

her contract beyond the three years agreed to in New York, the studio intended to work her every minute.

An intriguing announcement appeared in *Film Daily* on September 2, and in *Moving Picture World*, two days later. As the latter reported, "Greta Garbo will have the featured feminine part in 'The Ordeal' which Marcel De Sano will direct for MGM with Lon Chaney as star." [39] After working with three romantic leading men, what might Garbo have made of a role costarring with Chaney, Hollywood's brilliant male character actor? Nothing came of this project, however, and even before *The Temptress* was released, she was called back to the studio to begin work on her fourth film.

Diamond Handcuffs[40] was set to star Mae Murray, but she refused the script, so Thalberg announced it as Garbo's follow-up to *Flesh and the Devil*. But Garbo didn't like the project either or, under Gilbert's sway, the salary she was being paid. Whispers of both reached the press, and on November 12 an industry trade paper, *The Film Mercury*, conveyed all this and more: "It was also rumored that Miss Garbo had not only rejected the script but was talking of not accepting any other until there were various other adjustments, including that of her salary."[41] During the summer Garbo had acceded to Thalberg's wishes and joined the cast of *Flesh and the Devil*. This time she did not. Did Stiller countenance this behavior, was it Garbo's decision, or was Gilbert exerting a dominating control over the actress and her career?

A comparable bit of fluff was proposed: *Women Love Diamonds*, with Garbo to play another woman of questionable morality. Suddenly her producers broached the possibility of a serious film: might Garbo take the lead in a new production of *Anna Karenina*? It would be her third adulterous wife in a row, but at least it was based on a classic. The idea was sound, but Garbo was unwilling to sign on under the financial terms of her 1925 contract. The next month, with no resolution of the standoff, Garbo engaged Harry Edington to serve as her agent—not coincidentally Gilbert's too (Edington had previously worked at MGM in the accounting department).[42] During this self-imposed hiatus from film work, Garbo accompanied Gilbert for a weekend at William Randolph Hearst's fabled estate at San Simeon. A single photograph marks the visit, a group shot of mostly MGM notables clustered at the front door of the main house: producers Thalberg, Rapf, and Paul Bern, directors Vidor and Edmund Goulding, and besides Gilbert and Garbo, the actress Norma Shearer. Those not associated with MGM included Constance Talmadge, and Buster Keaton wearing his hair shoulder-length as he appears in *The General*.

Fifteen months in Hollywood had taught Garbo well. Not only had she figured out how to be a first-rate film actress, but crucially she was calibrating how to operate successfully within the tight constraints of the studio system. An MGM acting contract, as it is now obvious, gave nearly all advantages to the studio and few protections to the performer apart from a negotiated minimum salary.

Otherwise, actors were contractually obligated to do just about anything asked by their studios. Already Garbo knew she had no say over scripts, costars, publicity chores, and vacation time; she also served under a strict morality clause that allowed termination if any scandalous behavior was noticed. Perhaps most galling to Garbo was the fact that she was committed for three years to MGM, while the studio could drop her at a whim at the end of any twelve-month period. There's also evidence that Mayer tried to get Garbo to agree to extend her original three-year contract to five years the first month she was in Los Angeles. Her inability to return to Sweden to be with her family after the death of her sister, followed immediately by Stiller's abrupt termination from MGM in the midst of their first film together, sharpened Garbo's resistance to the accepted ways of her new employer. Gilbert may have coached her in the finer points of financial negotiation, but throwing off the studio's smothering blanket was born of her own experience. Garbo was a hard and proven dutiful worker, but she was willing to work only under terms that were satisfactory to her sense of fair play. That meant more money and some control over her scripts. Mayer decided not to budge on either, figuring his young star was without any real bargaining power, at least not until her three years were up in September 1928. It seemed a good gamble. He could, and would, place her on suspension without pay. This tactic generally brought unruly employees back to their jobs under the original studio-agreed terms.

Flesh and the Devil opened on January 9, 1927, at the Capitol Theatre in New York, advertised as the world's largest motion picture palace. It was also the flagship for the Loew's theater chain, MGM's parent company. "Records Are Smashed, 'Flesh and the Devil' a Decided Hit," blared the page-three headline in *Hollywood Topics*. "Practically every film theatre box office record of the world is being shattered by the magnificent drawing power of 'Flesh and the Devil,'" the article ran. "Clarence Brown's great production for Metro-Goldwyn-Mayer, which has just entered its fourth consecutive week at the Capitol Theatre, New York." Two weeks was the old record. "By remaining there for a fourth consecutive week this picture thereby sets a record which stands a good chance of never being broken in the future."[43] This was not press ballyhoo. In the late 1920s MGM was releasing a feature nearly every week, as was Paramount. Adding in the product of Universal, Warner Bros., and other smaller studios, often more than half a dozen new films were released each week. With so many vying for space, it was rare for one to play longer than a week at a first-run house in a big city.

Garbo and Gilbert attended the film's star-studded opening in Los Angeles on February 3 at the Forum, one of the city's grandest theaters. "Greta Garbo was lovely in chiffon and an ermine wrap," pronounced one society columnist.[44] After the full-length mink she'd worn a few months earlier for the *Bardelys* opening, she was seizing the prerogatives of her new stature. One press photo shows the stars exiting their cars in front of the theater, smiling broadly, and accompanied

by Emil Jannings and his wife, actress Gussie Holl. Also visible are MGM pro-
ducer Paul Bern, and publicist Howard Strickling, the latter seen watching over
the studio's valuable commodities. Another photograph, a close-up of Garbo and
Gilbert together, both smiling, was dutifully reproduced on the cover of *Hollywood
Topics* headlined "GILBERT-GARBO MARRIED."[45]

Before *Flesh and the Devil* reached theaters, the fan magazines were reporting
on the steamy screenland romance. Although Garbo did not intend to marry
Gilbert the previous September, throughout the fall they were noticed widely as
a couple, and the love scenes captured by Brown on film only made fans more
ardent for the fantasy to come true. But the GILBERT-GARBO MARRIED ban-
ner also came to nothing. Garbo seemed content enjoying her time off from
the studio at her own bungalow at Gilbert's Tower Grove Road house up in the
winding roads above Beverly Hills. Sunbathing and playing tennis were her cho-
sen relaxations, compensations for the social whirl she was forced to endure that
surrounded one of Hollywood's most extroverted personalities.

Another payoff, however, was the time she spent learning necessary negotiat-
ing tactics from Gilbert for her volleys with Mayer. And all the hobnobbing also
brought her into regular contact with English-speakers. Since arriving in America,
she and Stiller had socialized primarily with other Scandinavians, which helped
neither her language skills nor her acclimation to the alien world of Southern
California. Plenty of candid photographs exist of Garbo at various affairs sur-
rounded by director Victor Seastrom or Lars Hansen and his wife, actress Karin
Molander, or others in the lively Swedish colony in Los Angeles in the mid-1920s.
Away from Stiller, who seemed not to have been welcome at Gilbert's, Garbo had
to adapt—if a burden, perhaps also a pleasure. After all, Gilbert lavished bountiful
attention on her and saw to it that she was surrounded and entertained by the
most charming, talented, and successful men and women in Hollywood.

What became of Stiller during the Garbo–Gilbert dalliance? In the fall of 1926,
he was working at Paramount completing *Hotel Imperial*, which opened in New
York on January 1, 1927. He went to New York to discuss further work with the
studio and may have been there for his film's opening, as well as that of *Flesh and
the Devil* (his name does not appear in reports of its Hollywood premiere). It is
Sven Hugo Borg who has the most to say about the Garbo–Stiller relationship
during this fraught time (and again we must weigh Borg's words carefully). "Borg,
you must find a way—you know what I mean—an excuse to give Stiller," he writes
of Garbo's concern. "'I promised to join Jack this evening.' 'Why not tell Stiller
that you are detained at the studio to make retakes?' I would tell her. 'Not so bad,
Borg, not so bad,' she would say, tapping her front teeth with her fingernail, as
she frowned, 'but what if he finds out?'"[46] Stiller did communicate with Mayer
on Garbo's behalf in a long letter dated December 18, 1926, where he described
his role in the actress's success and attempted to negotiate new contractual terms
for her.[47] Stiller was back in Hollywood in 1927, again working at Paramount and

The City of Dreams [Page Eight]

Hollywood Topics 5¢

~cussed and discussed All Over the World

News · Graphic · Features · Fiction · Criticism · Satire

Screen · Stage · Society · Sports · The Intimate Truth

Vol. 1—No. 11 · WEEK ENDING SATURDAY, FEBRUARY 12, 1927 · Copyright, 1927, by Hollywood Topics, Inc.

GILBERT-GARBO MARRIED

JACK DEMPSEY RECOVERS

JACK DEMPSEY'S plans for beginning training to ascertain whether he considers himself fit for a ring comeback are taking shape again now that he is rapidly recovering from his blood poisoning. His general condition is reported to be greatly improved and the swelling in his left hand and arm has practically disappeared. Dempsey's wife, Estelle Taylor, and a trained nurse have been in constant attendance and as yet the the physicians have not allowed him to eat any solid food.

BARTHELMESS INJURED IN TENNIS PLAY

RICHARD BARTHELMESS was removed to his home last week from the Sylvan Lodge Hospital, where a fractured bone in his left foot was reduced last Sunday. With Dallas Squires and other guests he was playing tennis when an unusually difficult play threw him off balance and wrenched his foot painfully. He was removed immediately to the hospital and given surgical aid by Dr. Louis Regan.

Famous Film Star and Greta Married Last Friday at Santa Ana is Rumor.

Romance Started While Working in "Flesh and the Devil"

RUMORS that will not down are circulating throughout the film colony that John Gilbert, Metro-Goldwyn-Mayer star, and Greta Garbo, his temperamental leading lady of "Flesh and the Devil," were secretly married last Friday at Santa Ana.

Propinquity will do much to foster the spirit of romance, especially in two such emotional characters as Mr. Gilbert and Miss Garbo. When one considers the glowing love scenes in "Flesh and the Devil," one does not wonder that play acting became actuality away from the studio, with marriage as the natural reaction.

Verification of these reports from Mr. Gilbert and Miss Garbo was impossible, as both refused to talk.

INSULT AND INJURY

The Editor of Hollywood Topics recently received a letter from a film person, claiming that I had not only insulted but had injured him in the eyes of his producer. That his standing as a star was also jeopardized by a constructive criticism in a recent issue of Hollywood Topics.

I was also informed that unless I retracted the statement made regarding his histrionic ability I would receive "bodily injury" from his hands.

The only reason I do not publish the letter is on account of the filthy, degenerating language used. What I should do is to turn it over to the proper authorities and let the signer do a little worrying, but I'm not going to do this. Instead,

(Continued on Page 2)

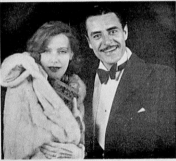

EDWARD J. MONTAGNE, chief of Universal's scenario department, is dividing his time between his editorial desk and collaborating with Director Edward Sloman on the script for "Lea Lyon," scheduled to be one of Universal's big specials for 1927. Mary Philbin is to play the starring role.

Marriage for the couple was thought by the press to be a certainty, and one trade paper, Hollywood Topics, jumped the gun and announced the nuptials in February 1927 with a photo taken at the Flesh and the Devil premiere the month before.

directing *The Woman on Trial*, with Pola Negri. Following the flurry of information recorded about him and Garbo in 1925 and 1926, the press went nearly silent in 1927. We have no reason to think their essential relationship changed after *Flesh and the Devil*, but they were now working at different studios, and Stiller's absolute control of Garbo's career had come swiftly and abruptly to an end.

Mayer tried many approaches to bring Garbo back to work. He threatened her with deportation, but since she longed to return to Sweden, such a threat had little bite. He told her for the balance of her contract she must take minor roles in secondary films. This, he figured, would sting Garbo's pride, anxious as she must be to retain the luster of her earlier successes. A secondary role in *Her Brother from*

Brazil was proposed.[48] Threatened with suspension without pay, Garbo relented and went for costume tests. "Mr. Edington tell me to do it," she told *Photoplay* reporter Ruth Biery in 1928, "so I did not say a word, but tried on the dresses and was already to play the little part in the picture, when Miss Pringle said she would not do it."[49] Aileen Pringle knew well enough not to share screen time with the much younger beauty who had created such a sensation the year before. Garbo returned to the protective lair on Tower Grove Road and waited. Press reports in January and February were contradictory; *Hollywood Topics* told readers that she was about to start on *Anna Karenina*.[50] The next month, *Exhibitor's Herald* reported, "*Anna Karenina* which was to have been produced with Miss Garbo starred, has been assigned to another actress."[51] When the following short mention was made in *Hollywood Vagabond* in mid-February, Mayer must have known that his authority over the temperamental Swedish actress was slipping away: "Metro-Goldwyn-Mayer's trump card is Greta Garbo, who, from the beginning, was a sensation. Her asbestos-destroying scenes with Jack Gilbert in 'Flesh and the Devil' are the talk of the town."[52]

At the end of March, an accord was reached. Mayer capitulated on money and script approval; Garbo agreed to sign on for five years in a new contract dated back to the first of the year. Garbo would be paid $2,000 per week for 1927, then $2,500 in 1928, raised to $4,000 in 1929, up to $5,000 in 1930, and $6,000 in 1931. The first film under the new terms would be the film discussed the previous fall, a contemporary version of *Anna Karenina* to be titled *Love*. In April, Fred W. Fox, editor of *Hollywood Vagabond* wrote, "The most sensational of the recent player vrs producer contractual duels is that, supposedly now ended, between Greta Garbo and Metro-Goldwyn-Mayer."[53] *Motion Picture* lamented the loss of good copy: "The end of Greta's quarrel will leave a lot of blank space in newspapers and magazines."[54]

Dorothy Donnell Calhoun, a Smith College graduate, was among the best, and most reliable, of the early Hollywood fan magazine writers. Calhoun had the chance to interview Garbo in April 1927 as she started work on *Love*, and published an article aptly titled, "They Learned about Women from Her," for *Motion Picture Classic* (August 1927). She described the typical contretemps between stars and bosses:

> "After the storm these temperamental stars always powder their tempest-tossed noses, and Do what they are told. Producers are *not* used to an actress who states calmly what she desires, and lets *them* do the storming . . . If a chuckle creeps into these lines, it is because Hollywood is seldom treated to the diverting spectacle of a mouse—albeit a blonde mouse with decided sex appeal—defying the Goldwyn lion . . . Two days before the final limit of her passport the company weakened. Producers' noses are never bitten off to spite their faces. This baffling Swede was worth a fortune to them." [55]

To this veteran reporter, "The heavy-lidded droop of her eyes seems not provocative as the critics say, but wary." Responding to the journalist's questions, Garbo stated, "I tell you what Greta does after six o'clock! Anyt'ing, everyt'ing to make me tired so I can sleep." Perfectly predicting the future, Calhoun concluded, "They say in Hollywood that the Scandinavian Sphinx has gotten away with it this time. I have a suspicion that she will get away with more before she is through!"

With a contract now paying her a star's salary, Garbo began preparations for *Love* with director Dimitri Buchowetzki, who had directed Mae Murray in *Valencia* for MGM the year before. Ricardo Cortez was cast playing Count Vronsky. Scene stills survive dated over about two weeks, from mid-April to the end of the month, documenting the production under way. During this time there are also photographs of Lew Cody visiting Garbo on the set (April 15), and Garbo with Lillian Gish and Victor Seastrom during a break in filming for *The Wind* (April 21). In these pictures Garbo seems well. Soon, however, rumors surfaced around the studio of her being ill with pernicious anemia. All we know for certain is that work on *Love* was suspended in May. Garbo took two weeks of unpaid leave, extending the termination date of her new contract to January 12, 1928 (and those two weeks at the 1927 salary). There was no provision in Hollywood contracts of that era for sick time.

Was the problem Garbo, the film, the director, the costar, or something else? The facts line up pretty clearly, though the machinations behind them do not. When *Love* commenced again in June, Garbo was still Anna. Buchowetzki was out, replaced by Edmund Goulding, relatively new to MGM, who had just directed *Women Love Diamonds*. Merritt Gerstad was the original choice as cinematographer, but he was replaced with Garbo ally William Daniels. Gone too was Cortez; John Gilbert would now play Vronsky. Between *Flesh and the Devil* and *Love*, Gilbert starred in *Twelve Miles Out*; back in the fall, MGM producers seemed to have not given any thought to casting him again with Garbo, and he was quickly put into another film. With the spectacular reviews and commensurate revenues of *Flesh and the Devil*, however, Mayer likely wanted a quick re-pairing of the studio's new dream couple. Was Garbo's "illness" a convenient excuse to suspend *Love* until Gilbert was available, or was it simply a coincidence that the many delays worked well for all parties involved? Cortez and Garbo in *Love* would have been a good marquee title, but Gilbert and Garbo in *Love* would ensure long lines forming at box offices nationwide.

Shortly before *Love* resumed with Gilbert as costar, Garbo lost a close friend, actor and Swedish compatriot Einar Hanson (the two had spent those several weeks together in Turkey, awaiting rescue after Stiller's project there lost its funding, and had appeared in Pabst's *Joyless Street* in 1925). Hanson was a protégé of Stiller's and had starred to acclaim in the director's 1924 film *Gunnar Hedes saga* (*The Blizzard*), playing the title character. He had immigrated to America shortly after Garbo and Stiller, with his travel expenses paid by MGM. (Stiller might have

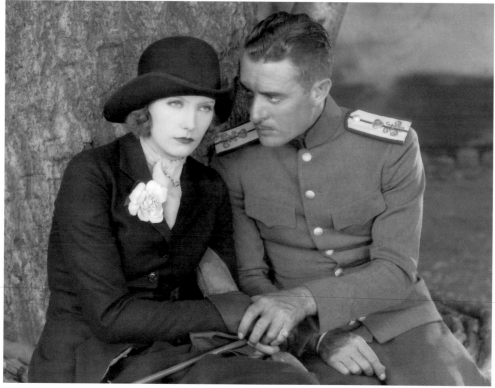

Portrait photographer Clarence Sinclair Bull, who could later be known as "The Man Who Shot Garbo," made his first photographs of the actress on the set of *Love*, many with costar John Gilbert.

introduced Hanson to Mayer in Berlin in the fall of 1924.) Hanson never worked at MGM, in fact, but made his American debut at First National working with Corrine Griffith in *Into Her Kingdom*. After a year working at both First National and Universal, he scored a Paramount contract, likely due to Stiller's influence, and in January 1927 Hanson signed a long-term contract with the studio. His fourth film for Paramount, *The Woman on Trial*, was directed by Stiller and costarred Pola Negri. On June 3, just after filming completed, Garbo and Stiller had dinner at the beach home of Hanson and his partner, Eugene Nifford. Swedish meatballs, apparently one of Garbo's favorite dishes, were served. So too was a Swedish punch that Hanson drank in abundance. After Garbo and Stiller left, the twenty-seven year-old actor, most certainly drunk, went for a drive (perhaps heading to a late-night party at Clara Bow's, with whom he had worked at Paramount), and his car skidded and crashed on the Pacific Coast Highway. He died shortly afterward.[56]

The pain of this loss might explain in part Garbo's treatment of Gilbert when a grand gesture he made toward the end of June—commissioning a yacht to be christened *Temptress* in her honor—backfired badly. King Vidor, a Gilbert pal, recalled that the plan for the maiden voyage was for the couple to sail alone to Catalina Island. Friends were invited to make their way across the channel to

inspect the boat and return later for a celebratory dinner on board. Vidor was among the guests who, while marveling at the boat, found no evidence of its "namesake." As the dinner hour approached, Vidor and the other guests awaited word on shore to join their hosts, only to see the boat sail away. Apparently, Garbo had failed to appear, and Gilbert headed back to the mainland alone without facing the tongue-wagging of his intimates. According to Vidor, soon after the boat was quietly put up for sale.[57]

Regardless of Garbo's ambivalence about Gilbert, work on *Love* began on schedule, and with new director, costar, supporting cast, and crew, the film was completed in just over a month, in mid-summer 1927 (though apparently Gilbert aggravated director Edmund Goulding by attempting to direct much of the film himself[58]). Two endings were provided to theaters, one loyal to Tolstoy for foreign markets, the second, happy, for America, showing the lovers reunited three years later, conveniently after the death of Anna's husband, Karenin. This was the third time in a row that variant endings were prepared for a Garbo film. *Flesh and the Devil* also had an optional second ending. In the original, Garbo drowns, leaving a reconciled Gilbert and Lars Hanson alone together on the Isle of Friendship. This might have had implications that the studio wanted to avoid; the alternative shows Gilbert finding love with another woman.

Garbo's ongoing relationship with Gilbert, whatever its true nature, was avidly described in the press. On-screen they were convincing as a couple madly in love. Mayer had taken a gamble that his recent recruit, newly christened a star, would be bankable, worth two thousand dollars each week. The risk vanished at the first previews. Garbo had earned her movie stardom; ticket buyers would line up. Any unfinished business with Stiller was brushed aside for the moment. He was busy at Paramount directing *The Street of Sin* with Emil Jannings, Fay Wray, and Olga Baclanova.

Surprisingly, given the normal efficiency of MGM's publicity office, when *Flesh and the Devil* opened, there was a lack of photographs depicting Garbo and Gilbert together to distribute to a press frantic to promote the studio's hottest couple. Garbo seems to have had only one brief session with Ruth Harriet Louise, which generated attractive, but not particularly glamorous images. There were none with Gilbert. That left Bert Longworth's stills taken on the set of *Flesh and the Devil*, especially those showing the stars in their most amorous moments, as the principal images available. With *Love* the publicity enterprise made sure there would be plenty. Clarence Sinclair Bull, who managed MGM's large fleet of more than a dozen still photographers, took many shots of Garbo and Gilbert together on set: Garbo costumed in an elegant riding habit and Gilbert dashing in his military jacket with shining brass buttons and epaulets. William Grimes, the still photographer assigned to the production, understood that with the public's fascination with the couple, his work would take on the authority of portraits, and he delivered stunning images of Anna and Vronsky that were widely

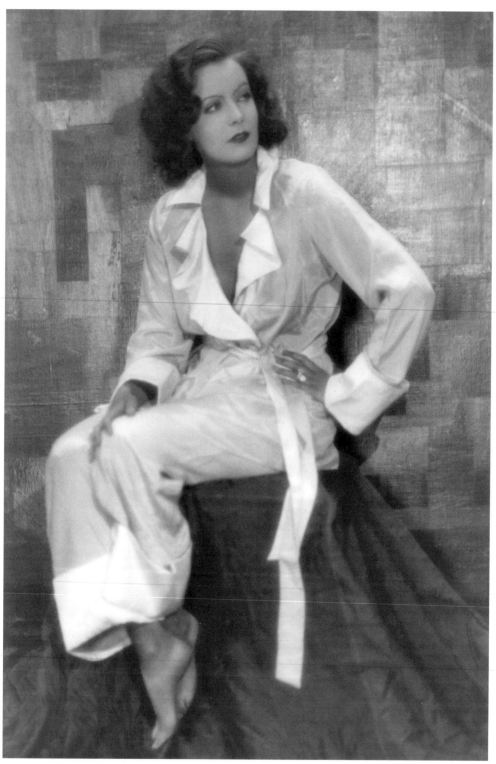

Garbo poses for Ruth Harriet Louise seated, wearing a pair of white pajamas, and barefoot. MGM was simultaneously promoting Garbo as a paradigm of glamour and a modern woman. Collection of Scott Reisfield.

circulated. Russell Ball, new to MGM, although he had photographed Garbo that first summer when she was in New York, made romantic gossamer studies of Garbo intended for the covers of fan magazines that would now clamor to feature her prominently. In the portrait studio, Louise would continue scrutinizing her subject and photographed Garbo in contemporary dress, including several shots showing the actress wearing white silk pajamas and barefoot. This was the start of MGM's simultaneously promoting Garbo as the paradigm of glamour and sophistication, as well as modern young womanhood. Both guises fit. When the two women met again that fall for Garbo's fifth film, *The Divine Woman*, Louise worked real magic, and the face of Garbo would become set for all time.

As a star, Garbo was accorded above-the-title credit, but her name was still listed after Gilbert's; thus, posters, lobby cards, and other publicity read, "John Gilbert and Greta Garbo in *Love*." Though her flame was hot, Gilbert was still the top-line star. This credit order would continue through their silent films together, but never would any other costar outrank Garbo for the balance of her career. Garbo's name and face saturated studio publicity. MGM issued a lavish program for *Love*, and the breathless first lines inside the front cover indicated that all was forgiven; only spectacular revenues mattered: "It is with sincere pride of genuine achievement that Metro-Goldwyn-Mayer presents these two great stars in this production . . . Imagine the daring, the personal magnetism, the virility of John Gilbert opposite the beauty, the appeal of this lovely flower of passion, Greta Garbo." MGM was no longer developing an actress but promoting a star with all resources available. Additionally, a Photoplay edition of *Anna Karenina* (published by Grosset & Dunlap) was issued, with Garbo and Gilbert in a romantic embrace on the colorful dust jacket. Garbo was selling not only movies but also Tolstoy himself.

Love opened in November to excellent reviews, and box office receipts generated $100,000 more in revenue for MGM than had the enormously profitable *Flesh and the Devil*.[59] Reviewing *Love* for the *New York Times*, critic Mordaunt Hall praised Garbo for giving "a performance above the usual Hollywood conception of characterization . . . Very few performances in pictures have been comparable to that of Miss Garbo on this current offering."[60] Critics were bewitched and so too were fans. As *Love* was readied for release, Anabel Lane wrote in the *Film Mercury* of July 1927 that for fans, "believing, as they do, that she is the reincarnation of Sheba, Cleopatra and other notorious ladies, Miss Garbo reigns as queen supreme."[61]

Stardom thrust upon Garbo, as it did on all her peers, an insistence that her films perform well at the box office. Regardless of script or director, in the end it was the name or names above the title that were expected to carry a film. Hollywood accounting—then and now—burdens top performers, often unfairly. This was particularly so during the era of the studio system, when virtually none had any involvement with finances. A month before *Love* was being readied for release,

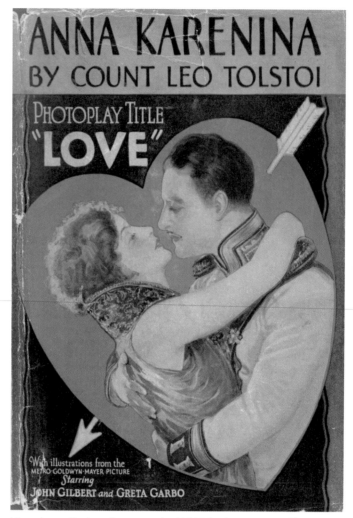

Not only was Garbo selling movies for MGM, but by starring in a film version of *Anna Karenina*, she also assisted in marketing books. Photoplay editions were popularly priced reprints of classic literature that had been adapted for the movies, and their colorful jackets featured the stars.

one of the industry papers, the *Film Spectator*, reported that $220,000 was being charged to the cost of the production "that had been wasted on previous attempts to make it . . . It cost Goulding perhaps one hundred and eighty thousand dollars to make the picture."[62] Whoever leaked these numbers had good access to MGM's accounting office, as the "official" final cost for *Love* was $488,000, and the film showed a profit of $571,000.[63] Using less aggressive accounting practices, the film's net after expenses would have been higher, and a greater testament to the drawing power of the stars. MGM's willingness to pay Garbo a large salary—one becoming enormous if each annual increase was picked up over five years—was predicated on her movies being successful. Shaving the margins distorted results

that allowed moguls leverage when contracts were up for renewal. If Garbo was only beginning to understand the workings of her studio, her new agent Edington undoubtedly coached her in how her true box office value was being manipulated by accounting shenanigans. For *Love*, Garbo shared the esteem of carrying a financially successful film with Gilbert. In the future it would be she alone who was responsible for the success or failure of her pictures.

THE DIVINE WOMAN

Once again, granting Garbo practically no time off, MGM cast her in another film, *The Divine Woman*, which went into production in late September. Perhaps in acquiescence to the actress's wishes, she would have a Swedish director, Victor Seastrom, and costar, old friend Lars Hanson. For the first time, the cinematographer on a Garbo picture would not be William Daniels, who was called to work with Norma Shearer on *The Latest from Paris*. Rivalry was intense among the studio's top female stars for the best talent. Garbo would be well served by Oliver Marsh, who had recently filmed two pictures for Lillian Gish and was known as Norma Talmadge's favorite cinematographer. The title, *The Divine Woman*, makes explicit reference to the Divine Sarah—Sarah Bernhardt—although aside from the lead character being French and turning into an actress, it is not a biopic. But it was a chance to watch Garbo ripen from an attractive young woman in the countryside into a magnificently jeweled and gowned stage star. The simple Marianne says farewell to her hometown suitor, played by Lars Hanson, who is off to war. She then travels to Paris, by chance ends up on stage, and is suddenly the most beautiful and desirable woman in the city. How she ends up back with Hanson provides the film's narrative.

The Divine Woman is the sole Garbo film that is lost. The majority of silent pictures have disappeared, so it is fortunate that with this one exception, all of Garbo's films survive. Studios at the time had little incentive to save films other than those that were box office juggernauts, such as *Ben-Hur* or *The Big Parade*, films that could be reissued profitably. The 2016 documentary *Dawson City: Frozen Time* masterfully show how films traveled from big cities to small, from towns to villages, and finally to rural outposts. Dawson City in the Yukon was the last stop on one film circuit. With no further requests for screenings, the works were destroyed. In Dawson City's case, the films were buried in largely frozen ground, and when they were accidentally excavated decades later, many were found in reasonably good condition. *The Divine Woman* sadly was not among the frozen artifacts. Once in a while an important film turns up in a foreign film archive. One reel of *The Divine Woman* did surface at the State Archive of Cinema in Moscow. Nine minutes long, it is probably the second of eight reels and shows Garbo and Hanson together before he heads off to war, and she to Paris and acclaim.

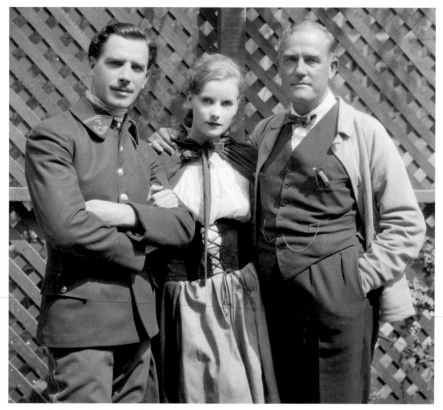

Garbo asked to work with Swedish compatriots director Victor Seastrom and actor Lars Hanson (left) when she made *The Divine Woman*, her only feature film that is lost. Photograph by Milton Brown.

But even a lost film can give evidence of the many ways motion pictures were developed and marketed. We can follow *The Divine Woman*'s narrative by examining the 154 screen stills taken by Milton Brown during the film's production. The film is loosely based on *Starlight*, a 1925 play by Gladys Unger; screenwriter Dorothy Farnum adapted the play for Garbo. Shortly after the film's release, an illustrated novelization of the movie was published, now adapted by Unger from Farnum's own adaptation. The colorful cover features Garbo and Hanson in a dramatic moment late in the story. The leading lady's name is now Marah (perhaps the character's name in the original play). As the film no longer exists, we can't know how closely the book follows it, but at least we have another clue to the lost film's narrative.

Just after filming commenced in early October, Garbo sat again for Louise in the portrait studio. Louise was the first to photograph Garbo when she arrived at MGM, and they had worked together on each of Garbo's films, most notably during the long-drawn-out production of *The Temptress*. Portraits were valuable currency in the 1920s and 1930s. They were the vehicles that promoted faces in fan magazines, newspapers, and posters, and on theater walls. Good portraits

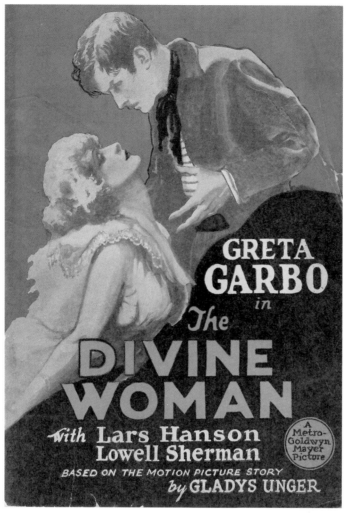

Films that started as a play or an original screenplay might later be "novelized,"
as was the case with Garbo's fifth American film, *The Divine Woman*. A cover
image of the film's stars, Garbo and Lars Hanson, helped sell the book.

caused a passerby to stop and gaze, or a magazine or newspaper reader to linger
a second. Hollywood portraits also assisted cinematographers in understanding
the best way to photograph a performer. Hours might be spent setting lights
for a particular scene on the film set, but how much better if William Daniels
could stop by Louise's studio and review her latest work? She was a particularly
sensitive photographer and tried with special care to put her subjects, especially
the women, at ease. She might play records, selecting jazz or classical to suit her
subject. She didn't say what she played for Garbo but told journalist Margaret
Chute in 1928 that she was "hard to photograph; she has so many sides to her
personality that one cannot do her justice easily in one picture. She is so young,

Two years in Hollywood had made Garbo so famous that she could be immediately recognized by only her silhouette. Photograph by Ruth Harriet Louise for *The Divine Woman* (1927).

and so sad; she has so many moods, and even when she smiles I always sense a great sadness."[64] It was Louise who better than any other photographer managed to capture images of Garbo at once ravishingly beautiful and poignant. Louise along with Daniels shares credit for creating the Garbo image that was marketed relentlessly to the public. The portraits made in November 1927 are wondrous. And Garbo had developed her skill as a sitter equivalent to her command before the movie camera. At MGM in the 1920s, only Joan Crawford was an equally thrilling portrait subject.

The Divine Woman was a financial success for MGM, though the film fared less well with critics. It was the first time that Garbo was not singled out for praise. "The picture is a huge disappointment," wrote *Screenland*'s reviewer. The actress who he describes as "the most potent personality on the screen" is now "a new Garbo, who flutters, who mugs."[65] Five months after the film's release, a relatively long review in *Film Spectator* opened with the following words: "*The Divine Woman* was one of the pictures so generally condemned by critics that I decided not to bother with it, notwithstanding the fact that it has such an important star as Greta Garbo." The writer found fault principally with the story but also had words for the star: "No one with a grain of common sense is going to take it seriously . . . Greta makes a fool of herself, and no picture with a fool for a heroine can make much of a hit at a box-office."[66] Even Garbo's champion Mordaunt Hall could not find much nice to say about the film, calling it "stereotyped and especially dull, so dull that even the pleasing and sometimes interesting presence of Miss Garbo fails to make it mildly interesting periodically."[67] When the last small theaters were finished showing *The Divine Woman*, MGM recorded a $350,000 profit; Garbo was still well worth her $2,000-a-week salary. Nevertheless, though Mayer and Thalberg might have bested the critics this time, they were keenly aware that better material was necessary to protect so important an investment.

As 1927 concluded Garbo marked the end of her first year as a bona fide movie star, making first-class productions with a top salary. Yet just then she lost the companionship and advice of her mentor. Stiller sailed for Stockholm in December 1927 on the steamship MS *Gripsholm* after twenty-nine months in America. When he and Garbo arrived in July 1925, Stiller had great ambitions for them both. Garbo's success was beyond what anyone might have imagined; his had far less luster. After losing his MGM contract, he directed three pictures for Paramount, *Hotel Imperial*, *The Woman on Trial*, and *The Street of Sin*. A fourth, *Barbed Wire*, began immediately after *Hotel Imperial* and was finished under the direction of Rowland V. Lee, possibly because Stiller was ill. *The Street of Sin* was begun in the summer of 1927; surviving photographs taken that August by Arnold Genthe show Jannings and Stiller together on a set; one photo of the pair appeared in *Vanity Fair* the following February.

What happened? Stiller worked but a single year for Paramount. His first film was successful; the others were yet to be released. Was a second-year contract offered? There are two mentions of Stiller in *Film Daily* from October 1927. The first, dated October 4, reads simply, "Emil Jannings and Mauritz Stiller enjoying the sights of Hollywood Boulevard." Five days later comes this intriguing announcement: "Mauritz Stiller, who has secured a five weeks' leave of absence from Paramount, intends to leave for Sweden this week. He has just completed direction of Emil Jannings in 'The Street of Sin.'" Did Stiller leave Hollywood with an agreement to return to Paramount, or was this an attractive fiction planted so as not to embarrass him? Five weeks to make the long voyage to Stockholm and back

is almost impossible. He was now seriously ill with a pulmonary condition; he may have decided it was time to go home. Sometime in November he and Garbo said their goodbyes, and he boarded the train to New York. If they hadn't already attended a preview of *Love* together, he could have seen the film in New York, where it had just opened, in the luxury of the Capitol, Loew's premiere theater. Among those sailing home with Stiller on December 9 were Prince Wilhelm, the second son of the Swedish king; Lars Hanson, who had just finished costarring with Garbo on *The Divine Woman*; and his wife, actress Karin Molander.[68] This was Hanson's last film in America, and he too was leaving the United States and Hollywood for good. Hanson was Garbo's first leading man, when they worked with Stiller on *Gösta Berlings saga*. One would like to know what these two giants of Swedish film said to each other, their Hollywood experiments concluded, during the voyage back to Göteborg.

THE MYSTERIOUS LADY

The title of her fifth American film heralded Garbo as the divine woman. The sixth proclaimed her the mysterious lady. Why spend extra money on advertising when MGM could promote her image by something so simple as what a film was called? After the release of *Love*, Garbo's fame began to soar. Martin Martin writing in *Screenland* proclaimed, "Thank thee, O Lord, for Greta Garbo, is the paean of filmdom's new favorites . . . Greta has done three things: 1. Made flapper and cutie types passé. 2. Reinstated tall women with curves. 3. Compelled leading men to build up the heels of their shoes and pad their shoulders."[69] MGM, naturally, picked up the first option on Garbo's contract; in mid-January 1928 her weekly draw rose to $2,500. She asked for leave to go back to Sweden for Christmas, but this favor was denied.

Thus began a six-month hiatus between pictures, during four of which Garbo was paid her lavish new salary despite not making a picture. Not much is known about her after *The Divine Woman* wrapped and Stiller's departure, and before she returned to work the following May. If her relationship with Gilbert continued, the three films he made in quick succession—*The Cossacks* with Renée Adorée, *Four Walls* with Joan Crawford, and *The Masks of the Devil* with Alma Rubens—kept him busy at the studio six days a week. A subtle but noticeable physical transformation can be seen in Garbo's appearance between *The Divine Woman* and *The Mysterious Lady*, suggesting that diet and exercise must have been part of her routine during those months. Garbo and Stiller remained in contact through a series of letters back and forth between Santa Monica and Stockholm. Stiller's first project after arriving home was directing a stage play, *Broadway*, at the Oscarsteatern in the Swedish capital. It was well received. A taste of the correspondence between the two survives in a tantalizing line in a letter from Stiller dated March 6, 1928: "If we shall stay together, we must—as I was against

it before—get married. If not, you don't have to give me any explanation—I will understand and keep you in my heart forever—but then I want us never to meet again."[70] A curious provocation given the miles that separated them, but it may have been a desperate ploy from a sick man who knew he hadn't long to live. Garbo's reaction to the letter, if any, is lost to time.

The Mysterious Lady was adapted from the novel War in the Dark. For the first time, Irving Thalberg would not be supervising a Garbo film, as he was traveling in Europe. Harry Rapf, Thalberg's colleague and another top MGM producer, took control. Rapf engaged Fred Niblo to helm, and cast Conrad Nagel to co-star. Niblo had directed successfully Garbo in The Temptress and had recently finished making Camille with Norma Talmadge and Gilbert Roland. Nagel was a handsome and successful MGM leading man who never quite achieved movie stardom. In January 1927 Nagel, along with thirty-five Hollywood colleagues, founded the Academy of Motion Pictures Arts and Sciences. As an actor he was a good support for MGM's female stars and had worked well with Norma Shearer and Marion Davies. Rapf must have thought he would make a good pairing with Garbo (perhaps similar to Lars Hanson). He was attractive enough to be a plausible love interest, but not so strong a personality as to distract attention from Garbo. The film's opening credits list her alone above the title, with Nagel below.

The first sight of Garbo in The Mysterious Lady is in a theater box, sitting alone as she attends a performance of Verdi's Tosca. The young woman who had captivated audiences and critics had suddenly been transformed into a transcendent countenance, one generally reserved for the raptures of poets and artists but hardly ever seen in the flesh (or even on screen). The loss of a couple of pounds, and the added maturity that six months can give a woman still in her early twenties, revealed Garbo as sui generis. Critically acclaimed prior to the summer of 1927, with the release of The Mysterious Lady Garbo now became in fact the woman Louise Brooks described when she wrote, "From the moment The Torrent went into production, no contemporary actress was ever again to be quite happy in herself." It was not simply her beauty; rather, Garbo had learned once and for all how to capture and retain the viewer's attention. In whatever scene she appeared, audiences' eyes followed Garbo. It would take a high-wattage costar like John Barrymore or Charles Boyer to balance the star dynamic.

For a romantic potboiler, The Mysterious Lady isn't half-bad entertainment. Garbo plays a Russian spy who ensnares and then rejects the hapless Nagel, who devolves from dashing fin-de-siècle Austrian aristocrat and officer to pathetic piano player. Naturally, by the final reel Garbo and Nagel are reunited. The weakness of the script for The Divine Woman—superficially the same story—had been addressed this time around in a screenplay by Bess Meredyth, and audiences now believe the final resolution.

Critics were catching on to the sameness in Garbo's pictures. "The Mysterious Lady has been done time and again on the screen," wrote Lawrence Reid in Motion Picture News. "It is old of plot that even the merest tyro at picture going can spot it

all of the way. It is fair enough because of the presence of Garbo."[71] The *Film Daily* critic was a bit more generous: "The story, although not original, has a number of unexpected twists. Its passionate love scenes will certainly shock highly proper maiden ladies."[72] Garbo, who two years earlier was adamant about not playing a succession of screen vamps, seems to have acquiesced to her employer's wishes. Her augmented salary may have softened the earlier resistance.

A WOMAN OF AFFAIRS

After the quiet winter off, the pace of Garbo's working schedule quickened considerably, and over the six months between May and November, she made three films. As soon as *The Mysterious Lady* was completed, work began on *A Woman of Affairs*. While this new film was under way, MGM took out a full-page advertisement in at least one of the trade papers, *Motion Pictures News*. Headlined "The Money Product," it listed the studio's stars and upcoming films. Under GRETA GARBO three projects were highlighted: "*Tiger Skin, Single Standard* and 1 more."[73] *Tiger Skin* was released as *Wild Orchids* and followed *A Woman of Affairs* (*The Single Standard* would be filmed in 1929). Honesty is seldom a hallmark of advertising, but MGM was certainly on the money this time, as they promised strong revenues to both exhibitors and shareholders from the pipeline they had developed for Garbo and the other blue-chip stars cited, including Lon Chaney, Ramon Novarro, Lillian Gish, and of course John Gilbert. There were even two films named under the Flash (the Wonder Dog), reminding readers that not all studio revenues came from sophisticated dramas.

Like each of Garbo's previous six films at MGM, *A Woman of Affairs* was based on a popular book. *The Green Hat* (1924) by Michael Arlen was a best seller and had become a successful play starring Katherine Cornell on Broadway and Tallulah Bankhead in London. It was also notorious, as it contained references to homosexuality, venereal disease, miscarriage, and perhaps abortion, none of which was suitable for motion pictures, even in the permissive 1920s before the advent of the Motion Picture Code. The studio had to distance itself from so daring a narrative and changed the title to *A Woman of Affairs*, with no reference to the book in the opening credits (although Arlen's name was prominent).

The old team supporting Garbo was back in place. Thalberg supervised, Clarence Brown directed, William Daniels was on camera, and John Gilbert returned to costar. New to the team was Gilbert Adrian, who like Garbo transcended the need for his given name and as Adrian would become one of Hollywood's top costume designers. He would create nearly all of Garbo's wardrobe for the balance of her career. Gilbert's name would again precede Garbo's in the above-the-title credits, with Clarence Brown listed right below. It was the last time any performer would outrank Garbo.

Arlen's name for his female protagonist, Iris Storm, was such a good one that it's a shame that MGM substituted Diana Merrick, more aristocratic to be sure, but less in keeping with the character's personality. Gilbert played Neville Holderness, and the cast includes a distinguished list befitting a prestige production: Johnny Mack Brown, Douglas Fairbanks Jr., and Lewis Stone; for the first time, a leading lady, Dorothy Sebastian, would join a Garbo cast. When an MGM film of this era was headed by a top female star, a Norma Shearer or a Marion Davies, the studio rarely cast another young, attractive woman in a featured role. Background decoration was fine, but women almost never appeared in Garbo's earlier films unless they were much older or younger. Sebastian was Garbo's contemporary, and they both had started at the studio in 1925. She had just completed *Our Dancing Daughters*, the film that brought Joan Crawford to the front ranks, and was rushed quickly into a supporting role in *A Woman of Affairs*, MGM figuring correctly she would not steal any of Garbo's thunder.

The thunder came from the story. In the novel Diana's husband commits suicide after discovering that he might have given his wife a venereal disease. The movie softens the crime to theft. After an affair with Neville, Garbo becomes pregnant but while staying in a sanitarium loses the child in a miscarriage; rife with guilt she goes temporarily mad. Pretty heady subjects for the movies in 1928. It was practically impossible to resolve happily, or even tie up satisfactorily, all these narratives in 1928, so in the end Diana dies in an accident-suicide. The censors had the final word, and it was not certain that the completed film would ever be released. "'Green Hat,' Formerly Banned, Produced by MGM in New Version," was the headline in *Motion Picture News*. "It is reported," ran the story, "that representatives of the Hays organization have tentatively approved the M-G-M version of Michael Arlen's play, 'The Green Hat,' which was, for some time, banned by Will H. Hays."[74] The latest in Garbo's series of films portraying women whose lives were outside the conventions of American middle-class morality was once again cleared by the censors. This must have pleased Thalberg and encouraged him to continue casting Garbo in similar kinds of roles.

During the summer months of 1928, as *A Woman of Affairs* was in production, the talk of Hollywood was sound. Harry Rapf, top MGM supervisor, was quoted in August: "If it makes pictures more entertaining, audiences will demand it and producers will use it in every picture."[75] The next month the *Exhibitor's Daily Review* ran a headline, "Metro-Goldwyn-Mayer Definitely Establishes Sound Policy," and the studio promised, "39 Sound-Talkie Features" for the upcoming season. Additionally, Loew's president Nicholas M. Schenck vowed, "More than a thousand theaters will be wired by January first."[76] Garbo's days as a silent film actor seemed to be approaching an end. And in early November, a giant technological advance was reported at the bottom of a back page in *Motion Pictures News*: "Use Made of Television in Talking Short." A short film "about 400 feet in length, included practically every star and player under contract to M-G-M

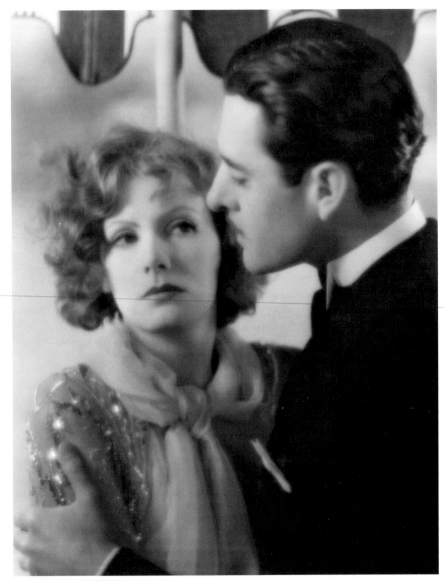

For Garbo's seventh film at MGM, *A Woman of Affairs*, she was reunited with John Gilbert. The steamy story, based on a popular novel by Michael Arlen, proved a winner at the box office, as the stars' screen chemistry continued to excite fans. Photograph by James Manatt.

with each giving a brief dialog via movietone," was made by the studio during the third week of October for the opening of the New Empire Theatre in London. The gimmick was that a combination of early television and overseas radio "put over the idea that the players were making personal appearances before the audience."[77] All but Lon Chaney, Ramon Novarro, and Garbo participated. No trace of this recording or film survives.

Ruth Harriet Louise photographed Garbo in the portrait studio in late August, and James Manatt made scene stills during the production of *A Woman of Affairs*, but it was a single short session with Edward Steichen, chief photographer for *Vanity Fair*, that resulted in the creation of perhaps the most famous and indelible image of Garbo. On Friday, August 3, 1928, MGM publicity chief Pete Smith sent word to the set that Steichen would be accorded a few minutes either at the end of the day or between the filming of two scenes. Howard Strickling, Smith's deputy, likely accompanied Steichen and watched over the proceedings. Garbo had just completed a scene with Douglas Fairbanks Jr., who was portraying her younger brother. She was dressed simply in a plain, long-sleeved black dress with a V-neck. Typically Garbo's sets were closed to outsiders, but MGM's publicity office recognized the cachet of the photographer and the publication he was representing, and convinced Garbo to accede to the interruption. Steichen and Strickling would have waited outside the closed door until filming was completed. Once admitted, Steichen set up his camera and placed a prop chair at the spot he wished to photograph the actress.

Like almost everyone who met Garbo or had a chance to work with her, Steichen reimagined their brief encounter and made himself a hero in it. He describes watching her work on set, which would have been a breach of protocol and is unlikely to have happened. He correctly remembers the five minutes accorded him turning into ten, and the chair he used to pose her (not a kitchen chair, but a small rounded-back chair used on the set), the backrest of which he covered with a black focusing cloth. The "five or six exposures" he said were made were actually half the final number, which included at least two of Garbo with Gilbert. When Garbo arrived she "straddled" the chair, resting her arms on the back. "It's too bad we're doing this with that movie hairdo," Steichen remembers saying, along with her response, "Oh, this terrible hair"—though it was simply parted on the left with a slight curl at the end, much as she wore it when she was not working. True to the event or not, it handily introduces Garbo's suddenly pushing back her hair and placing her hands on her head in a gesture that rendered the shot justly famous as a totem of glamour, portraiture, and Garbo. Yet it was unlikely to have been prompted by a discussion of her hair, since in the silent era such a dramatic placement of hands was part of the visual repertoire actors used to convey a specific mood. Louise had made a similar photograph the year before when she and Garbo were working on images for *The Divine Woman*, and Clarence Sinclair Bull would record her in a similar fashion the next year. Of course Steichen's superb eye and perfect model were enough; he needn't have come up with a narrative. And yet he could not resist giving himself a little plug at the end of it. "Oh you, you should be a motion picture director," Garbo ostensibly said as she departed. "You understand."[78] If she did say this, it would have been unlike any other comment recorded that she ever made to a virtual stranger.

A stubborn myth in the Garbo filmography asserts that she and Gilbert made a cameo appearance in the William Haines–Josephine Dunn MGM film *A Man's Man*, filmed in the fall of 1928, yet that film too is lost, so we can't be sure. What seems reliable is that footage of the two was included in the film. Its source is in dispute. At least three images, showing Garbo and Gilbert were included in the picture's publicity, and at least one review mentions "a number of scenes at the opening of the picture with thousands of locals standing in line for blocks to get a glimpse of the stars." Garbo and Gilbert are named. But two of the photographs, showing Garbo in a white fur coat and Gilbert in a tuxedo, were taken at the *Flesh and the Devil* premiere in January 1927, one from the newsreel footage and the other a press photograph reproduced in newspapers. A third reveals Garbo with her back to the camera, possibly signing her autograph, while in the foreground Gilbert speaks with Fred Niblo, serving as master of ceremonies and introducing the actors to the assembled fans. That footage is likely what was included in *A Man's Man*, since it makes no sense that Thalberg would place MGM's perhaps single most valuable asset in another actor's film, even one as popular as Billy Haines. And should Thalberg have thought it might be a good idea, Garbo certainly would not have consented, as she was increasingly careful with her screen image and never agreed to any promotional stunts. With no benefit to studio or star, an original cameo can never have been filmed. On the other hand, placing a bit of newsreel footage in *A Man's Man* showing MGM's two top stars being welcomed at a premiere would be good advertising and would not have required Garbo's cooperation.

A Woman of Affairs was popular with audiences and critics, although *Variety* called it "a vague and sterilized version of Michael Arlen's play" but credited "magnificent acting by Greta Garbo, by long odds the best she has ever done."[79] Earl Hudson for *Motion Picture News* gushed, "The only ban possible on 'A Woman of Affairs' is where city ordinances ban standing room in theatres."[80] The film's tragic ending, our heroine's death by suicide, follows the novel on which it was based. In a lovely MGM touch, when Diana's body is found in the roadster wreckage, character actor Hobart Bosworth kisses her hand in farewell, a gesture suited to Garbo's position as studio queen. Audiences did not seem to mind her characters having tragic endings. Anna Karenina also died, as others would in Garbo's later films.

WILD ORCHIDS

Drawing her new weekly salary, Garbo was going to be kept working. Announced soon after *A Woman of Affairs* wrapped late summer was *Heat* (originally called *Tiger Skin*), which went into production in October. Good title, not so shrewd

as an advertising tag, even if "Greta Garbo in *Heat*" could pass the censors. *Wild Orchids* was the innocuous final choice, alluding to the film's setting in Java, where many varieties of orchids are indeed native. Thalberg assigned Sidney Franklin to direct, someone new after Garbo had worked with old friends on her last three pictures. Franklin had collaborated successfully with MGM's other two top female stars, Norma Shearer (*The Actress*) and Marion Davies (*Quality Street* and *Beverly of Graustark*); it was his turn to make a Garbo picture. Swedish compatriot and friend Nils Asther costarred, and the leads were supported by Lewis Stone, who would go on to work with Garbo more than any other actor. Bill Daniels was on the camera, and Adrian, working with Garbo for the second time, now had the chance to create splendid costumes for Garbo, which helped secure his reputation as one of Hollywood's greatest couturiers.

Wild Orchids is another potboiler. Beautiful young woman married to a much older man (Stone) falls for a wealthy handsome younger man (Asther) while sailing from San Francisco to Asia. Garbo and Stone are invited to stay at Asther's sumptuous Indonesian villa, and when the older man retires early, hanky-panky naturally ensues during the wee hours. Asther not only seduces Garbo but gets her to put on an outlandish costume, which Adrian has contrived to suggest and complement the humid, orchid-scented, exotic Asian locale created by MGM top scenic design Cedric Gibbons on the studio's back lot. The authenticity of costume, location, and architecture is of little concern—what matters is the perfect fantasy of a Far East backdrop supporting the romantic antics of the Swedish stars.

Wild Orchids gives audiences a nail-biting ending as the prince almost dies after being mauled by a tiger and (possibly) simultaneously shot by the jealous husband; viewers could decide. Middle-class morality (in exotic upper-class sets and costumes) wins out again, although viewers even back in 1929 must have had a difficult time believing that Garbo would leave the beautiful and virile prince and his magnificent servant-filled palace to return to her elderly, white-haired husband. As compensation, she gave audiences quite an adulterous eyeful for two hours.

After eight films Garbo need not have worried any longer about playing "bad girls," the studio was not going to alter the formula that made sweet music at the box office. Instead she should have worried about portraying exactly the same character type time and again. No matter how successful she was at playing the high priestess in Hollywood's romantic dramas, MGM's films were becoming formulaic. Would fans tire of these variations on a single theme?

No other actress could approach her beauty, and her acting was impeccable. Garbo rarely socialized and had few friends outside the close-knit Scandinavian circle. By her orders sets were closed to visitors. When the Gilbert romance, or whatever it was, cooled off, no other suitors appeared, so fan magazines were left without the most precious copy—whom she was dating this month. Perfect, invisible, and inviolate, Garbo at twenty-three was unique in Hollywood. But

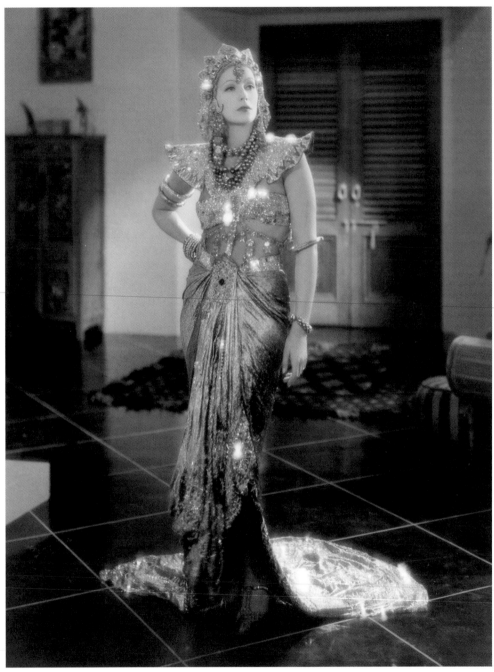

Adrian's magnificent and outlandish costumes for *Wild Orchids* rank among his greatest achievements as a costume designer. Photograph by James Manatt. Courtesy John Kobal Foundation

she was also taking a risk by becoming impenetrably cocooned. Stardom could
go up in smoke if fickle audiences lost interest in her world-weary, self-involved
middle-European ennui.

In the fall of 1928, Garbo might not have cared one way or another, but her
fans did. With each new film released, the latest magazine covers sporting her face
were on display at the newsstands, an avalanche of articles appeared in papers and
magazines around the world, and her fame increased. MGM, like all other studios,
had a large office devoted to receiving, sorting, and "answering" fan mail; Garbo's
numbered thousands of letters a month. Some stars helped respond, others did
not. Joan Crawford personally answered many of her letters and participated in
the small industry servicing her admirers by signing hundreds and finally thou-
sands of photographs to be sent to their mailboxes. Shearer, Davies, and Gish
all agreed occasionally to sign autograph books and photographs, and original
signatures of the three are not particularly hard to find today in the collectibles
market. In the case of Garbo, until her family auctioned her many possessions,
which included hundreds of cancelled signed checks, her signature was among
the rarest autographs and hotly sought after by collectors. Few photos signed by
secretaries survive, and even printed signatures are rare. MGM seems to have
participated from the earliest days in supporting the Garbo mystery, answering
fans' requests by sending off unadorned five by seven photos.

Filmland's press was no less besotted. In the late 1920s, it was common for staff
writers for *Photoplay*, *Motion Picture*, and dozens of other competitors to have
regular access to the studios, productions under way, and their stars. This was free
advertising, and fan magazines were among the top-circulating journals. Writers
were welcome through the gates and accorded special privileges. Garbo, from her
days in New York through 1928, met from time to time with journalists, although
she consented to very few proper interviews. The longest and most reliable was a
conversation she had with Ruth Biery in late 1927 or early 1928 that was published
in *Photoplay* over three issues, from April to June 1928. Margaret Reid, a top writer
for *Picture Play* interviewed Garbo in mid-1928, probably during the filming of
A Woman of Affairs. In an article she published in December, "Greta––As She Is,"
Reid captured her succinctly:

> "Her tastes are simple—for a picture star, exceptionally so . . . She is starkly
> devoid of affectation, being indifferent to opinions, whether good or bad
> . . . Compromise and quibbling are unknown quantities to her . . . Her
> magnetism is remarkable. It is not just a freak of the camera."

The final line might be the most extraordinary tribute ever published about Garbo:

> There are undoubtedly in her undiscovered areas of spirit, back of the
> silence, the stoicism, the reserve. Some day—forgive me if I idealize—the

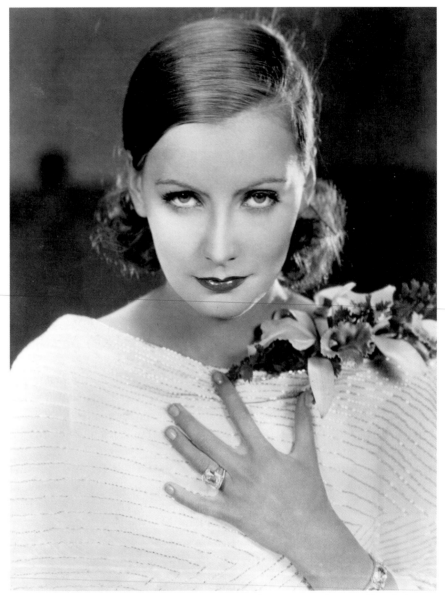

Garbo in a portrait taken by Ruth Harriet Louise to promote the South Seas drama *Wild Orchids*.

right story, the right environment, the right director, will uncover these. And on that day, the movies can lock up their studios and call it a task completed. [81]

Garbo assiduously avoided fans and had as little contact with the press as possible, instead giving full attention to her work. But something happened that had a profound effect on her—on November 8 Mauritz Stiller died in Stockholm of

pleurisy, at the age of forty-five. *Wild Orchids* was nearing completion, and if various published sources are accurate, Garbo received the news by telegram delivered to her either in her dressing room or while working on the set. Nils Asther, who had known Stiller from his early days as an actor in Sweden and had probably been romantically involved with him, gave Garbo friendship and the consolidation of shared sorrow upon hearing the news.

Stiller had spent part of the preceding summer in France hoping to find a cure from the rapidly progressing disease.[82] By fall his condition had deteriorated badly; he was hospitalized five weeks before his death. Victor Seastrom, who advocated for Stiller's American contract, had recently returned to Sweden for a long vacation (after completing *The Divine Woman*, Seastrom directed *Masks of the Devil* with John Gilbert) and to give his children "a real Swedish Christmas celebration."[83] As he later said, "I went to see him every day—but he became more and more weak."[84] The *New York Times* published a short obituary on November 9. No mention of Garbo was made. The New York–based *Jewish Daily Bulletin* ran a notice a week later datelined Stockholm: "Mauritz Stiller, famous motion picture producer and director, died here. A large throng attended the funeral exercises at the Jewish cemetery, where Chief Rabbi Dr. Ehrenpreis eulogized the late Mr. Stiller. Wreaths were laid at the grave on behalf of the American motion picture concerns Metro-Goldwyn-Mayer and Famous Players-Lasky."[85]

Only a year earlier, Stiller's future held promise, and the *Film Spectator*, in October 1927, had rated him fourteenth of sixty in a recap of top box office for directors, polling above Victor Fleming and Josef von Sternberg. Yet the director would soon be forgotten, his contributions to American cinema lost except for his single surviving film, *Hotel Imperial*, starring not Garbo but Pola Negri. His great contribution to the history of film in the end was not his work, however distinguished, but casting Garbo in *Gösta Berlings saga*. Her brilliant light left his talents in the shadow. But if a sun can have an aura, for Garbo it would be him. As she told Rilla Page Palmborg when interviewed on the set of *Wild Orchids*, "I owe all my success to Mr. Stiller."[86]

Enough was enough. Garbo had been in America for three years and four months. She had become a film star. She had also lost her sister and now her trusted friend and mentor. She missed her mother and friends, especially Mimi Pollak. Earlier requests to visit Sweden had been denied. Garbo filed an application to renew her Swedish passport on October 12 and stated her intention to travel to Göteborg in December. This time, holidays looming, she did not even ask permission to leave. The newly launched ocean liner MS *Kungsholm* would make its maiden voyage between Göteborg and New York, leaving Sweden November 24. It was scheduled to return departing New York on Saturday, December 8. Garbo booked passage.

Wild Orchids retakes were scheduled for the first week of December, and Garbo was contractually obligated to appear at the studio. But by Monday,

December 3, she was on the train bound for New York. This was the first time she had left California since she arrived at Union Station in September 1925. How different had been her transit the other way. Now traveling under the pseudonym Miss Alice Smith, Garbo stealthily boarded the train in Los Angeles. When she changed trains in Chicago, she was recognized, and pandemonium ensued. Not wishing to repeat that experience, she got off the second train before reaching New York City, and was able to spend an anonymous day or two before boarding the ship home. Telegrams were sent demanding she return to MGM; all were ignored.

Where Garbo stayed before she departed for Sweden has not been determined, but it might have been at the home of her lawyer Joseph Buhler in Greenwich, Connecticut. Buhler looked out for his increasingly famous client and helped her navigate the complexities brought by her newfound stardom. He did ask Robert Reud to accompany Garbo to the ship and to ensure that she was happily settled in her stateroom. Reud was a New York–based press agent who occasionally did tasks for Buhler, and he was also well known to the MGM press and executive offices in New York.[87]

Of Garbo's previous transatlantic crossing, we know nothing, apart from some mingy anecdotes describing a friendship with a young boy. Her return home had more to it. There was the luxury of the MS *Kungsholm* itself, flagship of the Swedish Line, and fitted out with a dazzling art deco interior, but also many illustrious passengers. Count Folke Bernadotte, cousin to the king, had just married American heiress Estelle Romaine Manville and was traveling home with his new wife and other members of the wedding party, including Sweden's Crown Prince, Gustav Adolf, and Prince Sigvard, his younger brother (whom Garbo danced with one evening).[88] Many candid photographs from the crossing survive, showing Garbo smoking a cigarette or pipe, relaxing with other passengers, and occasionally participating in on-deck activities. Newfound Hollywood motion-picture stardom provided the twenty-three-year-old Garbo an entrée to the most rarefied levels of high society, and she met Count Nils Wachtmeister and his wife Märta (who was known as Hörke), whom she would visit in January at their estate south of Stockholm, Tistad Castle; Hörke Wachtmeister would become one of Garbo's closest friends

The trip was marked by bad weather, and it took eleven days before the ship reached Sweden's west coast.[89] Garbo's closest friend, Mimi Pollak, beginning her own acting career and with many local theater credits, was among those meeting the ship, along with her new husband, Nils Lundell. Garbo's mother, Anna Gustafsson, and her brother, Sven, met the train from Göteborg shortly before it reached Stockholm, and photographs by Bertil Norberg record the joyous reunion. Anna, with her two surviving children grown, had moved out of the family's Blekingegaten apartment and into more commodious quarters, but Garbo leased her own accommodations.

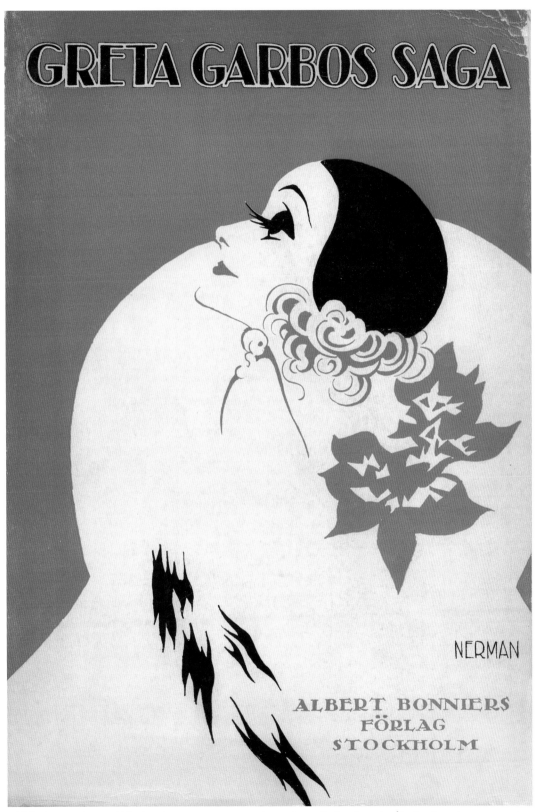

Published in Sweden in 1929 when the actress was twenty-three, *Greta Garbos Saga* by Åke Sundborg has cover art by Einar Nerman.

Greta Garbo

Foto: Metro-Goldwyn

FILMJOURNALEN

Nr 14 Pris 50 öre

Mauritz Stiller was introduced to photographer Arnold Genthe in New York in the summer of 1925, leading to a portrait session with Garbo. (*Filmjournalen*, September 11, 1927)

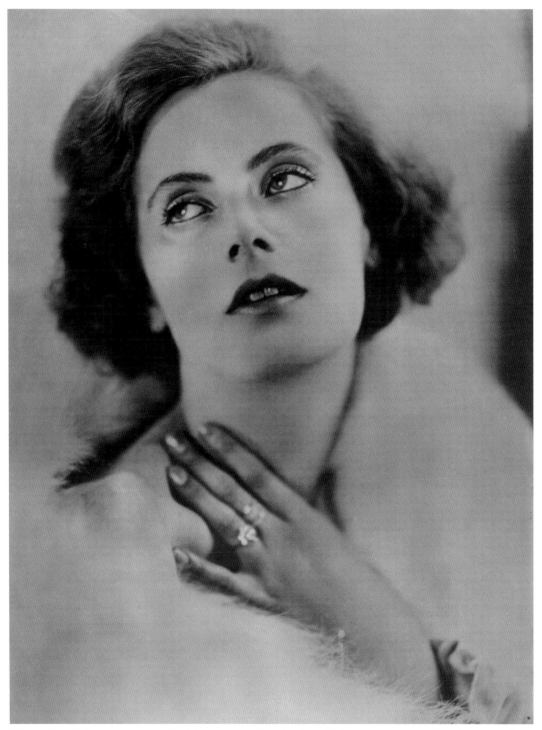

Taken in New York in the summer of 1925, this portrait, attributed to Russell Ball, was among the earliest photographs that MGM distributed of the newly signed actress.

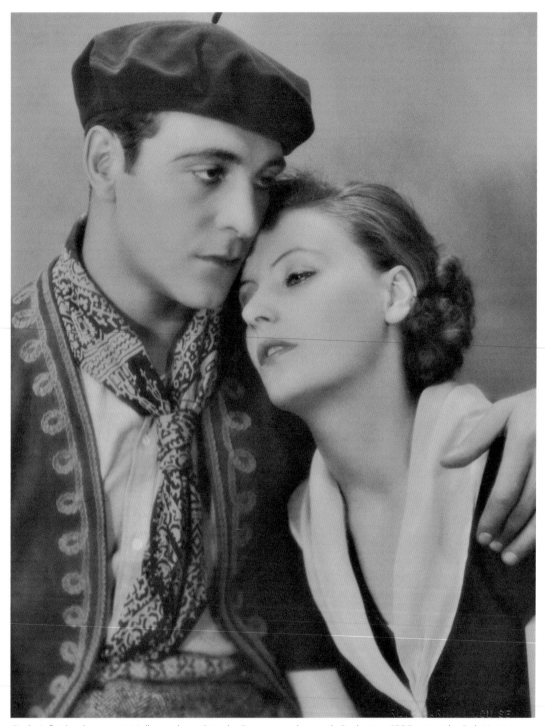

Garbo's first leading man in Hollywood was Ricardo Cortez, seen here with Garbo in a 1925 portrait by Ruth Harriet Louise taken during the production of *Torrent* (1925).

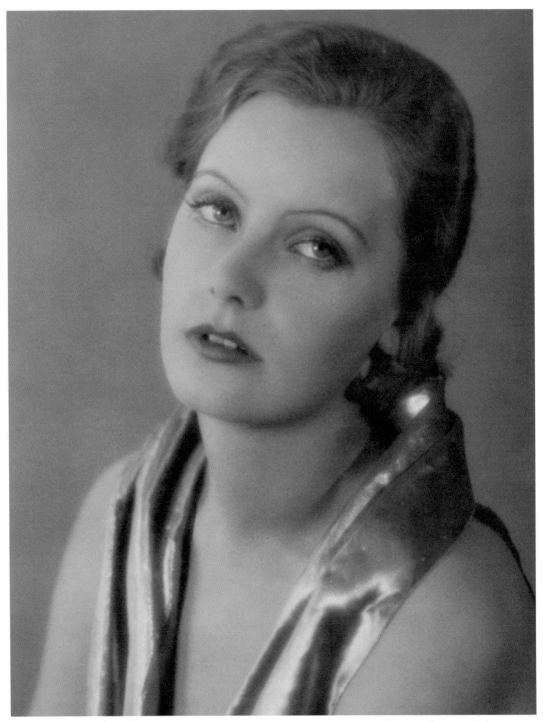

Ruth Harriet Louise helped shape Garbo's screen image in portraits like this one made during the filming of *The Temptress* (1926).

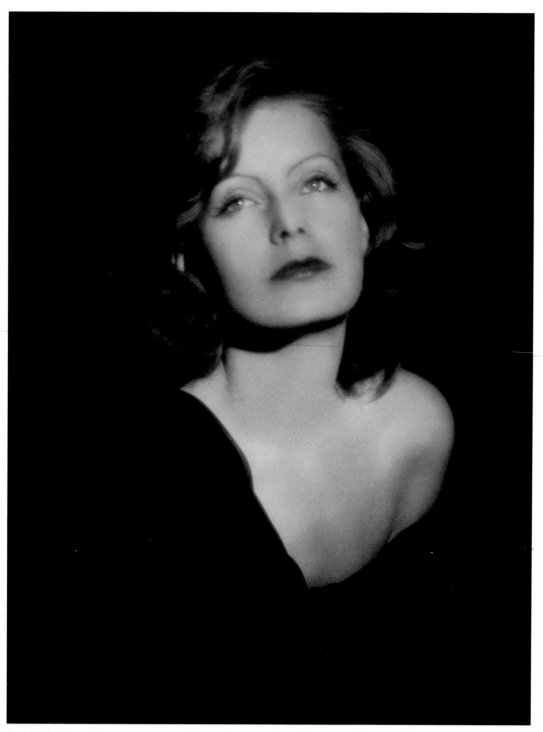

The title, *The Divine Woman*, was more a tribute to the actress than a description of the 1927 film's narrative.

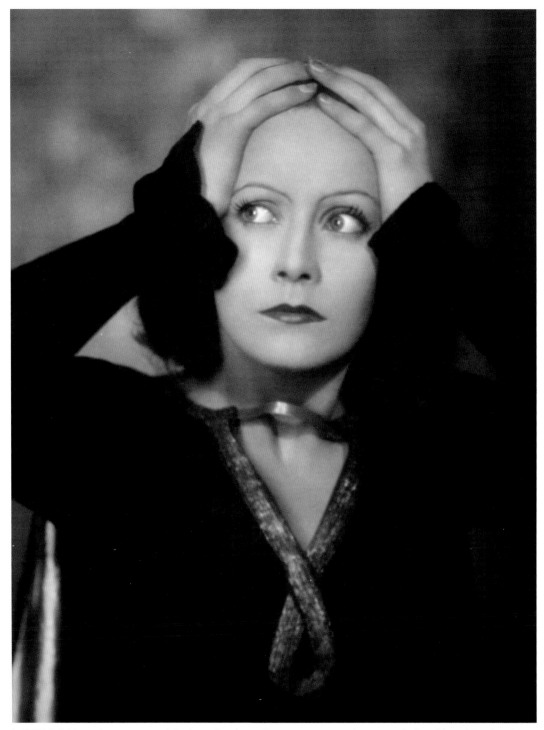

In 1927 Ruth Harriet Louise captured Garbo in this classic dramatic pose more than a year before Edward Steichen shot his famous photograph.

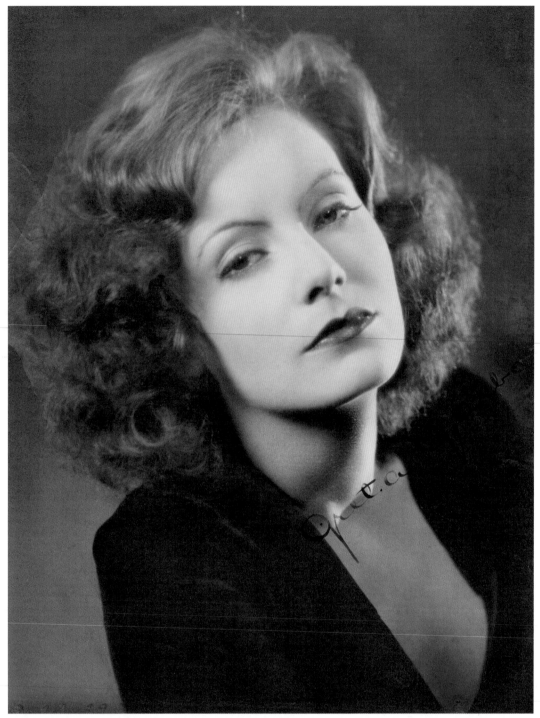

Garbo rarely signed photographs but made an exception in 1928 when she autographed this portrait by Ruth Harriet Louise to her new friend Robert Reud. Photograph courtesy of Jonas Kasteng.

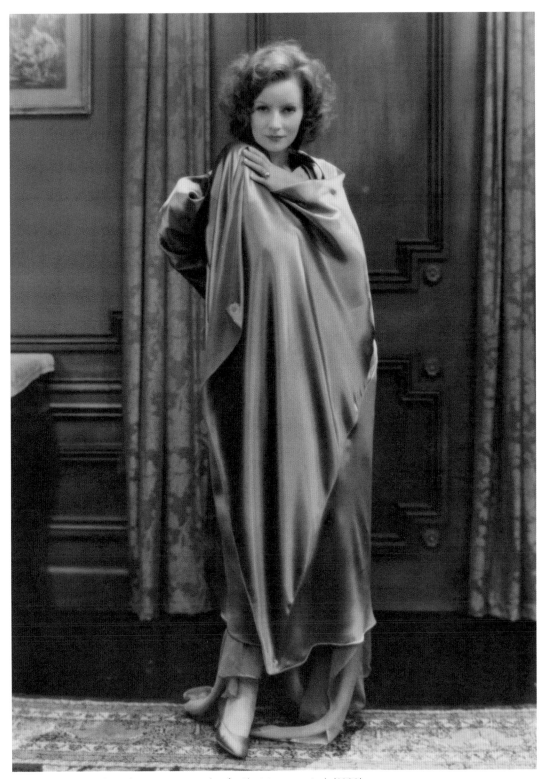

A rare on-set portrait by Ruth Harriet Louise, taken for *The Mysterious Lady* (1928).

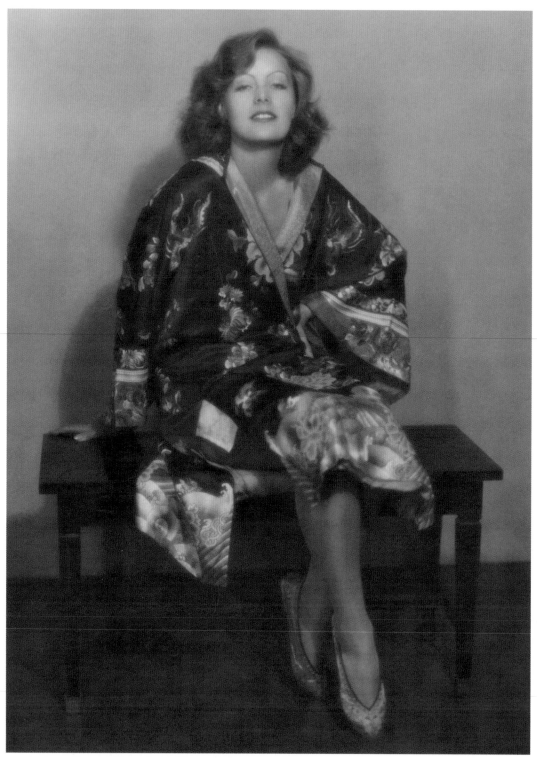

Garbo smiles for Ruth Harriet Louise in this portrait for *The Divine Woman* (1927).

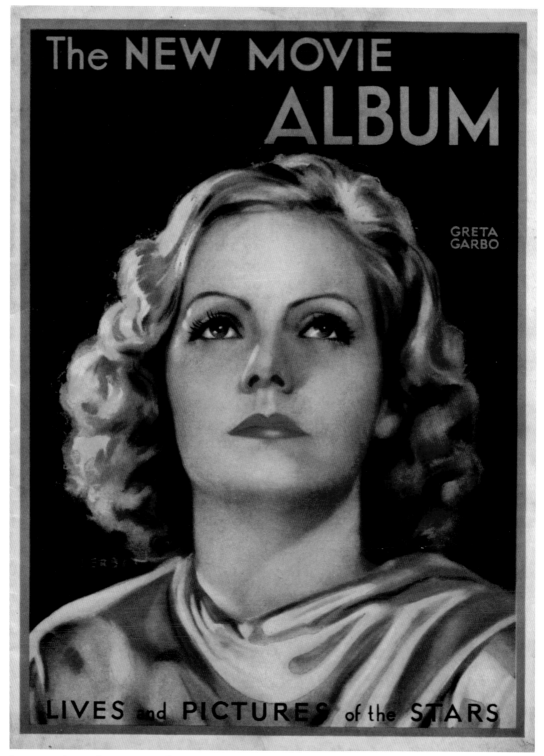

The NEW MOVIE
ALBUM

GRETA
GARBO

LIVES and PICTURES of the STARS

For a special issue of *New Movie Album* (1930), the magazine commissioned a painted cover from artist Julius Erbit that he based on a 1928 photograph by Ruth Harriet Louise.

Garbo poses for Ruth Harriet Louise wearing a pair of elegant pajamas (*A Woman of Affairs*, 1928).

From the beginning of her career, Garbo projected an image as the smart, modern woman. Photograph by Ruth Harriet Louise (1927).

In late 1929 Clarence Sinclair Bull had his first portrait session with Garbo, beginning an almost exclusive collaboration that lasted a dozen years.

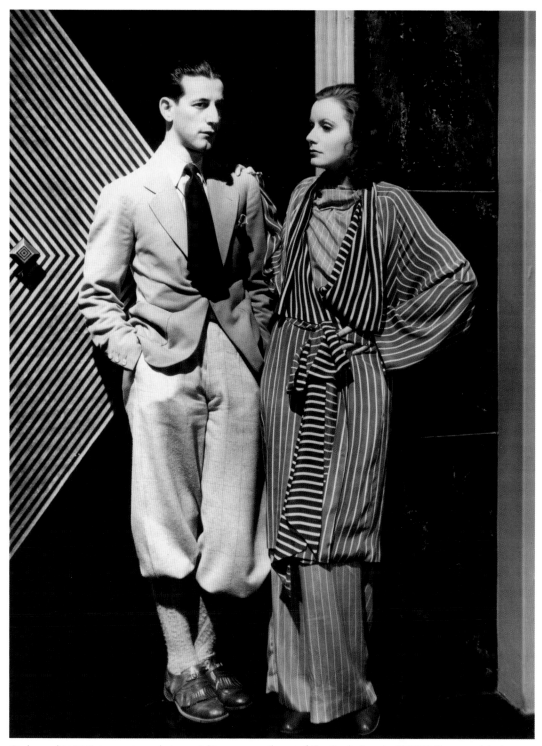

Garbo and MGM's top costume designer, Adrian, pose on the set of *The Single Standard* (1929). Photograph by James Manatt.

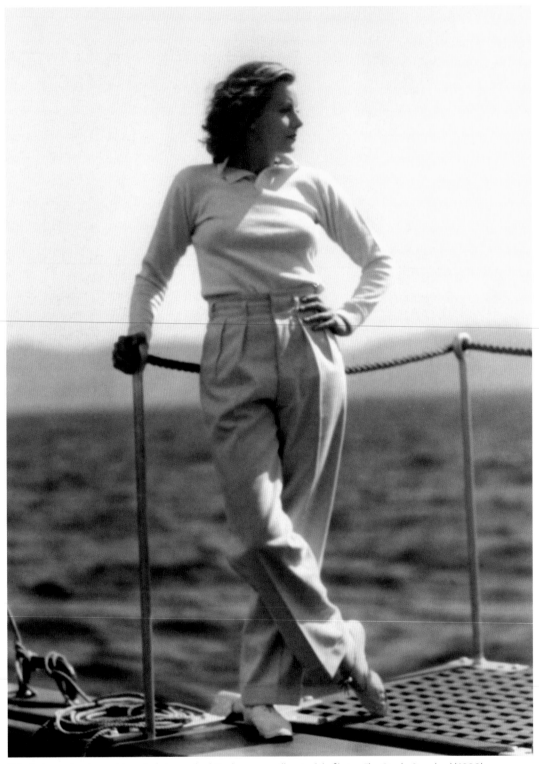

Still photographer James Manatt photographed Garbo on a sailboat while filming *The Single Standard* (1929).

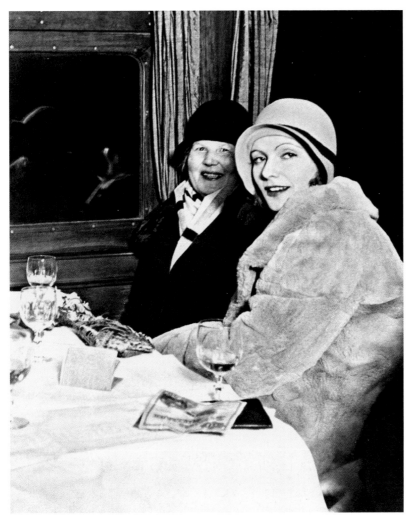

Garbo, making her first trip back home to Sweden in December 1928, is shown here with her mother on the train that carried her from the port at Göteborg to Stockholm. Photograph attributed to Bertil Norberg.

Soon after arriving in Stockholm, she visited Stiller's grave: "I bought a flower arrangement shaped like a cross at a florist's and placed it on his grave. The next day when I visited the grave again someone had torn the arrangement apart and thrown the flowers all over the place. When I asked someone standing nearby what this meant, he explained—what I in my ignorance had not understood—that the cross is a Christian symbol that has no place in Jewish life."[90] In the months after Stiller returned to Stockholm, he had directed the play *Broadway*; it would be his final work. It was still playing when Garbo arrived home, and she likely took in a performance. She also met Stiller's younger brother, Abraham. Garbo biographer Karen Swenson quotes a 1971 interview at which Abraham was asked

about his brother's relationship with Garbo: "'I can only judge by what Greta said to me when we met shortly after Moje's death,' Abraham Stiller replied. After their first meeting, Stiller asked Garbo to put her trust in him and emphasized that he regarded her as a niece. 'I'd rather you said sister-in-law,' Garbo said. And I think that is quite a clear message."[91]

Aside from time with her family and old friends, Garbo socialized with Prince Sigvard and his friend Wilhelm Sörensen, the son of a Swedish industrialist. By New Year's Eve the three were seen together at clubs, cafés, and the theater. When she visited Hörke Wachtmeister at her country estate, it was said she was among the gayest of the crowd that gathered around the count's dinner table, and one guest recalled: "After dinner all guests were supposed to put on a little individual performance. I remember Garbo sang an American cowboy song. She did it very cleverly."[92] How different this sounds from most descriptions of Garbo's social life during her three years in America. But in her typical Hollywood fashion, she continued not to grant interviews, which made the Swedish press as ravenous as the American to find out anything they could about her.

Back in Los Angeles, MGM was in turmoil. On December 19 *Variety* headlined just after Garbo's ship docked at Göteborg, "Louis Mayer Leaving M-G-M in March."[93] Although in the end Mayer stayed, a change in leadership was momentarily a distinct possibility during a tumultuous time in the young studio's history following the death the previous year of Marcus Loew, president and principal stockholder of MGM's parent. During 1928, lawyers for the Loew estate sought a buyer for Mrs. Lowe's four million shares valued at $50 million. William Fox hoped to purchase them, and others available on the open market, in order to take control of Loew's (incorporating MGM) and combine it with Fox Pictures, thus creating the biggest studio in Hollywood and a theater chain rivaling Paramount's. Meanwhile, Nicholas Schenck, Loew's deputy in New York, became president of the parent company. Although Mayer ruled as almighty in Culver City, he was only a vice president of Loew's and reported to Schenck. The *Variety* writer mentioned briefly that Fox had yet to conclude any deal about purchasing the Loew's shares. This was not true, and when Mayer realized that he might be working for a competitor, his announcement to retire was a warning shot across the bow of the MGM mothership in New York. He would not work for Fox.

Schenck and Mayer never seemed to have liked each other, but with Schenck minding the theater empire in New York and handling the banks, leaving Mayer in charge of motion picture production, they operated well together until John Gilbert's contract was up for renewal. In September it was announced that Gilbert was being courted by Joseph Kennedy for his newly formed studio, RKO.[94] Gilbert also considered joining United Artists. Finally, in late October, Gilbert's agent Harry Edington notified the press that a deal had been reached keeping the great star a part of the MGM family at one of Hollywood's highest salaries, $250,000 per picture. This deal was brokered by Schenck in New York and not Mayer, who

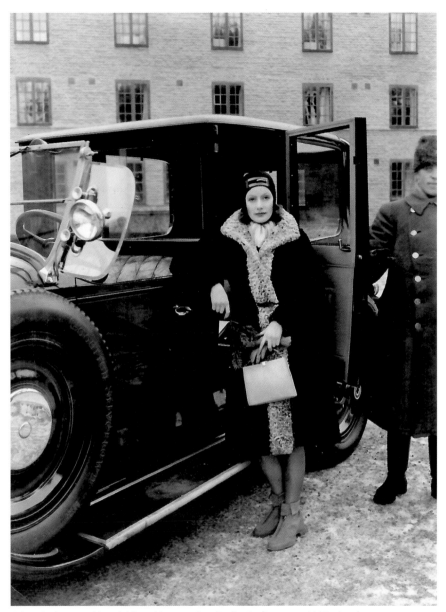

When Garbo visited her childhood home in Sweden for the first time in 1928 after three years in America, her status had changed from ingénue to star, and now she now traveled by a chauffeur-driven limousine.

typically handled the star contracts, and who had a longtime antipathy for Gilbert. Schenck had taken control of the negotiations, as he needed to deliver a signed Gilbert contract as part of the proposed deal with Fox. Mayer was dealt a double blow. He learned that Schenck was part of the deal to sell Loew's to Fox and that, regardless of the outcome, Gilbert would retain his position as MGM's top male star.

Gilbert's return helped ensure stability among the star ranks at MGM; so too was there little change among the women during Garbo's first three years at MGM. Marion Davies and Norma Shearer continued as top female stars, and Lillian Gish, who arrived at the studio shortly after Garbo, was in the midst of a lucrative multipicture deal (although the release of *The Wind* in late November 1928 would turn out to be her last for the studio). Shearer married Irving Thalberg in the fall of 1927, and from that moment forward her career was carefully managed and she had her choice of roles, but she never approached Garbo in popularity. She was, however, the first of MGM's female stars to make a talking picture, which was released to acclaim in the summer of 1929. Davies, after a brilliant success in the 1928 comedy *Show People*, was generally kept to costume dramas that were not particularly successful at the box office. Her relationship with William Randolph Hearst, and his close connection to MGM through both Cosmopolitan Pictures and his newspaper empire, made her immune, for a time, from box office considerations. Mayer also looked to younger and fresher talent, and he found it spectacularly with Joan Crawford, who joined MGM in January 1925 and by the end of her first year showed real promise. By the end of 1927, announcements in the trade papers began to suggest that Crawford's ascent to stardom was imminent. In October 1928 her studio made it official: "Metro-Goldwyn-Mayer have great plans for Joan Crawford. The first and foremost is a starring contract starting immediately. They are now looking for a story for her first starring vehicle."[95] The film was *Our Modern Maidens*, and it ushered in a legendary motion picture career spanning thirty years. Its title was indicative of the sorts of films MGM was promoting to the public, especially women. Soon sound would radically change Hollywood. Not only would film players be expected to speak, but new character types would be demanded by audiences: more natural, and more American, more like Crawford.

We do not know what Garbo thought about the possible corporate changes brewing at MGM, or whether or not she had an opinion about Gilbert remaining at MGM. No mention had been made in the press about her appearing in talking pictures, although Shearer's upcoming debut foretold that Garbo would be asked to speak, sooner or later.

After four months away, it was time to return to Hollywood. Almost a minute of newsreel footage survives showing Garbo departing Sweden for New York in March 1929 on the SS *Drottingholm*, the beginning of the long journey back to work. Wearing a fur coat and cloche hat, Garbo is obviously crying and dabs her eyes with a handkerchief. In Hollywood, Garbo had remained somewhat immune from the intrusive attentions of the press. Yes, she had been obligated to speak on occasion with fan magazine writers. And she was bothered by members of the press on her journey to New York. But in Sweden, and now on her way back to work, Garbo learned that she had entered the realm of the public figure. Even so private and intimate a moment as saying goodbye to friends and family was

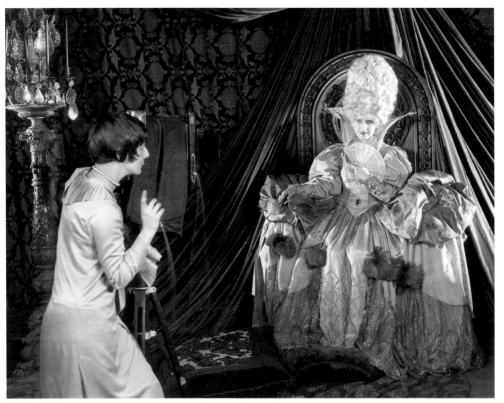

Norma Shearer joined MGM in 1924 and three years later married production chief Irving Thalberg. Ruth Harriet Louise photographs her on the set of *Upstage* (1926). Courtesy John Kobal Foundation

now a newsworthy event. "Everyone in Gothenburg apparently wanted to have one last look at the movie actress," wrote Palmborg, describing Garbo's departure. "Hours before the boat was due to sail the pier was packed with people. When Garbo and her friends went onboard, even the decks of the boat were thronged."[96] Garbo found herself utterly vulnerable. In the future she would devise strategies to avoid confronting the press's prying questions and flashing bulbs, and to become invisible to the watchful eyes of a public that she came to loathe. She believed her job was to make motion pictures, not to be a circus pony parading for the delight of fans. Many of her peers seemed to thrive on this adulation: Chaplin and Fairbanks certainly, and to a lesser degree Swanson and Pickford. Candid shots of movie stars traveling became a staple of fan magazines and newspapers, and by the early 1930s, top players were obligated to make public appearances promoting new films. Not Garbo. She was traumatized on this first trip home and became even more firmly set against having any contact whatsoever with the press or her public.

She could not, however, avoid the MGM brass. Garbo's lawyer Joseph Buhler innocently arranged to have Robert Reud meet Garbo at the dock in New York.

Joan Crawford joined MGM eight months before Garbo and had to prove herself in a series of small parts before finally landing a leading role in *Sally, Irene and Mary* (1925). Three years later MGM would anoint her a star. Photograph by George Hurrell (1933).

When Edington discovered this arrangement, he sent a pointed telegram to Reud: "[I] would not want you to do anything that would in any way interfere with Mr. Schenck's plans for meeting [Garbo] and taking care of her in New York."[97] Garbo was now too big to be left to lawyers and press agents. Only the top brass would do, whether she liked it or not. Reud was welcome, but only as a junior member of the welcoming party. Still, he got the prize at the end. Following Buhler's request that he make himself available to attend to Garbo's needs while in New York, Reud proved indispensable, and quickly the two became friends. She even broke a rule and autographed a photo the day she left for California.

Hubert Voight, the MGM publicist, was also at the pier. In his 1934 article for *New Movie Magazine*, he recounts how different her arrival was compared to the summer of 1925. Schenck "bought her a huge bouquet of flowers and trotted alongside like a schoolboy." Voight also recalls giving a dock pass to a ten-year-old girl who had made a scrapbook filled with Garbo's photos and press clippings. "The little kid gazed frantically at me, then at Schenck and then at Garbo . . . she fell in a dead faint on the concrete . . . the thrill was too much for her." Of course in Voight's telling the girl woke up just in time to get Garbo's autograph.[98] Did

this actually happen, or was it a fiction designed to humanize MGM's famously aloof property?

Voight did manage to get Garbo to sit for an interview with Mordaunt Hall of the *New York Times*. "That languid screen enchantress, Greta Garbo, was at the Hotel Marquery, Park Avenue," he wrote on March 24. "She wore a pink silk sweater with a short black velvet shirt, and coils of smoke rose to the ceiling from the cigarette she held in her long fingers." As to future projects:

> She puffed her cigarette, threw her head back, lowered her eyelids and vouchsafed: "Joan of Arc. But it probably wouldn't go so well. I would like to do something unusual, something that has not been done. I would like to get away from the usual . . . If I could get von Stroheim! Isn't he fine?" . . . When she was asked whether many people recognize her in this city, she replied, as she has a habit of doing to other questions: "I don't know." What did she do on her first evening in New York? She had dinner alone. All alone? "Yes, quite alone, and I loved to look at the—what you call—shyscrapers—No, what is it? Yes, skyscrapers." This would be hermit admits she knows very few people in Hollywood . . . Then the conversation turned to talking films, and Miss Garbo said: "If they want me to talk I'll talk. I'd love to act in a talking picture when they are better, but the ones I have seen are awful."

GARBO'S LAST SILENT PICTURES: *THE SINGLE STANDARD* AND *THE KISS*

Garbo's next film was being readied as she traveled by train back to Los Angeles. It was not a talking picture but another silent, *The Single Standard*, based on a novel by Adela Rogers St. Johns, who also had a good reputation as a reporter (both press and Hollywood) and as a screenwriter. And it was not "something unusual" but another romantic escapade, directed by John Robertson. Oliver Marsh, who had photographed *The Divine Woman*, was back behind the camera. Josephine Lovett, married to Robertson, adapted the novel for the screen.

Costarring were Nils Asther and Johnny Mack Brown. Garbo and Asther had probably become acquainted in Sweden and continued a friendship in America. During the production of *The Single Standard*, Asther rented a cabin at Lake Arrowhead ninety miles east of Culver City in the San Bernardino Mountains, where they spent a weekend. Both actors had been mentored by Stiller, which gave them a strong common bond, but otherwise the two had a complicated relationship. Although there is no evidence of a romance, Asther did claim to have asked Garbo to marry him, perhaps figuring that such a union would be useful to both. Garbo declined, and although they never worked together again,

the two remained friends. When Garbo's estate was auctioned off in New York in November 1990, among the contents was a painting by Asther that she had kept for many years. Titled *Platonic Love*, it depicted two elephants embracing.

The Single Standard is set in San Francisco and is the rare MGM romance from the 1920s to make extensive use of scenes filmed outdoors. Garbo plays Arden Stuart, a young woman who does not agree with the sexual double standard and embarks on a series of love affairs. The first is with her family's handsome chauffeur, played by Fred Sohm (also known as Robert Castle), who turns out to be a war hero and British aristocrat, but Garbo's character is unimpressed and the rejected lord commits suicide. She then takes up with an artist, Nils Asther, and they embark on a long windjammer voyage (filmed around Catalina). Marsh takes advantage of the brilliant natural light and wonderfully captures his gleaming Scandinavian stars on their idyllic journey (MGM publicity claimed that the two stars had such rich tans that no makeup was necessary). Two premarital affairs were two more than the censors would accept without a conventional marriage blessed by a child, so Johnny Mack Brown takes on the thankless role of the dull but presentable man who saves Arden from the ignominy of fornication. At the end she is tempted to return to the salt air and passionate embraces promised by Asther, but a glimpse of her young son in the final scene is enough to turn her back to her family.

The Single Standard's script was subtly shaped so that Garbo's character appears a bit more positive than the louche ladies of *Wild Orchids* and *A Woman of Affairs*. And, for the first time on-screen, she portrays an American character rather than an exotic foreigner. Although Arden Stuart—in typical Garbo casting—is promiscuous, the tone is markedly different from her earlier films. Yes, her chauffeur falls in love with her, and after some pretty heady lovemaking she casts him aside. Asther is her second conquest, and this time she is seen to be the aggressor; she's devastated when he leaves her, not for another woman (impossible) but for the freedom to sail off and pursue his art and travel unattached. When she enters into a loveless marriage—also typical—the script asks her to be both a loving wife and mother to a small boy. In a scene of supposed intimate domestic bliss, the child is depicted being cheerfully tossed back and forth by Arden and her husband. It does not ring true, and Garbo as a mother was not a successful film formula. She would play a mother only twice again in her career: in 1935 she remade *Anna Karenina*, and in *Conquest* (1938) she portrayed the historical character Maria Walewska, who has a son with Napoleon. Both children are necessary to the film's plots. Garbo never played mother to a daughter.

Nor did she ever marry John Gilbert, although he asked her many times. Reports of telephone calls during the European sojourn, and as soon as she returned to New York, were avidly printed in the press. Gilbert met Garbo at the station when she arrived back from Europe. His pursuit had been insistent but unsuccessful. All evidence suggests she cared deeply for Gilbert, but marriage

Garbo and her *The Single Standard* costar Nils Asther both got their start in the movies in Sweden under the direction of Mauritz Stiller. Asther came to Hollywood in 1927 and almost immediately achieved leading man status at MGM. Photograph by James Manatt.

was not a union she wanted. Garbo had probably gotten what she needed from their relationship during her strike in the winter of 1927, when Gilbert provided her good advice, a top agent, and sanctuary.

By the time Garbo returned to Hollywood, actress Ina Claire had transplanted herself from the New York theater world and was starring in *The Awful Truth* for Pathé along with Henry Daniell, the two playing in a now-lost film that would become immortalized eight years later in a remake headed by Irene Dunne and Cary Grant. Claire and Gilbert met in April 1929, and a few weeks later, on May 9, they married in Las Vegas. "Mr. Gilbert and his bride arrived in a special car after an all-night trip from Hollywood, Cal.," reported the *New York Times*, "and immediately motored up the dusty main street to the little courthouse where almost the entire populace had gathered . . . Las Vegas was chosen for the wedding, the couple said, to avoid the three-day wait imposed by California law in obtaining a marriage license."[99] Claire was one of Broadway's most popular and successful performers but did not have the same luck on film, despite being part of the first wave of stage stars to be recruited west for taking pictures. Success on stage, a new motion picture, and marriage to Gilbert all contributed to her rising fame, and she was featured on the cover of *Time* magazine that September 30. The

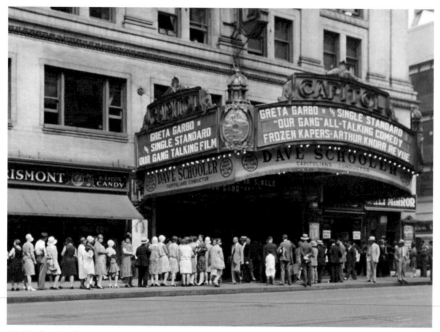

Well before the first morning screening of *The Single Standard* at The Capitol, Loew's flagship theater in New York, a line of anxious Garbo fans was already beginning to form. Photograph by Percy Loomis Sperr.

union would not last, and Claire retrieved her successful career back East. In a coincidence worthy of a movie script, one of her later, rare film appearances was an important featured role in Garbo's *Ninotchka* of 1939.

Filming of *The Single Standard* completed in early June 1929, and MGM had it in theaters at the end of July. Reviews were good and it made money for MGM. *Variety* summed up pretty succinctly both the film and Garbo's ongoing appeal, "What some girls do today, and a lot more would like to, Greta Garbo does in 'The Single Standard.'"[100]

The increasing popularity of talking pictures notwithstanding, Garbo still filled houses. The film did not have any spoken sequences, but a synchronized score was included with some music and sound effects. "Advertising and exploitation" material sent ahead to prospective theaters promised "Sound or Silent" and assured theater owners and operators that either version could be accommodated. A press photograph dated July 30 shows a long line forming outside the Capitol Theatre in New York in anticipation of the film's first showing of the day.

Why did MGM immediately rush Garbo into another silent film? Was it the financial decision of a studio worried about a prized investment? Was Garbo resistant to making the switch? Or was the wait necessary until a suitable talking project was readied? Whatever the reason, Garbo was among the last of the silent stars to speak on film, and *The Kiss* would be the final silent feature released by MGM. Belgian Jacques Feyder, who had been directing in France, sailed to New

York in January 1929 and by March was listed among the roster of MGM directors. Although the screenplay is credited to George M. Saville, the story, originally titled *Jealousy*, was actually by Feyder, who asked to use a pseudonym to avoid two screen credits.[101] Shooting began in mid-July. Garbo plays Irene, a beautiful young French woman married to a much older man, who has an affair with André, a handsome lawyer (Conrad Nagel). A still younger man, Pierre (Lew Ayres, in his first important screen role), has a fancy for Irene and becomes obsessed with her. As she attempts to smother his ardor, she grants him one kiss—but suddenly her husband appears. In a violent rage, he tries to kill Pierre, who is saved when Irene shoots her husband—accidently? deliberately?—with his own pistol. Irene stages the death scene to make it look like a suicide. André defends Irene and she is acquitted. But in the end, she confesses all to him, and a final kiss promises that they will live happily ever after.

Pretty much the same old story—woman married to an older man with one or more younger lovers—is saved by Feyder's elegant direction. Cedric Gibbons's sets evoke the self-conscious flair of upper-class Paris interiors in the late 1920s. Cinematographer Daniels gives the courtroom scenes a slightly film noir quality. The sumptuously streamlined sets and the intense brooding shadows serve Garbo artfully, and *The Kiss* became the only MGM film that evokes the atmosphere of her European work of just four years previously.

But if the film's style is more Berlin than Culver City, Garbo had become an authentic American motion picture studio product. Her looks and her movement were all refined in the MGM cocoon. Makeup, hair, and wardrobe, and the glamorous countenance projected around the world, were all products of the studio system of the late 1920s. Though she might have owed her career to Stiller, Garbo's legend was made in Hollywood.

Contributing to the sustenance of that legend was the brilliant service MGM publicity gave their now most important star. On the one hand, Pete Smith and his able team, including Howard Strickling, left Garbo alone. No call was made on her time other than making films. She did not greet the president, or Lindbergh, or invite cameras into her kitchen. No photographs exist of Garbo at night clubs or playing games at an MGM picnic. The single critical exception was the time she spent in the portrait gallery. Official studio portraits, created to promote each new film, were valued commodities in Hollywood. Printed on heavy paper in a large 11x14 inch size, they heralded an upcoming release, promoted the stars themselves, and advanced the studio brand. In the 1920s and 1930s, a chief goal of the publicity departments was to land stars and upcoming prospects, particularly women, on the covers of fan magazines, especially the grandest: *Photoplay, Motion Picture, Picture Play,* and *Screenland*—all of which had strong circulations among an avid readership. Portraits were also sent to newspapers, used for theater promotions, and distributed widely, generally by mail, by the tens of thousands and in smaller formats (8x10, 5x7) to fans. Garbo was probably the top cover subject

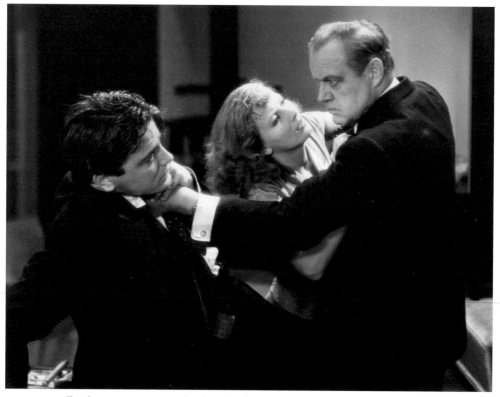

The climactic moment in Garbo's last silent film, *The Kiss*, was when her husband found her in the arms of youthful Lew Ayres (left), who had asked to claim a chaste kiss. Photograph by Milton Brown.

from mid-1927 until the mid-1930s; when *Silver Screen* debuted in November 1930, Garbo was featured. Although nearly all of the magazines had colorful painted covers, described as "from life," most of them derived from photographs. Typically, fan magazines wanted exclusive images, to avoid duplication from one magazine to the next, although plenty of portraits are found on more than one magazine across a period of years. In Garbo's case two photographs taken by Russell Ball in 1927 formed the basis of dozens of covers in both the top-line magazines and in lesser journals.

Ruth Harriet Louise provided the majority of Garbo's photographs that were translated to covers or sent to fans. They had worked together from September 1925 on every Garbo picture, nine in all, through *The Single Standard*. Louise had, as much as any cinematographer or director, helped craft Garbo's face and image. In June 1929 the two met together for the last time. When called for portraits for *The Kiss* on August 27, Garbo went to the studio of Clarence Sinclair Bull.

Bull directed MGM's large staff of still photographers but found time occasionally to shoot portraits. As Louise had helped shape the Garbo legend in the early part of the actress's American career, Bull would be responsible for recording the inviolate Garbo, "the Swedish Sphinx" as she was described by journalists

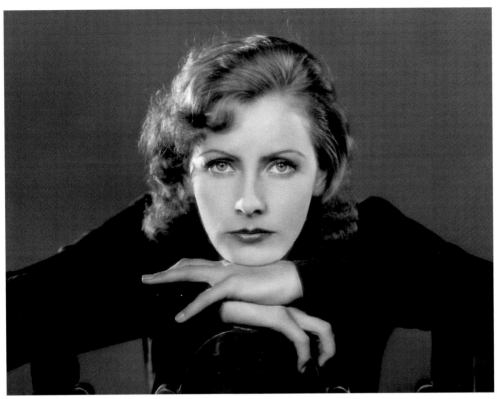

Clarence Sinclair Bull and Garbo had their first formal portrait session together for *The Kiss* in October 1929. Courtesy John Kobal Foundation

beginning in 1929.[102] For those first three and a half years, Garbo's portraits reveal a sensitivity and tenderness that almost completely disappear in front of Bull's camera. Make no mistake, Bull's photographs are masterful, and they are the principal images that, almost a century later, still define the face of Garbo. What photographer and subject created during the 1930s are not merely portraits of a woman, but emblems of stardom.

That first session must have been an extraordinary workday, given the spectacular results. Half or more of the day was devoted to portraits of Garbo alone. As Bull wrote in his memoirs: "For over three hours I shot her in every pose and emotion that beautiful face could mirror. Actually I had no control over myself and I wondered when she might say she'd had too much. She said nothing so I kept on shooting. Finally I ran out of film . . . There had been no break. She hadn't asked for even a glass of water."[103] Bull had photographed Garbo at least one time previously, on the set of *Love* with Gilbert. He might also have been among the many who shot off-set photographs of her in costume for *The Temptress*, although none stamped with his signature have been identified.

"Photographing Garbo" was the title of an article appearing in *Movie Mirror* in 1932. She made "no secret of the fact that she doesn't like that day in the portrait

gallery. But, like everything else in movie-making, it's just another thing to be done, so Garbo does it." The writer also noticed that when photographed, "she's always in character or mood—but never Garbo." Bull himself learned after several sessions with her that "she can 'feel' light! . . . She can actually sense when her face is properly lighted for a shot."[104]

During the afternoon of *The Kiss* session, Garbo agreed to pose for photographs with other cast members that would serve as the basis for poster art. She had done this earlier for *The Temptress, Flesh and the Devil*, and *The Divine Woman*. Typically scene stills provided the "action" shots that could be translated to lobby cards and posters, but on occasion the publicity department requested additional images with a specific compositional narrative. Photographs taken by Bull show Garbo acting out tableaux of the film's murder scene with Randolf and Ayres.

Had these sorts of images been necessary for *Mysterious Lady, A Woman of Affairs*, or *Wild Orchids*, Garbo's double would have stepped in. In the late twenties, Garbo look-alike Geraldine Dvorak served this role, spending hours patiently miming the actress's screen movements and waiting as lights were set, ensuring that all was ready when Garbo arrived on the set.[105] Dvorak was spotted in the rank of extras, and her resemblance to Garbo, both face and body type, brought her to this curious role. At first it was unrewarded apart from a forty-dollar-a-week paycheck and glancing access to Garbo, whom she must have regularly passed leaving the film set as Garbo entered. Filmland journalist Lois Shirley, writing in *Photoplay* (August 1929), could not resist poking fun at both star and double. Describing Garbo:

Her dislike of grandeur amounts to a passion . . . A publicity man's camera is a red signal for flight . . . The paraphernalia of stardom is anathema to Garbo . . . Stardom bores her, so she leaves her glittering, dazzling, successful garments at the studio.

And Dvorak:

And there Geraldine De Vorak [*sic*] finds them and puts them on . . . It is Geraldine's delight to be mistaken for the star . . . In order to supplement her meagre income Geraldine is one of the regular models at [Cafe] Montmartre on Wednesday. As she arrives and leaves the sight-seers mistake her for Garbo.

Dvorak enjoyed these instances of celebrity, but she flew too close to the sun and decided that if she could invent Garbo's social life, she could also emulate her working habits, arriving and leaving the studio as it suited her. "Geraldine's slight contract was broken. She returned to the extra ranks."[106]

Garbo did agree to a special portrait session with another famous New York photographer, as she had the year before with Steichen. Nickolas Muray visited Los Angeles for *Vanity Fair* in the summer of 1929. Hungarian born, he not only was a dashing New York camera artist but represented the United States in fencing at the 1928 and 1932 Olympics. Muray's chief goal was to return to New York with portraits of Garbo, but he also caught Joan Crawford and Douglas Fairbanks Jr. at the beach, Norma Shearer, Myrna Loy, and Mary Pickford and Douglas Fairbanks on the set of their first talkie, *The Taming of the Shrew*. *Vanity Fair* continued to be a perfect gauge of stardom, promoting those at the top of their profession, welcoming Crawford to the top ranks, and announcing a performer like Loy who was about to achieve frontline success.

Muray kept careful notes of his portrait sittings, including his single encounter with Garbo.

I asked that she wear a décolleté evening gown, because what I had in mind for the full page was a close-up, with just head and shoulders . . . [Howard Strickling] told me that their experience with her for publicity shots was difficult—not that she was temperamental, but she was unpredictable. Sometimes she would sit for one or two exposures and walk off the set without saying a word. Perhaps she might not show up at all . . . An hour passed before she arrived, dressed in a man's shirt, tie and jacket, and a beret . . . We got to work and I took about a dozen shots, with and without the beret, with and without the jacket, with and without the tie. Then I asked her if she would slip the shirt down a bit so that we could get a close-up of just head and shoulders. With complete cooperation she took off the shirt altogether.[107]

Of course Muray never took that photograph.

Vanity Fair declined to use any of Muray's Garbo photographs and continued to publish Steichen's portraits into the 1930s. Steichen, in his leading role at Condé Nast, may have decided that he alone should represent Garbo to the magazine's readership. In the October 1929 issue, his now-classic Garbo photograph graced a full page along with Muray's double portrait of Crawford and Fairbanks. At least seven photos from Muray's session with Garbo can be identified today. Four were reproduced over two pages in *Screenland* (February 1930) in an elegant spread titled, "Garbo Glamour." In later years Muray, unlike Genthe and Steichen, seems never to have marketed these pictures, and to this day they are rarely reproduced, though as images of Garbo they can stand proudly alongside Steichen's and Genthe's seminal work.

"Speech is silver—but GRETA GARBO is Golden!" So read an ad presented by MGM in the summer of 1929 as *The Kiss* was in production. Golden though she might be at the box office, her days as a silent actress were coming to an end. The studios frantically converted stages to sound production, which meant they

Nickolas Muray photographed Garbo at MGM during the summer of 1929 on assignment from *Vanity Fair*. Although marvelous portraits were taken, none were used by the magazine. In 1930 *Screenland* (February 1930) printed a selection.

all had to be soundproof—1929 was a year in which the racket of hammering must have been unceasing.

MGM was committed to a long-term contract with Garbo, now paying her $4,000 each week. The studio had recently signed an equally lavish deal with Gilbert, who like Garbo went blithely untested in sound. Gilbert was cast in the all-star talkie *Hollywood Review of 1929*, which premiered in late June 1929. Nearly the entire MGM star register had a few moments of screen time. Joan Crawford sang and danced, and came off pretty well. Marie Dressler and Laurel and Hardy

had small bits, and even (game) Marion Davies and (churlish) Buster Keaton were forced to sing in the chorus, or at least give a try at mouthing the words to *Singin' in the Rain*. Only Garbo and Lon Chaney were excused from participating. Gilbert was given the relatively easy task of performing a scene from *Romeo and Juliet* with Norma Shearer. They began the famous balcony scene speaking in Shakespearean English, which soon evolved into a colloquial American dialect. Both stars in this silly sequence manage to retain their dignity and reveal good speaking voices that augured success in the transition to sound.

But something unexpected happened to the actor now being paid $250,000 per film when his first real taking picture, ironically titled, *His Glorious Night*, was released. So confident was Thalberg in Gilbert's promise for success that the producer costarred him with unknown Catherine Dale Owen, who was making her motion picture debut. And as director he engaged Lionel Barrymore, best known as an actor, who had not directed a picture in more than a decade and had no experience with the new technology. On opening night, September 28, 1929, the soaring career of Hollywood's greatest romantic male star hit turbulence, and what at first might have seemed merely a small bump ultimately doomed Gilbert's seemingly unassailable position at the pinnacle of filmdom's star hierarchy. *Variety* waited two weeks to publish: "A few more talker productions like this and John Gilbert will be able to trade places with Harry Langdon. His prowess at love making, which has held the stenoes breathless, takes on a comedy aspect in 'His Glorious Night' that gets the gum chewers tittering at first and then laughing outright at the very false ring of a couple of 'I Love You' phrases."[108] Even the fan magazines, generally kind to stars, took notice. One of that industry's top editors, Frederick James Smith, writing for *New Movie Magazine*, said frankly, "Jack Gilbert made a disastrous start as a talking actor in 'His Glorious Night.' The general critical theory seems to be that Jack's voice is microphonically wrong."[109]

Thalberg had waited as long as he could. It was now time to put Garbo in a talking picture. For months the discussions had centered on casting her as the title character in a film version of Eugene O'Neill's 1922 play *Anna Christie*. Anna is a Swedish immigrant to America (Minnesota), and the story follows her visit to her father in New York. The first challenge of voice was mitigated by having Garbo portray an authentically Swedish character. Audiences would decide if they would accept her as a talkie star.

CHAPTER FIVE

Sound

ANNA CHRISTIE

AMONG HER MGM COLLEAGUES, LON CHANEY WAS THE ONLY ACTOR
to wait longer than Garbo to make a talkie, but it was his ill health and not the
studio's strategy that caused the delay. Charlie Chaplin made *The Circus* in 1928,
and his silent masterpiece *City Lights* premiered in January 1931. It would not be
until 1940 with *The Great Dictator* that he would speak on film. All the others
came first: John Gilbert, Norma Talmadge, Douglas Fairbanks, Mary Pickford,
Gloria Swanson—and none would go on to have a significant career in talking
pictures. Gilbert wanted to work, but the others were too wealthy and too stuck
in the past cinematic traditions to bother attempting to reinvigorate their careers
(although Swanson did give it a half-hearted try).

Shearer was rushed into four talking pictures in quick succession during 1929
and in all distinguished herself. She received Academy Award nominations for
two: *Their Own Desire* and *The Divorcee* (both 1929). Though her talent never
rivaled that of Gish, Crawford, or Garbo, it was supported resourcefully by her
husband, Irving Thalberg, who ensured that her career would flourish in the new
medium. Marion Davies was not so lucky, despite her association with Hearst.
Not one of her talking pictures is much remembered today. The coming of sound
was not only a technological revolution: it redrew the star map of Hollywood,
and within a few short years, actors like Clark Gable and Marlene Dietrich would
utterly replace earlier giants in the hearts of fans.

These acolytes were ready for a Garbo talkie. They had supported her silent
pictures through the last year of the 1920s, but now it was time for her to adapt.
Herbert Howe, one of the best known and best connected of the Hollywood
reporters (largely through his close relationship with Ramon Novarro) wrote
in *New Movie Magazine* in January 1930 just as her last silent film was nearing

120

release, "When at length she does sound off, as she will do in 'Anna Christie,' the effect no doubt will be that of the muezzin calling the faithful to prayer."

MGM did not consider seriously any property other than *Anna Christie* for Garbo's talking debut. The perfect choice, it was based on a recent and successful Pulitzer Prize–winning Broadway play by an eminent author, and best of all the title character was twenty years old and Swedish. Clarence Brown, who had worked well with Garbo in *Flesh and the Devil* and *A Woman of Affairs*, was called to direct along with others from the A team at MGM, including Cedric Gibbons and Adrian. Casting was more difficult, as Garbo needed the support of trained stage actors. MGM hired two Broadway veterans, George F. Marion and Charles Bickford, who had recently come west to work with Cecil B. DeMille on MGM's *Dynamite* (1929), and one former vaudeville legend, Marie Dressler, who had lately been cavorting in MGM silents, often costarring with Polly Moran.

Thalberg and Brown were cautious about introducing Garbo in her talking debut. Instead of the film opening in a bar, as does the play, the first scenes are set on a coal barge moored on the East River in New York City and captained by Anna's father, Chris Christopherson, played by Marion. The actor had originated the role on Broadway in 1921 and played the character again in the silent film version of 1923, starring Blanche Sweet as Anna. Screenwriter Frances Marion took a cue from vaudeville and softened up the audience with a five-minute prelude featuring a brilliant comic turn headed by Dressler. Showing every minute of her sixty years, she plays Marthy, an alcoholic former prostitute and companion to Captain Chris. Drunk though Marthy might be, she is an endearing and amusing character dispensing hard-learned wisdom. The film's second scene takes place in the bar where Chris learns of the imminent arrival of his daughter Anna, whom he has not seen in fifteen years, not since she was a child of five. Marthy is left alone in the bar's women's section when almost immediately a figure knocks at the door. It is Anna, newly arrived and in search of a drink before setting off to find her father. In her first lines spoken on film, Garbo growls, "Gimme a whiskey—ginger ale on the side. And don't be stingy, baby." These classic lines are still immediately recognizable and often quoted by fans. But it is a line spoken a minute or two later that must have seemed extraordinary to audiences in February 1930. Anna asks Marthy if she is allowed to smoke in the bar; the older woman replies that it's fine as long as she does not get caught. "Well, ain't they funny in this dump" is Anna's response. This is a new, tougher Garbo, markedly different from any screen character she had earlier portrayed.

In ten previous films, the studio had presented Garbo to the public as the epitome of glamour and sophistication. *Torrent* and *The Divine Woman* both showed Garbo as a simple country girl, but one who quickly becomes an urban goddess. In *Anna Christie* she portrays a woman common in dress and demeanor, and vulgar in language. Although favors might have been offered to men before, this time Garbo's character is a prostitute, no question about it. "I got your number

the minute you came in the room," Marthy says to Anna, who quickly rejoins, "You're me—forty years from now." Pre-Code dialogue close to O'Neill's own passed the censor's scrutiny.

Charles Bickford was a different sort of leading man for Garbo, and for Hollywood. Ruggedly good-looking, he was fair, where others had been mostly dark, and had a head of curls in contrast to the brilliantined hair of Antonio Moreno, John Gilbert, and Conrad Nagel. Before, Garbo's leading men portrayed city sophisticates. Bickford looked the part of a laborer, with his husky body and menacing demeanor. A Conrad Nagel character might get angry with Garbo, but audiences imagined they would work everything out over a glass of champagne in a drawing room with a string quartet playing softly in the background. Bickford was a manly man; no tuxedo could elegantly cover his frame. Garbo rose to working with new material and a different type of costar. She added steeliness to her performance, taking cues from both O'Neill's writing and from the challenge of acting with stage-trained Bickford. If she was going to continue to play "bad girls," Garbo reveals in *Anna Christie* that her screen characters can be played differently depending on the type and quality of script, cast, and direction.

Bickford was critical of *Anna Christie*. He did not like the film or his performance and was tepid about Garbo's. He also resented her supremacy at MGM. "Complete harmony is rare on a movie set," Bickford wrote in his memoirs of 1965, "and had it not been for my lack of enthusiasm for the play and for my role, it would have been a perfect engagement."[1] But later he turns decidedly negative about the film. "The critics raved and the public swamped the box-office to see a picture that was indifferently produced, directed, and badly acted by the entire cast. Not excepting myself."[2] The film was given a first-class production by Thalberg and was skillfully directed by Brown, especially in light of the obstacles of early sound and Garbo's first encounter with the medium—so what could have been the source of his animosity to film, studio, and especially costar? "In the campaign to put 'Anna Christie' over, ninety-nine and nine-tenths percent of all advertising was focused on *Garbo*," he tells us. "As far as publicity was concerned, the rest of us might as well have stayed in bed."[3] Bickford learned quickly that in the Hollywood of 1930, the star was the studio's principal asset and thereby the focus of attention. Hundreds of other supporting players, before and after him, even strong-willed and egoistic Broadway stars coming west, would be subjected to the tyranny of the system. Bickford might have wished that he had been invited to fill the slot created by talking pictures for the tough, attractive, working-class hero, but that place went to Clark Gable. Bickford would have a good career in the movies, and he worked continually for thirty-five years, but he never became a movie star.

Garbo's voice turned out to be ideal for sound pictures. Her deep alto with its rich timbre and slight continental accent, not quite Swedish, but not quite anything else, recorded beautifully. She succeeded to the same extent that Gilbert

failed. The magical transformation that causes a motion picture star to appear magnificently on film must have a parallel in the transmission of voice. What was really the matter with Gilbert's voice that caused audiences to titter? Why did audiences fall in love with Garbo, and equally Joan Crawford, when they opened their mouths to speak, but turn away abruptly from Norma Talmadge? Or be bored by Marion Davies?

Audiences were delighted to hear actors speak, but this one tremendous technological advance came with the heavy price of the static camera. In the best films of the late 1920s, camerawork was fluid: cinematographers could move the camera at will and edit the film to any shape necessary to tell a story imaginatively. Adding sound necessitated absolute quiet to ensure that only the actors' voices were recorded. Eliminating the prospect of any extraneous sounds, the camera was grounded and could only pivot slightly left or right; even camera noises could be a problem. Compensating for these constraints, Brown admirably created the illusion of movement in *Anna Christie* by the clever use of rear projection and extreme camera angles. In a long sequence filmed on Captain Chris's barge, he creates the sense that the boat is floating down the East River as New York City's tall buildings seem to pass by. And, in a later sequence filmed at a carnival, a rear projection of a spinning carousel animated an otherwise static scene of Garbo and Bickford sitting at a table and conversing. Similarly, dramatic shots, often taken from above, enliven scenes in which there is actually little physical movement, such as when Bickford plays the carnival game of High Striker. Fancy angles were not used when Garbo is onscreen, and she is generally shown delivering her lines using a minimum of movement. Stillness was always her hallmark, and it was, and continues to be, enough simply to watch the actress—and now for the first time to listen to her voice.

When *Anna Christie* finished filming in mid-November, Garbo had only a single obligation before a short rest. On November 19 Bull photographed her in his portrait studio. Following August's example, they had a long day together, making both portraits and a few publicity shots with Bickford and Marion that would be the basis for posters. The clothes Garbo wore in the film were relatively simple and not particularly stylish, so Bull, in most of the prints released, focused on her face. In one sequence she pantomimed drinking and being a bit drunk, recreating the mood of the sequence in which she spoke for the first time on screen. Garbo and her costars acted out dramatic moments from the scenes they played together on Chris's barge. She may well have enjoyed her portrait sessions with Bull, but she did not like making these sorts of publicity photographs. Since a hundred or more scene stills were taken for each film, surely that should be adequate for promotion. The still photographer would not shoot while the camera was running but would wait until the actors had finished a scene and then set up an interesting tableau to record. Garbo dutifully participated, and throughout her sixteen years at MGM there are hundreds of scene stills depicting her that are as

The last time Garbo agreed to pose for poster art was for Clarence Sinclair Bull after *Anna Christie*
finished filming. She is shown here with her costars George F. Marion (left) and Charles Bickford.
Courtesy John Kobal Foundation

well composed and finally as beautiful as portraits. But this would be the last time
Garbo would agree to pose for publicity photographs off set. Henceforth, when
additional pictures were necessary, a double would fill in for Garbo.

Just after *Anna Christie* went into production, the New York and, soon, inter-
national financial markets were in turmoil. On Thursday, October 24, the stock
market fell sharply. What became known as Black Tuesday, the twenty-ninth,
heralded what would become the Great Depression. At first Hollywood seemed
immune from the crisis. The one exception was at MGM. Back in March, "Wil-
liam Fox successfully closed the biggest deal in the history of the motion picture
industry . . . when he purchased the controlling interest in Loew's Inc."[4] Fox had
taken out a $50 million loan to pay Loew's widow for her 400,000 shares. He had
also purchased an additional 260,900 Loew's shares mostly on margin, controlling
660,900 of the 1,334,000 shares outstanding. With the dive in stock value, he
couldn't pay his bank obligation. Unable to satisfy his creditors, Fox surrendered

control of the motion picture empire, including the Culver City studio that he had purchased only eight months earlier. Louis B. Mayer won this round, Fox was out, but neither Mayer nor Nicholas Schenck in New York would control Loew's or MGM. Eventually a holding company would be established that would take ownership of the Loew's shares. In December 1933 a consortium led by Chase National Bank in New York would purchase the 660,900 shares of Loew's for $18,604,335 against the $76,000,000 paid by Fox in 1927.[5] The management of the theater chain would be left to Schenck, and the making of movies to Mayer. Both would be amply rewarded by drawing tremendous salaries, although neither would have any significant stock holdings in the parent corporation.

"Garbo Talks," proclaimed a banner in Los Angeles. "The Sphinx Speaks," was how columnist Herbert Howe described Garbo's talking debut. MGM rushed the opening of *Anna Christie* and on January 22, 1930, premiered the film, strangely without much fanfare, at the Criterion, a downtown Los Angeles theater. The feature proved a boon for the Criterion, and with Garbo as draw it recorded its highest weekly revenues ever. Typically MGM's prestige films debuted at the State Theatre owned by Loew's, but that theater was committed to showing *Hollywood Review*. As *Anna Christie* broke box office records, *Hollywood Review* flopped. Garbo, as was her custom, was not among the first-night crowd but took in the morning showing on the twenty-third accompanied by Sörensen, apparently left alone by other audience members.[6] Critics were uniformly positive. "GARBO FASCINATING AND CONVINCING IN HER FIRST TALKER,"[7] was the boldface headline in *Film Daily*, mirroring the sentiments of critics across the country. An English reviewer did not much like the film itself but wrote that "this talking Garbo wipes out all that wardrobe-mistresses romp with lace and orchids of the Gilbert films in one bored flick of a wrist."[8] Good reviews were fine, but more important for MGM was the revenue stream. *Anna Christie* netted more than a half million dollars, her best box office yet.

Garbo had achieved an artistic triumph, and passed the speech test, but most importantly was worth the studio's $5,000 per week. The amount was enormous even by the standard of Roaring Twenties Hollywood pay. Gilbert and Chaney were other top earners at MGM, although Gilbert's doom had been forecast, and Chaney would be dead in August. Elsewhere, Constance Bennett managed for a couple of years to score lucrative single-picture deals with Pathé, Fox and Warner Bros. that paid her $125,000 per film. For the most part, only the few who were self-producing and releasing through United Artists managed similar paydays, but it would not be long before Fairbanks and Pickford retired and Swanson reduced to making only occasional films. Chaplin alone continued as a creative and box office juggernaut. As the worldwide economy slid further, Garbo's compensation continued to rise in the face of diminishing corporate returns. Throughout the 1930s she would always be among Hollywood's highest-paid performers.

THE SOLE SURVIVOR

Photoplay included a full-page portrait of Garbo by Ruth Harriet Louise in the November 1929 issue as fans awaited the actress's speaking debut. "The sole survivor of the royal line of stars," read the caption—"the queen who, in the eyes of her devoted fans, can do no wrong. Greta Garbo now occupies a peculiar and solitary place in the hearts of picture lovers. Traits that might be unfavorably mentioned in the case of other players become positive virtues in the case of this amazing Swedish girl. 'Our Greta, may she always be right,' says her public, 'But right or wrong, our Greta!'"

When Garbo returned from Sweden the previous March, she gave up her apartment at the Miramar and moved into the luxurious Beverly Hills Hotel. She had been living near the beach in Santa Monica for more than three years in a small two-room apartment and accumulated little in the way of possessions. Whether it was her decision to move or agent Harry Edington's, swanky new digs awaited her. But living in a popular hotel swarming with famous film folks and well-heeled tourists was not to Garbo's liking, so in the early spring of 1929 she rented her first house at 1027 Chevy Chase Drive just up the hill off Benedict Canyon Drive. Eight miles from MGM, it was convenient to work but far enough away to provide Garbo some sense of remove from the studio.

With a house to take care of and a busy career, Garbo, in need of staff, hired a young Swedish couple, Sigrid and Gustav Norin, to serve as a combination cook/maid and gardener/chauffeur. Rilla Page Palmborg, for her 1931 biography, *The Private Life of Greta Garbo*, interviewed the couple extensively, and as a result we have a unique year-long window into Garbo's lifestyle. Showing little discretion or loyalty to their former employer, the Norins spoke candidly: "'She told us that we were expected to do all the buying for the house, but expected us to keep the bills down. A hundred dollars a month was to be the limit on household expenses . . . It was a struggle to keep the bills down where she wanted them' . . . After the second month Gustav gave up trying . . . 'We found we couldn't please her, no matter how we schemed.'"[9] From the details revealed in Palmborg's book, readers learned, among other things, that Garbo swam daily, liked simple food, took her meals alone, lived with cats and a parrot named Polly, and read the papers voraciously, looking carefully to see if she was mentioned. Her dishes were a set Emil Jannings left her when he returned to Europe.

Was Garbo aware that the Norins were not professional servants? In fact, this would be their first job in service. Recently immigrated to America, Gustaf had himself been a student at the Academy of the Royal Dramatic Theatre in Stockholm, the very place where Garbo had studied, although he had been in the division for younger students. Both his parents were also actors, and Gustav's goal was to have a career on the stage or, failing that, in the movies. He told Palmborg that he met Stiller at Paramount in 1927 and that the director promised him work,

Rilla Page Palmborg published in 1931 the first full-length biography of Garbo
in English, *The Private Life of Greta Garbo*. It relied heavily on the indiscretions
of the actress's housekeeper and gardener, who spoke freely to the journalist.
Cover photograph is by Russell Ball.

but of course that was the year Stiller left town, never to return. Looking for
employment, Gustav and Sigrid discovered Garbo was interviewing for a live-in
couple. Knowing the past brief connection with Stiller might have appealed to
Garbo if she learned of it, although it is likely that she would have been suspicious
of employing in her home anyone harboring fantasies of a motion picture career.

Much of Palmborg's book consists of anecdotes provided by the couple. Not
surprisingly, we learned from the Norins that while Garbo spent most of her time
working, she did have a few friends, sometimes went to dinners or restaurants,

and on rare occasions entertained at home. The few admitted to her circle were Europeans working in Hollywood, including British actor John Loder and his Austrian wife Sophie Kabel, French director Jacques Feyder, Nils Asther, and her new Swedish friend William Sörensen, whom she had met in Stockholm the previous winter. With the exception of John Gilbert, Garbo's male intimates were exclusively European. Less is certain about her female friends, with the exception of the Austrian actress Salka Viertel, whom she met at a party given by Ernest Lubitsch in 1929. Viertel, sixteen years Garbo's senior, had immigrated to America in 1928, and would become Garbo's friend and adviser, as well as writing several of her films in the 1930s. Later, after Garbo finished making movies, Viertel provided her a place of refuge in Switzerland during her annual late-summer visits. In the late 1920s, Garbo's name was linked to actresses Lilyan Tashman and French Canadian Fifi D'Orsay, both well-known lesbians, Tashman reportedly in a lavender marriage with actor Edmund Lowe. The Norins told Palmborg, "Garbo was beginning to get annoyed over the publicity she was getting as Fifi D'Orsay's friend."[10] Specifically, columnist Louella Parsons suggested in print that Garbo and D'Orsay had become "inseparable friends"—code at the time for lovers.[11] The friendship soon ended, when "D'Orsay gave out some interviews about being Garbo's intimate. After that Garbo would see her no more."[12] "I can't keep up with her myself," Tashman told Palmborg. "She has the strength of ten ordinary women . . . When she isn't working, she wakes me up before nine in the morning asking over the telephone, 'What will we do today? Where shall we go?'"[13] It is impossible to verify anything more than a casual relationship with either woman, and the continual joining of Garbo's name with theirs to suggest romance is at best speculative.

Garbo met Willem Sörensen in Stockholm through his friend Prince Sigvard. No surprise that he was taken with Garbo, but she genuinely liked him as well. Sörensen, the son of a wealthy Swedish businessman, was also related to Hörke Wachtmeister, one of the first of the older women whom Garbo came to trust and admitted to her tight circle of friends. When Garbo departed Sweden to return to New York, it was Sörensen who accompanied the actress to the boat. He promised to come visit her in Hollywood and finally did in late summer 1929, arriving at a relatively quiet moment when Garbo was between filming *The Kiss* and *Anna Christie*. Sörensen was Garbo's first and perhaps only house guest on Chevy Chase Drive and stayed one night before moving into a hotel. In 1929 it was not acceptable for an unmarried woman to be seen having a single man living in her house. That their relationship was never romantic mattered not to gossips and wagging tongues. Major scandals followed lesser crimes, and the morality clause in Garbo's contract insisted that she never do anything that might embarrass her or the studio.

For her birthday on September 18, 1929, "Sigrid and I made a birthday cake for Garbo and decorated it with twenty-four blue and yellow candles—Sweden's

colors," Gustaf Norin told Palmborg.[14] Sörensen was her guest that day, and in the afternoon the pair swam and ate cake by her pool. Earlier they had lunch together at the Ambassador Hotel. In the evening Garbo was celebrated at a small dinner hosted by Ludwig Berger, a German director who had worked at Paramount for two years. His first assignment had been to complete *Street of Sin* when Stiller left the film unfinished on his return to Sweden. Also present was Pola Negri, who had starred for Stiller twice.

Sörensen, like so many who knew Garbo, could not resist writing about her, although he did wait twenty-five years before recounting this day and providing his observations about Hollywood's most anticipated talking debut.[15] But he did speak with Rilla Palmborg in the fall of 1930, and she dutifully shared the news with fans in *Photoplay* (September 1931) under a bold title that must have made Sörensen wish he had skipped the encounter: "The Man Who Tried to Elope with Garbo: A never-told story of a fellow countryman who was hopelessly in love with her." Neither the alleged elopement nor the "hopelessly in love" parts were true, but Palmborg did manage to quote Sörensen accurately: "Soon after my arrival in Hollywood, I found the Greta Garbo of Hollywood was quite a different person from the Greta Garbo of Stockholm . . . At home she was a rollicking, mischievous girl, always ready for a lark on a minute's notice . . . In Hollywood she was a solemn, quiet young lady, living the secluded life of a hermit."[16] What Sörensen witnessed during his American visit was Garbo in the midst of a tremendous career. On free days, like her 1929 birthday, she might indulge in a restaurant lunch, a social afternoon by the pool, and a dinner with friends. But during much of the year that Sörensen was in California, Garbo was extremely busy working. She made four films in quick succession, including her first talking picture. In the summer of 1930, Garbo starred in a German version of *Anna Christie*, necessitating not only learning a new script but mastering a language that she had never spoken on stage or screen. Sörensen, free from the need to make a living, and without a social community in Hollywood (and relying on Garbo), was a bit resentful that his friend did not have endless free time to entertain him. Had he harbored romantic illusions, Garbo would never have invited him in the first place. Friend or not, by the time he returned home in October 1930, she must have been glad to see him off.

All her life Garbo loved to take walks alone, and earlier, when she lived just steps from the beach in Santa Monica, she could cross the road and walk down the flight of steps to the nearly deserted sand and enjoy solitude. She often went swimming by herself and must have enjoyed the cold Pacific water. Although she insisted that neither the Norins nor the studio give out her address, soon neighbors figured out who was living in the rented house. Her habit of taking walks continued but with unfortunate results. The curious gathered and she was often accosted. "Can't I go out for a walk anywhere without being annoyed?"[17] she asked Gustav. She was just twenty-four and would live for another sixty years,

most spent in retirement. But never again would she be able to go out, even for a stroll her neighborhood, without the real possibility of "being annoyed."

The publicity department was constantly juggling requests for Garbo's time, sometimes from inside the studio and others from outside. Garbo refused to meet any of the celebrated people who were constantly being escorted around the lot, from politicians and European aristocrats, to business leaders and even the friends of MGM bosses and colleagues. Howard Strickling, who took over MGM's top publicity post from Pete Smith, had a request that he delivered via Harry Edington. For the English premiere of *Anna Christie*, a radio hook-up between Culver City and the London theater was arranged, and he hoped to entice Garbo to say a few words to the audience gathered across the Atlantic Ocean. The answer was no. "For four days her manager pleaded and argued. But it did no good, Garbo would not talk over any radio anywhere."[18]

Although Garbo had agreed to pose for Edward Steichen and Nickolas Muray in late fall 1929, she refused Cecil Beaton. The twenty-five-year-old British photographer was at the beginning of his career when he scored a lucrative contract with Condé Nast to photograph stars principally for *Vogue*. Through his friendship with well-connected screenwriter Anita Loos (*Gentlemen Prefer Blondes*, 1925), Beaton was given entrée to a wide swath of Hollywood's in-crowd. His style was evident in his first Hollywood portraits. "One of the first things I did in Hollywood," he wrote in 1931, "was to photograph nearly all the stars with the mechanical part of the studio as background."[19] Nearly everyone was available to this dynamic new talent: Crawford, Shearer, and Novarro at MGM, Gary Cooper, Lilyan Tashman, and Ruth Chatterton at Paramount, among many others. But Garbo was the goal, and in a letter he wrote, "She was the only person with glamour."[20] His quest failed. "I at last got through to Strickling and, after having my hopes raised so high yesterday in answer to my 'What about getting Garbo?' there was the deadly 'Not a chance.'"[21] Beaton published a large selection of his Hollywood work in *Screenland* (May 1931), and the magazine took great care in beautifully reproducing his images in rich sepia. Unable to resist a little further self-promotion, in the winter of 1931, he made a list (published widely) of women whom he considered the most beautiful in films. Marlene Dietrich, Norman Shearer, Marion Davies, Lilyan Tashman, and Ina Claire made the cut, as did Garbo, the only one he had not photographed. So why was Garbo included? "Because she is absolutely mad; and being absolutely mad, is therefore ethereal."[22] When Beaton left Hollywood in early 1931, he was crushed to have not even had a chance to see Garbo, much less add her to his list of photographic conquests. The acquaintance he had hoped to make then would be delayed, but when it finally happened, a true intimacy evolved between the two, and he would make extraordinary portraits.

Two days before Christmas 1929, Garbo decided she wanted a real Swedish Yuletide in her house. "I want my friends in for Christmas Eve. I want them again

for Christmas dinner. We will get a big Christmas tree and armfuls of flowers and holly, she told Gustav."[23] The guest list for Christmas Eve was Jacques Feyder, Nils Asther, and Wilhelm Sörensen. She added John Loder and Sophie Kabel for Christmas Day. Garbo did her own shopping, knowing that she alone must choose what was necessary for the perfect Scandinavian celebration, though she invited the Loders and Sörensen along to keep her company. Of course Garbo was recognized and spoken to by other shoppers. "Can't I go anywhere without being pawed over by strange people?" she lamented to Gustav.[24] Yet, instead of going home, she invited her little troop to lunch at the Musso & Frank Grill on Hollywood Blvd. Back home Garbo decorated the tree, and Gustav laid a fire, which he lit shortly before eight when the guests arrived. A typical Swedish Christmas Eve menu was served: lutefisk, julgröt, Swedish apple cake, and coffee.[25] Garbo played Santa Claus and distributed gifts to her guests. For Christmas dinner the next day, she "wanted to serve a typical Yule Smörgåsbord. That meant at least twenty different dishes in addition to the main dinner." Curtains were tightly drawn, recalled Gustav, "to make us think there is snow outside."[26]

Loder had worked primarily in Germany throughout the mid and late 1920s. He was signed by Paramount and came to Hollywood in the fall of 1928, where he had a small part in Josef von Sternberg's lost film *The Case of Lena Smith*, followed by a featured role in *The Doctor's Servant*. How he and Garbo met is unknown, but many with whom she socialized worked at Paramount, including Loder, director Ludwig Berger, actress Pola Negri, and Ernest Lubitsch (and Stiller, Jannings, and Einar Hanson earlier). Among the places Garbo enjoyed visiting on free evenings was the Apex Club on Central Avenue, the heart of Los Angeles jazz, and one of the most popular Black-owned establishments in the city. Loder, who went there with his wife and Garbo on several occasions, described it as, "a garish place of checkered-red tablecloths, and paper roses. Garbo seems to like it, and no wonder, as it is quite the most amusing place in L.A."[27] Loder spoke with Palmborg for her forthcoming book: "Greta Garbo is a law unto herself. She will not endure restraint or routine. In the year and a half that I have known her I cannot remember that she ever made one definite appointment, even a dinner engagement, a day in advance. 'Perhaps I will drop in to see you to-morrow night' is the nearest intimation of her intentions that my wife and I ever got."[28] For someone who had gone out socially with Garbo and been entertained at her home more than once, the remarks seem disloyal, and, given that Loder knew of her distain for publicity, perhaps mean-spirited as well. With the Norins selling her story, and friends such as Loder, Fifi D'Orsay, and even Sörensen agreeing to speak behind Garbo's back for publication, it is easy to understand why the shy and private young actress developed such an aversion to the press and unwanted publicity—and at times froze out completely those in her circle whom she felt unable to trust. The press itself was actually sympathetic. As it was nearing publication, a short spot about *The Private Life of*

Greta Garbo appeared in *Motion Picture* (September 1931), concluding, "It must be hard to be a movie star and know that your personal friends will sooner or later betray you to the public."[29]

Among those Garbo admitted to her circle was one of the most well-respected of the foreign emigres who settled in Hollywood: director, and later producer, Ernest Lubitsch. He came to America in 1922, summoned by Mary Pickford, and later directed for Warner Bros. before settling at Paramount in 1928. Gustav Norin recalled that one of Lubitsch's first films for Paramount, *The Love Parade* (1929), was so favored by Garbo that she brought flowers to the director at his home.[30] He was a popular host, entertained often, and lived near Garbo on Beverly Drive. Sunday afternoon gatherings were common at the Lubitsch house, and once in a while Garbo could be counted among the visitors. It was at one such gathering that Garbo met Salka Steuermann Viertel.

Salka Viertel came to Hollywood in 1928 with her husband, Berthold. He had been invited and promised work as a screenwriter by director F. W. Murnau, who had scored tremendous international successes with his German films *The Last Laugh* and *Faust*, and was working on *Sunrise* (1928) with Janet Gaynor at Fox. Viertel and Garbo apparently took an immediate liking to one another. In her well-received memoir published in 1969, Viertel recalled her first impression of Garbo: "She was intelligent, simple, completely without pose, with a great sense of humor, joking about her inadequate German and English, although she expressed herself very well."[31] The Viertels quickly joined the circle of European intelligentsia living in and visiting Los Angeles, including Murnau, director Sergei Eisenstein, and even Albert Einstein. Eisenstein, who had been brought to Hollywood in the spring of 1930 to work at Paramount, recalled meeting Garbo at Ludwig Berger's house. He called her "Garbelle," and she answered him back "Eisenbahn."[32] Eisenstein's stay in America was brief, and within six months, with no project agreed, his Paramount deal was cancelled.

When the end of her year lease on the Chevy Chase house was in sight, Garbo decided she wanted a different residence. Gustav and Sigrid had tired of working as servants, so Garbo also needed to find new help. She dithered and when moving day came she found herself without a proper staff; Alma, her studio maid, was recruited to assist Garbo temporarily at home. Leaving Garbo's employment, Gustav got a job working in the scenic department at one of the studios. In the late 1930s, he was working at MGM's makeup department on films such as *The Great Waltz* (1938) and *The Wizard of Oz* (1939). His dreams of acting on screen never came to fruition, but he did have a long and successful career as a makeup artist. What did Garbo think of the Norins' betrayal when they spoke so extensively to Palmborg? The only evidence is a mention of a chance meeting between Garbo and Gustav reported in Cal York's column in *Photoplay* (December 1931). "The other day, Garbo accidently encountered Norin on the street. She stopped short, looked him over slowly from head to foot, and then husky-voiced, in inflections

of deep disdain: 'So, det are Du . . . !' Which, in Swedish, and English, means: 'So that's you?'"[33]

While Edington arranged a new house, Garbo and Sörensen made a trip to San Francisco. She traveled as Miss Sörensen and the friends stayed in the Fairmont Hotel. Garbo had stopped in San Francisco on her way to Hollywood back in September 1925, but this was her first chance to see the sights, including crossing the bay to visit Berkeley and Oakland. The pair were unmolested until Garbo sought to cash a traveler's check, revealing her identity. Suddenly anonymity vanished, and "Garbo saw curious eyes turned in her direction."[34] The sojourn was aborted.

The house Edington rented was on 527 North Camden Avenue, Beverly Hills, but quickly it turned out not to be suitable, as the sound of the streetcars running continuously nearby kept her awake at night. Sörensen claimed that it was he who then found a suitable house at 1717 San Vicente Boulevard. "What quiet and peace! Why couldn't I have found this place long ago?" she told Sörensen .[35] The one-acre property was bordered on both sides by empty lots and in the back by the Riviera Country Club, providing Garbo the seclusion she sought. A new staff was arranged; this time Garbo may have sought professional help who knew better than to talk to reporters. Although biographers and fans must have hoped for the prospect of additional inside scoops, Garbo now took pains to ensure that her privacy was respected. Sometimes her lack of affect was her best defense. Fan magazine writer Dorothy Calhoun might have thought she was gently scolding Garbo when she wrote, "Hollywood doesn't see Greta Garbo as a strange and seductive enchantress, but as a carelessly-garbed, athletic Swedish girl who tramps the Boulevard in stout shoes and mannish coats and stops to stare, fascinated, into the ten-cent store windows."[36] In that, as she did so many times, Garbo anticipated the behavior of stars many decades hence.

ROMANCE

Among the last tantalizing bits of gossip from the Norins was that Garbo was not enthusiastic about the property MGM had proposed as her next film.[37] *Romance* was based on a play of the same name by a popular playwright, Edward Sheldon, which already had been made into a film in 1920 starring Doris Keane (who originated the role on Broadway). The lead character, Rita Cavallini, was an Italian opera singer, so Garbo's accent would not be a hindrance, since it sounded suitably "foreign" if not actually Italian. The role of Cavallini was familiar—another woman of questionable morality who goes (sort of) good, but who still doesn't get the man she loves in the last reel. In the end Garbo agreed to make the film, and with her usual team on the set, Clarence Brown and William Daniels, the only open question was male lead.

Gavin Gordon is the least remembered of all the men who supported Garbo on film. Even Ricardo Cortez and Antonio Moreno had long and notable careers, although neither reached the top rank. Gordon started out on Broadway, and by 1929 was in Hollywood gaining small parts at Fox and Paramount. He tested at MGM to either act in a Norma Shearer film or to work for King Vidor—stories vary—but his screen test caught the attention of the *Romance* team. Garbo approved and Gordon was cast as Tom Armstrong, the young curate in mid-nineteenth-century New York who falls in love with the notorious opera singer. More than half a century later, as a distinguished Episcopal bishop, he recounts the story of his youthful love to his grandson. (The film plays fast and loose with chronology; the contemporary story in circa 1925 would mean Armstrong was about a hundred.) Gordon was good-looking, rather than handsome, and had a strong, rich speaking voice. But he was either utterly miscast or appallingly directed: it is hard to say even after ninety years. Tom is a conservative young man just beginning a religious career. But the exceedingly large helping of sanctimony Gordon heaps on his role makes it impossible to believe that Garbo/Cavallini would be interested in him for a second. Both Conrad Nagel and Lars Hanson were actors with a cool reserved demeanor, but both thawed convincingly at the sight of Garbo. Gordon remained ice, and in the final scene where his character claims having been ready to give up his vocation for Cavallini, not a second rings true.

Perhaps Gordon's problem was the injury he suffered on the first day of shooting. Adela Rogers St. Johns told the story in a long article she published in *New Movie Magazine* as *Romance* was about to be released. While driving excitedly to start work on the film, "another car turned out of a side street and crashed into him. He was thrown out onto the pavement and struck on his left shoulder." Desperate to make good on this big break, Gordon managed to get to the studio and appear on the set. But he was too injured, and before the end of the day he was in the hospital. Thalberg's response was immediately to start looking for another actor. Garbo "wanted Gavin Gordon given his chance, she wanted him to continue in her picture."[38] Thalberg and Brown conceded to Garbo's wishes, and the director began shooting the film without Gordon. On April 26 *Motion Picture News* ran a short spot telling filmland that "after spending nearly two weeks in a hospital, Gavin Gordon has returned to the M-G-M studio to continue his role opposite Greta Garbo." It was a remarkable gesture on Garbo's part, and she would show a similar kindness to John Gilbert in 1933 during the casting of *Queen Christina*. With or without Garbo's help, Gordon's performance would not augur a bright future for him at MGM. As *Romance* was readied for release in August, *Variety* wrote, "Contract of Gavin Gordon expires Sept 1 with Metro not renewing it."[39] He continued to work for decades, but only in small parts and often in uncredited roles, although he did have a long and happy relationship with comic great Edward Everett Horton.

Lewis Stone, who frequently joined Garbo on-screen in secondary roles, is superb in *Romance* as the older lover whom she rejects for Gordon. Although Stone was fifty when the film was made, he seems by comparison the younger, more exciting, romantic option, and with any luck Madame Cavallini would find Stone waiting for her just after the final credits.

Romance is not a film in which Garbo seems to be enjoying herself, although she looks great. Trying to portray an Italian was a mistake and allowed her to be described by the critic for the *Los Angeles Times* as possessing "the strangest Italian accent that ever fell upon the ears of an audience."[40] (Why didn't MGM simply reimagine the part as a Scandinavian or German soprano?) The film was Garbo's first in which settings and costumes were historical rather than contemporary. Adrian dressed her beautifully, upholstering Garbo in a series of gowns that, aside from the wow factor, serve principally to keep Gordon literally at arm's length. Period or not, the costumes also influenced fashion, especially a hat she wore: "There can be no doubt that the pair [Garbo and Adrian] was directly responsible for the Empress Eugenie hats which we are all tilting over our right eyebrows at this very moment," wrote Helen Louise Walker in *Movie Mirror*.[41]

The ticket-buying public might have enjoyed Garbo and her costumes, but for those working on the set there were difficulties in addition to Gordon's accident. Thalberg watched over this project carefully as he did all Garbo's pictures, but as the production neared conclusion, he didn't like the results. The lack of chemistry between the stars that we notice today was even more acute in the film's original cut. Thalberg ordered retakes that he supervised, and he oversaw the editing until he had a film suitable to release. Garbo was still bullet-proof, and once again box office numbers were strong. Critics were kind, although one reviewer stated the obvious: "*Romance* is strictly a star tailored vehicle."[42] *Variety* described it as "one of those affairs in which the story finishes way back of the star." But more typical was the breathless sputtering of one starstruck reviewer: "Somehow, mere words are not colorful enough to express the fascination which is Greta Garbo's. Just to see her sweep across the screen and to hear her low voice holds one spellbound."[43]

While Garbo's fame continued to soar, some of her contemporaries were not so fortunate. Douglas Fairbanks, Billie Dove, Clara Bow, and of course Gilbert were at or near the ends of their careers. Leonard Hall wrote an article for *Photoplay* (January 1930) titled, "Garbo-Maniacs" whose title names the extraordinary gusto of Garbo's admirers. He notes that many former audience favorites had "thrones built of raspberry jello. One false squirm, and away they go!" He continued, "All but Garbo! That weird and wonderful woman from the far north never seems to fumble a grounder, no matter how hard hit . . . As the race of queens dies out and is replaced by ordinary erring, faulty, frail men and women, she alone remains—the greatest and loneliest of a mighty line."[44]

Among the many changes at MGM during the transition from silent to sound was the hiring of a new portrait photographer, George Hurrell, to replace Ruth

Harriet Louise. Her contract was set to expire in December 1929, and the studio decided not to renew it; Norma Shearer had intervened and demanded that Hurrell be hired. Where Louise had taken elegant pictorialist photographs, Hurrell possessed the most contemporary style of any photographer working in Hollywood and was the master of sharp focus and high contrast. Gone was the elegant soft-focus that flattered most sitters, especially those over thirty. Hurrell's photographs are composed with rich blacks contrasting with brilliant whites. His focus was razor sharp, creating startlingly dramatic images, perfectly at one with the art deco design then current in Europe and America, and seen prominently in the sets designed by Cedric Gibbons. He asked his subjects to wear little makeup; he would take care of imperfections in the darkroom. Moreover, he was willing to retouch his negatives radically, ensuring his subjects were sleek and polished no matter. Working with Joan Crawford, Hurrell found his perfect muse. She responded both to his energy and photographic style, and together the pair created many of what now are considered iconic images of Hollywood glamour in the 1930s. Hurrell's camera made Novarro beautiful without feminizing him too much, and Norma Shearer sexy (which pleased the actress but not her husband). Later, Hurrell would take dazzling photographs of Jean Harlow, making her hair and clothing read as platinum—creating a vision of the actress more lustrous than the work of any cinematographer. For Marie Dressler, he took away two decades, giving her a sheen never seen in her movies but one befitting such an important star. Louise never worked at a studio again, although she took on private commissions occasionally during the 1930s. She died in 1940 at the age of thirty-seven (of eclampsia due to childbirth), long before the nostalgia boom, and seems never to have discussed in print why her professional relationship with MGM (and Garbo in particular) was terminated. It is a romantic notion that the two women, similar in age, forged a professional alliance, although there is no evidence, one way or the other, that Garbo tried to influence the decision to replace Louise.

Hurrell's contract started on January 1, 1930, so his first opportunity to photograph Garbo was after *Romance* wrapped in June. Three of the film's costumes accompanied her to the portrait studio. All were long period dresses made of heavy material, although two had low necklines to set off the actress's face. For the first time costumes might figure prominently in the portraits. After almost five years at MGM, Garbo's experience with photographers had been largely limited to those she liked and trusted: Ruth Harriet Louise, Clarence Bull, and Russell Ball. As her fame grew and demand for images reached outside the normal channels of MGM publicity, Strickling arranged with her assent for quick sessions with Edward Steichen and Nickolas Muray. Now Garbo would have a new photographer at home.

The session started out badly and, as Hurrell later noted, never improved. "By the time I had taken a meter reading and focused the lens, Garbo had turned sober."[45] Examining today the results of their first encounter confirms

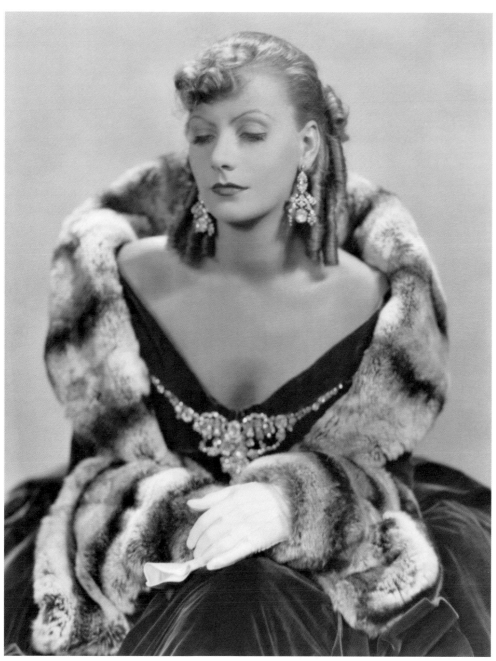

George Hurrell took the place of Ruth Harriet Louise as MGM chief portrait photographer in 1930 and photographed Garbo in costume for *Romance* in May. The results did not please Garbo or her studio, so Hurrell was never asked to photograph her again.

Jean Harlow was relatively new to MGM when she scored the plum leading role as Vantine in *Red Dust*, costarring with Clark Gable. The film had been intended for Garbo. *Red Dust* made Harlow a star. Photograph by Clarence Sinclair Bull.

that collaboration between subject and photographer is required to make great portraits. Garbo learned early in her career that she needed to work as diligently in the portrait studio as she did on the film set. But even so great an artist as she could not overcome what she decided was an unsympathetic creative experience. You can see from the images that she gave little to Hurrell. He tried a tactic that had worked for Louise and Bull, but Garbo "was pensive; she did not appear to respond very much to my popular recordings."[46] Writing decades later, Hurrell gently spun the occasion: "She was pleasantly amused by my antics, which grew more and more ridiculous as I tried to penetrate that marvelous composure and throw her off guard. But I felt I was getting very little reaction."[47] Garbo would never have been amused by "antics," nor would she respond to attempts at "penetration" or "throwing her off guard." The photographer's strong ego remained unchecked long after he left MGM, and all those many years later he still managed not to understand his subject as Louise or Bull had. Yes, some attractive portraits emerged from the session, but they neither supported Garbo's past glamorous image nor illuminated the new kinds of characters she would begin to portray in the early 1930s. Few Hurrell portraits of Garbo found their way into the fan magazines or newspapers. Whether he was the studio's chief portrait photographer or not, she would never let him photograph her again.

As *Romance* concluded filming, MGM teased fans with a hint of the actress's forthcoming schedule for the 1930–31 season: "Greta Garbo will be seen in at least three productions, the first being 'Red Dust' based on William Collison's story. It presents the Swedish star as a Parisian star transferred to the background of a Chinese rubber plantation."[48] The film would be based on a short-lived Broadway play of the same name, and the story resembled Somerset Maugham's successful play and later film *Rain*. In *Red Dust* Garbo would have played the part of Vantine Jefferson, a prostitute working near a Southeast Asian rubber plantation. The plantation manager was her primary romantic interest; the arrival of another woman—married, cultured, and sophisticated—provided the dramatic tension with a love triangle. One of the ladies would be left alone in the final reel. Although superficially this type of character was a Garbo stock type, either the actress or Thalberg determined that Vantine was too common, and that playing this role might not be acceptable to fans. Sure, Garbo had just portrayed Anna Christie, but her past was behind her, and respectability lay ahead. The script for *Red Dust* was morally vague. Thalberg must also have been concerned with casting the other leads with Garbo playing Vantine. No previous Garbo film had had another actress in a prominent role, especially one playing a romantic competitor.

Red Dust was recast with Jean Harlow playing Vantine, costarring with Clark Gable and Mary Astor. Perfect for Harlow, impossible for Garbo. Mary Astor was one of the great silent beauties, and although she never attained top stardom in the talkies, she had a long and distinguished career. With the new cast, *Red Dust* was released in the fall of 1932. By that time Garbo had worked with Clark Gable as her leading man in *Susan Lenox* (1931). Harlow was early in her career at MGM, and *Red Dust* would make her a star. She filled a vacant niche spectacularly at MGM at the end of the pre-Code area, that of the sexy, platinum blonde siren. Harlow was obvious in her sexuality, where Garbo was always subtle. Joan Crawford trod the middle ground; unlike the characters played by Garbo and Harlow, she portrayed scrappy working-class women seeking upper-middle-class respectability (at whatever cost along the way to the altar). Thalberg now had a full complement of female stars: Garbo as the ultimate romantic goddess, Harlow and Crawford taking care of the sex department, Norma Shearer as the grand lady, Marion Davies playing whatever role William Randolph Hearst permitted, and finally, with the largest following of all, Marie Dressler, who after her brilliant success with *Anna Christie* rose to become number one at Hollywood's box office.

FOREIGN-LANGUAGE FILMS

Talking pictures came with a new version of an old problem for American studios: they spoke English. In the non-Anglophone countries, especially the lucrative European market, films had to be dubbed, or subtitled, as the silents had been. MGM

started making multiple versions with different casts of films beginning with its first talkies. Gilbert's first-released talking picture, *His Glorious Night* (1929), was made in three foreign-language versions: French (*Si l'empereur savait* ça) and German (*Olympia*), both directed by Jacques Feyder, and Spanish (*Olimpia*), directed by MGM company director Chester Franklin. Taking the Gilbert role, Captain Kovacs, in the French film was Andre Luguet, and in the German, Theo Shall, who would costar the same year with Garbo in the German *Anna Christie*. José Crespo played Kovas in the Spanish-language film. The Norma Shearer film, *The Trial of Mary Dugan*, was similarly made in, French, German, and Spanish. Ramon Novarro, MGM's top romantic star after Gilbert, was Mexican-born and fluent in Spanish and French as well as English. In 1930 he starred in *Call of the Flesh*, and in short order MGM produced both a Spanish-language version, *La sevillana*, and French, *Le chanteur de Seville*. Novarro headlined all three, but the remainder of the cast changed in each film. Accents were a handicap to many foreign-born stars working in Hollywood, like Emil Jannings and Vilma Banky, whose heavy accents made them early casualties. But for Novarro and Garbo, speaking multiple languages turned out to be a boon to their early talking careers.

It was at this time that Garbo's brother, Sven, had dreams of a motion picture career of his own, and given the connection to his famous sister, he was given a chance. In 1929 Paramount took over the Joinville Studios in Val-de-Marne southeast of Paris and from there made many European versions of American features, occasionally scripting a new story for this market. A French film, *Un trou dans le mur*, was produced in 1930 and recast in Spanish, *Un hombre de suerte*, and in Swedish, *När rosorna slå ut*, in which "Sven Garbo" got a part. His sister's popularity was likely the reason the film played briefly in America in 1931 as *The Hole in the Wall*. *Photoplay* (April 1931) bothered to send a critic, who later wrote: "The film is reviewed here because Sven Gustafsson, brother of Greta Garbo, makes his American début in it . . . [He] doesn't bear the faintest resemblance to his famous sister. And he's punk actor, if this is a sample."[49] We can't second-judge: the film is presumed lost. Sven had earlier roles in two Swedish pictures, billed as "Sven Garbo," apparently against his sister's wishes, so he worked for Paramount as Gustafsson. In all he made only a small number of screen appearances, and by the early 1930s his acting experiment concluded.

As Germany was a strong market for American films, and Garbo conversant in the language, Thalberg decided to make a German-language version of *Anna Christie* under the direction of Jacques Feyder. Most of the sets could be reused, but this was not a simple shot-by-shot remake of the earlier film. O'Neill's play was sensitively translated into German, and the new script more closely followed the original. Gone was the comic opening prepared for Marie Dressler. The film has a grittier quality more in keeping with the spirit of the play, and German taste. Native German speakers were cast to support Garbo. Rudolph Schildkraut was selected to play Chris. Long a favorite of DeMille's, Schildkraut was best known for

Garbo rests between takes while filming the German version of *Anna Christie*. She is shown speaking with director Jacques Feyder at left as cameraman William Daniels consults a book at right. Courtesy John Kobal Foundation.

playing Judas in his *King of Kings*. Theo Shall, who came to Hollywood expressly to play roles in German versions of American films, was cast as Matt, taking over the Charles Bickford role (Lew Ayres had been considered for the part in early 1930). And as Marthy, so masterfully played by Dressler, Thalberg hired Garbo's new friend Salka Steuermann Viertel. Shortly after rehearsals began, on July 15, Schildkraut suffered a heart attack at the studio, and died later that evening at the home of his son, actor Joseph Schildkraut. One week later *Variety* announced that Hans Junkermann would take the role. Junkermann had been recruited by Universal to act in German-language films, but once in Hollywood he freelanced among studios. He was known at MGM from his work in the German version of *His Glorious Night*.

Even with Garbo remaining as the central character and the new script's fealty to the original, the later film is markedly different from the earlier version. Whatever trepidation Garbo might have had in making her first talking picture, by her third she was utterly comfortable working with a microphone. With Garbo dressed more flamboyantly in the early scenes, speaking a language closer to her

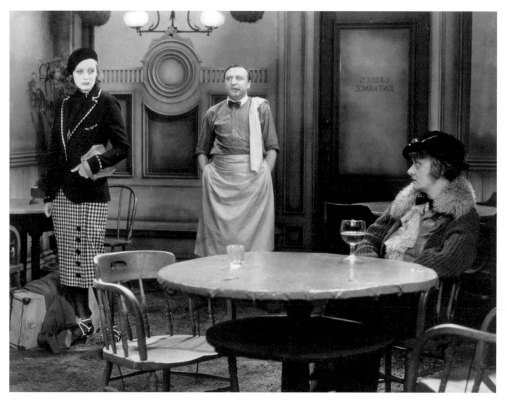

Garbo recommended actress Salka Viertel to play Marthy in the German language version of *Anna Christie*. The two women were close friends and remained so for the rest of their lives. Photograph by Milton Brown.

native tongue, and with different actors, the German-language *Anna Christie* is a new picture, and just might be the better film. German reviews are hard to come by, but the Berlin correspondent to the *New York Times*, C. Hooper Trask, wrote a lengthy article about it in his regular column "Screen Notes from Germany" (April 26, 1931). "The reception was mixed. Some critics praise Miss Garbo unstintedly, but the majority hung a lot of exceptions onto their affirmations." He directed his own venom, however, at Feyder, who "has no feeling for the German language and not the slightest notion of what the modern German wants. He sentimentalizes the story so that it is at times positively unbearable." His comments reveal German prejudice against the Hollywood decision not to engage a native director, but the remarks about sentimentalizing the story are so at odds with what we see on film as to make us wonder about his agenda. Another concern of Trask is Germany's instance that "it is necessary for Americans to invest money in German pictures in order to get their home product into the country." This in spite of the fact that "[Germany] has proved by turning out a hundred talkers within the last year that it is the second most productive film country in the world." The not-so-subtle subtext of Trask's article is his scolding of German

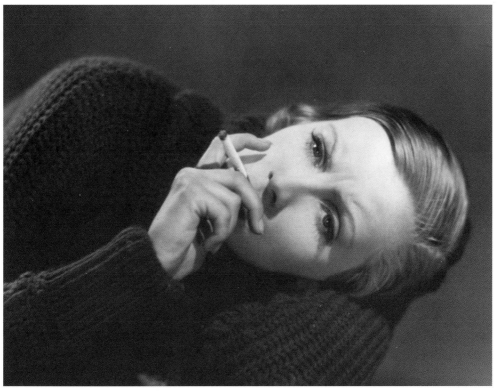

Clarence Sinclair Bull made many extraordinary photographs of Garbo, and the actress seemed to enjoy acting for him in the portrait studio, as she is seen here in the session for the German-language version of *Anna Christie* (1931). Courtesy Hood Museum of Art, Dartmouth College.

business practices that penalize Hollywood studios. By highlighting criticism to both Garbo and Feyder, he is attempting to sway Hollywood: "Americans should simply close up their distributing offices and retire from the field until the Germans see fit to revise their import regulations and give the Americans an even break." Given the importance German revenues were to MGM's bottom line, it is unlikely that Mayer considered seriously Trask's comments.

There would be few more German-language films emanating from the MGM lot. Dubbing would be refined so as to make foreign-language productions unnecessary. Germans would not hear Garbo speak again in the future. Unless her films were presented in the original version, it would be another actress's voice heard on the screen. Aida Stukering did the honors for *Mata Hari*, *Grand Hotel*, and *Susan Lenox*.

The Academy Awards were in their third year before Garbo received her first nomination. For the 1929–30 season, she was nominated for her work in two pictures, *Anna Christie* and *Romance*. During the Academy's early days, a single nomination might cover performances in more than one film. Garbo lost out to Norma Shearer, who won an Oscar for her work on *The Divorcee* and *Their Own*

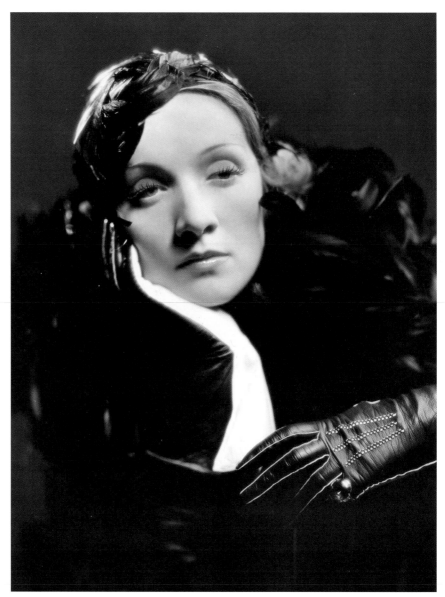

Marlene Dietrich costumed as Shanghai Lily in Paramount's exotic Asian romance *Shanghai Express* (1932), directed by her mentor Josef von Sternberg. Photograph by Eugene Robert Richee.

Desire. The other three nominated actresses were Gloria Swanson (*The Trespasser*), Ruth Chatterton (*Sarah and Son*), and Nancy Carroll (*The Devil's Holiday*). Clarence Brown was also nominated for both of the films he directed for Garbo but lost to Lewis Milestone for *All Quiet on the Western Front*. William Daniels was also an unsuccessful nominee for his cinematography on *Anna Christie*.

Marlene Dietrich had hardly begun work at Paramount in July 1930 when the comparisons with Garbo began. She had sailed to New York from Germany that

April, the day after *The Blue Angel* premiered in Berlin. Contrary to a legend she promoted that *The Blue Angel* was her debut in film, Dietrich was the veteran of at least twenty films before Josef von Sternberg cast her in the film that would thrust her to cinema stardom. Von Sternberg had arranged a Hollywood contract for the actress who would become his protégée, and when the pair arrived in New York they were welcomed with a lavish Paramount Pictures reception. On April 10, a spot in the *New York Times* read, "[Dietrich] was the guest of honor at a luncheon at the Ritz-Carlton. On that occasion, Jesse Lasky, vice president in charge of production at Paramount, announced that Gilbert Miller, the stage producer, probably would present Miss Dietrich in a play here between her film activities. The actress will leave for Hollywood on Sunday to appear opposite Gary Cooper in 'Morocco.'" How different an introduction to New York from Garbo's. Lasky decided that Dietrich should make *Morocco* and have Paramount release it before *The Blue Angel* was screened in America, and the film was shot during the summer under von Sternberg's direction. *The Film Daily* added fuel to the nascent Garbo–Dietrich rivalry in an article published in October, three weeks before *Morocco* opened and before any American audience had had a chance to see Dietrich on screen. "Despite sincere efforts by Paramount officials to put a stop to the penchant for comparing Marlene Dietrich, their newest German importation, to Greta Garbo, Hollywood writers continue to harp upon the belief that the Swedish star has a rival as the screen's Lady of Mystery . . . It would seem that Miss Dietrich is playing into the hands of the Hollywood scribes, for she now refuses to give interviews and keeps to herself even in the studio. This von knows, is Garbo to a 'T.'" [50] Although Dietrich went on to have a spectacular career on screen, and in concert halls, when she came to America she imitated Garbo with the blessings of her director. But Dietrich quickly found her singular voice and went on to become an authentic twentieth-century legend.

INSPIRATION

Five years almost to the day that Garbo first started working on an MGM film set, she began her fourteenth production for the studio, and in all she had the featured or starring role. No woman had ever been credited above her on screen. And in October 1930, no woman outranked her as a romantic star in Hollywood. Her movies were almost always the same, and Garbo had given up trying to influence the sorts of characters she would portray, although by the fall of 1930 she had script and costar approval. As an actress she must have longed to try new parts, although as a star she would have understood the fragile relationship between performer and fans, one that might not prove strong enough if an acting experiment failed. Garbo was acutely aware of her value to the studio and was careful with the enormous salary she drew weekly. The world's financial crisis loomed

ominously, and she sought to make and to save as much money as possible, given the unpredictability of the future. Garbo observed careers around her rise and fall, and no actor has secure enough an ego not to be watching out of the corner of an eye for signs that hers might be next.

Thalberg proposed *Inspiration*, originally titled *Sappho*, based on a nineteenth-century French novel, as her next film. Garbo agreed to star and for the fifth time to work with Clarence Brown. She would play Yvonne, an artist's model and muse, the inspiration of the film's title. Yvonne had affairs with some of the artists with whom she worked, as well as wealthy older men. The film opens at a party where, surrounded by her many admirers, Yvonne spies a handsome (and innocent) younger man, André, who captures her fancy. Predictably they fall in love, but in the end she leaves him so as not to spoil his chances for professional success. Robert Montgomery was cast as André. He had played a bit part two years earlier in *The Single Standard* but quickly rose to leading-man status, making his mark with Joan Crawford in *Untamed* (1929). From there he made two films with Norma Shearer in quick succession and was at the top of the cast of *The Big House* (1930), the prison film that was a huge hit for MGM. Lewis Stone and veteran stage actress Marjorie Rambeau also costarred.

Brown and Garbo had had great artistic (and financial) success with *Flesh and the Devil*. The director successfully brought Garbo over the talking threshold in *Anna Christie*, and together they managed to survive the messy production of *Romance*, a film whose success at the box office ultimately was all that mattered. Despite this history of profitable collaboration, the professional partnership and friendship between the two would be tested during the filming of *Inspiration*.

"Before the picture was half finished Hollywood knew there was trouble brewing on the Garbo set. Such news leaked out through extras, electricians, prop boys, and other members of the cast."[51] Not since the publicity following the release of *Flesh and the Devil* had Garbo been subjected to such critical press. Even *Photoplay* (March 1931), normally respectful of stars in general and MGM in particular, piled on with a story titled, "Did Brown and Garbo Fight?" "Garbo has broken every rule of star living. It is not surprising, therefore, that she should break rules on the set."[52] Neither Garbo nor her director was satisfied with the script, and rewrites continued as filming progressed. Brown, attempting to deliver a good picture despite the obstacles, asked her to rehearse extensively; she refused. And, now that her words were being heard by audiences, she monitored her dialogue closely, reportedly saying on the set, "I never hear people talk like dot [*sic*]."[53] She was probably right to object. Thalberg, weary of the conflicts between star and director, is said to have shut down the production at the end of November.[54]

The same old story notwithstanding, the script needed massaging to ensure it passed the censors. Racy subjects had been around since the dawn of cinema, but with talking pictures the problem became acute. In silent pictures sex was more subtle. Unless a couple was actually seen in bed together, which they were

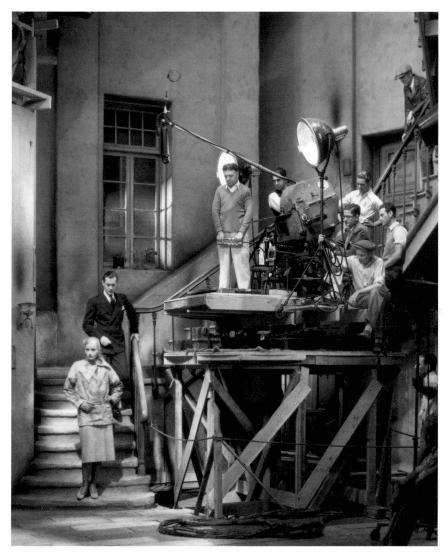

Garbo and costar Robert Montgomery on the set of *Inspiration*. Director Clarence Brown stands at center, and cinematographer William Daniels is behind the camera. Courtesy John Kobal Foundation.

not, what thoughts might be passing through the actors' minds was up to each moviegoer to imagine. As such, Garbo's rich assortment of women of questionable morality had been largely censor-proof as long as costumes were not too revealing, title inserts avoided the obvious, and bedrooms functioned as salons, not places to sleep. Dialogue added a new dimension to characters that were expected to engage in natural conversations. Screenwriter Gene Markey had the vexed job of rendering a fin-de-siècle romance as a contemporary story. Struggles with getting it right continued into filming, with both Brown and Garbo frustrated with the results.

To appease the censors, Brown had to sanitize a scene at the film's conclusion—one in which there was virtually no dialogue. Yvonne, ever noble, takes leave of André for the last time, writing a note while he sleeps. This should be happening in the early-morning hours, but that would reveal they had spent the night together. Instead, Brown films André napping while sitting in a chair in his living room. In the bright light of day, Yvonne pens her farewell and leaves a gently snoring Montgomery unaware of her departure. The facade of chastity remains intact.

Garbo might not be immune from criticism of her behavior, and her films were coming under increasing scrutiny by the censors, but MGM didn't care: their star remained box office gold. Two weeks after the premiere, the returns were excellent: "Garbo in 'Inspiration' eases into top position this week with a gross of $41,021. 'Inspiration' is one of the best vehicles that has fallen to the great Garbo and a big take was expected."[55] *Film Daily* said the actress "dominates every situation and is the Garbo the fans want . . . Garbo brings to the screen all the great possibilities of her talents with a combination of heart-gripping emotion and care-free indifference."[56] A caption under a photograph of Garbo and Montgomery in *Photoplay* (February 1931) reads in part, "Her name before a theater means a flood of gold."[57] The British press was no less appreciative, with one critic observing that *Inspiration* "is another instance of a conventional plot being camouflaged by brilliant acting."[58]

Clarence Bull was one of the team of magicians who worked behind the scenes to ensure that the image that was promoted was commensurate with the public's fantasy of Garbo as goddess. The result was one of his fabled photographs. He superimposed a portrait taken on December 12 on a photograph of the head of the famous Great Sphinx of Gaza in Egypt. It is not certain who first dubbed Garbo Sphinx, but by late 1930 the title stuck. Bull formalized that distinction by fusing the actress and the mythical creature. The Sphinx historically is associated with the sun, but in popular culture, like Garbo, with inscrutable silence.

Most of the written sources from the 1920s and 1930s that discuss Hollywood in general and Garbo in particular are ephemeral: fan magazines, trade papers, newspapers and journals covering the movies, programs, and movie heralds announcing upcoming films. Motion pictures were still in their infancy, and few books were written about this nascent industry. Palmborg's *The Private Life of Greta Garbo* was a rare example of a film star biography. Only a few others stars received such treatment—Chaplin, Douglas Fairbanks, the Talmadge sisters, Valentino (after his death), and producers such as Samuel Goldwyn or Adolph Zukor, although many of these were autobiographies or vanity productions. But slowly books from reputable commercial publishers started to enter the marketplace, as not just fans had an appetite for more definitive descriptions of Hollywood films, stars, and life. Elinor Hughes, the motion picture editor of the *Boston Herald*, published two books in quick succession about Hollywood's top players, the first a beautifully designed volume called *Famous Stars of Filmdom*

(Women) in August 1931 and a companion volume on men the following year. Garbo was the youngest among the sixteen actresses included. In writing about them, Hughes reveals a thoughtfulness typically lacking in fan magazine coverage. Her conclusions about Garbo do not read as extraordinary ninety years after they were written, but how must her fellow actresses have felt reading Hughes in 1932? "A very normal person in private life, she continues to represent on the screen the epitome of mysterious fascination and languorous charm . . . It is amazing to see with what assurance and poise she portrays these ladies of wisdom, experience and sorrow, when one realizes that, after all, she is still very young." Responding to the rumors that Garbo might leave America when her contract expires, Hughes writes, "If this happens, the American screen will suffer an incalculable loss . . . Twenty-five years old, eight years of film experience behind her, and an enigma; answerable to no one but herself, unconcerned with the rest of the world, she remains the idol of millions."[59] Mary Pickford and Gloria Swanson had received similarly enthusiastic accolades before and were literally crushed by fans, sometimes numbering in the thousands, when they ventured out into public. Joan Crawford had emerged as a star of the first rank and also was idolized by an adorning fan base. Garbo was different; she created frenzy while remaining invisible. Pickford and Swanson labored to meet and engage with the public that made them wealthy and legendary. Crawford sent out thousands of signed photographs and answered countless fan letters. Garbo's eighty or ninety minutes on film, with a new work coming out twice a year, was all the public got. MGM was stingy with the number of new photographs sent out, as Garbo posed for so few. Her name was never associated with a product except the MGM brand. Yet at twenty-five she was without a peer on the screen.

As diligent as Garbo was in not allowing her image to be marketed except through MGM, and only in service of promoting her films, once in a while something appeared that must have made her shudder. In 1931 the artist Julian Bowes exhibited a glazed ceramic bust of Garbo at the Society of Independent Artists located in New York at the Grand Central Palace on Lexington Avenue and Forty-Sixth Street. *Photoplay* could not resist running a photograph of the sculpture, full-page, in its May issue, captioned, "Garbo's proportions are identical with the famous statue of Athena by Phidias." Looking at the image today, it reads almost as a caricature and might best be described as kitsch. Bowes was not able to resist the temptation to merchandize his creation and made an edition of five-inch replicas, which sold nationally for two dollars each. How many buyers he found for this statuette is an unanswered question, but a quick search on the internet reveals that examples still linger in the collectibles marketplace.

Frosty silence was the response to any inquiry made to Garbo about her future plans, so when the rumor circulated in mid-1931 that she would appear on stage for Max Reinhardt in Berlin when her contract was up the next year, magazines ran the story—just in case it turned out to be true. As reported in *Modern Screen*

(September 1931), Reinhardt told an interviewer in New York, "I would give any-thing in the world to be able to direct her in a stage production." On the strength of nothing more than that, the magazine asserted, "It is definitely known that the German producer has begun negotiations with the sixteen-thousand-dollar-a-week mystery woman of the American screen." Did Garbo ever consider the pros-pect?[60] She did later work with Reinhardt's son Gottfried, who produced her last film, *Two-Faced Woman*, in 1941. But the press was desperate to report the least spore of news or rumor, and a Garbo–Reinhardt pairing was not an outlandish possibility; if nothing else it kept her name in the headlines.

And if one of her friends talked anonymously about a private evening out and the magazines got wind of the story, it invariably made the press. One evening,

> Garbo accepted an invitation to a stag-party from one of the "stags" who happened to be her friend. To call it a stag-party is to call it wrongly, for in reality the twenty boys or so there were drawn from the ranks of chorus-boys and young juveniles. The kind that wear too-fancy clothes, slave-bracelets, slick their hair until it looks as if it had been soaked in olive-oil, and are not above sneaking a bit of lip-stick and rouge on the sly, they sat around in poses of indolent handsomeness and waited for the great Garbo to arrive.
>
> Garbo did arrive. The door was opened to her, and she took one look into the smoke-filled, perfume-y room. Clapping her hand to her forehead she exclaimed, in her low voice, "Gott! I am de best man in de room."[61]

Saying nothing had made her among the most coveted subjects in journalism. *Photoplay*'s Ruth Waterbury summed up the allure pretty accurately in 1931: "One star in Hollywood can do exactly as she pleases. She can work when she wants to, have any story her lonely heart desires, pick her own directors, leading men, and the very carpenters who pound the sets of her pictures. She can be a recluse and refuse invitations to visit Pickfair. She can snub Will Hays. In other words, she can get away with anything."[62]

The magazines were not so fortunate. If one of the popular Hollywood month-lies did not regularly cover Garbo, readers would write in outrage. "One month we went to press without a picture or a story of Garbo." These words led off a caption for a full-page photograph taken by Bull for *Inspiration* that appeared in *Screenland* (April 1931). "We herewith apologize. We didn't mean it. We think Garbo is the greatest, grandest, most transcendental actress in the whole world, and just to prove it we give you this picture of Our Weakness as she really is—a charming young girl with laughing eyes, but whose genius will not let her rest."[63]

Garbo was the subject of a biography, she was regularly covered in magazines and newspapers, her face was plastered on theater walls. Fans cut out pictures and articles and made scrapbooks tracing her films. In 1930 she achieved the distinction of being included in a work of fiction. Evelyn Waugh published

a contemporary satirical novel, *Vile Bodies*, set in England. A short exchange references Garbo. "'What is at the Electra palace, do you know, Mrs. Florin?' 'Greta Garbo in *Venetian Kisses*, I think, sir.' 'I don't really think I like Greta Garbo. I've tried to,' said Colonel Blount, 'But I just don't.'" Obviously the title *Venetian Kisses* is made up. Do these words reflect Waugh's own judgment of the actress, or is he being deliberately provocative? This might be the first use of her name in an iconic way. A film star, yes, but one whose name is expected to be recognized the world over and which could now be considered an emblem for motion picture stardom.[64]

Over the two years since they were introduced by Ernst Lubitsch, Salka Viertel was increasingly becoming an important part of Garbo's life, a friend she respected and trusted. By 1931 the Viertels were established near the beach in Santa Monica at 165 Mabery Road, about a mile and a half (and an easy walk) from Garbo's new abode on San Vincente Blvd. The Viertels' house had gained a reputation as a gathering place for European expatriates and visitors. The normally reticent Garbo occasionally ventured out during periods when she was not working and might drop in unexpectedly on Viertel, even with the prospect of encountering strangers. Although her friendship with Sörensen had caused her some turmoil, with his departure back to Sweden, Garbo found herself without a pal. Viertel filled this gap in her life and, in a way somewhat reminiscent of Gilbert, provided her with a place to go where she might encounter interesting people. As a guest she had no obligations; if she was amused she would stay, if not she was free to depart. Garbo preferred Viertel's intellectuals over Gilbert's peppy American friends, although she must have missed the regular tennis games up at his house on Tower Grove Road.

One of the illustrious European *émigrés* that Garbo met and befriended through Viertel was director F. W. Murnau. Working for Fox, Murnau had scored two successes directing Janet Gaynor in the Academy Award–winning *Sunrise*, and *4 Devils*. Unhappy at Fox, he set off without studio backing to make a documentary film in the South Pacific. Throughout much of 1930, he worked in Tahiti on *Tabu*, with a script by Robert Flaherty, who had made *Nanook of the North* back in 1922. Paramount picked up the distribution rights for *Tabu*, and Murnau was back in Los Angeles editing the final cut in the winter of 1931. Salka Viertel and Murnau were particularly close friends, and while editing he "came every evening to have dinner with [the Viertels]."[65] With the Paramount deal signed, he agreed to return to Germany to promote the film in Europe. Before he left, one remaining obligation was a trip up the California coast to Monterey, where he would be working on a photographic serialization of *Tabu* for a magazine. Murnau, his chauffeur John Freeland, and a young man, Garcia Stevenson, along with his dog, Pal, left Santa Monica on March 10; approaching Santa Barbara, the car, "while swerving to avoid collision with a truck . . . plunged off an embankment, rolled over twice as it crashed down thirty feet."[66] Murnau was seriously

injured and died the next morning. It turned out that his young companion, the fourteen-year-old Stevenson, had been driving, against the wishes of the chauffeur. Both Stevenson and Freeland survived. Learning of the accident, the Viertels immediately drove up to Santa Barbara and were with Murnau when he died. Although he was a highly respected filmmaker, his funeral on March 19 was attended by only eleven friends. Along with the Viertels, among those paying tribute were director William K. Howard, actors George O'Brien and Herman Bing (who had a small role in the German *Anna Christie* and had accompanied Murnau to America), and Garbo.[67]

SUSAN LENOX

Garbo had a five-month rest before starting her fifteenth film, *Susan Lenox (Her Fall and Rise)*. In April the studio reported the film would be directed by King Vidor,[68] but by the next month Thalberg replaced him with Robert Z. Leonard, one of the most reliable in MGM's stable of directors. As we have seen, during its first decade, the studio subordinated the role of the director to that of producer. Although Leonard is also listed as producer on *Susan Lenox*, he worked for Thalberg, and it would be Thalberg alone who would approve the film's final cut. Garbo's films had a sameness that was attributable in part to the stories. But individual style, typically associated with a director's work, was usually crushed by the weight of the MGM brand. What was consistent, and consistently distinguished in Garbo's films, was the cinematography and set design. Daniels photographed nearly all Garbo's films, and Cedric Gibbins oversaw the art direction. Adrian designed the wardrobe of Garbo and the other leading ladies, and Douglas Shearer (Norma's brother) was in charge of sound. Each of the major studios had an individual style that was rigidly controlled by the front offices. History would know a different version of Garbo had she been signed originally by Warner Brothers.

Susan Lenox, like many of Garbo's films, was based on a popular novel. David Graham Phillips finished the manuscript in 1911 but was murdered that year, contributing to the book's notoriety. Published in two volumes in 1912, *Susan Lenox* is the story of a young woman, Helga, born illegitimate, who, shortly before entering into a marriage forced by her father, escapes and has a series of romantic adventures—joining the carnival, appearing on stage, living in a Park Avenue penthouse, traveling to South America—before finding true love (and redemption, thus the "fall and rise" of the title) with Clark Gable. Clean-shaven Gable was a new recruit at MGM, one of the generation of actors hired during the transition to sound. In his first year at the studio, he was rushed through a half dozen films and costarred successfully with Norma Shearer, Jean Harlow, and Joan Crawford. MGM's producing team was looking for replacements for John Gilbert, William Haines, and possibly Ramon Novarro, the latter two considered

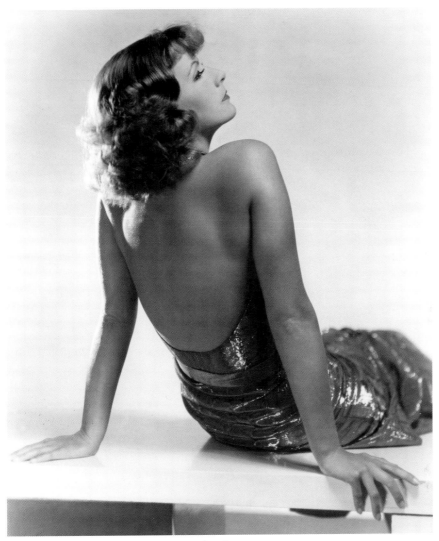

Clarence Sinclair Bull, for *Susan Lenox: Her Fall and Rise.*

possibly too effeminate for talking pictures. A new breed of leading man was born in Hollywood around this time, and masculine and handsome (with moustache) Gable would turn out to be the archetype. Thus far in talking pictures, Garbo had worked well with rugged Charles Bickford, disastrously with the effete Gavin Gordon, and satisfactorily with the youthful Robert Montgomery, but she needed a strong costar to reignite the magic moviegoers had witnessed in her silent love scenes with Gilbert. Would Gable be the answer?

The answer was yes and no. Gable proved to be a good pairing with Garbo, and they believably conveyed desire for each other. Still, his aggressive manliness was at odds with the way Garbo was increasingly being presented on-screen.

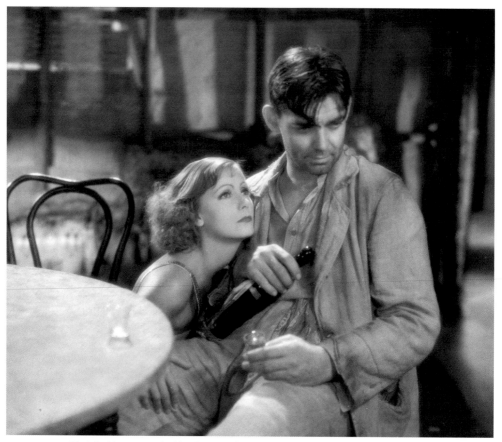

Clark Gable was an ideal leading man for Garbo; his overt carnality melted her cool glamour. Alas, she would never again have such a good romantic partner. Photograph by Milton Brown.

With each new film, she seemed more distant. Her beauty ripened, her acting remained irreproachable, but the flesh-and-blood woman was viewed as a remote goddess. This was part of MGM's strategy: elevate Garbo to Hollywood's uppermost echelon, where she would be alone and inviolate. Sex remained on the menu, but after her next film, *Mata Hari*, it became more of an idea than a physical act. The grand ladies she would play after 1932 might swoon with passion (once in a while), but no later leading man would take Garbo into his arms as convincingly as Gable did in *Susan Lenox*.

Shooting took place over most of May and June; there were rumors of strife during the production, and there were even suggestions that Garbo walked off the set one or more times, belying her reputation for professionalism. One small issue troubled MGM's front office, but it involved Gable and not Garbo. He had been living openly with Maria Langham, sixteen years his senior, who decided that now that Gable was on the verge of stardom, she wanted to become his wife. Gable resisted, looking to return to his bachelor ways and hoping to continue his

Garbo's dressing room at MGM. Hanging on a hook at right is a costume for *Susan Lenox*. Photograph by Milton Brown.

affair with the married Joan Crawford. Langham went to Howard Strickling and promised to call every reporter in Hollywood if Gable did not come through. The strict moral clause in Gable's contact with MGM was clear: either he married Langham, or he would be dropped by the studio. On Friday, June 19, they were married at the courthouse in Santa Ana.[69] Filming of *Susan Lenox* continued the next day—or maybe not. A tidbit from September's *Modern Screen* suggested the cast and crew were in a conspiracy to avoid working on Saturdays. "Director Bob

Leonard is mighty glad that Greta Garbo always picks Saturday to get sick and not appear at the studio for work . . . He likes his Saturday tennis match down at Malibu—and when there is no Garbo, there's no work."

Nearing twenty-six, Garbo was considered a mature actress. For the most part, in future films she would be cast opposite established actors such as John Barrymore, Ramon Novarro, John Gilbert, Frederic March, or Charles Boyer. No more hot (young) red-blooded American males for Garbo. It's a pity, because Gable might have suited her. But Hollywood prejudices were already set. Although at thirty Gable was nearly five years older than Garbo, when they shared the screen, he registered as a younger man. What he projected was decidedly carnal (and not cerebral), which is why he worked so well with Crawford and Harlow. Never working with Garbo again did not hurt Gable's prospects for success, and he soon became Hollywood's number one leading man and remained a top star for the next thirty years. Among women, only Joan Crawford and Katharine Hepburn approached Gable's professional longevity, and both enjoyed top-line success for more than three decades.

However ethereal Garbo was becoming in the cinema, on the ground her pictures were continuing to make money. The *Film Daily* put it succinctly following *Susan Lenox*'s opening in October: "Here's one to bring in the real dough."[70] The *New York Times* corroborated the phenomenon: "The Capitol was thronged yesterday for the first showing of Greta Garbo's latest picture, 'Susan Lenox.'"[71] *Motion Picture* called it "second-rate" but added, "Don't miss seeing 'Susan Lenox.'" One theater in Troy, New York, sponsored a promotion in conjunction with *Liberty*, a popular weekly magazine. Eight thousand photographs of Garbo were ordered, inserted into the magazine, and given away free to patrons.[72] Providing these take-aways turned out to be a successful gimmick and added to the theater's return at the box office.

MERCEDES DE ACOSTA

Mercedes de Acosta was born in New York City in or about 1892, the daughter of a prominent Spanish family. In 1920 she married the artist Abram Poole, although by the end of the decade they were living largely separate lives. De Acosta came to Los Angeles in 1931 with an introduction from New York theatrical agent Bessie Marbury and the prospect of working as a screenwriter at RKO.[73] Marbury suggested that de Acosta, who had written several plays, might be able to come up with a good story for Pola Negri, who was hoping to renew her stalled film career after a three-year European sojourn following her (unwise) marriage to Serge Mdivani and her foolish decision not to extend her lucrative Paramount contract, which had expired in late 1928. De Acosta's career as a playwright was unremarkable, but during those years she befriended many of the theater's most

admired actresses and, if her accounts are accurate, took many to bed. The list is long and gossipy, and included Eva Le Gallienne (certainly a lover), and (probable) Eleanora Duse, Alla Nazimova, and Isadora Duncan. Film work was a new venture for de Acosta, and with several produced plays to her credit, along with the support of a powerful coterie of women, she got her chance. De Acosta worked with playwright and screenwriter John Colton on a script titled *East River*, which was purchased for Negri by RKO but never produced (in 1932 Paramount bought it for Marlene Dietrich, but it was still never made).

In her memoirs published in 1960, de Acosta recalled that on her third day in Los Angeles, she was invited for tea at Salka Viertel's house in Santa Monica. She must have known of Viertel's friendship with Garbo and expected, or at least hoped, to encounter her. De Acosta claimed that years before in Berlin she had purchased a bracelet for Garbo, presumably anticipating that one day they would meet. Garbo did turn up, and the gesture was made. According to de Acosta, "she didn't stay long. She explained that she was still shooting *Susan Lenox* and had made this visit as an exception. 'I never go out when I'm shooting. Or perhaps, I just never go out,' she said, adding with a laugh, 'Now I will go home to dinner which I will have in bed. I am indeed an example of the gay Hollywood night life!'" De Acosta was bewitched, and when Viertel returned from walking Garbo to the door and told her, "Greta liked you and she likes few people,"[74] the newcomer set her sight on this Hollywood prize.

They soon met again at the Viertels' house, and if de Acosta is to be believed, Garbo was equally entranced by her new friend. As they started spending more time together, de Acosta became acquainted with Garbo's mercurial behavior: "I realized how easily her moods and looks could change. She could be gay and look well and within five minutes she would be desperately depressed and apparently terribly ill."[75] Following the completion of *Susan Lenox*—"My present prison term is over"[76]—Garbo borrowed "a little house on an island in a lake in the Sierra Nevada" from actor Wallace Beery: "No one will know where I am and no one can reach me."[77] Off Garbo went on her solitary idyll, and de Acosta reported to Paramount to work on the screenplay for *East River*. Two days later Garbo called: "I am on my way back. I have been to the island but I am returning for you." She did, and with her chauffeur, James, at the wheel of Garbo's Packard, the two women set off for the mountain retreat three hundred miles north of Santa Monica.

De Acosta said the vacation lasted six weeks, but she contradicts herself, having earlier asserted that Beery's loan was for just three weeks. Nevertheless, there is no doubt that the new friends spent time together in the Sierras in late July and early August 1931, probably no more than two weeks, given the late invitation and travel time. Garbo never mentioned the holiday, but de Acosta did and took many photographs that have been published over the decades. They show a happy and seemingly relaxed, suntanned Garbo, sometimes topless, with the magnificent mountain scenery as a backdrop. Given Garbo's aversion to being photographed

outside MGM, and her increasing suspicion that friends might betray her to the press, it is astonishing that she allowed this license. The images might be the best evidence that Garbo shared at least a close friendship with de Acosta.

When she returned, Garbo was called back to the studio for some finishing touches on *Susan Lenox*. Although de Acosta describes a long idle period between it and Garbo's next film, *Mata Hari*, the new film was under way by late September 1931. We do correctly learn that Garbo moved residences once again, leaving San Vicente Blvd for a new place in Brentwood. Did Garbo move so often because her addresses were discovered by pesky fans? "Garbo herself is 'somewhere in Santa Monica,'" wrote Cal York in *Photoplay* (December 1931). "Nobody knows the address—not even studio execs."[78] In a city where famous folks lived in splendid houses well known to the public—Mary Pickford and Douglas Fairbanks at Pickfair, John Gilbert on Tower Grove Road—why couldn't Garbo find a residence that she could ensure was private? Perhaps her unwillingness to buy property was the issue. De Acosta took this move as an opportunity to further insinuate herself into Garbo's life. The house next door to the new Garbo place on Rockingham Road was available, and she rented it. The moment coincided with her being dropped from Paramount's writing staff, as it became official that the option on Pola Negri's contract was not going to be exercised, and the script for *East River* was placed on the shelf. With no studio work to keep her busy, Garbo became her primary occupation and obsession.

MATA HARI

Ramon Novarro needed a hit. The star of *Ben-Hur* had remained among MGM's most popular and durable stars through the silent era, and while he made a successful transition to talkies, none of these films was a box office bonanza. In 1931 Novarro starred in two pictures both directed by Jacques Feyder: *Daybreak*, which recorded a small loss, and *Son of India*, which showed a small profit. Novarro was drawing a salary of $125,000 per picture, which contributed to the tepid margins these films returned to MGM.

It had been MGM's policy not to cast two frontline stars together in a film. Costarring Gilbert and Garbo in *The Woman of Affairs* was an exception made deliberately to appease fans. Box office returns were strong, although either star alone might have been sufficient to generate the profits realized. As the Depression reached its second year and revenues were slipping, Thalberg decided it would be in the studio's interest to change the policy. Previously, Novarro had worked with Helen Chandler on *Daybreak* and Madge Evans on *Son of India*—but neither actress is much remembered today. Garbo had costarred with the forgotten Gavin Gordon in *Romance*, although in her next film, Gable clicked with audiences and went on to become a motion picture legend.

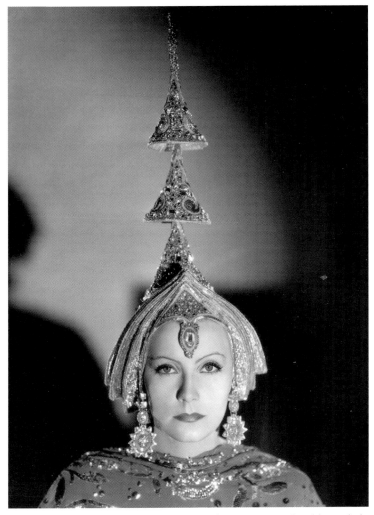

Clarence Sinclair Bull photographed Garbo in Adrian's outrageous headdress, which she wore in the opening scene of *Mata Hari*. Courtesy John Kobal Foundation

Mata Hari was up next for Garbo, and Thalberg proposed Novarro as costar. He wanted to work with Garbo and was anxious to be cast in what would surely be a popular attraction. The problem was money and credit. Novarro's contract was up for renewal, and the studio dropped hints in the trade papers that he was variously being difficult in salary negotiations and/or was leaving MGM (for a singing career; to enter a monastery . . .) . A deal was reached wherein Novarro would be paid $50,000 for *Mata Hari*. Previously, Novarro received sole over-the-title billing. This time it would be Garbo before Novarro in all the film's advertising and promotion.

An often-quoted story is that on the October morning the cast and crew began working on *Mata Hari*, Novarro left a bouquet of pink roses in Garbo's dressing

room with a note that read, "I hope the world will be as thrilled to see Mata Hari as I am to work with her."[79] Although the two had worked at MGM for six years, there's no evidence they ever socialized. Back in early 1926, as Garbo's first film was being readied for release, *Ben-Hur* opened and began its amazing journey to become one of silent films' box office juggernauts. Six years later the thirty-two-year-old Novarro's star still shone over Hollywood, but its luster was waning. *Mata Hari* would prove to be a tremendous success for both leads and MGM, yet it would also mark the moment when Novarro's career began its descent; Garbo's fame, on the other hand, would continue to soar.

Mata Hari was based on the life of Margaretha Zelle (1876–1917), a Dutch-born exotic stage performer and prostitute who was accused of spying for Germany during the First World War and executed for treason in 1917. Zelle was known for her remarkable wardrobe, and Adrian's designs closely approximate the sorts of outlandish costumes she wore on stage. The film depicts Mata Hari as still performing when she was accused of spying, although historical evidence suggests her career was over well before the start of the war. The story nonetheless provides viewers with an atmospheric adventure at least founded on truth.

Such a film was bound to run into censorship problems, especially as the Hays office (the Motion Picture Association of America) was diligently watching over scripts. It would be another two years, however, before the censors would come down once and for all, eliminating the prospect that something like *Mata Hari* could be made in Hollywood for many years to come. Mata Hari, in life and on film, was a beautiful woman who had affairs with many men, just the sort of character that Garbo had established as her principal stock in trade. Casting Novarro as Alexis Rosanoff, the fictional Russian flyer who succumbs to Mata Hari's charms (and who remains loyal to the end), was a nod to the censorship concerns. The decidedly boyish quality he projected on the screen in his love scenes with Garbo (though six years older than she, he reads younger alongside her) let some of the steam out of the script, perhaps placating the Hays office, which left it intact. These issues were not confined to America, and *Mata Hari* was initially banned in Great Britain, although strategic edits finally made it palatable to British censors.

Adrian's costumes for *Mata Hari* must rank as among the best he ever designed. At the film's beginning, the extravagantly costumed Garbo, wearing a crownlike hat with a twelve-inch spire is shown dancing, and it is one of the few times she looks awkward and ill at ease before the camera. Slinking about on stage might have worked for the original Mara Hari, but after Garbo bravely thrusts her hips at the audience for a few seconds, the camera gracefully pulls away. Director George Fitzmaurice was new to the Garbo team. Daniels was back as cinematographer; Lewis Stone, Lionel Barrymore, and Karen Morley supported Garbo. Collectors today dispute whether the best portraits Clarence Bull took are of Garbo attired in the outlandish Asian fantasy costumes (with the headdress

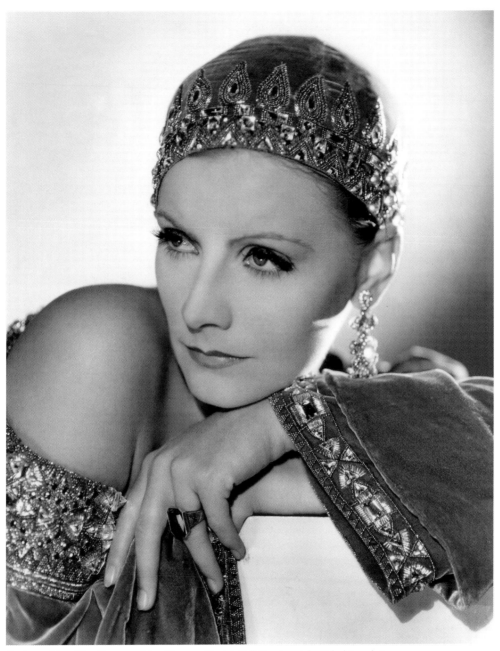

Garbo as Mata Hari. Photograph by Clarence Sinclair Bull. Courtesy John Kobal Foundation

Adrian's costumes for *Mata Hari* are acknowledged as among the best ever created for a Hollywood film. Photograph by Milton Brown. Courtesy John Kobal Foundation

most especially) or the deceptively simple photographs of Garbo in an unadorned black dress with her hair combed severely back, as Mata Hari awaited execution before the firing squad.

When Garbo resolved not to work past five is unknown, but Novarro records this practice during the making of *Mata Hari*.[80] The tradition in Hollywood was that shooting continued until the director concluded for the day (which often might go well into the evening). Garbo decided to protect the possibility of a good night's sleep and left the set promptly as soon as the signal from her maid was spotted. If she agreed to work a little longer one afternoon, she would appear commensurately later the next morning.

Another habit of Garbo's was her unwillingness to go over lines with her co-stars. "When we began to work together I discovered Miss Garbo did not care to rehearse. It was her habit to walk into her scenes and go right through with them." Novarro was one "to rehearse with the lights, camera, microphones, just as it will be when it is actually filmed."[81] Garbo relented, he wrote, and they did prepare their scenes together prior to the cameras rolling.

Mata Hari was a huge success for Garbo and MGM. Profits to the studio nearly hit $900,000. Critics liked the movie, and most fan magazines ran features about Garbo's wardrobe or exciting costar. *Screenland* gave readers a seventeen-page feature and concluded by asking readers, "Is Garbo in 'Mata Hari' greater than Garbo in 'Susan Lenox' and Anna Christie'? You decide!"[82]

As a 1931 holiday gesture to moviegoers, MGM produced a nine-minute short titled *The Christmas Party*, released the week before Christmas. The studio produced dozens of short subjects each year, but this one was unique, as virtually every top star on the lot appeared. The gimmick was a Christmas party on an MGM set hosted by child actor Jackie Cooper for his young friends. The adult stars served as waiters. Marie Dressler stood behind the buffet table alongside Wallace Beery and Polly Moran, serving the children. Clark Gable, Marion Davies, Norma Shearer, Lionel Barrymore, Anita Page, and Ramon Novarro were among the stars recruited to pass food and drinks and chat with the kids. Only Garbo was excused. She had different plans for Christmas, and once *Mata Hari* was completed, she managed to get from Los Angeles to New York City for a vacation without being spotted.

Accompanying her were Salka and Berthold Viertel. Perhaps de Acosta was being too insistent, and Garbo needed some distance, but in any case it seems that competition for her attention was mounting between the two women. Both were older—de Acosta twelve years, Viertel sixteen years—accomplished and sophisticated, and they traveled in the company of many of the era's most interesting people. But they did not like each other, and Garbo was the reason. She traveled the four days to New York under the name Gussie Berger and checked into the brand-new Hotel St. Moritz on Central Park South. For a time she managed to remain anonymous, but soon word was out. She was spotted at a speakeasy with Berthold, and one afternoon at the Metropolitan Museum of Art. Another evening she watched Katherine Cornell in *The Barretts of Wimpole Street*. If accounts are accurate, Garbo went backstage to greet the stage legend and was rebuffed—no one in Cornell's entourage believed it was really she. When Cornell discovered Garbo was indeed in town, she remedied the slight with a dinner invitation. Novarro was also in New York, and he and Garbo were spotted together in another speakeasy (she insisted they meet "in places off the beaten path—places where roving eyes behaved"[83]); naturally this sparked rumors of a secret romance.[84] The St. Moritz could not resist marketing its movieland associations. Copy from an ad that ran throughout 1933 and 1934 read, "These Celebrated Film Stars Make

THE ST. MORITZ Their New York Home"; first on the list was Garbo, followed by Joan Blondell and Joan Crawford. On future trips to New York she took her business elsewhere.

An enterprising con man set up a telescope in Central Park and charged voyeurs for a purported peek at Garbo. "The telescope commanded a view of a St. Moritz room. In the room one of the innumerable Garbo doubles walked back and forth in front of the windows. For a quarter and a squinted eye the suckers could see her."[85] Another time she was spotted in the park and chased by one or more ardent fans; only a passing taxi saved her from this unwanted intrusion. "No spy in a foreign country, under war conditions, has been more thoroughly shadowed than Garbo has been by Hollywood's writing sleuths,"[86] Ruth Biery had written just before Garbo left for New York; by the time her article appeared in *Photoplay* in January, the actress was dodging both reporters and fans and in New York. Caught by members of the press while changing trains in Chicago as she headed back to Los Angeles, Garbo exchanged a short volley with her pursuers and answered the shouted questions. "No, I am not in love. No, I will never marry. No, I am not to stop playing in movies, they are my life to me. I am happy to have left New York. They are so impolite in New York."[87]

GRAND HOTEL

Garbo's New York excursion coincided exactly with the start of the production of her next film, *Grand Hotel*, which ushered in a new type of movie: the all-star cast. During the fall Hollywood's press closely followed the tidbits parceled out sparingly by MGM publicity. Would Garbo play the role of Grusinskaya, the aging ballerina? Would Thalberg cast her alongside John Barrymore, Lionel Barrymore, Wallace Beery, and more significantly, Joan Crawford, who had become one of the most popular female stars? Although the trades enjoyed reporting, "She's in," "She's out," no one else was ever really taken seriously as a possible Grusinskaya. Thalberg's challenge was to have Garbo agree to share the over-the-title credit with such a long list of star actors, and for the first, and last, time with another woman.

Edmund Goulding was assigned to direct; work began at 9:00 the morning of December 30, 1931, when the cast came together for a reading of the script.[88] Lewis Stone and Crawford arrived punctually; both asked to be excused, claiming they already knew their lines. Beery soon followed, and by 10:30 the Barrymores had arrived. Someone had the audacity to ask, "Where's Garbo?" Did Goulding have the courage to tell his high-wattage talent that Garbo was vacationing in New York? Spending time in New York would make joining the assembled group impossible, which might have been the point of Garbo's trip east. Goulding arranged the film's shooting schedule so that Garbo's scenes would be shot at the end of the production. Among the illustrious cast, Garbo would work with only

one, John Barrymore. Crawford mentioned many times that she never met Garbo while the film was being made. In an interview for a British magazine, Goulding said, "No director has any right to take any bows for any performance of Garbo's. She is director proof."[89]

Garbo was back in Culver City and ready to work in mid-January. On the first day her scenes were to be shot, so the story goes, Garbo decided to greet John Barrymore outside the entrance to the set. He apparently entered another way, and when Garbo had not appeared fifteen minutes after work was set to commence, Goulding sent one of his assistants to find her. A prop boy, in on Garbo's plan, approached Barrymore and said, "Miss Garbo has been waiting outside the door since nine o'clock to escort you to the set. It was an honor she wanted to pay you."[90] She enjoyed working with Barrymore, and before shooting was completed, she said in front of others on the set, "You have no idea what it means to me to play opposite so perfect an artist."[91] Recalling their time together shooting *Grand Hotel*, Barrymore claimed that "simplicity" was responsible for Garbo's great success and that "she has eyes like a boa constrictor and can see anyone strange on the set immediately." [92]

Grand Hotel was Garbo's first American film where her character did not dominate the drama. Most of her scenes were shot in Grusinskaya's suite, and she worked largely with members of the film's supporting cast. The ballerina's deep malaise, a combination of advancing age and loneliness, was temporarily broken by the sudden appearance of a jewel thief played by Barrymore. This was a peculiar part for Garbo. Never before had she played a victim. When she stood before a firing squad as she did in *Mata Hari*, or committed suicide as she did in *Love*, and perhaps in *A Woman of Affairs*, her characters seem in control of their destinies. Grusinskaya, on the other hand, is a pathetic figure. It is fascinating watching her come to life under the strange seduction of Barrymore, and it is certainly a treat to watch two great cinema professionals share the screen. But Garbo never seems settled in the role, which is fragmentary rather than demanding a complete characterization. Better is watching her change from a negligee to a ballet costume and finally to a traveling suit. In the film's time frame of twenty-four hours, she passes through the hotel lobby four times in four fabulous fur coats.

Screen credit proved not to be a problem. Garbo was listed first, John Barrymore second, and Crawford third, followed by Beery and Lionel Barrymore, all above the title. And though, as noted in *Motion Picture* (April 1932), "beginning with 'Grand Hotel,' Greta Garbo will drop her first name and will be billed simply as Garbo," posters and other forms of publicity credited her both ways; this would continue for the balance of her film work.

While work on the new film was under way, *Mara Hari* premiered in Hollywood on Thursday evening, January 26, 1932, at Grauman's Chinese. A stiff five-dollar admission was charged, and Sid Grauman produced what was reputed to have been a spectacular live show (including a fan dance and a ballet) to kick

The cast of *Grand Hotel* never appeared on the set at the same time, so a studio photographer cleverly pasted together a series of images meant to suggest MGM's expensive cast answered the call for a group shot.

off the program before the main feature. The souvenir program was a sumptuous embossed silver affair tied with a cord and sporting a cover photograph of Garbo in a decorative window-cut mount. She herself, of course, did not attend. After a long day's work, she was home trying to get a good night's sleep.

Typically one still photographer was assigned to a film and would make the necessary publicity and continuity photographs; ordinarily about one hundred on-the-set stills would be taken. Milton Brown was assigned to *Grand Hotel*,

Fred Archer worked sporadically at MGM and was hired to be among the many photographers who shot stills and portraits on the set of *Grand Hotel*. Archer made this elegant portrait of Garbo as the ballerina Grusinskaya.

having shot Garbo on her six previous films beginning with *The Kiss*. Brown is one of the small group of unheralded still photographers who extensively photographed the top stars, but whose work has come down through film and photography history uncredited. George Hurrell, Clarence Bull, and Ruth Harriet Louise are remembered today and collected avidly, but Brown and his MGM colleagues who also worked with Garbo, James Manatt and William Grimes, are forgotten even though their work is still regularly reproduced. Brown was likely the photographer who created a *Grand Hotel* "cast shot," which artfully pasted together a collage of the principals who were never all on the set together, along with director Goulding sitting off to the side in the background.[93]

Grand Hotel was a complicated production with a shooting schedule that had to accommodate the schedules of all its top stars. MGM's publicity department, which oversaw the still and portrait work, had to navigate carefully the relationships performers had with photographers. Joan Crawford, for example, was brilliantly served by Hurrell, who took her finest portraits. He rarely worked on film sets but did for *Grand Hotel*, making remarkable photographs of her as well of Beery, and the Barrymore brothers. After *Romance*, Garbo would not

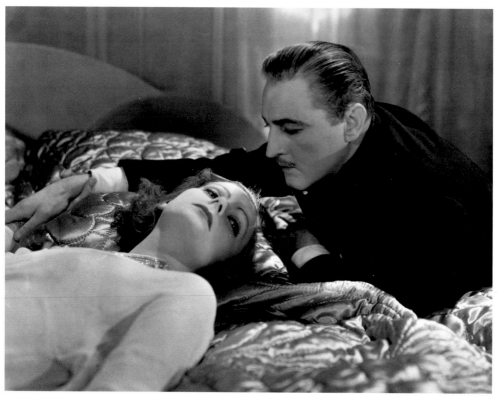

The lonely ballerina meets the aristocratic jewel thief played by John Barrymore in *Grand Hotel*.
Photograph attributed to Clarence Sinclair Bull. Courtesy John Kobal Foundation

allow Hurrell to take her picture, either in the portrait studio or while working. While Brown made stills throughout *Grand Hotel*, he seems to have stood back when Hurrell was on the set. Fred Archer, a leading Hollywood photographer who had previously worked at Universal and Warner Bros, was also called in. He worked mostly freelance during the early 1930s, often filling in when needed at Paramount. It is not clear how many photographs he made for *Grand Hotel*, but he was at MGM toward the end of the production and photographed scenes that included Garbo. Unfortunately, few of his photographs are credited; among those securely given to him are photographs of Garbo in a ballet costume. Garbo did not have a portrait session with Bull after filming concluded, although there is some evidence that he shot her with Barrymore on the set one day.[94] A photograph of Garbo with John Barrymore in a romantic embrace was included in a portfolio of photographs Hurrell issued in the 1970s; though he boldly signed his name to each print in the edition, the shot might have been taken by Bull (or Brown or Archer). Had Hurrell forgotten he was not the photographer, or could he not resist the chance to take credit for such a glamorous image?

As *Grand Hotel* had begun its life as a best-selling novel, had become a smash on Broadway, and was now sure to be a successful film, Vicki Baum's book was an

obvious candidate for a Grosset & Dunlap Photoplay Edition reprint—the third time a Garbo film would get this treatment, after *Love* (*Anna Karenina*) and *The Single Standard*. For *Mata Hari*, Blue Ribbon Books issued a reprint edition of Thomas Coulson's biography, which formed the basis for the film. Typically these books were illustrated with something on the order of a half-dozen scene stills and wrapped in a bright colorful dust jacket. For the *Grand Hotel* reprint, the Depression economy necessitated skipping photographs in the book, although retaining an illustrated dust jacket. To distinguish Garbo her photo was in the center, and she was depicted in a circle; her costars were above and below, and their pictures (slightly smaller) were in a square format.

MGM planned a noisy release for *Grand Hotel* lest anyone mistake this extravaganza for a run-of-the-mill programmer. Grauman's Chinese hosted the star-studded West Coast premiere on April 12, 1932. The evening began with an exciting Pete Smith short, *Swing High*, starring the Flying Codonas. A reported crowd of twenty thousand gathered to see the stars arrive. Along with many from *Grand Hotel*'s stellar cast, others among MGM's top draws were in attendance, including Harlow, Gable, and Shearer. So too was Marlene Dietrich, as well as rival producers Darryl Zanuck and Jack Warner. Conrad Nagel received guests in the front of the theater while MGM cameras recorded the parade. Will Rogers, one of the highest-paid performers of his era, served as master of ceremonies. His fame and popularity placed him among the elite of Hollywood, national politicians, and sport stars. A leading vaudeville player and humorist, he later made movies that generated huge revenues for Fox, was a prolific author, and penned one of the most widely read newspaper columns in the country, "Will Rogers Says–."

"After I had introduced all the principals of the cast except John Barrymore, who was not there," he wrote on May 15, "I announced that on account of the importance of the occasion and the prominence that this particular picture had received, that Miss Garbo would break her rule and be there . . . Well, I had framed up a gag with Wally Beery . . . and he got some dame clothes. And he was my Greta Garbo. Sounds kinder funny don't it.

Well it wasn't to them . . . Wally did fine . . . Now they should have known that Garbo wasn't going to be there any more than Coolidge, but they go and believe it and then get sore . . . Now about the only way I got making good is to produce Garbo some time. Course I cant do it."

Rogers was a pro and carefully thought out and staged any gag meant to entertain his audience, but he had not counted on the reverence Garbo's fans had for their favorite, and they were unwilling to see her unflatteringly parodied. Rogers and Beery bombed.

Gentle parody might be tolerated. A year after the release of *Grand Hotel*, Vitaphone (the short subject department of Warner Bros.) made *Nothing Ever*

Happens (1933), a humorous burlesque of it. No coincidence is the casting of
Geraldine Dvorak, Garbo's former double at MGM, as the dancer, here called
"Madam." The screenwriters wrote a rhyming script, which worked pretty well;
many of the characters break into song at some point during the film's nineteen
minutes. Dvorak bears hardly any facial resemblance to Garbo, and she registers
poorly as an actress, as she spews out one Garbo cliché after the next. She might
have been acceptable standing in for Garbo on the set, but her talent seems to
have ended there. Better was the Garbo caricature that *Vanity Fair* commissioned
from Miguel Covarrubias for the cover of the February 1932 issue. One of Amer-
ica's foremost illustrators of the period, he was well known for his "Impossible
Interviews," which paired unlikely subjects such John D. Rockefeller and Joseph
Stalin, or Garbo and Calvin Coolidge. *Vanity Fair* covers generally featured poli-
ticians like Mussolini, Hitler, or New York mayor Jimmy Walker; the Garbo image
gave readers some relief from the trials of the Depression and the worsening
conditions in Europe.

AS YOU DESIRE ME

Five years had passed since Garbo and her MGM producers locked horns over
wages and scripts in the winter of 1927 as *Flesh and the Devil* was opening in the-
aters. She was now in the final year of that contract, drawing $6,000 per week, one
of Hollywood's highest salaries. Well worth her pay, every one of her MGM films
showed a profit, except *The Temptress* back in 1926. Along with the money came
tremendous fame and the status of unrivaled first lady of Hollywood. With days
added here and there for illness or time off, the earlier contact was set to expire
on April 24, 1932. The press hinted that Garbo was finished with Hollywood, and
as soon as her commitments were satisfied, she would leave America for good.

Before that could happen, Thalberg rushed Garbo into her fifteenth film under
the current agreement (and eighteenth since she had started at MGM in 1925).
With barely a month off, she began work in *As You Desire Me* based on Luigi
Pirandello's play *Come tu mi vuoi*. Garbo would play the role of Zara, an amnesiac
working as a cabaret performer who might or might not be the wife of an Italian
aristocrat. MGM was running out of romantic leading men. Continuing the
goal of releasing a new feature nearly every week put stress on the casting office.
The great ladies of the 1920s continued as the studio's marquee names: Garbo,
Shearer, Davies, and Crawford. Robert Montgomery and Clark Gable had been
added to the male ranks, but Garbo had recently costarred with both. For her new
film, two actors were borrowed to play her competing romantic interests. Silent
director Erich von Stroheim returned to MGM to work on the acting side of the
camera. Garbo had expressed interest in working with him in a 1929 interview
with Mordaunt Hall. Thalberg, who had dismissed von Stroheim back in 1925

In *As You Desire Me*, Garbo, wearing a short blond wig, plays Zara, an amnesiac cabaret entertainer who might or might not be the wife of an Italian aristocrat. From left: Albert Conti, Garbo, Roland Varno. Photograph by Milton Brown.

when he was directing *Greed* due to the director's slow pace and cost overruns, must not have been enthusiastic about bringing him back, but Garbo prevailed, and he was cast as her cruel lover. For the romantic lead, the man who might (or might not) be her long-forgotten husband, Thalberg borrowed Melvyn Douglas from Samuel Goldwyn.

George Fitzmaurice directed and offered movie fans what must have been a shocking sight—Garbo as a platinum blonde with hair chicly styled and closely cropped. For the opening scene in a nightclub, Adrian designed a stark but elegant costume: tight black pants and a waist-length black smock. She changes into an equally vivid black dress, mostly backless. Both outfits dramatically set off her new look, which signaled audiences that Zara would be a match for von Stroheim's brutality. Later, when Garbo leaves him to determine if she is in fact Douglas's long-lost wife, her character is reimagined. The high-wattage siren Zara becomes Maria, the elegant goddess; both guises were catnip to her fans.

Melvyn Douglas was new to films, and in his motion picture debut he worked with Gloria Swanson. On Broadway he had starred in *Tonight or Never* with his wife Helen Gahagan. Samuel Goldwyn bought the play for Swanson and brought

Melvyn Douglas costarred with Garbo in *As You Desire Me*. For this film her character assumes two distinct personalities, the sophisticated woman of the world and the elegant wife. Photograph by Milton Brown.

Douglas west to re-create his role. "Miss Swanson . . . was having things very much her own way at this stage in her career," Douglas wrote. So too was Garbo. Like most of her costars, Douglas claimed that he "never got to know Garbo well." And like all others, he was captivated by her beauty: "Garbo had an extraordinary face . . . When she began to play, it acquired an astonishing animation." Stage-trained, however, he was critical of Garbo's line reading: "Her best work was done in love scenes . . . Her technical abilities for other kinds of scenes were not as fully developed."[95] Douglas was one of the few actors to work with Garbo who had anything other than the highest praise for her ability before the motion picture camera.

Nearly all MGM films were made at the Culver City studio, on sound stages and on the plentiful backlots that could be used for urban or suburban exteriors. Garbo rarely left the studio to work; one exception was for *The Single Standard*, where scenes were filmed on board a yacht sailing around Catalina Island. Three years later the waterfront scenes for *As You Desire Me* were filmed at Laguna Beach. To shoot the film's interiors, meant to evoke the Mediterranean villa owned

by the count played by Douglas, cast and crew headed up to James Waldron Gillespie's palatial Montecito estate, a location favored by film crews seeking a continental ambience that nicely replicated Monte Carlo, Portofino, or any other sun-drenched European coastal locale.

Fans enjoyed the novelty of an all-star-cast production and relished Garbo's role in *Grand Hotel*, but they would have been glad to see her headlining a film on her own once again. Zara/Maria dominates every scene in the film. The story suited Garbo perfectly. Not only was she a woman torn between two men, but the mystery of her character's identity jibed beautifully with the enigmatic persona both Garbo and her studio perpetuated. The entire supporting cast is good, and much pleasure derives from watching von Stroheim. Unlike Douglas he had nothing but praise for Garbo and, after work concluded, said she possessed "the spark of dramatic genius that makes a truly great actress." While working, "she throws a sort of aura around herself." He described her as a "combination of Bernhardt and Duse."[96]

"Garbo Worshippers Form Capitol's Biggest Line . . . Line reached from Broadway nearly to Eighth Avenue" blared a New York headline on opening day, June 2.[97] Hall proclaimed in the *New York Times* that if *As You Desire Me* "is her valedictory to the American screen, then the talented Swedish player has the satisfaction of leaving the Metro-Goldwyn-Mayer studios in a blaze of glory."[98]

Did Garbo actually want to return to Europe to make films? Or was the chatter that filled trade papers and fan magazines in late 1931 through 1932 the ploy of a clever press department seeking to create the illusion that she was going away for good, only to be able to announce in the future a triumphant return? There is scant evidence that she considered seriously turning her back on America. Whatever professional bumps she felt, MGM was a trusted home. Thalberg took care of his most precious asset, and Garbo had been brilliantly served by her creative team. As an actress, she might have sought new challenges. And certainly she could have found work in Germany or Sweden, or in any other Hollywood studio. An intriguing spot in *New Movie*, for example, told readers, "Joseph P. Kennedy, who used to finance Gloria Swanson's pictures, is said to have come out to Hollywood offering $3,000,000 in cash, 'and a lot more where that came from,' if Greta Garbo would agree to make two pictures a year for him."[99] But rightly or wrongly, in the end she was satisfied with her studio. Her compensation was extraordinary, and over the past five years she had consolidated control over her films, gaining approval of scripts, cast, and crew. There was simply no reason to leave MGM; Hollywood's enigmatic independent was nothing if not a creature of habit. Still, Mayer and Schenck brooded over what they could offer to entice Garbo into signing a new contract.

She planned to leave for a European vacation in mid-summer, necessitating a quick negotiation by Edington to secure a contract that would satisfy his client and her employers. The film Garbo wanted to make after her extended vacation

was *Queen Christina*, based on the life of the seventeenth-century Swedish monarch who became queen at the age of five, abdicated at twenty-one, and moved to Rome, where she converted to Catholicism and lived a splendid royal life as guest of a series of popes. On her way to the Holy City, Christina disguised herself as a young man and made her way secretly through Denmark. The story appealed to Garbo.

Thalberg agreed and Garbo asked to have her friend Salka Viertel hired by the studio to write the screenplay. Although bits of information about contract negotiations slipped into the press, for the most part the public was still under the impression that Garbo would leave for Europe with no plans to return. "Greta Garbo was dropped yesterday from the group of stars at present scheduled to make pictures [at MGM] next season," reported *Film Daily* on June 30.[100]

"Another Coast Bank Blows," *Variety* headlined on June 7, 1932, and right below, "Garbo Believed Heaviest Depositor—Had $1,500,000 in Cash."[101] That was the First National Bank of Beverly Hills, which closed on Saturday, June 4, leaving depositors stranded. Whether *Variety* reported Garbo's holdings accurately, she suffered tremendous losses. *Variety* described how a woman, presumed to be Garbo, had unsuccessfully attempted to withdraw a large sum of money earlier the week before. According to Mercedes de Acosta, Garbo told her "that every cent of money she had earned since her arrival in America was in this bank."[102] De Acosta claimed she helped Garbo sneak into the bank in order to remove securities locked in a safe deposit box.[103] She did send a telegram to President Hoover to ask his assistance in helping with Garbo's financial dilemma. No response is recorded. MGM's reaction to the national banking crisis was to take out a double-page ad proclaiming in all capital letters, "TO HELL WITH DEPRESSION." In an attempt to calm industry nerves as box office revenues plummeted and as more and more people worldwide were out of work, the ad continued, "During tough times it becomes more apparent than ever that you're licked if you haven't got STAR names!"[104] MGM was banking that headliners would help safeguard at least minimal profits to keep the studio afloat. Garbo was the star name they wanted to keep on the roster. Ironically, given the precarious global financial situation, she was able to negotiate a contract for more money. Given the losses she sustained, she was anxious to secure the best deal possible.

The contract Garbo signed with MGM on July 7, 1932, was simple. She would return to Los Angeles in the summer of 1933 and over a year's time would star in two films for which she would be paid $250,000 each. The first would be *Queen Christina*; the second would be determined later. The actress and her lawyers set up Canyon Productions, a company working through MGM that would exclusively handle the financial details of future Garbo films.[105] MGM would pay Canyon for Garbo's services, and the actress would be the sole beneficiary of the new enterprise. The agreement was unique in Hollywood, the first during the period of the studio system giving a star almost absolute control of her films, including

choosing the dates she was willing to work. Upon signing the contract, Louis B. Mayer handed Garbo a check for $100,000.[106]

Ink dry on the contract, she left for New York, reportedly in the company of de Acosta. Passage to Sweden was booked on the MS *Gripsholm*. Unlike in her previous trip to New York, where she was hounded by the press and appeared in public with friends, this time Garbo was almost invisible. There was a report that she visited Bronxville in the company of a man and that the two spoke Swedish together.[107] The night before her ship departed she stayed in Greenwich, Connecticut, at the home of her lawyer Joseph Buhler and his wife.[108] From a telegraph office in Greenwich she sent a wire to Viertel that underscores their close relationship: "Thank you for everything you have done for me but above all thank heaven that you exist Auf Wiedersehn Liebe Salka Hope to God you had a chance to pay Black and White [the name Garbo called Mercedes de Acosta on account of her dramatic wardrobe]."[109] Garbo boarded the MS *Gripsholm* on July 30, a day before it was scheduled to sail; two detectives were placed outside her cabin door. Her name was not included on the passenger list, but the two guards looming in the hallway must have given other travelers some idea of who was on board. De Acosta said goodbye in New York. Garbo traveled home alone.

Newspapers and magazines were filled with speculation about whether or not she would return to Hollywood. MGM publicity was mum, only intensifying interest. Garbo's largely stealth visit to New York and sequestration on the ship caused the spotlight on her to brighten further. All in all, it was a brilliant strategy. No matter what she did, her fame increased. Dorothy Calhoun declared in *Motion Picture*, on newsstands at the time, "Any story that dares to breathe the slightest suggestion that she is human, or has ever been anything but the glamorous creature she is to-day, raises a storm of criticism . . . Greta Garbo is not only a legend, she is on her way to being made a saint."[110]

Intermission

HOLLYWOOD

WHEN GARBO LEFT CALIFORNIA IN THE SUMMER OF 1932, BEGINNING what would be an extensive European vacation, she had plenty of cash in her pocket and the security of knowing when she returned to work it would be under the most lavish terms thus far offered a star under a studio system contract. But Garbo was Hollywood's great exception. That year saw great financial challenges to the movie business. It was a moment when producers looked carefully at their roster of stars. The swift ascent of talking pictures had markedly changed the faces on the screen. Plenty of old-timers continued to work successfully, but many failed in the new medium. New prospects came west daily to be screen tested. Garbo was twenty-six and the undisputed queen of films. She was not always the biggest moneymaker, or at the top of annual lists of favorites, but she was the most magical presence in the land of make-believe. Yet fan devotion could be fickle, and there would be constant challenges to her supremacy.

Following the consolidation under the studio system, the motion picture industry had enjoyed relative stability. By 1932, however, the Depression was showing its full effects in Hollywood. Revenues were down substantially, and cost cutting was rampant. Trade papers such as the *Hollywood Reporter* and *Film Daily* were filled with articles on industry pay cuts, and some top studios teetered on the brink of receivership. Yes, Americans still went to the movies, but audiences had thinned, and increasingly studio revenues were generated from nickels and dimes paid by patrons at second-run theaters, rather than dollars at first-run movie palaces. Among the top studios, only MGM continued to run in the black.[1]

To survive, every studio economized and looked carefully at their offerings to the public. The biggest competition in Hollywood that year was not between performers or directors but among the studios, and the grandest rivalry pitted

Loew's-MGM against Paramount. The two had been competitors since MGM's formation in 1924, although the seeds were planted earlier in the complicated professional and personal relationships of Adolph Zukor, Marcus Loew, and Louis Mayer. Zukor once worked for Loew, and although at one time they were heads of competing film corporations, they were bound by the marriage of Zukor's daughter to Loew's son. Mayer, hired by Loew in 1924 to run MGM, sought to make his studio the industry leader. Following Loew's death in 1927, and the family's stock sale that followed in 1929, the two companies became even greater rivals, each jockeying for dominance in annual revenues, quality of pictures, and the importance of stars under contract.

MGM had been a steady operation for eight years. Even the Fox takeover bid back in 1929 had not harmed it. Consistent, able management in New York (Schenck overseeing the Loew's theater chain) and Culver City (Mayer overseeing film production), and Irving Thalberg's guidance ensured a reliable product at theaters. MGM's list of performers changed little over the years, and the occasional additions to the top tier—Marie Dressler, Clark Gable—only strengthened its reputation. Whether or not the public was advised, Garbo would be back working in 1933. Norma Shearer continued to have her pick of prestigious films. Marion Davies, Ramon Novarro, Wallace Beery, and Joan Crawford all continued to headline MGM features.

Paramount suffered from feuding management and a less reliable star register. Adolph Zukor was the boss but ran studio operations from New York and ill-advisedly tried to maintain both East and West Coast production facilities, which with the advent of the Depression proved disastrous. Jesse Lasky was the production chief in Hollywood, and under his watch the studio suffered catastrophic financial losses. He oversaw a disparate group of producers who enjoyed a degree of autonomy unheard of at MGM, such as B. P. Schulberg, who owned Clara Bow's contract. During her heyday Bow's pictures had contributed substantially to Paramount's bottom line, but by 1931 that revenue was way down. DeMille had been a top producer for Paramount but left the studio in 1928 to join MGM. Lasky was forced out in 1932. Gloria Swanson and Rudolph Valentino both left in 1926. Claudette Colbert started at Paramount in 1929, but not until 1934 did she finally become a star. Gary Cooper was a bankable leading man, and 1932 was the year he began his ascent to top stardom. Directors too enjoyed some freedom, which made the studio popular with many of the era's best, such as Ernst Lubitsch. Stiller found a home at Paramount after being fired by MGM, as did Josef von Sternberg. Sternberg is credited with bringing Marlene Dietrich to Paramount in 1930—an important addition to the studio's star roster. Nonetheless, given the competition with MGM to release new features weekly, Paramount lacked sufficient female stars to meet this demand. Unlike MGM, a studio that carefully nourished its top talent, Paramount seemed content to jettison stars when they got too expensive, often leaving a void where it mattered most.

Paramount stars Marlene Dietrich and Claudette Colbert (right) are enjoying an afternoon off work at a party hosted by Carole Lombard on the Venice Pier. Photograph by Don English. Courtesy John Kobal Foundation

Mae West was, in 1932, a formidable presence on the New York stage. If not a star, she was well known for her bawdy humor and willingness as both writer and performer to push the limits of propriety. Her play *Diamond Lil* was notorious for its sexual frankness. Paramount came calling in the late spring of 1932 when she was cast in a featured role in *Night after Night*, starring George Raft and Constance Cummings. Thirty-eight years old, neither particularly attractive nor screen-sleek in body, she was a surprising candidate for motion picture stardom. What she had in abundance, along with magnificent self-assuredness, was an engaging naughtiness that was adult but packaged as parody, allowing her flagrant sexuality to be regarded as cheerful rather than coarse. *Night after Night* opened in October; reviews were tepid and none of the cast was singled out for particular praise, but once West spoke the line "Goodness had nothing to do with it, dearie," the audience was hers from then on. Trade papers soon alerted readers that West had been signed to a long-term Paramount contract. In the fall she was shooting *She Done Him Wrong* with Cary Grant; they paired up again in *I'm No Angel*, a huge hit for Paramount that sent West to the heights of Hollywood fame. The final imposition of the Motion Picture Code took full effect in 1934, and her career could not survive. For a few years, however, West was a force in Hollywood, constantly challenging the censors but charming

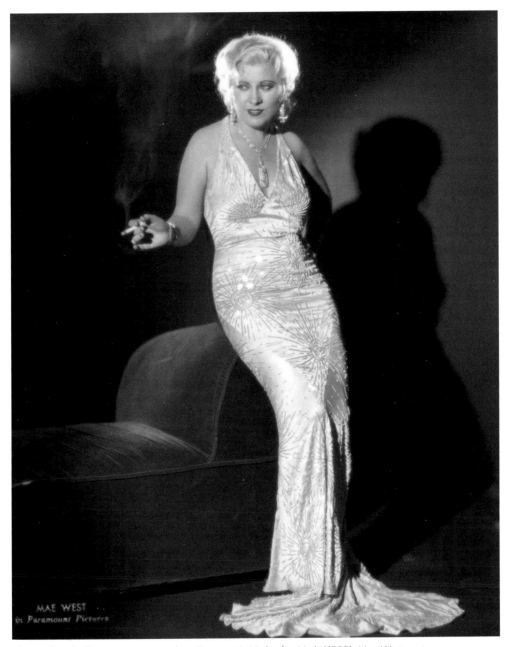

After stealing the film in a supporting role in Paramount's *Night after Night* (1932), Mae West went on to become one of her studio's biggest moneymakers. Photograph by Eugene Robert Richee. Courtesy John Kobal Foundation

audiences with her gently vulgar wit and immense style. Most importantly, she was a bonanza for Paramount, coming to the rescue just as the studio was desperate for a box office juggernaut.

Could West ever have been competition for Garbo? True, they were both sex goddesses but hardly of the same species. Yet they shared an abstracted carnality. Still, did any man really fanaticize about bedding Mae West? Could audiences imagine either young handsome Cary Grant or Gilbert Roland as her lover? Garbo and West each operated in tight orbits that were entirely self-referential. They were not like Joan Crawford or Constance Bennett, or even Marlene Dietrich, women who had a youthful, lively sexuality that steamed up theaters. West was a brilliant comet that lit up the sky for three years, but she never challenged Garbo as the authentic glamour goddess (although for a year her films made more money). She had a renewed burst of success costarring with W. C. Fields in *My Little Chickadee* (1940); while popular, the film was heavily censored before it could be released. But she was working at Universal and not Paramount, and further offers were not forthcoming. She quickly slipped into club and stage work, entertaining audiences for decades in an increasingly long-in-the-tooth spoof of her golden moment on film.

Paramount and MGM were but two of the studios that were vying for new talent. The same month that Garbo started for Sweden, a train departed New York carrying a film newcomer west to try her luck before the movie camera. Katharine Hepburn was a successful East Coast stage actress who in the spring of 1932 appeared in a revival of *The Warrior's Husband* on Broadway. Seen by a scout for RKO, the studio hired her to play the part of John Barrymore's daughter in *The Bill of Divorcement* under the direction of George Cukor. Unlike Mae West, who was desperate to reinvigorate her career, the twenty-five-year-old Hepburn did not at first seem particularly interested in making movies. She went, made the film, and headed immediately back east. It did not, however, take Hepburn long before she was enticed by the professional and financial lures of Hollywood, and in September she signed a five-year contract with RKO agreeing to make two pictures a year while continuing to act in New York. Agreement signed, Hepburn left for a month's European vacation and was abroad when *A Bill of Divorcement* opened to raves in November. "This picture makes history," claimed *Photoplay*; "Not since Greta Garbo first flashed before screen audiences in 'The Torrent' has anything happened like this Katharine Hepburn."[2] Jack Alicoate, publisher of *Film Daily* took over the cover of the October 1, 1932, issue with a signed rave:

> The direction of George Cukor is splendid. John Barrymore is his usual capable self and the cast, including Billie Burke and David Manners, is unusually fine. It remains, however, for a newcomer to the scene, Katherine [*sic*] Hepburn, to capture ranking honors. You'll hear a great deal more from this young lady.

He got that right. Hepburn went on to have one of the most distinguished careers in film. Unlike Garbo, she was not afraid of the mirror and was constantly willing to reimagine her screen persona. For sixty years after coming west to try her luck, Hepburn continued to work on stage, in film, and later television.

But Garbo's producers and friends were not concerned about pretenders to her temporarily vacant throne. Rather, they were busy readying the new script about Queen Christina of Sweden. The question before Thalberg was how to handle the delicate history of a queen who possibly gave up her throne rather than marry, and to avoid as much as possible the lesbian associations such a story might evoke. The narrative would necessarily focus on the abdication, the single great event in Christina's life. Salka Viertel recounts the saga of the project at length in her memoirs. Immediately after Garbo departed for Sweden, Viertel met with Thalberg to work out the contractual details. With Garbo thousands of miles away, he decided he could take an aggressive position with her friend and designated screenwriter. When Viertel asked him to buy the story she had written along with collaborator Margaret (Peg) LeVino as the basis for the screenplay, he responded: "But there is nothing to buy. You have no copyright. Anybody can come and write a story on a historical subject."[3] "I looked at him speechless," Viertel recalled.[4] She had been advised that $10,000 was a fair fee—copyright or no copyright—and waited to see what the producer's offer might be. Did he want to antagonize Garbo before she had even reached Sweden? Or was this a calculated negotiating ploy in order to undermine Viertel's confidence and force her to accept far less than the work was worth? "After an armistice of a few days, Thalberg offered $7,500 for the story, and Peg said we should accept."[5] Thrifty Thalberg saved MGM $2,500. To soften the deal, Viertel was put on salary at $350 a week for the time it took to write the screenplay. As she was not an experienced writer, Thalberg insisted she collaborate with an established studio scenarist and proposed Bess Meredyth (who had worked on *A Woman of Affairs* and *Romance*). Over the next year, many other writers would work with Viertel readying the *Queen Christina* script. Before Garbo departed, Viertel had encouraged her to consider filming *Queen Christina* in Europe. Viertel wanted to return home and convinced herself that a better movie could be made working across the Atlantic. Garbo must have feigned enthusiasm for this plan, but by the next spring she wrote Viertel that it would be shot in Culver City.

Although Mercedes de Acosta claimed that she had come up with the idea for the *Queen Christina* project, there is no evidence she was involved other than perhaps discussing the prospect with Garbo before she took off on vacation.[6] The two were quarreling that summer, and Garbo quit Los Angeles without saying goodbye.[7] "After she left, Hollywood seemed empty to me," de Acosta nevertheless claimed.[8] But not for long. She was soon pursued by Marlene Dietrich, and the two carried on an affair that lasted almost a year.[9] Both Cecil Beaton and Dietrich's daughter, Maria Riva, confirm the relationship. Whatever affection Garbo

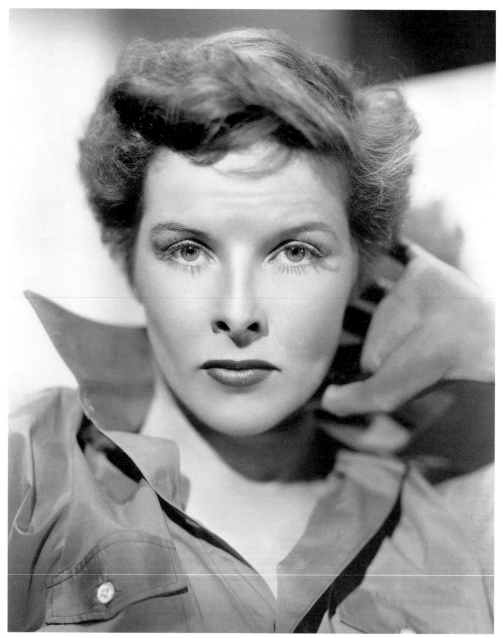

Katharine Hepburn, brought to RKO to play a leading role in *A Bill of Divorcement* (1932), was hailed as the find of the year and signed to a long-term contract. She made her final film appearance sixty-two years later. Photograph by Ernest Bachrach.

might have felt, de Acosta's blatant lesbianism and erratic personality would have troubled the actress who, in all matters of her life, professional as well as personal, demanded the utmost discretion and privacy. Garbo later resumed their friendship, and they remained in each other's circle until de Acosta committed an unpardonable offense in 1960.

GARBO IN EUROPE

Garbo's brother Sven greeted the ship from New York when it docked at Göteborg in mid-August along with "hundreds of policemen [who] had to restrain the throng of admirers."[10] He had been asked by members of the press to prevail upon his sister to meet with them for a few moments, and she obliged. When asked to confirm rumors that she was writing her memoirs and had penned biographical articles, Garbo responded:

> "I have never written a line. That's all pure invention, words put in my mouth." She hesitated. "To be honest, I don't see how it can interest the public to know what an actress does outside the studio, or what her views on food are, or what she thinks about people marrying" . . . "What will you do at home?" one reporter asked. Garbo's response, "Rest."[11]

In the fall, Garbo and her friend Hörke Wachtmeister set off on a journey from Sweden to London and Paris. They managed the leg to London unmolested. Garbo traveled as Miss Gustafson (or Gustavson) and sported a black wig and dark glasses; the glamorous screen goddess was nowhere in evidence. For six days in November, the two women stayed at the Washington Hotel on Curzon Street in Mayfair. Wachtmeister tended to the hotel registration, and apparently none of the staff or other guests ever guessed Garbo's identity. "The actress and the countess occupied a suite of two small rooms," the International News Service reported after they had stealthily departed London. The Washington, centrally located in the most fashionable part of the city, found its "clientele select, consisting of wealthy recluses seeking rest, elderly society people and retired business men . . . [Garbo] arose every morning at 7 o'clock, breakfasted, and then went for an early walk in Hyde Park. She spent one afternoon in a movie house where 'Grand Hotel,' her latest starring vehicle, played. Historical spots, such as the Tower of London, were also on her itinerary." The hotel staff noted, "Miss Garbo brought stacks of luggage with her, but unpacked none of it. She wore the same costume day in and day out, consisting of a floppy felt grey hat, black shoes, black stockings, a dark coat and the ever present spectacles."[12] Danish actor Carl Brisson was appearing in a revival of *The Merry Widow* at the time, and it was reported in the papers that Garbo attended a performance. She had known Brisson, at least as an actor,

Garbo and her close friend Hörke Wachtmeister at Tistad, the Wachtmeister estate south of Stockholm. Courtesy of Scott Reisfield

from Stockholm in the early 1920s. When Garbo had safely left town, Brisson confirmed that she had visited him backstage.[13]

Following London, Garbo and Wachtmeister went to Paris, taking rooms at the Hotel de Castiglione on the rue du Faubourg Saint-Honoré. The privacy accorded the women earlier was soon interrupted, and the police were called to guard the hotel to keep pedestrians and automobiles from blocking the road in front of the hotel.[14] "Perhaps by behaving this way," one member of the French press wrote of Garbo's refusal to grant an interview, "La Mysterieuse wanted to get herself more publicity. An indication that that was so was her way of dressing. If she had really wanted to be left in peace, surely she would not have equipped herself with hats three feet wide, straw slippers and sunglasses, so that everyone could say from a mile off: 'There comes Garbo!'"[15] Did she in some way enjoy the game of cat and mouse with the press? Was it just a coincidence that some disguises worked and others did not, or had the journalist guessed her intention correctly?

With the Parisian press already on the qui vive, Garbo's return to Sweden was sure to be compromised. Arriving in Copenhagen she was again recognized. At the train station she "was met by a squad of newspapermen who quickly picked her out despite the 'disguise.' She refused to be interviewed and drew a cloak over her head to prevent photographs, speeding away in a waiting cab. Miss Garbo was pursued in taxicabs as she sped through the city trying to cover up her destination. Speed limits and traffic lights were ignored in the chase."[16] The 1997 media pursuit of Lady Diana that resulted in her death inevitably comes to mind. Garbo

managed to escape the onslaught, and soon she and Wachtmeister were safely ensconced at the countess's villa at Tistad south of Stockholm.

Back home she could return to the security of familiar surroundings and friends such as Max Gumpel, a stylish figure in 1920s Stockholm. He was born to wealth and privilege, and had won Olympic medals in water polo. He and Garbo met before she left for America the first time, and he gave her a ring with a small diamond. Later he married but was divorced by the time Garbo retuned to Stockholm in 1932. She looked up her old friend, and they became regular companions during her time in the city. The press tried to spot a romance, but if one existed, it was kept quiet. Gumpel, like Garbo, enjoyed playing tennis. To guarantee privacy he "hired all the courts at the Tennis Stadium when they played, so as to keep spectators away."[17] He had become a successful builder, and there was much speculation that he was helping her find property to buy and perhaps build a home on. (She never did that but later purchased a farm for her family.)

Garbo became an aunt for the second time in April. A daughter, Ann-Marguerite (known later as Gray), was born to her brother, Sven, and his wife, Marguerite (Peg). Sven already had an older son, Sven Åke, whose mother Sven never married. Garbo did not acknowledge this nephew, and her brother may have had little or no relationship with the child. When Garbo signed her last will, Sven Åke was excluded from any inheritance. Her brother and his family moved to America in the late 1930s, and Gray became a devoted companion to Garbo in her later years in New York.

Irving Thalberg had a heart attack in December, though not fatal. His ability to shape scripts intelligently had aided in sustaining the Garbo legend by ensuring each film suited her perfectly and met her fans' expectations. If he encouraged a relatively narrow range of screen characters, it was done with her approval and to protect her hard-won stardom. He guided most of Garbo's films, and when he was not available selected the supervising producer (typically the director) while diligently watching over the final product. Though the nature of their relationship is unknown (neither ever spoke about the other), his illness would change the professional dynamic between Garbo and MGM. In the short term, he had planned an extended European trip beginning in February 1933, in part to seek medical treatment in Germany. Looking further ahead, he was considering leaving MGM to set up his own production company. Might Garbo have followed had he become an independent producer in the mold of Samuel Goldwyn? The new contract obligated her to MGM for two pictures; after that Garbo was free.

But for now it was time to get back to work. When she signed her 1932 contract, she had been paid $100,000; another $150,000 was due upon the completion of *Queen Christina*. Director and costars were still undecided, although Garbo would have final say in both. Viertel and her team continued to work on drafts of the shooting script. Harry Edington notified MGM that Garbo would be available to start work on May 15, 1933.[18]

Writing to Viertel on New Year's Eve 1932, Garbo discussed her upcoming trip back to America and indicated that she was looking to return on a boat that avoided New York.

There were few options for travel between Sweden and Los Angeles. Garbo's two previous transatlantic crossings had been on board one of the luxurious ships operated by the Swedish America Line. After about ten days of sea travel, the ship would dock in New York, where a West Coast–bound passenger would typically depart by train first to Chicago and from there transfer to a second train for the final leg of the journey. Garbo decided this time to book passage on the Johnson Line, a Swedish shipping company that operated a fleet of steamships that principally hauled cargo across the Atlantic to points in South America or to the West Coast of the United States. The next boat heading there was the *Annie Johnson*. In addition to cargo, she could accommodate thirty cabin-class and thirty third-class passengers. Two cabin-class rooms could be joined with an en suite bathroom, affording a bit more space and privacy—an accommodation Garbo might well have chosen. She left Sweden on March 25 bound for Hollywood via the Panama Canal, traveling as Mrs. John Emerson.

She hoped Viertel would meet her in San Diego so she could return "secretly," rather than disembark in San Pedro, where the boat was scheduled to stop. Additionally she asked to stay with her on Mabery Road; it would "kill me," she said, to stay in a hotel. And would Viertel have a look at a house Garbo had considered renting previously and find out, discreetly, if it might be available? The rent should be "as cheap as possible."[19] Garbo's close circle of friends, especially the women, and usually older, were increasingly becoming handmaidens, a role all seemed to relish. She ended the letter saying she had no news, though she had been extraordinarily busy traveling extensively in the recent months. She never mentioned Hörke Wachtmeister—she seems to have liked keeping her close friends separated.

The passenger list for the *Annie Johnson* has never been discovered, so we don't know how many travelers accompanied Garbo on her long journey, which included a stop in Antwerp, and two stops in Colombia before landing in San Pedro, just south of Los Angeles. Garbo made the acquaintance of at least one, according to *New Movie Magazine*, Ture Teen, a twenty-four-year-old Swedish sportsman, "with whom she was known to have played shuffle board and deck tennis."[20] Daily she also "escaped for an hour or two into one of the lifeboats . . . [where] she took her sunbaths."[21] Did Garbo relish the idea of a long and quiet sea voyage and the chance to visit places that in 1933 must have seemed exotic and far away? Or was she simply tired of the commotion associated with travel, first arriving in New York and then making two train connections with the certainty of facing a swarm of reporters and the curious?

When the *Annie Johnson* docked in Antwerp, Garbo "went ashore for a couple of days wandering about the city visiting its art museums and galleries and

port."[22] Apparently she was unrecognized, and only after the ship departed did the natives learn of her visit.

The Atlantic crossing, the passage through the Panama Canal, and the journey up the west coast of Mexico took just under five weeks. As the press carefully tracked Garbo's journey, noting when the boat was in the Panama Canal and its anticipated arrival near Los Angeles, Garbo asked the captain if she could disembark earlier to avoid the fuss that would undoubtedly await her in San Pedro (San Diego was apparently not an option). She wrote Viertel as the boat was near Los Angeles that a "fast boat" had been arranged to ferry her from the *Annie Johnson* to the dock, and could she kindly pick her up.[23] Viertel agreed. A horde of press members discovered the plot and was waiting when Garbo stepped ashore. "She smiled and trembled, obviously frightened to death before them"[24] but still managed politely to entertain a few questions before Viertel transported her back to the relative sanctuary of Mabery Road in Santa Monica.

As Garbo had left the *Annie Johnson* early, her luggage remained on board to be unloaded later and delivered to her in Santa Monica. Even back in 1933, luggage separated from its owner could ignite a ruckus. "Contradictory statements made by Greta Garbo caused Federal officers to hold the actress's trunks for inspection. Miss Garbo assertedly reported to have listed herself as an American citizen returning to her home, and also a Swedish citizen arriving in the immigration quota."[25] How this international incident was resolved has been lost to history, but Howard Strickling or another member of MGM's publicity department likely made the short trip to San Pedro to sort out the customs issues.

The day after Garbo's return, a reporter for the *LA Times* published a short poem recording the shock of the dockside exchange:

> *A shattered illusion,*
> *Another delusion;*
> *The spell is broken,*
> *Garbo has spoken.*[26]

Triumph

QUEEN CHRISTINA

GARBO WAS BACK IN HOLLYWOOD. GOOD NEWS FOR FANS, BUT NOT for journalists, one of whom wrote, "Garbo's return, unlike that of beer, did not bring Happy Days to everyone. Four hundred news correspondents in Hollywood groaned and wept in their seidels. She's more work than all the rest of Hollywood combined."[1] Squeezing news from a sphinx was a tough beat.

One of her first tasks was to change lawyers. Although she had stayed with Joseph Buhler in Connecticut just before sailing for Europe, he had apparently assigned another lawyer in his firm to look after her interests; displeased, she decided to find legal representation closer to home. Los Angeles–based Lawrence Beilenson, who helped establish the Screen Actors Guild and the Screen Writers Guild, replaced Buhler. Garbo may have been introduced to him through Salka Viertel, who would have approved his pro-labor position and saw him, correctly, as an up-and-coming young lawyer. At the time she was working at MGM as a writer, the studio cut writers' salaries in half, though as a protégé of Garbo's she might have been immune. Still, she could have predicted how important Beilenson would become to screenwriters. He continued to represent Garbo through the balance of her acting career, and through his influence Garbo joined the guild herself in 1937.

Buhler was not the only allegiance she changed. It was big news when *Variety* reported in May, "Greta Garbo has dropped Harry Edington as her business and studio-relations manager after six years . . . Understood that Garbo is now handling her own film deals, aided and advised by Mrs. Berthold Viertel, wife of the director, and Mercedes de Acosta, writer . . . Edington is now handling Marlene Dietrich, and the latter seems to emulate Miss Garbo in the matter of silence and secretiveness."[2] Might the publication of an article have contributed to Garbo's decision to fire Edington? "The Man behind Garbo" appeared the previous

September in *Movie Mirror*, and over three pages detailed her indebtedness to her agent. Edington had worked with her since they were introduced by John Gilbert during her 1927 salary dispute with MGM and negotiated all her contracts beginning with the sweet deal he arranged when she was cast in *Love*, through the splendid agreement she made with MGM the previous summer. The article told readers that it was he who had instructed Garbo not to speak with journalists.[3] Whether planted by Edington or not, this sort of press would have irritated the actress. Viertel had insinuated herself successfully as Garbo's adviser, and now she was promoted from de facto to the "officially" recognized manager, although Edington would still help organize aspects of future contracts. In addition, Viertel would author many of Garbo's scripts and serve as factotum taking care of her capricious needs.

While Garbo was still in Europe, occasional spots in the trade papers, including *Variety*, mistakenly mentioned Berthold as the author of the *Queen Christina* script, which must have galled Salka, especially as her husband was living and working abroad.[4] Playwright S. N. Behrman helped with the dialogue. Thalberg was in Europe, so was not available to oversee the film. Walter Wanger, who started his career at Paramount in New York and later worked at Columbia, came to MGM in the spring of 1933. His stay was brief, only time enough to serve as producer of two films made simultaneously, *Going Hollywood*, starring Marion Davies and Bing Crosby, and *Queen Christina*. Garbo may or may not have been consulted on the appointment of Wanger; his role was set at the time she returned to MGM.

What was not set was the director or costar. While Garbo was away, names of potential directors were proposed. First, Clarence Brown was slated to direct.[5] On March 29, while Garbo was sailing, Wanger (or Mayer) suggested Robert Z. Leonard (*Susan Lenox*) or Edmund Goulding (*Grand Hotel*). Garbo responded: Goulding.[6] Both he and Leonard turned out to be unavailable. By May, Josef von Sternberg was "in the running," according to the *Hollywood Reporter*,[7] although five days later a notice in *Variety* indicated that Garbo had nixed him.[8] Rouben Mamoulian recently scored a success for Paramount with *Love Me Tonight* (1932), starring Jeanette MacDonald and Maurice Chevalier, and had just completed *Song of Songs* (1933) with Marlene Dietrich. MGM approached him. "Approve Mamoulian," Garbo wired MGM on May 17.[9] He demanded a substantial fee of $50,000. The studio bowed but insisted the amount was "flat" and that there would be "no overages."[10]

Casting of the leading male character, Don Antonio, was more complicated. Wanger first considered Leslie Howard, following his successful costarring role opposite Norma Shearer in *Smilin' Through* (1932), a tremendous moneymaker for MGM.[11] Then newcomer Bruce Cabot was tested, based on his leading role in *King Kong*, which had opened in April.[12] Others considered included Ricardo Cortez, Nelson Eddy, Paul Cavanaugh, and Victor Jory. With no actor acceptable

to both studio and Garbo, the *Hollywood Reporter* announced at the beginning of June that "the selection of a male lead is holding up actual shooting . . . Everyone in Hollywood of importance has been tested for the part."¹³ Wanger and Mamoulian would look elsewhere.

Laurence Olivier had made three films in Hollywood—*The Yellow Ticket* (1931) at Fox, and at RKO, *Friends and Lovers* (1931) and *Westward Passage* (1932); in the fall of 1932 he was back in England working with Gloria Swanson on *A Perfect Understanding* (1932). In the spring of 1933, he was costarring in *The Rats of Norway* on stage in London with Gladys Cooper. Garbo and Mamoulian screened *Westward Passage* and decided Olivier might be a good choice to play Don Antonio. While still in London, Olivier signed an agreement for fifteen hundred dollars a week, four weeks guaranteed, and received first-class passage to Hollywood. Contract or not, Garbo still retained the right of veto over this potential costar. At first she must have been optimistic about working with Olivier, for just as he arrived at the beginning of August, she approved in writing the four actors who would support her: Olivier, Ian Keith, Lewis Stone, and Reginald Owen.¹⁴

By all accounts nothing went well from the start. Garbo normally refused to rehearse but bowed to Mamoulian's wishes and agreed to prepare a scene with Olivier. "The director said I was to come forward," the actor recalled, "grasp Garbo's slender body tenderly, look into her eyes and, in the gesture, awaken the passion within her . . . But at the touch of my hand Garbo became frigid."¹⁵ Forty years later Olivier was interviewed on television by Dick Cavett, who was taken by the story and pressed for details. "I just didn't measure up," Olivier told the host. "I wasn't good enough for her . . . She was an absolute master of her trade . . . I was just groveling like a puppy dog in front of her . . . I wasn't really surprised when I was fired . . . It was at the time very embarrassing."¹⁶ Olivier's chivalry belies the fact that he had gotten along well with Gloria Swanson, who could not have been less touchy than Garbo. At the beginning Swanson worried about working with the younger and less experienced actor but agreed when she saw that "he could almost not make a wrong move, his instincts and technique were so finely coordinated."¹⁷ Why Garbo felt differently, she never said.

No entirely satisfactory account of John Gilbert's casting as Don Antonio has come down through the many histories written about the principals and the film. Gilbert told *Modern Screen* that he was contacted by Wanger late in the summer and asked to come to MGM. He told the producer that he was working and unable to make the visit. "Better come, Jack," said Wanger, "they want you for the Garbo picture."¹⁸ At some point Garbo obviously decided she wanted to work with Gilbert. Did the two have a plan, possibly instigated by Edington? After a series of thankless roles and lackluster performances, Gilbert was at a career low. "I have had my head on the guillotine for years," he told reporter Gladys Hall.¹⁹ A leading role in MGM's most prestigious film for the 1933–34 season could catapult him back to top stardom. Garbo might have felt she owed him a favor after

Garbo insisted John Gilbert replace Laurence Olivier as her costar in *Queen Christina*. Photograph by Milton Brown.

his help back in 1927 with both her contract negotiations and image shaping, or she might have calculated that bringing back the Garbo–Gilbert marquee could only help with the box office. It was a low-risk gamble. Fans bought tickets to Garbo pictures but, alas, no longer to Gilbert pictures. He could help the film, but in the end he could do little or no damage. In mid-August Garbo notified the studio, "This is to confirm the approval heretofore given to me that John Gilbert shall be substituted therein, in lieu and instead of Laurence Olivier."[20] *Film Daily* (August 26) reported that Olivier and his wife were on their way to Honolulu for a vacation, presumably a form of severance from MGM.

Mayer accepted the choice, although he was not anxious to have Gilbert back on the lot. Years of personal animosity had only sharpened his dislike, and the actor had just completed what was to have been his final film for the studio, *Fast Workers*, which opened to bad reviews and box office in March and ultimately lost $360,000, hurting MGM's already shaky bottom line.[21] Thalberg's return after eight months abroad might have worked in Gilbert's favor, as the two men had always been friends. Mayer was perhaps being sadistic when he offered Gilbert a seven-year contract upon signing for *Queen Christina*, and Gilbert masochistic when he agreed. His fee for *Queen Christina* would be $20,000. Subsequent films

would be negotiated individually. No one has recounted Gilbert's feelings about being paid less than one-tenth his costar's salary, but he signed on and reported dutifully for the first day of shooting in late August.

When the time came for credits, Garbo's name, alone, would precede the title, and in large letters; so posters, lobby cards, and the like read: "Garbo in *Queen Christina* with John Gilbert, Ian Keith, Lewis Stone, Elizabeth Young, a Rouben Mamoulian Production." Keith had originally been promised second billing, but with the addition of Gilbert to the cast he agreed to third. Along with his insulting salary, listed as "with" was quite a come-down for the once-great leading man.

Did the movies' number-one love team from the twenties ignite the screen again? Gilbert supports Garbo beautifully, and they are certainly at ease with each other. He is still handsome, but at thirty-six his years of hard living and alcoholism are noticeable, though nothing is wrong with his voice. But the fire of their three previous three films together had been extinguished over the intervening years. Part of the problem was Garbo; part was the stilted script. Rather than coming to life on screen as a historical figure, Christina becomes a reflection of the Garbo myth, the work of a sycophantic screenplay. Garbo, not the historic queen, is the focus.

Viertel and her team created a fictional love story within the historical narrative to spice up the film: the Spanish ambassador, Don Antonio (Gilbert), comes to Sweden at the behest of his king to carry a message asking the queen's hand in marriage. The queen refuses but falls in love with the messenger. Queen and ambassador meet on a snowy evening when Christina, dressed as a man, is forced to take refuge at a country inn. The two "men" must share a room, but it takes only seconds before the queen's disguise evaporates and she is revealed as a woman. Her true identity, however, remains hidden. *Queen Christina*'s best scenes are paeans to the Garbo legend. After three nights of passion, Garbo slowly moves about the bedroom she has been sharing with Gilbert and memorizes its details so she can recall the room in the future. William Daniel's camera follows her with devotion. Ultimately, the scene is not romantic but narcissistic. But it is also splendid, because what the audience wants is not a romance but the glory of Garbo, seen often in majestic close-up.

In 1937 Martin Quigley, who owned several industry trade papers and was (secretly) the author of the Production Code, wrote a book titled *Decency in Motion Pictures*, which served as an apologia for why he believed the Code was necessary. Singling out *Queen Christina*, Quigley described the film as:

> a re-writing of history that transcends dramatic license, presenting among other objectionable incidents a bedroom sequence which registers with voluminous and unnecessary detail the fact of a sex affair. The sequence is emphasized and dwelt upon beyond all purposes legitimate to the telling of the story, thereby assuming a pornographic character.

The bedroom scene stayed in the film, which aggravated Quigley, and he used his influence, especially with the Roman Catholic bishops, to ensure that the Code went into full force in 1934. *Queen Christina*, as filmed, would never have been approved had it been made a year later. The authors of Garbo's future scripts would write in the face of even stronger conservative influences than they had encountered previously.

Another scene escaped what would later have been the censor's edits. The script hints at the unmarried queen's attraction to women. The extremely subtle lesbianism was allowed because of its presumed factual basis. Christina dresses as a man, rides astride, kisses Countess Ebba, and delivers one of her most famous screen lines: "I shall die a bachelor."

In the fictional story that runs alongside the historical record, the writers tease audiences with the possibility that Christina and Antonio might end up happily together in some unnamed mystical place. First, however, Antonio must settle a score with a Swedish aristocrat (played by Ian Keith and based on a real character), but it is Antonio who is mortally wounded in a duel. Gilbert dies in Garbo's arms (as does his career). The same boat that takes Christina away from Sweden also transports the body of her dead lover. What must Swedes have thought of this travesty? Nevertheless, the final scene is justifiably one of the most famous in cinema. Beginning the long journey south that will eventually bring Christina to Rome, the former queen walks along the ship's deck to the bow. With the wind gently blowing, she stands looking out at the sea before her. Much has been made of Mamoulian's request that she think of nothing as the camera slowly moves in from long shot to extreme close-up. It is not a blank face that Garbo gives the camera, but one of quiet determination. She is resolute in her decision to give up her crown and move to Italy. It is not a face devoid of thought, but rather one that affirms her certainty and, like the actress herself, is impervious to outsiders.

Queen Christina opened on December 26, 1933, and if it did not become the gold mine MGM desired, it was still another success for Garbo, and thus far her third-most-profitable film after *Grand Hotel* and *Mata Hari*. She was worth her queenly salary. "The Nordic star, looking as alluring as ever, gives a performance which merits nothing but the highest praise," gushed the ever-reliable *New York Times*.[22] Sophisticated publications did not always share this enthusiasm. "I do not find it in me to write about this picture, for it would be too cruel," British critic Paul Rotha told readers in *Cinema Quarterly* as he took aim at the film but not at its leading lady. "But I must write instead of Garbo, who contrives, though Heaven knows how, to surpass all the badness they thrust upon her. Of her many American pictures, all without exception have been trash; yet this astonishing woman surmounts the very crudity with which they choose to surround her."[23] Garbo's pictures were always popular overseas, and *Queen Christina* was no exception. Germany had been a profitable market and the *Times*'s "The Berlin Communique" alerted American readers: "The success of Greta Garbo's 'Queen

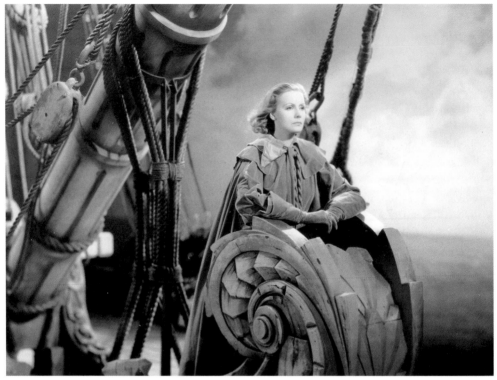

Among the most famous in cinema history is the final scene of *Queen Christina*. Having abdicated her throne, the former sovereign is about to depart for permanent exile in Italy. Garbo with her inscrutable face dares moviegoers to guess what the former queen is thinking—a case of art imitating life. Photograph by Milton Brown.

Christina,' unparalleled by any German film this season, continues with dubbed versions now running in the 5,000 houses throughout the Reich. Here Germany did not follow America's lukewarm lead. Garbo wears the halo of a really great actress here. Her position is uncontested."[24]

Nine months after *Queen Christina*'s premiere, an article about the fate of Garbo was published in *Photoplay*.

Figures, cold figures, reveal that the popularity of Garbo today is not the popularity of the Garbo of that golden age . . . Several things worked against it; bad times; an always doubtful costume play with characters of little general appeal; this rise of new idols; Katharine Hepburn—and an inexplicable Garbo apathy . . . Statistics showed her former box-office ranking had been passed by almost a dozen stars . . . Garbo is still Garbo—but she can't stay away like this and keep her place.[25]

This was advice Garbo ignored. Instead of working harder, she elected to make fewer pictures. One a year soon became one every second year. Still, the fans did

not give up, her films continued to make money, her salary continued to increase, and, fan magazine predictions notwithstanding, her fame flourished throughout the 1930s.

Indications of that fame could be found in unexpected places. British artist Boris Anrep was commissioned in 1933 to design and execute mosaic floors for the National Gallery in London. For the vestibule of the main entrance on Trafalgar Square, Anrep created *The Awakening of the Muses* and cast Garbo as Melpomene, the muse of tragedy. Clio was modeled on Virginia Woolf, and ballerina Lydia Lopokova served as inspiration for Terpsichore.

The old saw "imitation is the sincerest form of flattery" probably did not mean much to Garbo, but whether she liked it or not, her image was being exploited in many places. She was not alone—most of Hollywood's elite shared the problem—and some probably enjoyed the attention. Mickey Mouse was a veteran of almost sixty films when Walt Disney cast him in *Mickey's Gala Premiere* (1933) and surrounded him with many of Hollywood's biggest stars. The seven-minute animated film has Mickey cavorting with Groucho Marx, Charlie Chaplin, and Boris Karloff (as Frankenstein) among the men, and Gloria Swanson and Joan Crawford among the women. Garbo was saved for the end, and she wears a skin-tight evening gown slinking up and across the stage in order to plant a kiss on the delighted Mickey (who turns out to have been dreaming the whole time). The knockoff is excellent, lightly mimicking Garbo's movement, her alleged big feet (not true), and the slow drawl of her husky voice.

One afternoon shortly before *Queen Christina* began filming, Garbo and Viertel visited Olvera Street in downtown Los Angeles, home to the Mexican community and a place alive with shops, restaurants, and theaters. Garbo, in a black polo coat and a black slouch hat, was spotted, but that day she did not seem to care. "Nemo," a writer for the *New Movie Magazine*, was surprised to catch sight of the actress. "She marched along like the Pied Piper of Hamlin with a motley crowd of Mexicans, tourists *and me*, following at her heels. . . . Eventually she (and yours truly) came to the puppet show and, seeing herself advertised as part of the show, she purchased tickets and went in." The entertainment was provided by a marionette troop, the Yale Puppeteers, who entertained at the eighty-seat El Teatro Torito. A gimmick of the show was that many of the marionettes were based on contemporary movie stars and other celebrities. There were puppets of Chaplin, Cary Cooper, Albert Einstein, and one of Garbo. There are photographs of both Cooper and Einstein holding their puppet likenesses. Garbo was depicted in costume for *Anna Christie*. The theater was probably her destination that afternoon. According to "Nemo":

> She complained bitterly over the puppet that was supposed to resemble her. She didn't like the pompom on its hat . . . When she left, the proprietor asked her to autograph the book and she said, "I never give autographs" . . .

By this time the glamorous Garbo was a bit irritated and suddenly turned to her companion, the ever-present Mrs. Berthold Viertel, and said: "I think I go home." [26]

Cartoons and marionettes, even kids got into the imitation game. *Baby Burlesks* was a series of eight Universal short subjects starring very young children, perhaps two or three years old. Shirley Temple got her start in these films. In March 1933 Universal released *Kid'in' Hollywood*, in which Temple did a burlesque of Marlene Dietrich in *The Blue Angel*. In a short sequence, Gloria Ann Mack appears as "Freda Snobo," lounging in bed and too tired to work. A large pair of shoes is in evidence. On stage in Los Angeles in May 1933, seven-year-old child star Jane Withers (who in the 1960s became well known as Josephine the Plumber on television commercials) also got into the act. Jimmy Hazlewood writing for *Hollywood Filmograph* "saw that lil' Georgia peach, Jane Withers, on the program at the Figueroa Playhouse last Saturday night and if a show was ever stopped—Jane stopped this one! Her mimicry of Sophie Tucker and Jimmy Durante nearly tore the house down and her impersonations of Garbo, Chevalier, Dressler . . . completed the damage." [27]

Another reliable indicator of status in Hollywood was how often a star appeared on fan magazine covers that were a staple of newsstand sales in the interwar period. Since 1927 Garbo's face had been among the most frequently featured in the brilliantly colored designs. If news of her descent from the upper reaches of stardom was now being circulated, it was, during the years 1931–35, despite her image appearing, at least annually, on the cover of each of the top American fan magazines. Worldwide the evidence is even greater. Walking down the street in any major city and in most towns, passersby would see Garbo peering from the magazine racks. For MGM, this was excellent advertising. For Garbo, it was further proof that she was star of stars.

If *Queen Christina* cemented Garbo's authority at the studio, the hoped-for boost to Gilbert did not happen, and he never made another film at MGM. It's doubtful that Mayer even seriously considered a new Gilbert script. The first option after six months was picked up but not the second, and the deal struck the year previously evaporated. Gilbert, frustrated with Mayer's seeming intransigence, took out a full-page advertisement in the *Hollywood Reporter* on March 20, 1934. "Metro-Goldwyn-Mayer will neither offer me work nor release me from my contract. Jack Gilbert." The studio let him go. Gilbert made one more film, this time at Columbia working for Harry Cohn. Lewis Milestone directed an "all-star" cast in *The Captain Hates the Sea* in the spring of 1934. Columbia's idea of all-star was different from MGM's, and Gilbert was surrounded by Victor McLaglen, Wynne Gibson, Alison Skipworth, Fred Keating, and Walter Connolly. Even in this ensemble, Gilbert did not have top billing. The film went over budget in part due to his heavy drinking and unreliability on the set. Cohn had promised

Gilbert that if the film went well, he would help his career. It did not, and Cohn was later quoted, "If a man wants to go to hell, I can't stop him."[28]

Had Garbo cared, and likely she did not, she might have been amused that in 1935 Gilbert took up with Marlene Dietrich. Was it a coincidence that Dietrich had had an affair with Mercedes de Acosta in 1933 and was now cavorting with Gilbert two years later? The Hollywood press followed the romance and noted the many public appearances of the glamorous couple. For a moment Gilbert seemed his younger self. There was even talk of his appearing in Dietrich's upcoming film *Desire*. But fast living finally caught up with Gilbert; he had a heart attack in December 1935 and another in early January. The fatal one occurred on January 9, 1936. Gilbert was thirty-eight. Garbo was silent on the subject.

Their affair had cooled many years before, so the press was eager for a new Garbo romance to be shouted from the newsstands. If the *Hollywood Reporter* got it right, one weekend in early September 1933, in the midst of filming *Queen Christina*, Mamoulian arranged a weekend getaway with Garbo to a dude ranch outside Victorville, at the edge of the Mojave Desert and a two-hour drive north of Los Angeles.[29] It was probably the North Verde Ranch, a popular retreat for film folks. The caller (Mamoulian or an assistant) who booked the reservation asked for "the utmost privacy and seclusion." The manager agreed but was annoyed to find that each time Garbo wanted to go for a walk, he had to "get the other paying customers out of the way so that Greta could walk out unspied upon." Finally this proved too much of an inconvenience, and the manager had to tell Mamoulian, "If you insist we should put blindfolds on our other patrons every time Miss Garbo wants to take a walk or a ride, you had better go some other place." They did.

Mercedes de Acosta was back in Garbo's good graces, and she describes a trip they made to Yosemite at the end of the year that might well be a fabrication.[30] Although Garbo agreed to such a trip, she apparently stood up her friend and instead took off with Mamoulian in January to La Quinta, a desert inn just east of Palm Springs known then for its solitude and discretion.[31] Also reported was a visit to the Grand Canyon.[32] Unsuccessfully dodging reporters' intrusions, Mamoulian was forced to acknowledge, "We were not married and we have no plans whatever for marriage."[33] In fact, he was just the sort of fellow who would appeal to Garbo. Russian-Georgia born, he was intelligent, charming, sophisticated, successful, and content to do her bidding. So happy was Garbo with Mamoulian that she lobbied MGM to select him to direct the second picture promised under her 1932 agreement, *The Painted Veil*, based on a story by Somerset Maugham.[34] The crush, if that is what it was, did not last long. But while it did, Garbo seemed to have enjoyed this male companionship, especially in light of the press's repeated insinuations about her friendships with Viertel and de Acosta. Although she remained devoted to Viertel and continued to have a complicated on-and-off friendship with de Acosta, after 1934 Garbo made a point to be seen publicly in the company of prominent men.

After the frenzied speculation about Garbo's relationship with Mamoulian cooled down, there was little news about her to report. The least trivial would qualify, such as the story in June 1934 that Garbo's driver had changed the windshield wiper on her car.

> If it has any connection with Garbo, you may rest assured there isn't a paper in the country that would miss printing it. Garbo is good copy, but she won't give. However, she has got that old 1925 Lincoln and the other day a bright p.a. noticed that it had a 1933 windshield wiper. Just for the hell of it, he wrote a story on it, and to the amusement of the publicity department, every newspaper [to] which it was sent printed it, just for the use of Garbo's name.[35]

On the topic of automobiles, there is a persistent rumor in the Garbo canon that she once owned a Duesenberg. A magnificent red 1933 convertible occasionally appears on the market with the Garbo provenance proudly heralded. Alas, she herself stated that she never owned such a car, widely considered the greatest automobile ever made. Gary Cooper and Clark Gable both were the proud possessors of 1930s models, but not Garbo.

Her 1932 contract was intended to be Hollywood's most lavish for a performer, and indeed when the list of top earners came out early in 1934, Garbo was on top, having been paid $9,000 a week. Close on her heels were Will Rogers, Maurice Chevalier, and Constance Bennett, who each made $7,000 weekly.[36] As for the future, Harold Weight predicted in *Hollywood Filmograph* that "among stars, the Mae West fad will be well on the wane by the end of 1934. Greta Garbo will return to the head of the class, and Katharine Hepburn will be second if good vehicles are selected for her."[37]

THE PAINTED VEIL

Garbo would have a new producer and director for the *The Painted Veil*, Hunt Stromberg and Richard Boleslavsky. The lead writer was Salka Viertel, but she later claimed to have "repressed the memories of the film."[38] Most of Garbo's team at MGM were back, including Daniels on camera and Milton Brown for scene stills, as well as Adrian and Cedric Gibbons, and the ever-reliable Clarence Bull for portraits. The film would be set largely in China, so the studio sent cinematographer Clyde de Vinna across the Pacific to shoot backgrounds.[39] A Garbo picture had to have the proper atmosphere, and few expenses were spared to ensure that a dazzling exotic spectacle would greet ticket buyers.

The Painted Veil gave Garbo a familiar role, playing once again an adulterous wife. Parroting *Wild Orchids*, an unhappily married woman has an affair with a dashing man in the mysterious East. Again, casting held up the production,

Garbo is recorded in a portrait by Clarence Sinclair Bull taken at the conclusion of filming of *The Painted Veil*.

originally scheduled to begin late winter of 1934. In mid-May Herbert Marshall was announced to play Garbo's husband. But it would not be until two months later that George Brent, on loan from Warner's, would be cast in the plum role of her lover. Simply being announced as working with Garbo could be career defining. "The choice of Herbert Marshall as Garbo's leading man in *The Painted Veil*, her next, stamps this tall, suave Englishman as the highest ranking leading man in Hollywood. All the biggest feminine stars have been clamoring for him—but the Garbo lead is the accolade," reported *Photoplay*.[40]

The conceit in the film is that her inamorato (George Brent) does not wish marry her, which sends her back to her husband whom (it turns out) she loved all along. This bit of sentimentality might have been written into the script to appease the censors (the Production Code Administration had been established that June just as *The Painted Veil* was under way). The MPPDA had been working under the so-called Hays Code, but studios were able successfully to find ways to bend the rules. The newly imagined PCA intended "to strengthen in every considerable way the effectiveness of the Code."[41] Garbo's scripts had always been carefully scrutinized; henceforth, the censors would have even greater say in determining the shape of her films.

George Brent was a particularly dashing Hollywood leading man. For most of his career, he was at Warner Bros., where he hit his stride in 1931, and for two decades he worked in many now-classic films such as *Baby Face* (1933) with Barbara Stanwyck and *42nd Street* (1933) with Ruby Keeler and Bebe Daniels. Brent is best known for supporting Bette Davis in many films in the 1930s and 1940s, including *Jezebel* (1938) and *Dark Victory* (1939). His leading ladies became many of the most-beloved screen icons, but though he was attractive, his slightly bland acting style prevented him from reaching movie stardom. Garbo took a liking to Brent, and by the time filming was completed, they were seen together discreetly socializing around Los Angeles. This created another press frenzy.[42] Would they marry? Brent and Garbo shared quiet personalities and an aversion to journalists, so even less was known about their times together than the few tidbits reported the year before when Garbo kept company with Mamoulian. Brent lived in Toluca Lake in the San Fernando Valley, and his house became a place of meeting and solace for Garbo. The reporters were on her trail and published whatever morsels they could gather. "Ssh! Brent Woos Garbo in Silence," wrote the *Omaha Herald* in late 1934; "many visits [were] paid at the Irish actor's home by the great Garbo, who hurriedly draws her cloak around her as she steps from her neatly painted old limousine and rushes to the front door."[43]

Something of a tradition was developing by which Garbo's leading men gave an interview about what it was like to work with her. Ramon Novarro, Robert Montgomery, and John Gilbert spoke for publication about the honor of costarring with Garbo. Now it was Herbert Marshall's turn. In November *Photoplay* published, "What It's Like to Work with Garbo: Herbert Marshall's intimate revelations will surprise you." Not all that revelatory, in fact, although she was "very companionable and friendly." Marshall did tell a story about renting Edmund Goulding's house, which included a tennis court. One day he noticed two women playing tennis, one of whom was Garbo. Marshall decided to leave them to their game but later found out "that Goulding had given Garbo a standing invitation to use the court when she pleased."[44] Though she was well aware of the new tenant, she characteristically thought nothing of it.

The Painted Veil was finished in September and selectively released on December 7, 1934. Audience response to an early preview was negative, so the film

was sent back for some judicious editing and retakes.[45] Director Boleslavsky was apparently not available, so Woody Van Dyke, famous for his quick and efficient directing style, was called in to reimagine the film. Stories circulated that he called Garbo "honey" and "kid" on the set, but instead of bristling at this informality, she is said to have responded, "Just call me Chocolate."[46] Even with the new scenes, *The Painted Veil* got mixed reviews. Garbo's number-one supporter among critics, Mordaunt Hall, had retired from the *New York Times* shortly before the film opened. But his successor, Andre Sennwald, was no less enamored of the actress: "She continues to be the world's greatest cinema actress in the Oriental triangle drama."[47] *Variety*, on the other hand, panned it (a rarity for a Garbo film), calling it "a bad picture" and even proclaiming, "Miss Garbo is fair, although she doesn't get much time to emote."[48] This was a tricky juncture in Garbo's career; for the first time, there were serious indications in the press of weariness with both the unchanging product and the old-style glamour goddess's continued invisibility. Still, box office for *The Painted Veil* was good, bringing in $1,658,000, but as Garbo's pictures were expensive to make, after all costs were deducted, it returned only $138,000 to the studio, the lowest since *The Torrent* (profit $126,000) and *The Temptress* (loss of $43,000).

Nevertheless, Garbo got a raise. In October she signed a contract for one film to be made in 1935 at a salary of $270,000. Canyon Productions was closed that summer after the two films made under the 1932 agreement were completed. Henceforth, her salary would be paid to her directly. Garbo and Viertel were anxious to film *Anna Karenina* again, this time in a production closely following Tolstoy's novel. Her producers were concerned that the public had tired of costume dramas and thought she would be better served in a contemporary drama. Garbo was not convinced. The MGM team must have hoped they could convince her to consider a more exciting offering, if not a modern story, so an item was dropped in the press in November that she would play Lola Montez, the nineteenth-century dancer who "vamped the King of Bavaria."[49] Nothing came of that idea. Mercedes de Acosta wanted Garbo to play Joan of Arc and spent much of 1934 working on a script, although it is unclear how keen Garbo was to do it. Although the two were friends again, even to the point that de Acosta rented the house directly next door, it was increasingly obvious to any who paid attention that it was Salka Viertel who had the greatest influence on Garbo's professional life.

ANNA KARENINA

Garbo and her producers were all looking for a project that would reenergize her brand; they just had different ideas of what film would bring her back on top. David O. Selznick, son-in-law of Louis B. Mayer, joined MGM in 1933 and, after a string of successful pictures, was appointed producer of Garbo's 1935 film. Thalberg, back from Europe in the summer of 1933 and in reasonably good health,

no longer held the position as MGM's top producer. He was overseeing his own films, often starring his wife, Norma Shearer; in early 1935 he was working on *Mutiny on the Bounty* with Clark Gable. Selznick was among the new generation of producers at the studio and made pictures that sang at the box office, beginning with a big success, *Dinner at Eight* (1933). He spent much of 1934 in England filming *David Copperfield*, with Freddie Bartholomew playing the lead. Nepotism or not, his films were adding significantly to MGM's annual profits. Next up for Selznick was the new Garbo picture.

Garbo was vacationing with George Brent at La Quinta near Palm Springs in early January 1935 when she received a letter from Selznick, hand-delivered by Salka Viertel. It read in part:

> We have lost our enthusiasm for a production of Anna Karenina as your next picture. I, personally feel that audiences are waiting to see you in a smart, modern picture and that to do a heavy Russian drama on the heels of so many ponderous, similar films, in which they have seen you and other stars recently, would prove to be a mistake.

Selznick had another film in mind. "I find that if I act very quickly, I can purchase *Dark Victory*, the owners of which have resisted offers from several companies for many months." Tallulah Bankhead had starred in the play on Broadway the year before, and the lead character was a contemporary woman similar to Diana Furness, whom Garbo had played to great acclaim in *A Woman of Affairs*. "I request and most earnestly urge you to permit us to switch from *Anna Karenina* to *Dark Victory*," he concluded, "and you will have a most enthusiastic producer and director."[50] Why *Anna Karenina* remained on track despite Selznick's misgivings has never been adequately explained. One issue that loomed over either (or any) production was that Garbo planned to leave for Sweden early in the summer, so time was limited. Viertel had already written a draft of the script for *Anna Karenina*. Purchasing *Dark Victory* would be expensive, and a screenplay would need to be prepared.[51] Even with Selznick's eagerness to cast Garbo in a contemporary drama, given her schedule and the money already invested, it was perhaps inevitable that in 1935 Garbo would (once again) star as Anna.

While negotiations about her upcoming film project were continuing, Garbo surprised many in Hollywood by making a public appearance with a group of friends at the brand-new Café Trocadero on Sunset Boulevard.[52] Late in the evening of January 25, she was seen in the company of a distinguished group of foreigners, including directors Max Reinhardt and Fritz Lang, as well as Natalie Paley, cousin to the last czar of Russia. The next day the press was filled with articles testifying to the rare outing but also commenting on Marlene Dietrich's presence at a nearby table. Apparently the two screen goddesses ignored each other. A few months later, Garbo and Mercedes de Acosta were tracked by

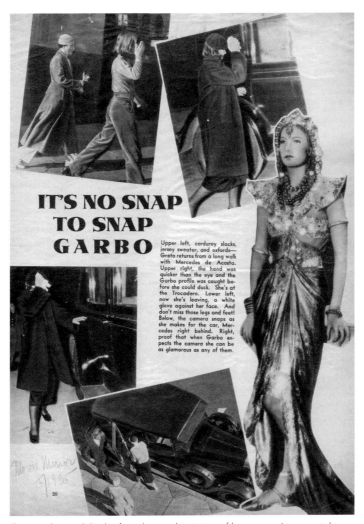

IT'S NO SNAP TO SNAP GARBO

Upper left, corduroy slacks, jersey sweater, and oxfords—Greta returns from a long walk with Mercedes de Acosta. Upper right, the hand was quicker than the eye and the Garbo profile was caught before she could duck. She's at the Trocadero. Lower left, now she's leaving, a white glove against her face. And don't miss those legs and feet! Below, the camera snaps as she makes for the car, Mercedes right behind. Right, proof that when Garbo expects the camera she can be as glamorous as any of them.

The press haunted Garbo from the very beginning of her career. At upper right and below, she and her friend Mercedes de Acosta try unsuccessfully to avoid the intrusion of the camera as they spend two afternoons shopping in Los Angeles (*Movie Mirror*, May 1935).

photographers as they were walking together in Los Angeles. Photographs of the two were published in *Movie Mirror* (May 1935) under the caption "It's No Snap to Snap Garbo." In one photograph the women are seen walking briskly, both wearing trousers. In another they are seen getting into Garbo's well-known, now almost antique limousine.

Casting was simpler for *Anna Karenina* than it had been for her previous two films. Fredric March was one of the most prestigious male actors of the 1930s, having achieved great acclaim in films such as *Dr. Jekyll and Mr. Hyde* (1931) and *Design for Living* (1933), and Selznick was anxious to have him work with Garbo in her next film. March preferred *Dark Victory* but agreed to play Count

Vronsky, the role played eight years earlier by John Gilbert. Garbo was happy with this choice. To play her son, Selznick cast Freddie Bartholomew, coming off his triumph as David Copperfield. Basil Rathbone would round out the top-billed cast, playing Garbo's husband, Count Alexei Karenin. George Cukor was mentioned as a possibility to direct, but it seems his interest was limited to *Dark Victory*. Selznick recruited Garbo stalwart Clarence Brown, who would now direct Garbo for the sixth time.

Salka Viertel believed *Anna Karenina* to be the right film for Garbo in 1935, but she was candid about the producer's initial response to her work. "Selznick found the screenplay we delivered much too long, the scenes Victorian, the dialogue too stilted, and he wanted changes."[53] The final film was a mere ninety minutes, so in the end the script must have been cut. "Victorian" might not be the best description for *Anna Karenina*, but it must have seemed old-fashioned even to audiences in 1935. Set designer Cedric Gibbons shares some of the responsibility for that. Although he created some of the most modern interiors in Hollywood and could design captivating period sets, *Anna Karenina* was anchored stiflingly to the past. The dialogue is stilted, as is often the case when a famous literary text is the source. Garbo plays her role well but in the narrowest range of emotion thus far seen in her many performances. Chemistry, romantic or otherwise, is so lacking between Garbo and March that Rathbone, playing the distant and punishing husband, almost seems a better choice for Anna.

The same reviewer at *Variety* who had called *The Painted Veil* "a bad picture" gave *Anna Karenina* a rave review, declaring that "Garbo has never had a part which suited her more comfortably."[54] The entire cast is acclaimed, including March. But *Photoplay*, generally supportive of Garbo and MGM films, let loose with, "This is really a weak and dull picture, yet the pervasive genius of Garbo raises it into the class of art . . . Fredric March seems very stuffy as her lover."[55] Sennwald in the *New York Times* was enthusiastic about the film, describing it as a "dignified and effective drama which becomes significant because of that tragic, lonely and glamorous blend which is the Garbo personality."[56] Alistair Cooke, writing from London, noticed a subtle change in the actress: "Garbo's maturity is not the maturity of her career, it is a wise ageing of her outlook. The old, bold, slick disdain has given way to a sort of amused grandeur."[57] More important than reviews were receipts at the box office, and *Anna Karenina* was among Garbo's most successful films to date, equaling *Mata Hari* and only slightly behind *Grand Hotel* and *Queen Christina*. Returning a net profit to MGM of $320,000, it was not a big moneymaker, but it covered the high costs associated with a Garbo picture and ended up comfortably in the black. When tax returns were filed for 1935, Garbo was on top of the list for the biggest earners among performers at MGM, taking home $332,500 for work in a single picture. Wallace Beery was second at $278,500 and Joan Crawford third with $241,500, but both appeared in multiple releases.[58]

The New York Film Critics Circle was founded in 1935 as an association of film journalists to honor the best screen work coming from Hollywood and abroad. The first year's awards were announced on January 2, 1936, naming John Ford's *The Informer* as best picture and Ford as best director. Charles Laughton was honored as best actor for *Mutiny on the Bounty* and *Ruggles of Red Gap*. Garbo took top place among women and won for her performance in *Anna Karenina*. Katharine Hepburn was runner-up for *Alice Adams*. The Circle hosted a gala dinner at New York's Ritz-Carlton Hotel on March 2, 1936, with playwright and critic Robert Sherwood hosting, and which was broadcast coast-to-coast over the radio.[59] None of the top honorees was present—Laughton was in England, Ford was in Hollywood, and Garbo was in Sweden. The Swedish consul-general in New York accepted for Garbo. Still, plenty of luminaries attended, including Ernst Lubitsch, Clarence Brown, Robert Young, and Carmel Myers.

The previous September *Anna Karenina* was awarded the Mussolini Cup for best foreign film at what would later be known as the Venice Film Festival. The citation read, "The excellent interpretation of Greta Garbo, joined with the efficacious and human translation into images of Tolstoy's masterpiece, makes of this film a work of undoubted artistic value."[60] King Vidor received the cup as best director for *The Wedding Night*, starring Gary Cooper and Anna Sten. When the Academy of Motion Picture Arts and Sciences released its nominations for the best screen work for 1935, *Anna Karenina* was ignored in all categories. Bette Davis won for best actress in *Dangerous*.

With *Anna Karenina*, Garbo consolidated her position as to the sort of films in which she would appear. Fans and the press saw her as Hollywood's greatest actress, the world's most beautiful woman, the successor to Sarah Bernhardt and Eleonora Duse. Whether or not Garbo agreed, henceforth her screen characterizations would reflect this lofty position. She was supported by Mercedes de Acosta, who still lobbied for *Joan of Arc*, and Salka Viertel, who was working diligently on a script about the life of Maria Walewska, Napoleon's mistress and mother of his illegitimate son. Contemporary stories were out of the question. At thirty Garbo would consider only noble heroines from literature or history, giving her public what she felt they wanted, regardless of the suggestions that might come from her producers. Moreover, she would appear in roles that in her view would add luster to the carefully calculated Garbo marque. Joan Crawford, Bette Davis, and Katharine Hepburn could have their pick of roles playing modern women. Garbo, sitting on her perch above, claimed to be cinema's heir to theater's distinguished dramatic past.

CAMILLE

MGM publicity added a new strategy to the marketing of Garbo in 1935. As she was never available to the press, made only a single film per year, and limited her time in Clarence Bull's portrait studio to one day following each film's completion, official stories, penned by studio employees who worked with Garbo, were now selectively distributed to newspapers and fan magazines. This was entirely contrary to the previous model by which MGM imposed a rigid code of silence, with the exception of allowing the occasional costar to pronounce to one journalist or another the wonders of working with the actress and how down-to-earth she really was. Costume designer Adrian was one of the first to go on record. The two seem to have had a cordial friendship, and he had designed all her film wardrobes since *A Woman of Affairs* (1928). "Adrian Answers 20 Questions on Garbo" appeared in the September 1935 issue of *Photoplay*. Likely put together by a publicity department employee based on interviews with Adrian, the piece is bland and reveals nothing personal about the actress. But it does have the authority of an important colleague and over three pages answers simple questions truthfully. When asked about "mysterious propaganda" (which sounds like a publicity department slogan), Adrian responds that Garbo "desires to live a private life." About her desire to be alone, he says that "if she finds she cannot have the privacy and the pleasure of being unnoticed in public that the majority of us have, she has a perfect right to have that, wherever else she can find it." He describes Garbo as shy but says she has a sense of humor. Her "wardrobe consists of tailored suits, various top coats of the sport variety, sweaters, slacks, berets, sport hats, stocking caps (with visors that fit over them) and sports shoes." To "Garbo's reactions are selfish ones?" his answer was, "I think a great many of them are. But I think they are her own business!"[61] Having Adrian speak as the studio's official voice serves to demystify Garbo (somewhat) while keeping the legend firmly in place. Readers in 1935 might think they knew her a bit better now, but in the end the words have been carefully chosen, and *Photoplay* has published a packaged studio puff piece designed mainly to keep their absent star in the public eye.

The next month, Garbo's favorite cinematographer, William Daniels, was interviewed for an article in *Hollywood*, with the headline proclaiming, "*Garbo's* Cameraman Talks At Last." "Garbo is the finest person in the world to work with," says Daniels, toeing the MGM party line, "Quite apart from her greatness as an actress, she is a supremely great personality." It goes on like that. He describes the best ways to photograph her, long shots and close-ups, and notes that "she often gives her best performance on the first 'take.'" And, probably no surprise to readers, he tells us "she almost never troubles to look at the 'rushes' of her films, nor even at the first rough assembly of the picture. Instead, she waits for the preview, calmly confident that each of us will see to it that no flaw exists in any department." With Garbo's increasing, and increasingly prolonged, absences

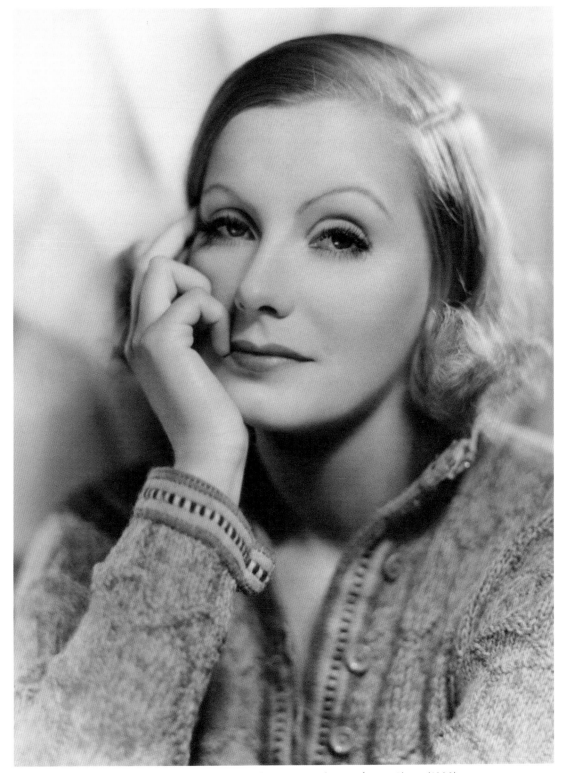

A portrait taken by Clarence Sinclair Bull for the German-language production of *Anna Christie* (1930).

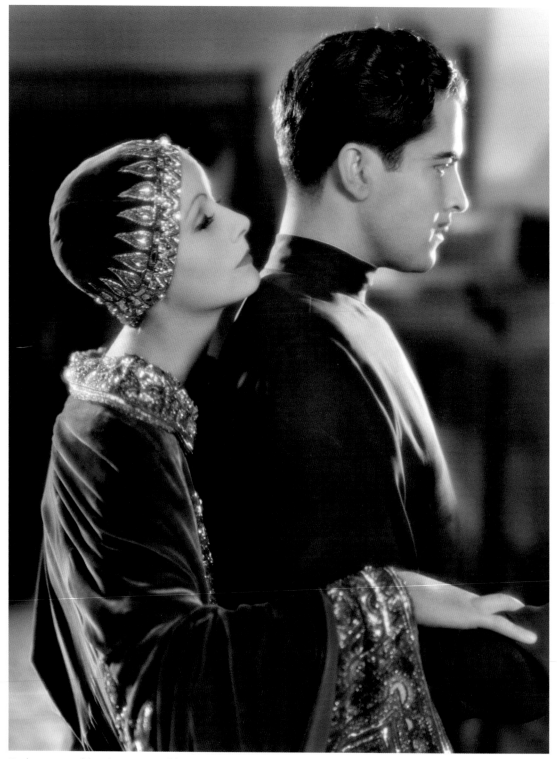

Garbo portrayed the glamorous World War I spy Mata Hari in 1931, costarring with Ramon Novarro. Photograph by Milton Brown.

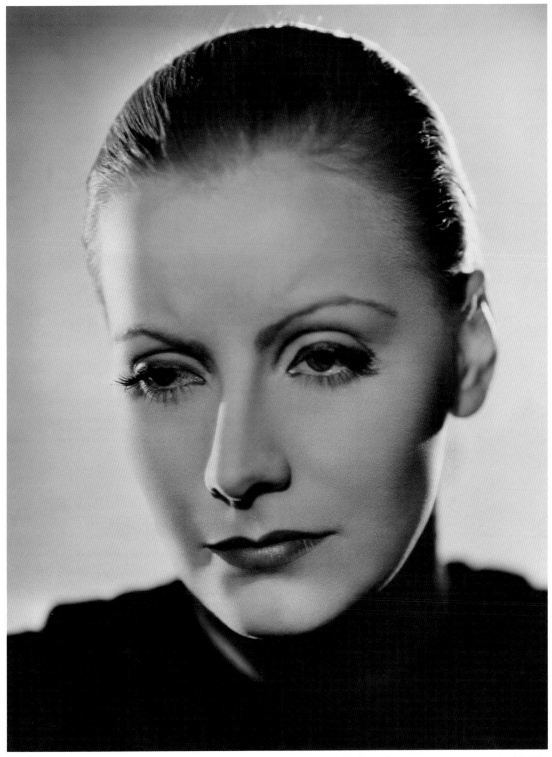

Clarence Sinclair Bull photographed Garbo costumed for the scene in which she faces the executioners in *Mata Hari* (1931).

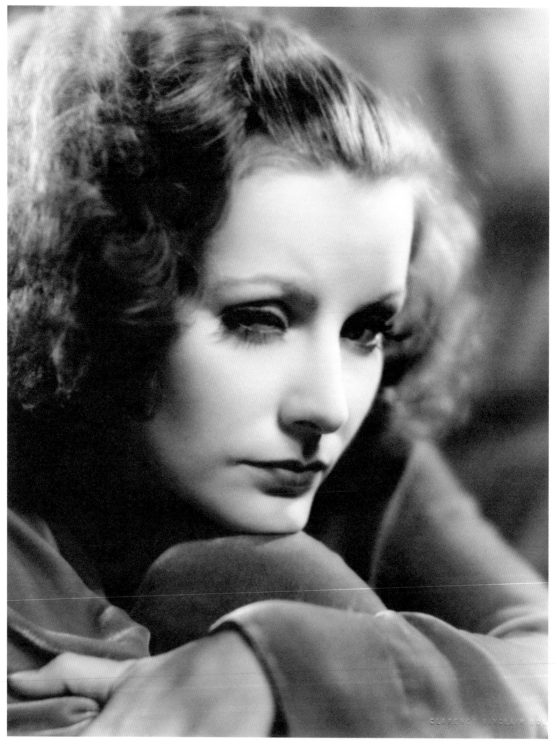

Garbo's face registered magnificently in close-up whether on screen or in portraits. Photograph by Clarence Sinclair Bull for *Inspiration*, 1931.

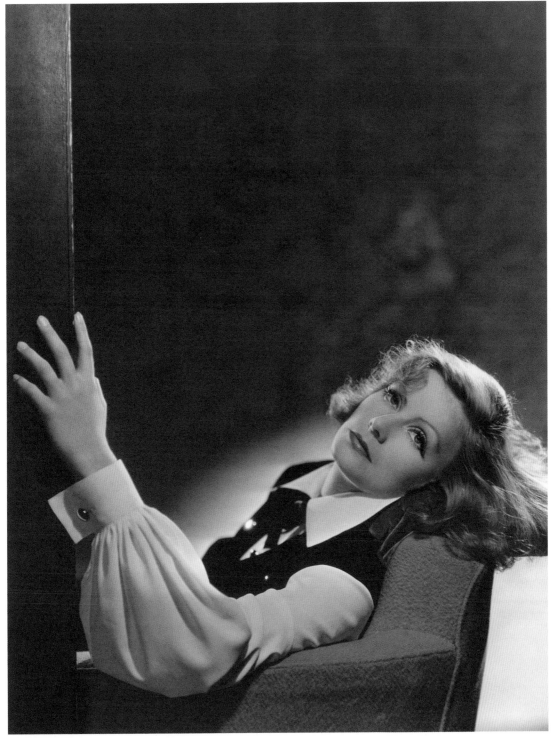

By the time of Clarence Sinclair Bull's 1932 study of Garbo, the photographer was no longer recording an actress playing a role: he was capturing the face of a legend.

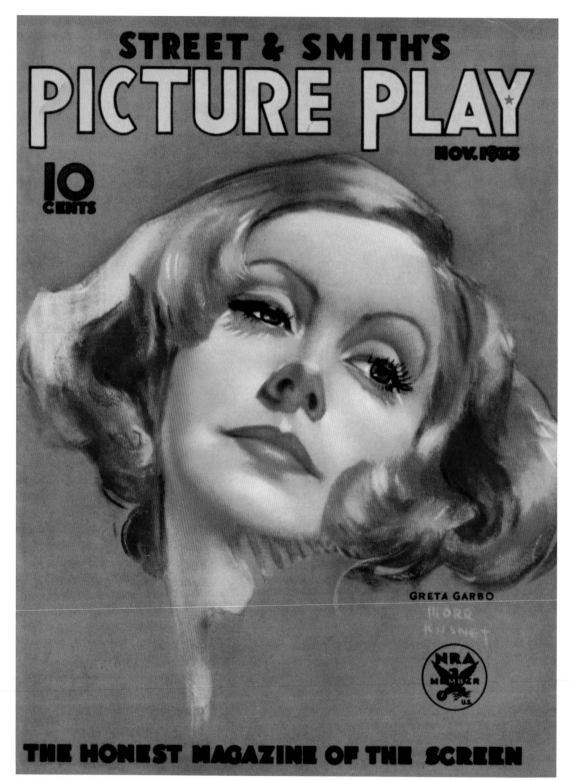

Illustrator Morr Kusnet based his painting for the cover of *Picture Play* (November 1933) on a 1932 portrait Clarence Sinclair Bull took for *As You Desire Me*.

In 1932 when Garbo left America for a long European vacation, Mae West briefly challenged her at the box office, but Garbo soon regained her place as audience favorite. (*Ballyhoo*, February 1934)

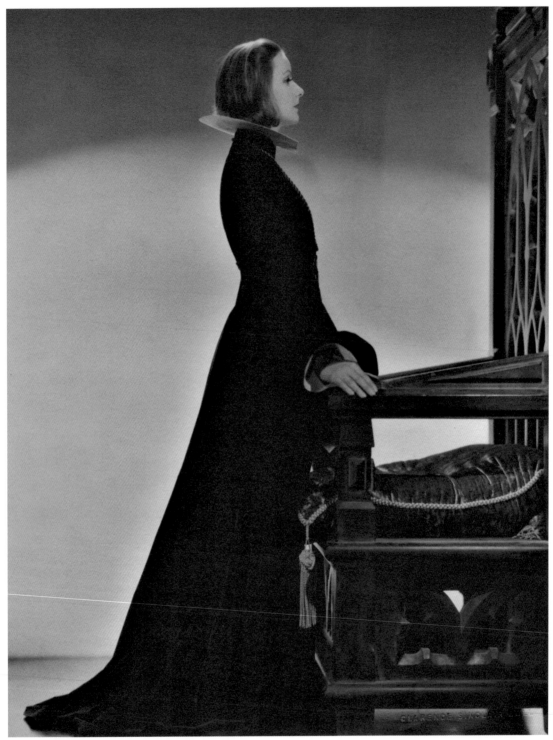

Garbo as Queen Christina, contemplating the throne she is about to renounce. Photograph by Clarence Sinclair Bull (1933).

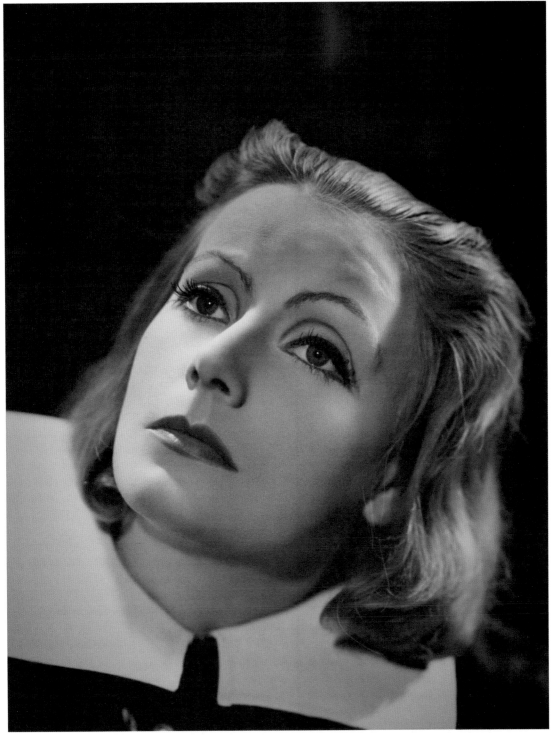

Garbo had long wanted to play Queen Christina and finally got the chance in 1933. Photograph by Clarence Sinclair Bull.

Garbo as the courtesan Marguerite Gautier in the 1936 film version of Dumas's *La dame aux camélias*. Photograph by Clarence Sinclair Bull.

Garbo's performance in *Camille* is often acclaimed as among the finest by a motion picture actress. Photograph by Clarence Sinclair Bull (1936).

Garbo portrayed Napoleon's paramour Maria Walewska, in *Conquest*. Photography by Clarence Sinclair Bull (1937).

There is a rumor that Garbo had a hand in the design of the hat her character wore in *Ninotchka*. Photograph by Clarence Sinclair Bull (1939).

Illustrator Jacques Kapralik gently parodies the Garbo legend in his 1941 drawing to promote *Two-Faced Woman*.

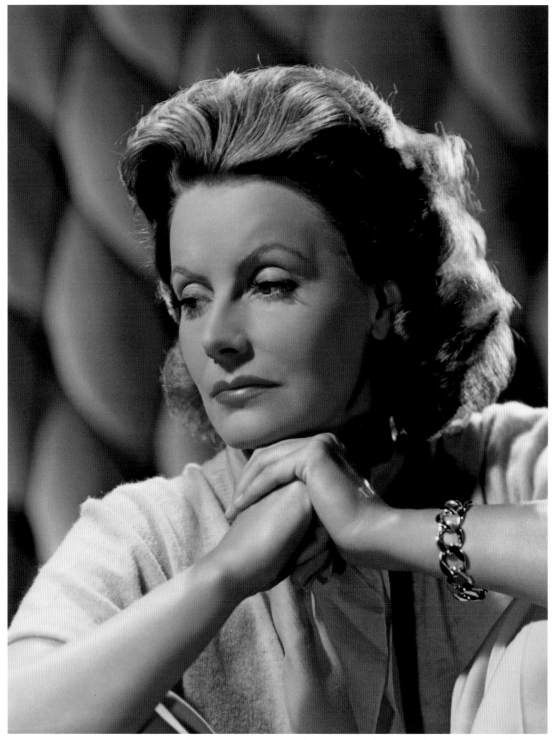

Clarence Sinclair Bull made this color study in October 1941 during the production of *Two-Faced Woman*, in his final portrait session with Garbo. Courtesy John Kobal Foundation

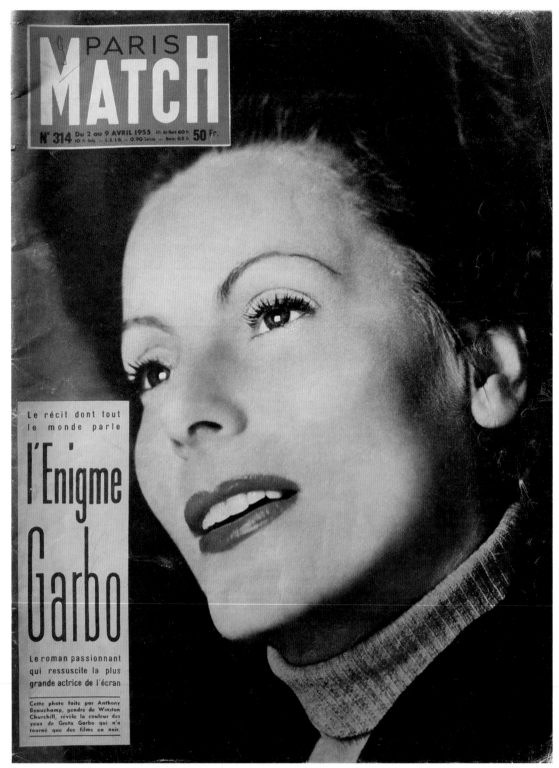

PARIS MATCH

N° 314 Du 2 au 9 AVRIL 1955 Ar. du Nord 60 fr. 50 Fr.
(0 fr. Belg.) — C.E.I.E. — 0.90 Suisse — Naroc 65 fr.

Le récit dont tout
le monde parle

l'Énigme Garbo

Le roman passionnant
qui ressuscite la plus
grande actrice de l'écran

Cette photo faite par Anthony
Beauchamp, gendre de Winston
Churchill, révèle la couleur des
yeux de Greta Garbo qui n'a
tourné que des films en noir.

Antony Beauchamp photographed Garbo in color in the fall of 1950, and the images graced the covers of magazines inter-
nationally throughout the decade. (*Paris Match*, April 2, 1955)

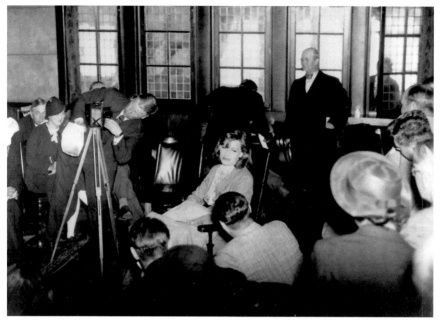

Garbo rarely spoke with members of the press, but when she did it was mostly while traveling. In June 1935 when the MS *Gripsholm* docked at Göteborg, Sweden, she met with reporters in the ship's first class lounge.

from America, the studio needed to reassure readers (whether true or not) of her reciprocal devotion to her adopted country and used the authority of Daniels' voice: "Miss Garbo is fond of America. She loves the California sunlight, basking in it, walking in it incessantly. She drinks it in as some people drink fine wine; I don't think she could ever get enough."[62]

She had had enough in June 1935, for as soon as *Anna Karenina* finished filming in early May, she made plans to sail immediately for Sweden. Portraits were made in Bull's studio on the seventeenth, and two weeks later, on May 30, she signed a contract to make a film the next year and packed her bags. The name of the film and the date when it would be made were left vague, although the titles were likely to be *Camille* and/or *Maria Walewska*. A photo dated June 4 shows Garbo in a New York taxi leaving the train station, but for the most part she did a good job, once again, of evading the press. By mid-June she was back in Sweden.

A small charter boat had motored out to the harbor so that reporters could board before the MS *Gripsholm* reached its dock. Trapped unless she could figure out a way of disembarking unnoticed, Garbo reluctantly gave her compatriots a few minutes, although in proper movie-star, form she made them wait an hour in one of the first-class saloons until she appeared. The best record of the interview appeared in *Movie Classic* in October 1935. Asked about *Queen Christina*, Garbo said that she was disappointed with the film. One reporter asked about a manuscript in Stiller's hand, recently discovered, that the late director wanted to

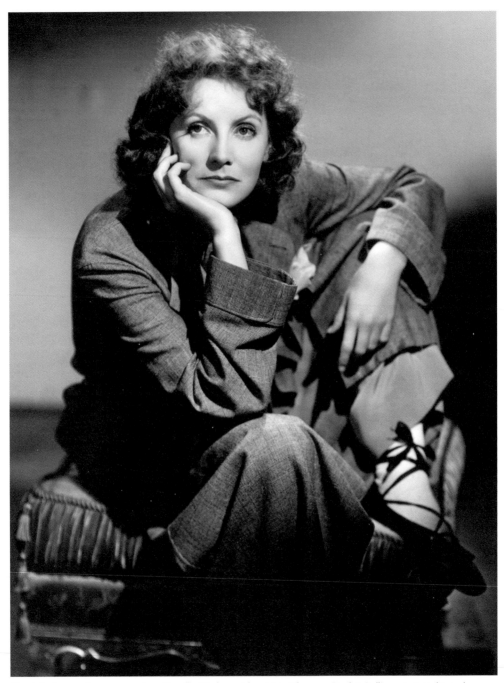

Shortly before work commenced on *Camille*, Garbo paid a visit to Clarence Sinclair Bull's portrait studio and agreed to sit while he exposed three negatives. She is not wearing a costume but is dressed in the clothes she wore to the studio that day.

film with Garbo as lead. "How can I make any statement about that off-hand?" she responded. "It is entirely too important—maybe—and very near to my heart." Asked about her plans, she gave the typical Garbo answer, "How do I know? I make plans and change them. I never know what will happen. I have as yet no idea what I will do tomorrow."[63]

Soon after arriving in Sweden, Garbo visited the Wachtmeister estate at Tistad, south of Stockholm. Thousands of miles from Hollywood, she was still preoccupied with her work and wrote Salka Viertel that she was "thinking about the Napoleon story" (made in 1937 as *Conquest*) and requested that she include a scene in which her character, Maria Walewska, wears "trousers, maybe her dressed as a soldier," as "I have a great longing for trousers."[64] She makes up a little poem about girls and trousers, which she signs "G. Stein." In the same letter Garbo hopes that "black and white" (Mercedes de Acosta) is not making Viertel's "life miserable." Perhaps searching for another alias, Garbo signs the letter, as she often did, G.G., but included after it "= 99" [*G.G.* = 99].

In another letter to Viertel, she writes of receiving a wire from "Swartzweise" ("black and white"), who asked to come to Sweden "and wait and accompany me back." Garbo stated she was not planning to answer, but given the complicated relationship between the actress and de Acosta, she ultimately relented.[65] De Acosta wrote in her memoirs that Garbo invited her for dinner at the Grand Hotel—which was enough encouragement for her to book passage on the SS *Europa* for the journey from New York to Bremen, Germany. From there she would make her way on to Stockholm. In early October, de Acosta was sailing, and upon arriving in the Swedish capital told that she was given the Grand Hotel's Royal Suite.[66] Garbo did entertain her at the hotel and later invited her to visit the Wachtmeister estate. One evening in Stockholm the pair went to the theater. As they were leaving, "a gang of photographers was lined up outside waiting."[67] Garbo sprinted off, escaping the reporters, and hid in a small shop nearby. "I wonder if press photographers actually realize," de Acosta later wrote, "what a thoroughly miserable time they have given Greta over all the many years of their relentless and merciless pursuit."[68] Before leaving Stockholm, Garbo took her to see the Gustafssons' former home on Blekingegatan. De Acosta did not stay in Sweden long enough to accompany Garbo back to Hollywood.

While Garbo was away, plans were being made for her next film. The studio was preparing *Camille*, based on the nineteenth-century novel and later play by Alexandre Dumas *fils*, *La dame aux camélias*; Thalberg would produce. From Sweden she was keeping tabs on what was happening back in Culver City and using Viertel as her "eyes and ears" while negotiations continued in her absence. In one letter she asked Viertel to relay her concern to Thalberg that *Camille* was "so like Anna" that maybe *Maria Walewska* should be made first. Napoleon would be better, she believed, as "he isn't a usual figure on the screen, like my other fifty thousand [sic] lovers."[69] Garbo also expressed displeasure that Clarence Brown

was under consideration as director. Garbo inquired whether Viertel would be working on the *Camille* screenplay and hoped that she and Sam Behrman would write it together. Viertel does not mention it in her autobiography, suggesting that Thalberg had another idea. Garbo read that Frances Marion was working on the picture and wondered why Viertel was not: "Beilenson [her lawyer] has not then fixed it right at MGM."[70]

Garbo wrote to Mayer in December describing that she had been ill most of the fall and wanted to delay her return to America.[71] Although there is strong evidence that she was suffering from respiratory ailments that fall and winter, during those months she was also well enough to travel between Stockholm and Tistad, to entertain Mercedes de Acosta and to stay with Hörke Wachtmeister. The letter also indicates that Garbo and Mayer had settled on *Camille* as her next film. Garbo did not get back to New York until May 3, 1936, having "travelled alone and under the name 'Mary Holmquist' without secretary or maid."[72] Again she consented to a shipboard chat with reporters. Photographs show a seemingly relaxed Garbo sitting comfortably in their company (as usual, mostly male). From New York she traveled by train back to Hollywood, where preparations were under way to start filming *Camille*.

Thalberg offered director George Cukor either *Camille* or *Maria Walewska*, and Cukor chose the former.[73] Garbo agreed. She did not get her way about writers; Thalberg asked Marion and novelist James Hilton to coauthor the script. As delivered, it was "ludicrous—flowery, overblown," recalled the film's associate producer, David Lewis.[74] Playwright Zoë Akins was brought in as script doctor; Cukor claimed that she "did a new one from scratch."[75] In any case her sensitive touches fixed the problems and made the script ready for filming. Hilton later wrote Cukor praising the film and wondered about the author of the screenplay: "Who was it, by the way?"[76] All three (Marion, Hilton, Akins) received screen credit.

The contract Garbo had signed the previous May had not only promised her $250,000 for her work on *Camille* but also outlined strict guidelines for the amount of time she was willing to work—twelve weeks—and required the studio to adhere to a defined shooting schedule, owing her an additional $10,000 weekly if she was required at any other time, before or after. Filming was scheduled to begin in late July, but Garbo was needed earlier to meet with Adrian about the elaborate costuming. Ultimately she agreed to do so, with no additional cost to MGM.[77]

Garbo would play Marguerite Gautier, a character based on the life of the Parisian courtesan Marie Duplessis. Robert Taylor was cast as her lover Armand Duval. Six years Garbo's junior, he would be her only younger leading man. Although he was only twenty-five, Taylor had completed sixteen films at MGM. Later, Cukor recalled filming the climatic final scenes: "We were lucky . . . to have Robert Taylor . . . Because [he] was young it came alive." Taylor admitted to being in awe of Garbo when the casting call came, and a simple "How do you do?" was all he got from her the day they met on the set. It was not until later that the two

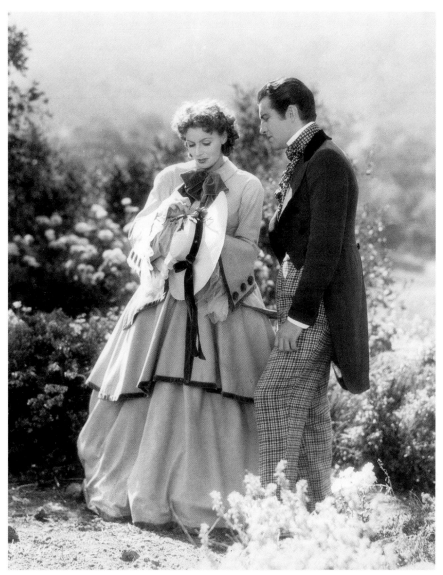

One of Hollywood's greatest romantic films, *Camille* paired Garbo and heartthrob Robert Taylor as the ill-fated lovers. Photograph by William Grimes.

developed a friendship. "One day suddenly she started talking to me . . . As Marguerite (Camille) warmed up to Armand in the script, Garbo's attitude toward me changed completely."[78] Many years later Garbo told a friend, "I really appreciated what [Taylor] did when he visited Stockholm for the premiere of *Camille*, which was to send flowers to my mother, twelve gorgeous orchids."[79]

Further casting for the film was impeccable. Henry Daniell gave a career-defining performance as the Baron de Varville, who pays for Marguerite's attention. Laura Hope Crews, Lenore Ulrich, and Rex O'Malley shine in supporting roles.

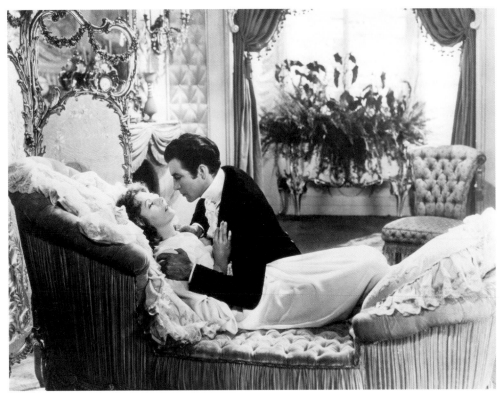

Garbo's performance in *Camille* is generally accepted as among her finest. Shown here, Garbo and Robert Taylor play the final scene, in which her character Marguerite Gautier dies from consumption. Photograph by William Grimes.

Lionel Barrymore is a bit stiff as Armand's father but adds the script's necessary severity to his scenes with Garbo.

She would be playing, once again, a prostitute, as she had in *Anna Christie*, *Inspiration*, *Susan Lenox*, and *Mata Hari* (rather than an adulterous wife, as she had in her two previous films). Even with enhanced censorship, the screenwriters and producers managed to retain the integrity of the story. Skillful writing was important, but as Cukor later noted, "Garbo had this rapport with an audience, she could let them know she was thinking things and thinking them uncensored."[80]

On September 14, 1936, shortly before the film wrapped, Irving Thalberg died of pneumonia at the age of thirty-seven. He was buried three days later. MGM closed for the day of the funeral, and Garbo was among the great producer's mourners. *Camille* was dedicated to him, and for the only time in his career, Thalberg's name appeared on screen. Bernard Hyman, not David Lewis, who had been working on the film with Thalberg, took on producing responsibility, which meant overseeing the film's final cut. By all accounts his work was poorly received, and *Camille*'s first preview in early November in Santa Barbara was unsuccessful.[81] According to Lewis, "Hyman had screwed the picture to hell and gone."[82] Lewis

wanted to restore Thalberg's original vision of the film, and to do so he had to go above Hyman and get the studio's top brass to agree to further rewrites and the filming of additional scenes. This would trigger the $10,000 a week for Garbo's extra time, but Mayer relented and the work was done in late November and early December. Garbo wrote Wachtmeister that December: "Camille never ends. We have to shoot retake after retake."[83] Cukor, Lewis, writer Akins, and the marvelous cast saved the film. The next preview was in Palm Springs on December 12, and word was that Garbo attended with the director.[84] "It is not exactly a masterpiece," she said in the same letter.[85] But if not, it was pretty close.

Losing Thalberg almost ruined *Camille*. He had intended to set up his own production company when his MGM contract expired and must have hoped Garbo would join him. Recognizing their close professional partnership, *Motion Picture* (December 1936) wrote, "With Thalberg Gone Will Garbo Retire?" His achievements as a producer are among the finest in the annals of Hollywood, and *Camille*, one of the last projects he supervised, is a testament to his tremendous skill.

During the making of the picture, "the crowd of star-gazers and autograph seekers which customarily hangs around the MGM entrance and the auto park across the street [had] tripled in size."[86] In order to exert some control, MGM "had to triple the guard on the gates to keep the Garbo-peepers away."[87] In a letter to Salka Viertel written just as *Camille* was finished, Garbo described all the attention she was getting but concluded, "I guess I can't complain because after all, I'm only a circus lady."[88] Those same fans flocked to the theaters and gave Garbo the professional boost she needed and added to MGM's revenues. *Camille* would be her only film to take in more than three million dollars at the box office, and it showed a profit of more than half a million dollars. "That this outmoded museum piece of sentimentality would draw by its story merits is doubtful," wrote the critic Topper, "but with the box office magic of the Garbo–Taylor combination it promises to be irresistible."[89] A new journal, *Motion Picture Review Digest*, debuting in 1936, gathered forty reviews of *Camille* from magazines and newspapers other than fan magazines. Every one raved about Garbo's performance, even if a few were somewhat critical of the old-fashioned story.[90]

Garbo received an Academy Award nomination for her work on *Camille* but lost to Luise Rainer for *The Good Earth*. Rainer had won the supporting award the year before, appearing in but a single scene in *The Great Ziegfeld*. The New York Critics Circle honored Garbo as best actress, as they had done two years previously.

"Garbo Is Still Queen," wrote Ida Zeitlin in *Motion Picture*: "Ten years have passed since Garbo made her debut, yet her star shows no sign of waning."[91] *Camille* fortified the Garbo legend. Yet a small indicator of the fleeting nature of mid-1930s movie stardom appeared in *Film Daily*, reminding readers that "Shirley Temple tops Garbo and Gable as the premiere box-office attraction of the country."[92]

CONQUEST

Maria Walewska was born in 1786 the daughter of a Polish count. At eighteen she married a much older man. Walewska met Napoleon at the height of his success, and their adulterous affair produced a child. Garbo, encouraged by Salka Viertel, had been interested in making a film about the life of Walewska since she completed *Queen Christina*, and together they convinced Thalberg of the merits of filming this story. Although her MGM producers had tried to steer her toward more contemporary stories, so far she was right, and portraying Queen Christina, Anna Karenina, and Marguerite Gautier had given her three successes in a row at the worldwide box office. Whatever hesitation Mayer and Hyman, now Garbo's producer, had about filming a Napoleonic era drama, they acceded, if grumbling, to Garbo's wishes.

Viertel based her screenplay on a biography by Wacław Gąsiorowski. Again she collaborated with Behrman. On the surface Walewska's life should have provided good material for a Garbo film. At its center was an ill-fated romance between two fascinating figures. In promoting her script vigorously, Viertel encouraged Garbo to make a film that turned out to be a strategic blunder. For the first time in her American career, Garbo's character would be subordinate to her leading man's. Napoleon's life and legend had remained so enormous that in 1937 it was still impossible to shift the balace away from his authority. The most famous actress in Hollywood ended up being overpowered by one of the most famous characters in world history.

As Cukor had chosen to direct *Camille* in 1936, Hyman appointed Clarence Brown for *Maria Walewska*. She had not wanted him for *Camille*, but he had been responsible for many of her successes, and this time she approved. In the two years since they worked together on *Anna Karenina*, he had made *Wife versus Secretary* (1936) with Jean Harlow and Myrna Loy, and another nineteenth-century costume drama, *The Gorgeous Hussey* (1936) with Joan Crawford and Robert Taylor. Hyman though he was the right director for a film that was on track to become a big-budget epic. For cinematography, he selected Karl Freund rather than William Daniels. Daniels and Garbo had collaborated for eight years, and not since Oliver Marsh handled the camera for *The Single Standard* back in 1929 had another cinematographer overseen a Garbo production. During the summer of 1937, Daniels was at MGM shooting *Double Wedding* with Myrna Loy and William Powell and *The Last Gangster* with Edward G. Robinson, so he would have been available had Hyman wanted his services. Freund, however, was one of cinema's great camera masters. In Germany during the silent era, he shot *The Last Laugh* (1924) and *Metropolis* (1927). A recent addition to the MGM roster, Freund had just completed *The Good Earth*. The year before, he assisted Daniels on *Camille*, so he had some experience working with Garbo. After Thalberg's death Hyman may have wished to create his own team at the studio, and with her consent Freund was engaged.

Hyman did not like the script the Viertel–Behrman partnership submitted and asked that it be rewritten. He also requested that Sam Hoffenstein (who had recently contributed to *The Gay Divorcee* and *Desire*) be brought in as a third contributor. This did not please Viertel, of course, but she had no choice but to bend to Hyman's wishes. Like a typical MGM producer of the era, Hyman wanted the film to be more sentimental and told Viertel that her script "was sophisticated and cold. It did not make you cry."[93] One conflict between the writers and producer was how to portray Napoleon at a time when dictators were dominating much of Europe. Hyman wanted to humanize him. The writers intended to stay closer to the historical record. Hoffenstein seems to have understood the problem with both the man and the script, and told Hyman, "If you want to feel sorry for Napoleon then let Garbo play him."[94] He knew he was writing a Garbo picture, but her character was becoming increasingly secondary. Maria might have more screen time than Napoleon, but he was the film's driving force. Viertel recalled the rewriting "a small, then a huge nightmare."[95]

Charles Boyer was cast as Napoleon. The French actor had relocated to Hollywood in the mid-1930s under contract to Walter Wanger. He teamed with Marlene Dietrich in 1936 in *The Garden of Allah*, and the two reunited to make *I Loved a Soldier*, which was never completed. After many successes in Hollywood and Europe, Boyer was the logical choice to play the emperor and gave a superb performance. As written, directed, and edited, the film's emphasis was so squarely on Napoleon that the title was changed for the film's release in the United States to *Conquest*. Hyman might have felt that "Maria Walewska" was a title that many Americans could not pronounce, or he might have believed that the central European name suggested too specifically the brewing troubles abroad. Did he convince Garbo that the "conquest" referenced in the new title was Maria's conquest of her lover? The title is strong but ultimately refers first to Napoleon's conquest of Europe and secondarily his seduction of Maria. Garbo had lobbied for this film for two years, but when it was released it was her costar's picture. Surprisingly, she plays most scenes passively, allowing Boyer to reign until she finally takes control at the film's conclusion. *Picture Play* commented: "The only great actress of the screen is Garbo. Every other talent is mundane. She is of ether, the stars and the moon, the sea and the sky. She is poetry, music, the still, small voice in the heart of man." Yet, a few lines later, "Hollywood . . . is quick to assert that Charles Boyer dominates 'Conquest' and steals the picture from Garbo."[96] Many had tried before, but *Conquest* was the first film in which an actor succeeded in matching Garbo's powerful screen presence. "There is something about Garbo, like Medusa, that customarily petrifies her leading men," wrote London critic C. A. Lejeune: "Up-to-date, to her great distress, she has petrified sixteen of them. Boyer . . . has resolutely refused to be petrified."[97] Ruth Waterbury, one of the best-respected American film journalists, described him as "giving what for my money is the finest character performance I have ever seen on the screen," although she continued diplomatically, "yet somehow not overshadowing that greatest artist of them all,

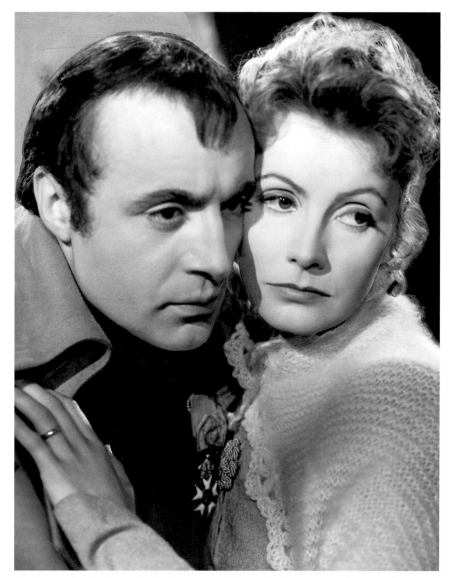

French actor Charles Boyer played Napoleon to Garbo's Maria Walewska in *Conquest*. Photograph by William Grimes.

the divine Greta."[98] The Motion Picture Academy agreed and nominated Boyer for an Oscar. He lost to Spencer Tracy. Garbo was not nominated.

Critic Richard Griffith, who would later become curator of the Museum of Modern Art's Film Library, wrote an article, "No Awards for Garbo," observing that the Academy had failed to honor her in its first decade despite having singled out Mary Pickford, Helen Hayes, Katharine Hepburn, Bette Davis, Janet Gaynor, and Luise Rainer, among others. Why this omission? He wondered if voters, which included many top producers, were of the opinion that Garbo might be a mere

personality, rather than an actress. He also noted that "nearly all won their awards on the strength of the fashion of the moment . . . Garbo is never fashionable . . . Styles change but she does not . . . It is the simple sincerity of her pretending that makes her acting so great that it does not seem like acting at all."[99]

Boyer deserved the praise he received, and if Garbo was not always the prime focus of critics' attention, she was nevertheless elegant and luminous as Maria, even if her acting is quieter and more introspective than usual. Twelve years at MGM had not diminished her beauty, and she was thinner than ever before on film (for her future films she would not diet so strenuously). She was still queen of the studio. Ralph O'Dell, an MGM guard, observed during the making of *Conquest* "how stages emptied to watch Garbo whenever she walked across the lot for a meeting at the producer's building."[100]

Portraits were made in Bull's studio on September 2. One appeared on the *Life* cover of November 8, 1937. In its new pictorial format, *Life* was only a year old but was selling a million copies a month at ten cents an issue. Inside was a two-page illustrated spread on the film; *Conquest* had "a certain sluggishness in the narrative," the copy ran, but "not through lack of dramatic fire in its two chief characters."[101] Of sure interest to Garbo's fans (and *Life* readers) were the three pages later in the issue devoted to her background, focusing on her early days in Stockholm and including pictures of her birthplace and a grammar school class photo. The last of the ten pictures published was of the guard dog behind a chain-link fence at Garbo's house in Santa Monica, reminding fans that visits would not be tolerated.

The year before making *Conquest*, Garbo had written to Viertel that it was time to have someone different from those earlier "fifty thousand lovers," but Napoleon turned out to have been the wrong choice. Even the strength of Boyer's performance was not enough to ensure success at the box office. The cost of the production was also a factor; when finally delivered to the theaters, it was reputed to be MGM's most expensive film—the total cost calculated at almost three million dollars—since *Ben-Hur* back in 1925 (and in Hollywood, since *Hells Angels* in 1930). Advertisements for *Conquest* claimed that the studio "had never before made a picture so lavish in scale as this. Its grandeur will dazzle your eyes." But audiences were not convinced. A popular feature in the trade journal *Motion Picture Herald* consisted of comments collected from theater managers across the country, assessing recent films they had exhibited. *Conquest* was not popular outside urban centers. "Garbo and Boyer do a good job," wrote the manager of the Reel Joy Theatre in King Center, California, "but the costume stuff is ancient history . . . Ticket sellers almost went to sleep."[102] A bit farther north, in Sumas, Washington, the Rose Theatre reported: "Oh, what a headache. Poorest weekend gross for a long, long time . . . Movie patrons thought it was the bunk."[103] *Conquest* brought in more than two millions dollars in ticket sales, pitiful, in fact, for an epic of this magnitude. The long production schedule, which was exceeded only by

The Temptress among Garbo's films, added to the cost. The studio ended up losing $1,397,000. Garbo, on the other hand, had her best year yet, earning $472,499 and almost doubling her contracted salary with overtime pay for weeks of retakes. The historical spectacle would make a blazing return in two years' time with the release of *Gone with the Wind*, but for now, the Garbo-Viertel-Hyman-Mayer producing team would have to consider very carefully what would be the next vehicle for the star.

NINOTCHKA

Eighteen months had passed since Garbo had last visited Sweden. As soon as her obligations on *Conquest* were completed, she again booked passage on the MS *Gripsholm*. Although she rarely planned ahead, this time her trip abroad would include a visit to Italy to meet up with a new friend, conductor Leopold Stokowski. The two had met the previous spring at the home of screenwriter Anita Loos, who had been working at MGM, including writing scripts for Jean Harlow. Stokowski was conductor of the Philadelphia Orchestra, and his enormous musical talent, mixed with a flamboyant personality, had made him famous. Called to Hollywood in 1936, he costarred, playing himself, in *One Hundred Men and a Girl* (1937) for Universal, the film that launched the career of Deanna Durbin. He also conducted at the Hollywood Bowl. Although married to Johnson & Johnson heiress Evangeline Johnson, Stokowski told Loos that he wanted to meet Garbo, and if Loos's memories are correct, he said he wanted to start a romance.[104]

Garbo seems to have been taken with the conductor from the start. Her friendship with George Brent, which continued as she was making *Camille*, had cooled, and he married actress Constance Worth in 1937. For much of that year, Garbo was occupied filming *Conquest*, and she rarely allowed time for social life when she was working. There were few reports of Garbo and Stokowski being seen together. This would change dramatically the next year.

Garbo departed New York in mid-December, and Stokowski, along with another friend, Robert Reud, accompanied her to the ship as she began the voyage back to Sweden. Reud was an unusual candidate for a Garbo confidant. They had met in New York back in December 1928 when she made her first trip home after the death of Stiller. He was a press agent, and his home base was the St. Moritz Hotel, where Garbo often stayed. He broke the first rule of his profession by never uttering a single word about his famous friend. As a reward he was invited into Garbo's inner circle. He helped find places for her to stay when she visited New York, they dined together at restaurants like the Marguery and the Colony, and he escorted her to the theater. Reud always knew the back entrances and the ways to avoid the photographer's flash. They also shared an interest in astrology—both were Virgos—and references to the zodiac and the Virgo personality pop up in

Leopold Stokowski (center) is flanked by his costars in *One Hundred Men and a Girl* (1937), Misha Auer and Adolph Menjou. The film was completed shortly before he began his pursuit of Garbo, which included a month-long interlude together in Ravello on Italy's Amalfi coast. Photograph by Ray Jones.

their letters and wires. Reud was an avid correspondent and often addressed his letters "Dear Goddess," and he always remembered her birthday with a gift. Garbo reciprocated with letters and telegrams, sometimes calling him "Dear Darling Sir." In addition to restaurants and theater dates, Reud brought her to the Church of the Transfiguration (The Little Church around the Corner) on lower Fifth Avenue. He was one of the confirmed bachelors that Garbo enjoyed having in her orbit, especially those who were perfectly loyal and who were available at her convenience.[105]

Stokowski was a different matter. At the time Evangeline Johnson divorced her husband in Nevada in December 1937, Garbo's name was being linked with the conductor in the press. Her only other public romance (if that's what either relationship was) was with the conveniently single John Gilbert. Dalliances with a married man were another matter. Being named in a divorce put Garbo front and center in the gossip columns under "scandal," a place she had previously largely successfully avoided. The divorce was granted five days before she sailed, so Stokowski was free to meet her in Italy as a bachelor.

One reason why Garbo was anxious to return home before Christmas was that the year before she had purchased her first house. "Greta Garbo has bought a 1,000 acre estate at Hårby, near Stockholm, Sweden,"[106] reported *Film Daily* as *Camille* was being filmed. Count and Countess Wachtmeister helped her find

Garbo purchased a private lakefront retreat, Hårby gård, on a secluded Swedish peninsula. She did not have much opportunity to enjoy the property, as wartime conditions in Europe made travel impossible. She sold the house shortly after the war concluded.

the property, called Hårby gård (Harby Farm), and it became the residence of Garbo's mother, brother, and his family. The size of the property was exaggerated in the press; it was closer to two hundred acres and was an elegant working farm. For Christmas 1936 Garbo had remained in America, so it was not until the next year that she embarked on a long-overdue family holiday at her lakefront house in the Swedish countryside.

Garbo may have enjoyed a quiet family reunion, but it was the calm before the press explosion that began early in the new year. The *Washington Post* reported that a wedding was likely, even though Garbo "told a reporter there [was] absolutely nothing to her rumored romance with the symphony conductor."[107] Two weeks later another paper reported: "The gangplank of the Italian liner *Conte di Savoia* was being raised at noon today, when an excited figure rushed down the pier with two porters, just in time to get aboard with his luggage. His ticket bore the name 'A.R. Allen,' but his passport said 'Leopold Stokowski.'"[108] Departing New York, the ship was bound for Genoa. In late February, Garbo, quietly and without being recognized, made her way south from Sweden to Italy. Anonymity ended on the first of March when the international press reported "their discovery on holiday in the little village of Ravello, near Naples."[109] They were staying at the grand Villa Cimbrone, perched high above the Mediterranean, which Stokowski had rented for a month from an English noblewoman. He waited six days before Garbo finally arrived. "Garbo dashes about Ravello and surrounding towns in her unmistakable sun-glasses, low-heeled oxfords, and camel's hair coat with a high

turned-up collar," locals reported.[110] On a visit to Naples she was "mobbed by a crowd which collected outside a famous fashion shop . . . When she attempted to leave the shop the crowd had grown to such proportions that police had to take her out a rear door and into a taxicab."[111]

Reports flooding the news wires were no longer about a mere romance but the "certainty" of an upcoming wedding. This brought newsreel cameras and scores of journalists to the idyllic Amalfi coastal village hoping to catch a glimpse of the alleged engaged pair. Increased press presence brought guards to protect the villa from unwanted intruders. "Miss Garbo has been obliged to have long curtains hung around the terrace to shield her from the attentions of the persistent photographers," the London *Times* reported.[112] Indeed, hardly a photograph exists of them together, Garbo being too canny to allow pictures taken during the weeks she lived under siege. Occasionally, Stokowski chatted with the press, and he made a deal with them that if Garbo consented to a short interview, they would leave the couple alone for the balance of their Ravello sojourn. A select few were then brought into the villa, no photographers were allowed, and Garbo nervously gave them a few minutes. Asked about her time in Italy, her response was that "she had seen little because of the curious crowds, who had ruined her visit."[113] To the many questions about her relationship with Stokowski, she denied repeatedly rumors of a romance. This only made the assembled all the more curious about what exactly what was going on behind the walls of the Villa Cimbrone.

Robert Reud, back in New York, read the daily press reports and apparently heard nothing from the lady herself. In a pique on March 7, he sent her a night letter cable:

> Dear Goddess: Am I completely lost[?] Please give me some word or sign so I may have cause to live. Despite current American newspaper headlines am still prayerfully hoping that at last you may blessedly decide to marry me in the end. I live that I may see you. Yours forever till death do us part and beyond devotedly. (Signature:) The Old Chest.[114]

Reud must have assumed that they would live parallel bachelor lives and that he would occupy a small bit of her orbit. Stokowski posed a threat he hadn't counted on. Silence from Garbo put Reud into a state of anxiety. Concerned who might see the message in Italy, he added the following instructions: "My name is definitely <u>not</u> to appear at any place on this cable." She may never have read Reud's plaintive words, as Stokowski might well have been acting as Garbo's secretary. Her friend back home needn't have been worried.

After departing Ravello the Italian travelers were spotted in late March traveling on the SS *Citta di Palermo* from the Sicilian capital to Tunis. Later they visited Rome, and one photograph shows the couple leaving the Vatican Museum. Finally, using the skills Garbo had honed after a dozen years of being hounded by the

press, they vanished from the public eye. In the late spring, they were reputed to be together in Sweden, still unmarried. They popped up in the papers again in June when "the automobile in which they were riding between Stockholm and Hårby overturned in a field. The accident occurred when Mr. Stokowski, who was driving, took a corner too sharply. Passersby helped them right the automobile, and he and Miss Garbo drove away in it after a quarter of an hour."[115] Soon thereafter Stokowski left Sweden alone to return to America. Later that year he would sign a contract with Walt Disney to work on a project that would become *Fantasia* (1940), the film that has contributed most to ensuring Stokowski's legacy.

Garbo had spent four months with Stokowski, first traveling in Italy and later hosting him at Hårby gård, suggesting she must have felt some affection for her admirer. But she was always clear that marriage was out of the question, and the commotion took its toll. "I am sorry I didn't stay at home in the USA," Garbo wrote to Hörke Wachtmeister from Italy on March 17. "But I am so polite to friends and acquaintances once I've got to know them. And when they have got plans like going to Italy, I can't say no."[116] It is curious that Garbo would have embarked on such a public flirtation with another famous international figure. Perhaps the knowledge that her last film had done poorly at the box office impelled her to find a way to keep her name in the papers. Garbo knew that having a private holiday in Ravello with Stokowski would draw journalists, whom she seems to have enjoyed titillating with her wanderings. Whether the ensuring publicity was encouraged or unintended, the Garbo–Stokowski affair kept her name squarely in the papers throughout 1938, her year off from acting. Fan magazines typically placed stars on the cover to promote new films. With no new Garbo release in sight, *Modern Screen* (June 1938) nevertheless featured a cover of Garbo and Stokowski, and proclaimed in bold capital letters, "Garbo Finds Love." She did not, but she did manage to keep her fans enthralled—without making a movie, and without even being in America.

Some publicity was unwanted. In early 1938 the Garbo Restaurant opened at 148 East 48th Street in New York. It was also a bar and nightclub, and musical acts were advertised in *Variety* and New York newspapers up to the start of the Second World War. As though any patron might miss the connection, advertisements also extolled the Swedish cuisine. Enlarged photographs of the actress adorned the walls, and the waitresses often mimicked Garbo's screen hairstyles. Not every scheme succeeded. At about the same time, a fellow named Bert Lewis purchased the American rights to Garbo's 1925 film *Streets of Sorrow* and planned, by adding voices and editing the film substantially, to cash in on Garbo's fame with a "new" film to be titled "I Vant to Be Alone." In November 1937 he applied for an exhibitor's license to the New York State Board of Regents. The board denied the license, and again on appeal in December: "It is obviously intended as a burlesque, ridiculing the said star of 'Streets of Sorrow' . . . and the serious conditions portrayed in that picture."[117]

The Garbo restaurant on East Forty-Eighth Street in New York opened in early 1938 with portraits of the actress lining the walls and featured waitresses attempting to imitate the namesake. Swedish cuisine was served, and in the evenings there was live music. Photo by World Wide.

While Garbo and Stokowski were vacationing in Sweden, a small spark ignited back in Hollywood. A full-page advertisement was taken out in the *Hollywood Reporter* on May 3, 1938, by the Independent Theater Owners Association (ITOA) headlined "WAKE UP! HOLLYWOOD PRODUCERS." The incendiary copy charged that "practically all of the major studios are burdened with stars—whose public appeal is negligible—receiving tremendous salaries necessitated by contractual obligations. . . . Among these players, whose dramatic ability is unquestioned but whose box office draw is nil, can be numbered Mae West, Edward Arnold, Garbo, Joan Crawford, Katharine Hepburn, and many, many

others." They were labeled "box office poison." Hollywood reacted quickly; nine days later *Film Daily* explained: "The articulate public feels the players are more sinned against than sinning . . . When a star does a nose-dive at the box-office, the cause is not any suddenly developed personal antipathy but the presentation of the actor in the wrong vehicle."[118] This was certainly the case with Garbo and *Conquest*. Still, "box-office poison" was a potent tag, and whether accurate or not, the ITOA members felt acutely the financial loss when a big star's picture did poorly at theaters, especially in rural or small urban markets. These complaints gave ammunition to the studio producers to negotiate aggressively when star contracts came up for renewal.

Garbo granted a press interview when she was in Sweden, and at least one American was present, Hettie Grimstead, writing for *Screenland* (April 1938), who had followed the actress home. "I am tired of period pictures," she quotes Garbo as saying, "and I want to do something modern now. My next film is to be a comedy, as I expect you know. Will I be allowed to keep my lover in it? Certainly I am hoping so! Don't you think it is high time they let me end a picture happily with a kiss?" This sounds heavily redacted, but the gist was true: she was through with period pictures and ready for a comedy.

Garbo had left America the previous December without a signed agreement for a new film. In late September when it was time to go back to work again, she departed Göteborg aboard the MS *Kungsholm* and arrived in New York in early October. She stayed for a couple of weeks and was spotted out with Bob Reud. A photograph taken at the restaurant of the Marguery Hotel on Park Avenue has become an iconic image of the actress. An intrepid photographer, Dick Sarno, surprised the two sharing a meal together. As the shutter snapped, Garbo dropped her hat and placed it in front of her face. By chance she was sitting next to a mirror, so her profile is recorded perfectly.

Despite Garbo's wish to make a comedy, MGM announced in the 1939 "Screen Forecast," a small brochure published annually for film fans, that she would next appear as the title character in *Madame Curie*, portraying the famous scientist, and even predicted it would be the "No. 1 hit for 1939." Throughout the year the picture was advertised as an upcoming Garbo project.

She finally signed a contract on December 29 to make one film for MGM at a fee of $125,000. This was half the contracted figure she was paid for each of her last five films (and in all cases, with overtime figured in she was paid substantially more). Whether or not being branded "box-office poison" had any effect on the terms of the new deal, two factors were evident. *Conquest* lost a tremendous amount of money for MGM, and Garbo's previously reliable European returns were at risk due to the unrest in Europe. On March 12, 1938, while Garbo and Stokowski were vacationing in Ravello, Hitler had annexed Austria. Although the war would not begin officially until September 1939, the political situation was so grave that American businesses were cautious about any ventures in Europe.

You can't spot Garbo out to lunch at New York's Marguery Hotel with her friend Robert Reud in 1938 unless you look into the mirror at right, where her profile is perfectly revealed. Photograph by Dick Sarno.

Garbo's films had been especially popular in Germany, and this market was fragile given the political upheaval.

"Ernst Lubitsch will direct Greta Garbo's next picture, Ninotchka, for Metro-Goldwyn-Mayer," a spot in *Motion Picture Herald* announced.[119] This would be Lubitsch's first job at MGM after a long career at Paramount, where for a time in the mid-1930s he was production chief. Lubitsch had been hoping to make the film *The Shop around the Corner*, and as part of his deal with MGM, the studio agreed to take on that project as well if he would first undertake *Ninotchka*. After the two pictures, he planned to set up his own production company with United Artists. Sidney Franklin, who had directed Garbo in *Wild Orchids*, was making the transition from director to producer, and *Ninotchka* would be one of his first films in that new role. By coincidence he would produce *Madame Curie* in 1943, but with Greer Garson starring rather than Garbo. William Daniels, who had not worked with Garbo on *Conquest*, was back behind the camera for *Ninotchka*. Together they had created the glorious vision of Garbo that remains indelibly etched in cinema history, and this would be their last collaboration.

A comedy for Garbo at last. *Ninotchka* was based on a story by the Hungarian writer Melchior Lengyel. The plot was simple: Ninotchka, a humorless young Soviet official serving as a special envoy to Paris, finds romance and adventure in a stronghold of Western capitalism. Garbo was the ideal choice to play the

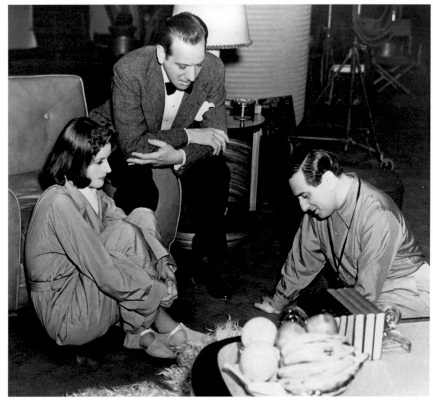

Still photographer Milton Brown caught Garbo along with costar Melvyn Douglas (center) and director Ernst Lubitsch in a relaxed moment during rehearsals for *Ninotchka*.

lead, who softens under the champagne and soft music of the French capital. Her accent, reputation for aloofness, and cool beauty would all be to the film's advantage. All that was needed was a perfect script.

Salka Viertel was not asked work on *Ninotchka*; her friend's year abroad, and the preoccupation with Stokowski, allowed MGM to concoct the project without any interference from the actress's cronies. Instead, Viertel was sent to Paris to conduct background research for *Madame Curie*.

Billy Wilder and his frequent writing partner Charles Brackett were engaged to write the *Ninotchka* script, which proved a boon for the film and Garbo. Walter Reisch, recently brought to Hollywood from Austria by Louis Mayer, also contributed. Good writing had never been a hallmark of Garbo's films. *Ninotchka* would prove to be the great exception.

Delays, as were typical for Garbo's films, mounted, and filming did not begin until early June 1939. To costar MGM had hoped to secure the services of Cary Grant to play the Parisian playboy who falls for and finally captures the heart of Ninotchka. Industry reports suggest that Columbia, Grant's studio, would not give him the necessary time off.[120] This is one of the saddest "What ifs?" in the

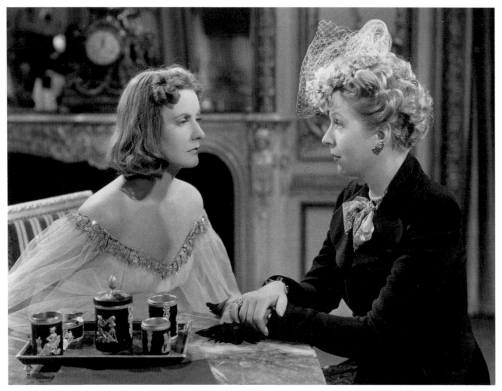

John Gilbert married Broadway star Ina Claire shortly after his relationship with Garbo cooled. The marriage was short-lived, and Gilbert died in 1936. Claire occasionally took a film role, including supporting Garbo in her first comedy. Photograph by Milton Brown.

Garbo chronicle. Instead she was reunited with Melvyn Douglas. Ina Claire was cast as a third lead, playing a former Russian aristocrat whose jewelry, and its ownership, becomes an essential plot device. Claire had wed John Gilbert back in 1929, but the marriage lasted hardly a year. When Gilbert died, in 1936, he was married to actress Virginia Bruce. It is intriguing to fantasize about what Garbo and Claire might have said to each other about the former great star, though they probably said nothing.

For a decade Garbo had strictly adhered to the practice of making only a single day-long visit to Clarence Bull's portrait studio at the conclusion of each film. Perhaps her long absence from the screen and the paucity of new publicity material to send out to the anxiously awaiting fan magazines encouraged her to sit just before filming commenced. She posed first wearing her street clothes, trousers and a sweater with a scarf, rather than in costume. Then she agreed to be photographed with a slightly revealing white fabric draped over one shoulder. These pictures hit the newsstands even before *Ninotchka* was released.

"Garbo Laughs." Even eighty years later this succinct tagline instantly evokes this now classic film. Surprisingly, MGM did not at first intend to use it for

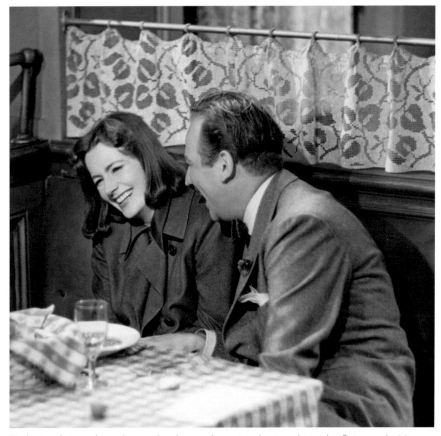

Garbo Laughs! was the tagline used to draw audience into theaters playing her first comedy, *Ni-notchka* (1939). Melvyn Douglas's simple pratfall triggered the famous guffaw. Photograph by Milton Brown.

advertising. Early publicity focuses on the name: "'Ninotchka'—don't pronounce it—SEE IT!" But the studio quickly saw the potential revenue boost by revealing a new Garbo to the public, one who is happy and now willing to smile broadly for the camera. Most posters feature a cheerful Garbo. The great tragic heroine of *Anna Karenina*, *Camille*, and *Conquest* had retired, replaced by a brilliant contemporary comedienne.

Ninotchka opened at New York's Radio City Music Hall in November. Audiences flocked to see the comic Garbo. The film was held over for a second and then a third week. "Garbo's 2nd Week Smasho at $100,000," headlined *Variety*.[121] Along with the famous stage show, which included a symphony orchestra, audiences were treated to a new technicolor Disney cartoon, *Autograph Hound*, featuring Donald Duck, with a cameo by Garbo.

Her reviews were as splendid as they had been for *Camille*, and the film was an artistic triumph. Frank Nugent in the *New York Times* found "the screen's austere first lady of drama playing a dead-pan comedy role with the assuredness

of a Buster Keaton . . . It must be monotonous, this superb rightness of Garbo's playing. We almost wish she would handle a scene badly once in a while just to provide us with an opportunity to show we are not a member of a fan club. But she remains infallible."[122] *Variety* picked up on another angle: "The punchy and humorous jabs directed at the Russian political system and representatives are the most direct so far in an American film."[123] In a review titled: "MGM Lays an Egg," the left-wing magazine *New Masses* predictably took the other side. "Ninotchka is a most forthright propaganda film: I cannot remember a picture so industriously twisted back and forth to cover every single slander on socialism."[124] The writer was silent on the merits of Garbo's performance. Most critics focused on the star and the excellent direction. "Lubitsch has rarely in his career had so free an opportunity to display his adroit skill at creating an atmosphere of bubble and lusty froth," wrote *Box Office Digest*.[125] Last word should be given to *Screenland*'s Delight Evans: "Until you have seen Garbo getting high and giggly on champagne you haven't really been to pictures."[126]

Nobody was going to beat Vivien Leigh as Best Actress for the Academy Award given for *Gone with the Wind*, but, in perhaps the best of all years in movie history, Garbo was included on the final list of five nominees (along with Bette Davis for *Dark Victory*, Irene Dunne for *Love Affair*, and Greer Garson for *Goodbye, Mr. Chips*). In another year, any of them might have taken home the statuette. Likewise, the New York Film Critics Circle honored Leigh, with Bette Davis and Garbo taking second and third place.

Planning to continue her biannual working schedule, Garbo took off 1940. She may have hoped to return to Europe, but transatlantic travel was discouraged, and most lines curtailed the numbers of ships sailing. Concerned about her family's safety, she arranged with the assistance of MGM for her mother, brother, and his family, to immigrate to America; they arrived in New York in November as *Ninotchka* was opening in theaters, strangers in a new country, as Garbo had been fifteen years before. The Gustafsons (they changed the spelling of their name from Gustafsson to Gustafson) joined Garbo in California, soon moved to New Mexico, and later settled in suburban New York City.[127]

The year was a busy one for the formerly invisible actress. While filming *Ninotchka* she had met, through Stokowski, Gayelord Hauser, a well-known German-born food writer, nutritionist, and diet guru. Since her days with Stiller, Garbo had been concerned about her weight and often dieted strenuously between films. Hauser was the author of many successful books about healthy eating and its relation to weight loss and general well-being, and in 1939 he published what became among his best sellers, *Eat and Grow Beautiful*. Garbo became enamored of both Hauser and his eating-dieting philosophies, although there would be no romance, as he was generally accompanied by his companion Frey Brown. Not only did he advise Garbo on health matters, but they traveled together extensively. Hauser was the ideal escort; made wealthy by his publishing successes, he could

Garbo met Gayelord Hauser, a celebrated nutritionist and author, in 1939, and soon the pair were frequently spotted together. The press caught wind of the new friendship and reported a romance. (*Photoplay*, February 1940).

ensure that every detail of their time together would be perfectly orchestrated. During 1940 they visited Palm Beach and Nassau, and Hauser introduced Garbo to his coterie of affluent friends, some of whom entertained the trio on their yachts. Fan magazines were among the first to pick up on this new friendship, and by November 1939 *Screenland* mused in the title to a long article, "Garbo in Love Again?"

Hauser not only fed Garbo countless carrot and spinach cocktails at the Jones Health Food Store in Beverly Hills, entertained her often at small dinner parties at his grand hilltop home in Los Angeles, and accompanied her to elegant

ocean-front resorts, but somehow managed to help her become more comfortable in social interactions. One day during the production of *Ninotchka*, Myrna Loy was disturbed in her dressing room, which was located right beneath Garbo's. Garbo had asked Artie Shaw and Benny Goodman to drop by to teach her to dance, which they did, and with enthusiasm.[128] On occasion Hauser was admitted to the *Ninotchka* set and at least once brought along friends.[129] This was a new Garbo.

Being out with Hauser, however, did not protect Garbo from the pesky intrusion of fans. While visiting New York together, Garbo learned that the Museum of Modern Art had a print of *Gösta Berlings saga*, and she asked the film curator, Richard Griffith, with only an hour's notice, to arrange a private screening. Griffith agreed, and after the film concluded Hauser suggested they view an exhibition of American Indian art. Garbo hesitated, but Griffith assured her that visitors to the museum were not the sort who "gawk or ask for autographs." Perhaps not for most film stars, but they did just that when Garbo appeared in the galleries. She was pursued by fans, and Griffith finally had to rescue her crouching in panic in a replica of a cave that was part of the exhibition's installation. Both actress and curator were in a "state of shock." But as Griffith was leading her to safety she told him, "None of this is your fault. You couldn't have known."[130]

For a decade and a half Garbo had managed, through the brilliant strategy that helped launch her career in Sweden and allowed it to continue with nary a bump, to remain at the highest echelon of Hollywood actors. Moreover, *Ninotchka* notified the skeptics that Garbo could successfully reimagine her screen image. But could she keep it up? With the sole exception of Chaplin, none of her predecessors or contemporaries had had such an unbroken run of successes. Duncan Underhill, writing for *Screen Book*, summed up her place in the Hollywood pantheon: "After 15 years of murderous competition that has seen the rise of this and that beauteous and talented newcomer, Garbo is still the Hollywood nonesuch. Faintly-middle aged, and in her hugely unexciting private life a bit of a frump, the hefty spinster from Stockholm, judged by any standard you like, is still in the top spot. Any of a shoal of rivals would willingly commit murder to inherit it."[131]

TWO-FACED WOMAN

While on sabbatical Garbo discussed with Viertel potential projects for 1941. Before one was set, Viertel was abruptly fired by one of the studio's top executives, Eddie Mannix. The unstated but obvious reason was that she had recently joined the screenwriters guild and employed an agent to act as go-between in her contract negotiations.[132] It was a stunt on Mannix's part, as he knew that Garbo's clout would oblige him to welcome Viertel back. When he did, she decided, with the consent of her agent, to sign a new deal directly with the studio, and, as she later wrote, "much to Greta's pleasure . . . returned to the 'MGM fold.'"[133]

Garbo signed a contract on November 20, 1940, well before a decision had been made about her next film, though a comedy was a given. With the success of *Ninotchka*, Garbo was offered a slight raise over the $125,000 salary she received two years earlier and would be paid a base of $150,000 plus the usual accommodations for overtime. Seven months would pass before her new film would begin shooting.

Viertel remembered seeing the 1902 German play *The Twin Sister* by Ludwig Fulda in Europe and thought a contemporary version of the story would make a fine comedic follow-up to *Ninotchka*. Received lukewarmly when it debuted in English, first in London and later on Broadway, the play had been turned into a silent film in 1925, *Her Sister from Paris*, starring Constance Talmadge. Fulda's work tells the tale of a woman who, in order to preserve her faltering marriage, creates a fictitious "twin sister" in the hope of luring back her wayward husband. The film's conceit depended upon the husband's being unaware of his wife's duplicity. Garbo would have the chance to play two distinct characters, the sporty country wife and her supposed twin, the cosmopolitan vamp. Properly done it would add luster to her new image. With a sexier, more adult script than the typical Irene Dunne or Claudette Colbert screwball comedy, MGM sought to boost Garbo into the top ranks of sophisticated comedic actors.

The studio liked the idea, as did Garbo. Viertel would team again with S. N. Behrman and for the first time work with George Oppenheimer; first drafts called the project *The Twins*, but during production the title was changed to the catchier *Two-Faced Woman*.

The picture is often described as the one that ended Garbo's career and is labeled variously as an artistic and commercial failure. These descriptions are not entirely accurate. The film, the studio, and finally Garbo were hit by an unexpected storm of such ferocity that *Two-Faced Woman* collapsed at the box office. The script had been approved by the Production Code Administration (PCA), but soon after its release the film was condemned by the Roman Catholic Legion of Decency. Formed in 1933 to police the content of pictures coming out of Hollywood, the Legion in fact rarely exercised its authority over a picture released by a Hollywood studio by declaring it morally objectionable—and viewing it as a mortal sin. The C rating levied on *Two-Faced Woman* caused an uproar across America. The film was banned in Providence, Boston, and St. Louis. Police in some other cities prohibited it from being exhibited. Having previously received a green light from the Hays Office, MGM was blindsided by the Legion's announcement.

Filming began in June 1941. George Cukor was slated to direct; since *Camille* he'd had a string of successes, including *Holiday* (1938), *The Women* (1939), and *The Philadelphia Story* (1940). Being removed as director of *Gone with the Wind* (1939) bruised his ego but did not affect his exalted position in Hollywood. Joseph Ruttenberg, who had worked well with Cukor on his recent MGM films, serve as cinematographer. Despite buttressing by this expensive talent, what was obvious

by the summer of 1941 was that Garbo was not being coddled as she had been over the past fifteen years.[134]

One small example was her wardrobe for *Two-Faced Woman*. Adrian designed a dress that was presented to the PCA for approval; it was rejected as too revealing.[135] Yes, the PCA vetted not only scripts but costumes as well. Hedda Hopper swooned over the dress as she reported the Code's decision: "One gown . . . is so beautiful. It is made of suntan soufflé over the same shade of lining, gathered skirt, gold-lace belt with lace coming up the front."[136] Cukor and the film's supervisors, Bernard Hyman and Gottfried Reinhardt (the latter, protégé to both Hyman and Viertel, would get final credit as producer), sided with the censors, even going so far as to declare it was time to stifle the old-time Garbo glamour and bring the actress "down to earth."[137] The producers also wanted to reduce the costs of Garbo's wardrobe—previously an unthinkable action—and costume her in a more generic series of dresses, classy and correct rather than celestial. Whether or not his experience on *Two-Faced Woman* was the provocation, Adrian left MGM as shooting was under way. He correctly saw the future. The great age of glamour (and suntan soufflé) was dead.

Garbo's costar Melvyn Douglas played almost exactly the same character he had portrayed in *Ninotchka*. In both films he is a decent, intelligent, sophisticated man besotted by Garbo. As the script was originally filmed, he is so taken by the flashy twin that he fails to notice that she is in fact his wife. This gives *Two-Faced Woman* its sexual charge but also suggests adultery, even if only imagined. Constance Bennett, another of the glamorous figures of 1930s Hollywood, supported Garbo, something of a comedown for a former top star, but she had not had a success since *Topper* in 1937 and never would again. She played Douglas's lover, a woman who has no intention of deferring to the propriety of his marriage. Stage actress Ruth Gordon made a rare film appearance in a secondary role as Douglas's secretary, and the cast was rounded out by Roland Young and Robert Sterling.

If a print survives of *Two-Faced Woman* as released that fall, it is rarely if ever screened, which makes it difficult to assess precisely what audiences saw. The picture previewed on October 21, and the first review appeared in *Variety* the next day. It was mixed. "In a daring piece of showmanship, the Metro studio breaks down the long established screen tradition which has enveloped Greta Garbo like an opera-cloak, and presents the one-time queen of mystery in a wild, and occasionally very risqué, slapstick farce." Trouble is spotted a bit further along: "Just how some of the lines of dialogue escaped the scissors is a[s] much of a mystery as how the screenwriters . . . so completely flopped in providing a reasonably satisfactory finale . . . There's a double entendre to nearly everything that is said between [Garbo and Douglas], and nearly everything is said."[138] Ten days later a critic for *Film Bulletin* wrote: "Garbo is a grand actress. She takes well to comedy and looks gorgeous in a variety of pajamas, negligées and décolleté evening gowns."[139] Delight Evans, writing for *Screenland*, was more enthusiastic:

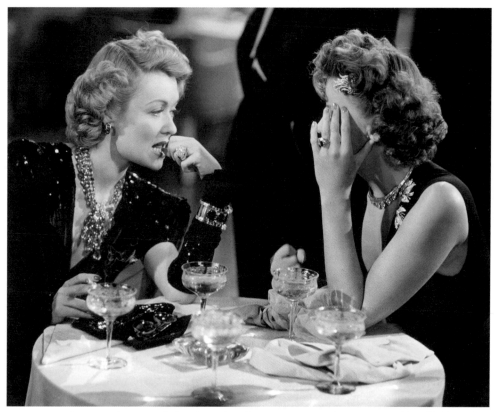

Constance Bennett rivaled Garbo early in the 1930s as among the most successful and highly paid female stars. Her popularity peaked with *Topper* (1937); afterward she often played second leads and supported Garbo in *Two-Faced Woman*. Photograph by William Grimes.

"Whether her new coiffure, her wise-cracks, her extreme gowns will please her old audiences is something to ponder—but strictly as a piece of showmanship her performance in "Two-Faced Woman" is sensational."[140]

What would turn out to be Garbo's last MGM portrait session took place on October 3, just after shooting completed. Bull exposed about one hundred negatives, and for the first time Garbo was not photographed in any of the film's costumes. Instead she is depicted in the clothing she wore to the studio that day, a pale yellow short-sleeved sweater and the ubiquitous pair of Verdura curb link gold bracelets that were among her favorite pieces of jewelry, and that she would wear regularly for the rest of her life. Freed from the upholstered gowns she wore in her costume dramas, she appears relaxed and happy. Bull's photographs have a lightness not seen since her days working with Ruth Harriet Louise. Was the decision to depict Garbo casually her choice or Bull's, or did it come from MGM's publicity department? For the previous decade, Garbo's portraits were intended to remind fans that she was a great dramatic actress, a magnificent beauty, flawless and unapproachable. Now she was photographed to make her seem more

available to audiences—softer than Katharine Hepburn and with a playfulness associated with Carole Lombard.

Two-Faced Woman went into a limited run during November. Three weeks later the bombshell exploded: on November 23 the Roman Catholic Legion of Decency condemned the film. New York Archbishop Francis Spellman, the nationally influential Catholic leader, asked priests across America to announce the condemnation of the Garbo film from their pulpits the following Sunday, November 29. Spellman believed the film was "a danger to public morality" and "an occasion of sin."[141] Immediately following the edict, the police amusements inspector for Providence, Rhode Island, banned the showing of *Two-Faced Woman* at the city's Loew's Capitol.[142] Boston followed. This was a crisis in the executive offices, because no MGM film could remain in release with a C rating. Nonetheless, box office revenues predictably increased. A headline in *Variety* (December 3) read, "HOTCHA GARBO DITTO AT B.O.," in other words, Steamy Garbo Picture Burns Up at the Box Office. Business was booming in Philadelphia. Still, in the same issue, a witty writer reported after consulting with the MGM home office, "Every effort to revamp the Garbo picture will be made."

Film trade papers throughout November and December covered the developments of the story. Even a congressman entered the fray; Martin J. Kennedy, a Democrat from New York, wrote a letter to Will Hays demanding "that distribution of the film be halted forthwith."[143] What would MGM do? Given the power of the Catholic Church in America in 1941, the studio had only one option, and that was to edit the film radically, which necessitated calling back much of the cast and crew to shoot new scenes. "Likely that the Garbo starrer will have played the majority of large key spots by Dec 16, when it is to be recalled for revamp," reported *Variety*.[144] *Two-Faced Woman* had run for almost two months before the offending film was pulled from circulation (without the condemnation and the additional expenses MGM incurred, it would have been a financial success).

A shock of a different sort had a much greater effect on Hollywood, America, and the world when Pearl Harbor was attacked on December 7, and the United States declared war on Japan. Four days later America was also at war with Germany. An international crisis of this magnitude was felt by businesses across the country, and motion pictures were no exception. *Variety*, which reported daily on theater and film revenues, noted an immediate drop in attendance.

Perhaps too late, "with additions and eliminations," *Two-Faced Woman* was resubmitted to the Legion of Decency, which granted the film a new rating of B, allowing adult Catholics to attend screenings of the film without committing a mortal sin. To eliminate the hint of adultery, a scene was added showing Douglas's character learning early on that his wife was in fact impersonating a nonexistent twin sister. This removed the film's one essential plot device and turned it into a foolish yarn where the husband merely indulges his wife's role play. The reedited film went into general release on December 31. The enormous publicity generated

For the first time in her talking-film career, at the conclusion of *Two-Faced Woman*, Garbo posed for Clarence Sinclair Bull wearing her street clothes, rather than modeling the film's costumes.

for two months was a boon for markets in which the film had been allowed to play. But in its reimagined state, *Two-Faced Woman* was much less appealing. Bosley Crowther waited to see the edited version before reviewing it for the *Times*. He was not kind. "Miss Garbo's current attempt to trip the light fantastic is one of the awkward exhibitions of the season."[145] The critic for *Time* called it "an absurd vehicle for Greta Garbo . . . It is almost as shocking as seeing your mother drunk."[146] Later, Cukor was just as critical, telling Gavin Lambert, "I think it's lousy . . . You know, I really *cringe* when people say, 'I saw *Two-Faced Woman*, it was very interesting.' The awful thing is, they're not being polite. They mean it."[147]

The edited version is available today on DVD, so we can see what later critics who lambasted the film saw almost eighty years ago. It might be twenty-first-century nostalgia or knowledge that the film would be Garbo's last, but for all its many weaknesses, *Two-Faced Woman* does not seem to merit its reputation as an artistic failure or the harbinger of the end of a magnificent film career. Garbo attempted to bolster her reputation by attempting broad comedy, and she demonstrated that she could do it well. Financially, despite the furor over decency, the film showed only a slight loss at the box office, even after all the reshooting expenses that MGM

Photographer William Grimes took this outdoor candid shot of Garbo on the MGM lot during the filming of *Two-Faced Woman* as she joined other members of the cast and crew in June 1941 to watch the inaugural flight of the B-19 bomber. Courtesy John Kobal Foundation

incurred to make it palatable to the prelates. MGM had hoped for a moneymaker, especially in light of Garbo's relatively modest salary. But the start of the Second World War only exacerbated the many troubles facing *Two-Faced Woman*.

Her reduced fee was made public in a *New York Times* article published in late November. Garbo's contracts were almost always confidential, and it was only after MGM files were opened in recent years that more details have emerged. All the more surprising that the paper, reporting from Hollywood, was able to tell readers, "Greta Garbo had the local citizenry gasping on the ropes this week with

the disclosure that she had requested a 50 per cent cut in salary before appearing in Metro's production of 'Two-Faced Woman.' Inasmuch as the greatest source of revenue from her films, the foreign market, no longer existed she felt obliged to share the hard luck." She was called "an enigmatic figure" that "is reported to live on a diet halfway between the regimen of a canary and a rabbit."[148]

With America at war, international travel was out of the question. As she had since 1938, Garbo would remain in the United States while she and the studio plotted her next film, scheduled to be made in 1943. She must have been wounded by the critical response to *Two-Faced Woman* and ended 1941 with the certain knowledge that even the great Garbo and her team could no longer outwit the censors. When she was young, her enigmatic personality could make even the most insignificant film seem a work of art. But as she entered her middle years, the Garbo magic could not save films as different as *Conquest* and *Two-Faced Woman*. She had never given a bad performance, and, for what it was worth, her name was on the final ballot that year for best actress from the New York Film Critics Circle. Joan Fontaine won for *Suspicion*, Olivia de Havilland (*Hold Back the Dawn*) was second, Garbo and Dorothy Comingore (*Citizen Kane*) completed the field. If at thirty-six her popularity was waning slightly, Garbo was still spoken of in hushed tones. To her fans, and perhaps others as well, she was still the world's most beautiful woman, she remained cinema's greatest actress.

CHAPTER EIGHT

Drifting

AS SHE HAD BACK IN 1938 AND 1940, GARBO TOOK 1942 OFF. SHE HAD no new contract, and no upcoming project. Time spent with Gayelord Hauser had changed, or at least softened, her attitude toward being seen out in public, and in both Los Angeles and New York the pair was spotted at restaurants; a photograph even records a visit to a fashion show. "Greta Garbo sat hidden behind a screen in a ballroom of Manhattan's St. Regis Hotel last week," *Time* reported in February, "to hear her good friend Bengamin Gayelord Hauser lecture to a roomful of A.W.V.S. [American Women's Voluntary Services] socialites."[1] When visiting New York, the Ritz Tower at the corner of Park and Fifty-Seventh Street replaced the San Moritz as Garbo's favored stopping place. Writer Harry Evans, who owned *Family Circle*, told the story of how Garbo had recently considered subletting an elegant apartment at 30 Sutton Place. Evans, who knew all the principals involved except Garbo, described that first the actress asked a friend to check out the place, then Hauser made a visit, and finally the lady herself. But Garbo decided it was too expensive, as she had recently contributed heavily to the Red Cross. Although she was making an effort to travel and spend time with old friends and make new ones, being tied down to a year-long rental in New York was a commitment more serious than she was ready to make.[2]

Garbo enjoyed the company of talented, successful, and charming men, and someone new entered her orbit in 1941, German-born writer Erich Maria Remarque, author of *All Quiet on the Western Front*. He and his wife had immigrated to America two years before, although the couple quickly separated. Remarque was involved with Marlene Dietrich at the time he met Garbo. Gossip columnist Hedda Hopper caught wind of the new relationship and told readers that "fur will fly if it's true that Garbo has taken Marlene Dietrich's best beau, Erich Maria Remarque, away from her."[3] The affair was short-lived, but it was Remarque who stimulated Garbo's serious interest in paintings and likely encouraged her to become an art collector.[4] Hauser, who also collected paintings, would have supported

this newfound enthusiasm, and by the fall of 1942, Garbo began purchasing the works of art that would eventually become a significant collection. In November of that year, she bought at least four important Impressionist paintings, three by Pierre-Auguste Renoir and one by Pierre Bonnard. They were purchased from prominent New York art galleries, and Garbo retained possession of these masterworks for the rest of her life. All were featured in the auction of Garbo's art collection after her death in 1990.[5] It is surprising that any nascent collector would enter the field so quickly and with such enthusiasm. Moreover, although it is not known what prices she paid for the paintings, even back in 1942 they would have been highly sought after and expensive. In addition to being nudged by Remarque and Hauser, Garbo might also have been encouraged by Alfred Barr, director of the Museum of Modern Art. Apparently the two met by chance one afternoon that November at the Jacques Seligmann Gallery, and Barr recommended the purchase of a portrait depicting Renoir's young nephew Edmond.[6] A fact sheet about the painting retained in the Seligmann archives has a pencil notation at the bottom: "Call Greta Garbo."[7] She bought the painting. Edmond, along with her other early purchases, was sent to Los Angeles, but it was not until Garbo bought an apartment in New York in the 1950s that she had a home worthy of exhibiting her ever-expanding, and increasingly impressive, collection.

Less than a month after her whirlwind art-shopping expedition, Garbo was back in Los Angeles and ready to get back to work. On December 20, 1942, Garbo signed a contract to make a film with a fee identical to what she had been paid for *Two-Faced Woman*, $150,000. Seventy thousand dollars was paid in advance; the balance would be collected when the new film was completed.[8] The previous September, Garbo had lost a strong advocate at MGM when Bernard Hyman died suddenly at forty-five. According to Viertel, he had selected a story titled "The Girl from Leningrad" as Garbo's next offering. Based on a 1941 Russian film of the same name, Viertel described it as "a moving, simple story about a wounded soldier and a nurse, made during the Russian-Finnish war, but changed into the Soviet-German conflict."[9] Garbo had enjoyed great success four years earlier playing a Russian, so perhaps lightning would strike twice. Viertel and Garbo were both enthusiastic about the project, but Mayer thought the film might appear "sympathetic to the Soviets."[10] With Hyman's death a new producer for Garbo was needed, and Mayer deputized Gregory Ratoff. "Return of Greta Garbo to the screen has been finally arranged. She will appear in 'Dancing Soldiers,' story of modern Russia in which the star will play the role of a dancer who turns sniper when she is stranded in a city beleaguered by the Nazis," *Film Bulletin* reported on February 8, 1943. "Dancing Soldiers" is not mentioned again, but soon another project is proposed for Garbo, *Song of Russia*, the tale of a conductor and a pianist whose love affair is threatened by the Nazi invasion. Viertel describes it as "not merely a tribute to the sacrifice of the Russian people; it was also intended to exploit the then much publicized Garbo/Stokowski romance."[11] Ruth Waterbury,

writing for *Movieland*, reported a disagreement between star and director as the reason the film was never made: "La Garbo forwarded some of her ideas about how the role and the picture should be done. The result: a polite razzberry from Ratoff." Whether or not Waterbury's reporting is accurate, it was the message that MGM transmitted to the fan magazines. No longer was Garbo immune from criticism; her opinions were not the only ones that mattered. If she was to work again at MGM, she would be expected to follow orders.

"The Girl from Leningrad" was never made. *Song of Russia* was produced in 1944, directed by Ratoff and starring Robert Taylor and Susan Peters. It was a success for the studio. Garbo was offered no more scripts. Mayer decided to cut his losses and to pay her off. The actress who had greatly enriched the MGM trademark over almost two decades of peerless work and whose box office successes had helped make him rich was now being handed a check for $80,000 to go away. Clarence Brown told Kevin Brownlow in 1966 that Garbo "never took a nickel of the rest of the money she was entitled to under the contract."[12] Was it pride or humiliation? We will never know whether the studio, as the war raged and tastes changed, had had enough of Garbo, or if it was she who had had enough of MGM. "The destruction of stars is a very subtle process," Irving Thalberg had noted back in 1933. "You scarcely notice that it is happening."[13]

With the release of *Ninotchka*, Garbo was a supernova, the star that shines brilliantly one last time before fading forever, and the publicity was accordant with the success. Don't bother to trace the number of times Garbo is mentioned in the fan magazines during late 1943, or in 1944 or 1945. She hardly appears. Ingrid Bergman was the big news in 1943 Hollywood, and plenty of articles appear following the careers and personal exploits of Rita Hayworth and Lana Turner, too. Garbo rarely gave writers good copy, at least not until she was discovered in Ravello with Leopold Stokowski. Her career had been the news because it was like no other. Without a new film under way, what would the writers have to say about her? Hadn't enough words been spilled about her beauty, her talent, and her unwillingness to play the Hollywood game?

Garbo intended to work in 1943. Any notion that she retired in 1941 and began a long period of exile and wandering is not true. Like her producers, she understood that much of the profit, as opposed to the revenue, generated by her films had come from the overseas market. In 1943 the war had been going on for four years, and America had been involved since December 1941. After the troubles with *Two-Faced Woman*, it is understandable that all parties were hesitant to embark on a new film unless a sure-fire hit could be imagined. When Garbo departed MGM for the last time in 1943, did the door close behind her, or was there an expectation that one day she would return? This is a question that has never been answered.

Garbo was unemployed. From a financial point of view, this probably did not matter much to her, as she was flush from her lavish paydays, and her cronies,

Garbo and her trusted friend and advisor George Schlee are caught by a photographer while travel-ing together circa 1950.

especially Hauser, helped her with investments that ensured her riches would continue to grow. Among the good deals that he proposed was investing in com-mercial real estate properties in Beverly Hills.[14] At one point she even became landlord to former MGM photographer George Hurrell at 333 North Rodeo Drive.[15]

Hauser introduced Garbo to Valentina and George Schlee during a trip to New York, which would prove to be one of the signal events in Garbo's post-MGM years. Valentina, working under her first name, was a leading couturier—her store thrived throughout the 1940s and 1950s. Hauser rightly thought her quiet and elegant taste would benefit Garbo, and Valentina provided clothing for Garbo for many years, outfits she wore for the rest of her life. Schlee's occupation is a little hard to establish. He served as Valentina's business manager, and although this was not Hauser's intention, he did the same for Garbo, taking over from his home base in New York the sort of role that Salka Viertel had played earlier in in Los Angeles. Viertel continued to be among her closest friends; they corresponded and visited regularly, and Garbo would ask her advice about potential scripts. But from the early 1940s onward, it was Schlee who was the intermediary in considering and negotiating prospective film projects, and her most regular traveling companion.

Back in Los Angeles in the summer, Garbo met actor Gilbert Roland. A hand-some and successful film actor, he never quite reached movie stardom. Though he was married to Constance Bennett, he and Garbo had a brief fling, which was not revealed until thirteen letters that she wrote him that summer and fall were

put up for auction in 1995. When the two met, he was serving as a lieutenant in the military, stationed in Washington, D.C., and later in North Carolina. The correspondence began in late July, with Garbo writing that she missed Roland. The next month her letters became more personal; she referred to herself as "Mountain Boy," and "a cold careful bachelor . . . but . . . also gentle and sweet." By October she was addressing him as, "My little soldier!" The inevitable followed, and she wrote, "I cannot see you for a while." The last letter was dated just before Christmas, and Garbo proposed that "maybe . . . after the war" she could "explain a few things."

With wartime conditions making even domestic travel difficult, Garbo still managed to move easily between the two coasts, dividing her time among Hauser, the Schlees, Viertel, Bob Reud, for a moment Gilbert Roland, and occasionally Mercedes de Acosta. But work remained on her mind. Perhaps thinking she needed a base in Los Angeles, in 1944 she bought a house on North Bedford Drive in Beverly Hills. Producers, including David O. Selznick, proposed projects, and her former agent Harry Edington tried to entice her to RKO, which he had joined as production chief.[16] But none of these offers were taken up, and after so many years at MGM, it is hard to imagine Garbo moving to another studio, where she would be asked to work without the support of her loyal team. Still, in a December 1945 letter to Hörke Wachtmeister, she wrote, "I have been considering a film I might try making, but I don't know. Time leaves its traces on our small faces and bodies."[17]

Garbo had turned forty that September 18. None of her MGM contemporaries, the great female stars who epitomized the studio's glamour in the late 1920s and 1930s, were still working at the studio. Norma Shearer, three years older than Garbo, made *Her Cardboard Lover* in 1942 costarring Robert Taylor, who was nine years younger (and looked it). It was a flop at the box office and with critics. Her last success had been with *The Women* (1939). The former "first lady" of MGM retired in 1942, married a much younger ski instructor, and had, by all accounts, a happy marriage. Shearer's costar in *The Women*, Joan Crawford, made her last film at MGM, *Above Suspicion*, the next year. Crawford, a year older than Garbo, was her only MGM peer to rival her in fan magazine attention. She often was listed near the top of the studio's lists of annual salaries. But Mayer, having turned his attentions away from veteran actresses, offered her material she considered unworthy. On the cusp of turning forty, and after nineteen years of loyalty and hard work, Crawford decided not to renew with MGM. Jack Warner thought differently, and in one of the best comebacks in the history of motion pictures, she signed with Warner Bros. and won an Oscar for her first picture there, *Mildred Pierce* (1945). *Humoresque* (1946) was next, followed by *Possessed* (1947) and another Academy Award nomination. She was never nominated during her two decades at MGM.

While Crawford handily finessed this transition into her forties, Garbo had a bit of a fallow period, though untypically she made up for it by maintaining

a frantic social schedule. In addition to Hauser and Schlee, she now welcomed the attention of another man, Cecil Beaton, encountering him in March 1946 at a party hosted by *Vogue* editor Margaret Case. They had first met back in the early thirties, and Beaton had developed something of a fixation on the actress. During the ensuing years he had been unable to renew the acquaintance, though not for want of trying. It was worth the wait. By good fortune, they crossed paths just when Garbo's passport expired, and now she needed, of all things, to have her portrait taken.

Would Beaton do the deed? He must have been ecstatic at the request. He might also have been amused, remembering that she had denied him access back in 1932 during his first trip to Hollywood. The location for this impromptu session was his suite at the Plaza Hotel; it would be the first time that Garbo would sit for a portrait since posing for Clarence Bull back in October 1941. "She stood stiffly to attention," Beaton recalled, "facing my Rolleiflex full face as if it were a firing squad."[18] Although Garbo's intention might have been for Beaton to take a single headshot that she could forward to the Swedish consulate in New York, in the end their afternoon together produced dozens of negatives and one of the most extraordinary series of photographs taken over her long career before the camera. Never before had Garbo seemed so utterly relaxed, and he captured many moods, including, improbably, a shot of her on a couch, lying on her back, with her knees pulled up to her chin, and smiling broadly. Garbo, who had always insisted on approving every image taken of her distributed by MGM, viewed Beaton's contact sheets and "pronounced them 'strong' and clean-cut and of good quality."[19] Beaton may have come to feel in competition with both Hauser and Schlee for Garbo's affections, but eighty years later the other two men are forgotten, and it is he whose reputation endures, as an eminent set designer, diarist, and most notably as a photographer. His April 1946 portraits of Garbo, among his finest work, helped to ensure his reputation.

Beaton could not resist offering examples from this extraordinary opportunity to his editor, Alexander Liberman, at *Vogue*, and the July 1947 issue ran fourteen photographs of Garbo. Though Beaton would have asked her permission first, there are accounts that she was unhappy that so many were published. But as their friendship continued, and seems to have grown into a romance, it is more likely that she was quietly thrilled with the renewed attention. After all, Garbo was seriously considering returning to work. The great strategic mind that had served her brilliantly for two decades would have calculated that these pictures, taken in an elegant and contemporary surrounding and revealing her to be as beautiful as before, would be beneficial to her reentry into the screen world.

The war ended in 1945, but it was not until mid-1946 that Garbo was able to travel home. The Swedish line's MS *Gripsholm* had been used for service during the war by the Americans, and finally in June 1946 the ship was ready to reinstate passenger service between New York and Göteborg. Garbo booked passage. With

Garbo needed a new passport in 1946 to travel home to Sweden. She asked her friend Cecil Beaton to take the necessary photograph, and what started as a simple headshot became an afternoon of portraits, many among Garbo's best. Courtesy of Sotheby's.

her family relocated to America, this trip would be primarily to visit friends such as Hörke Wachtmeister, Max Gumpel, and Mimi Pollak, as well as to check on Hårby gård, the estate she purchased back in 1936. For the first time since she departed Sweden with Stiller back in 1925, Garbo had a transatlantic traveling companion; she invited George Schlee to accompany her while Valentina stayed behind in New York. Also, for the first time since she crossed the Atlantic in 1925, she traveled under her own name. The ship sailed on July 6, and the next day a New York paper ran an article about her departure, along with a shipboard

Garbo made her first trip home to Sweden following the end of the Second World War in June 1946.
A photographer snaps her on the deck of the MS *Gripsholm*. Photograph by Acme.

photograph captioned: "Greta Garbo Is Going Home."[20] Thousands of fans were
waiting for her at the pier in Göteborg, but she ignored them as well as the press
and was "smuggled ashore" to avoid any intrusions.[21]

The trip to Sweden was short, and she was back in New York in early September.
Returning with her were actresses Lillian and Dorothy Gish, who told reporters
that they had been to England and Sweden scouting talent for the Theater Guild.
After the boat docked in New York, Garbo gave a few minutes to the waiting
journalists. "She faced cameramen impatiently, but in the interview she stood by
until her interrogators were satisfied," wrote the the *New York Times*. Asked about
her well-known "exclusive tactics," she replied: "I haven't been exclusive. Being in
the newspapers is awfully silly to me. Anyone who does a job properly has a right
to privacy." She told a reporter that "she had no plans for future appearances," and
when asked where she would live, answered, "I'm sort of drifting."[22]

"Drifting" was not the stuff of good copy, so unless a publication could score a
great coup as did *Vogue* in 1946, mentions of Garbo diminish in the press in the
mid-1940s. But she was not forgotten. *Variety* reported in February 1947 that the
"most popular foreign stars in Russia are Greta Garbo and Charlie Chaplin—and
Walt Disney's cartoons."[23] The war would have prevented the distribution of many

of her later films in Russia (and elsewhere in Europe and Asia) until after 1946, resulting in this surge in popularity (and some additional revenue to MGM).

Neither was Garbo forgotten as the subject of books, uniquely so among the motion picture actors. After the publication in Sweden of the first "full-length" Garbo biography by Åke Sundborg, *Greta Garbos saga* in 1929, when she was just twenty-four, a proliferation followed in the 1930s, and books appeared in Germany, England, Spain, and the United States. During the war and after, she largely vanished from the watchful eyes of the movie magazine writers. Without the good services of the MGM publicity department quietly working in the background, even issuing one refusal after another for an interview—which in itself was newsworthy—the Hollywood press had little to report. Still, Garbo remained a figure of great interest. Beginning in 1946, biographies about the actress started appearing. The first, *Greta Garbo: The Story of a Specialist*, by E. E. Laing, was published in England. Over the next seventy years and counting, dozens more would be published. No longer did news of an upcoming film matter. Her life and career were considered worth analyzing, her story better than mere fodder for fan magazines and newspapers. It would now be bound in cloth, wrapped in an attractive dust jacket, and sold in smart bookshops.

An occasional spot in the press mentioning the possibility of a new vehicle titillated fans although nothing seemed certain. Garbo considered many different films after she returned from Sweden in 1946. Biographies and business and personal correspondence from directors and producers such as George Cukor and Walter Wanger and friends such as Salka Viertel reveal an ongoing quest to find a suitable project. But what was the real likelihood that she would return to work? Even as she considered new scripts, Garbo was beginning to be considered a historic figure. The Museum of Modern Art included five Garbo movies in a film series presented in January 1947. The next year George Benjamin, in an article titled "How Long Can You Stay Great?" discussed longevity among current favorites and concluded, "Garbo is the greatest star in the history of Hollywood."[24] A compliment to be sure, but there is that word "history."

Cukor and Wanger, two of her great allies from the MGM days, led the campaign to get Garbo back to work. Since she no longer had a studio tie, the likelihood was that if there were a next film, it would be an independent production made in Europe. Costs would be lower abroad, and Wanger had good prospects for financing from Italian investors. In 1947 two ideas seemed strong possibilities. The first was a story based on the life of the novelist George Sand, with the added appeal of her long relationship with Chopin. The second was a life of Sappho, based on the play by Alphonse Daudet—a typical Garbo story about a woman who conducts a series of romantic affairs but who might find happiness in the end. While a script for *Sappho* was being prepared, Wanger decided it might run into censorship problems back home. He and Garbo agreed it was better to start with the George Sand project with Cukor as director. *Sappho* could be saved

as the follow-up. But suddenly Cukor was called back to Hollywood to direct Katharine Hepburn and Spencer Tracy in *Adam's Rib* (1949). He undoubtedly knew that returning to Los Angeles and working at MGM with Hepburn was a sure paycheck, whereas continually waiting for Garbo to commit to making a film might be futile.

Billy Wilder also tried to get Garbo back on the screen in Hollywood and wanted to write a script for her. He proposed many ideas, including Elizabeth of Austria, often considered the reigning beauty of nineteenth-century Europe. But Garbo claimed she'd had enough of crowned heads after her performance as Queen Christina. Wilder pushed, asking what sort of character she *would* like to play. "A clown," she answered, "a male clown . . . Under the make-up and the silk pants, the clown is a woman. And all the admiring women in the audience who write him letters are wondering why he doesn't respond."[25] Seems Garbo had the best idea of all; what if Billy Wilder had written *that* script?

In the end, the idea that got the most traction was based on the Balzac novel *La duchesse du Langeais*. As in *Conquest*, Garbo would play a married woman who embarks on an adulterous affair with a general, but this time she would end up in a Spanish convent. Wanger would serve as producer, and backing from Italian investors was arranged. Shooting was scheduled to take place in Rome, initially in the summer of 1949, later changed to the fall. Since Cukor was not available, Max Ophuls was engaged to direct. James Mason would play the general.

That previous spring when Garbo was in Los Angeles, she made a series of screen tests. Undoubtedly, she was anxious to see how she appeared on film after an absence of nearly eight years. And the tests could serve to remind investors that the star was still as magnetic as she had been the decade before. Wanger arranged for cinematographer Joseph Valentine to photograph Garbo at Universal Studios on May 5, 1949. Valentine had worked recently for Wanger in the Victor Fleming film *Joan of Arc*, starring Ingrid Bergman. The test, long considered lost, reappeared shortly before Garbo's death. She looks radiant, and from the camera's point of view, she was certainly ready to make a new film. But Valentine died suddenly less than two weeks later, on May 18. Wanger, fretful about keeping *La duchesse* on schedule, quickly lined up two potential replacements, William Daniels, Garbo's old friend behind the camera on most of her MGM films, and James (Jimmie) Wong Howe, with whom he had worked back in 1938 on *Algiers*, starring Hedy Lamarr and Charles Boyer. A second day of shooting tests was set for May 25, 1949; one photographer worked with her in the afternoon, and the other in the evening. Wong Howe recalled that the "purpose of the test was to test cameramen, rather than Garbo. Those who did the best shots would get job."[26] All three tests show Garbo seated and depicted from the waist up. The cameras hardly move at all, only occasionally moving in on her face. She engages directly with the camera, is animated, and often smiles broadly. Occasionally she turns, revealing one or the other profile. There are no props, but in some brief segments

This AP Wire photograph from September 1949 was taken while Garbo visited St. Peter's Basilica in Rome during the ill-fated production of the film *La duchesse de Langeais*.

she puts on a scarf or hat. In the sequence shot by Wong Howe, "I asked her to sit down and lean against a column, and she lighted a cigarette. When the camera started to roll, she started to come to life . . . You could see her personality come out, her mood change; and she became more beautiful."[27] Although the films are silent, Garbo is seen conversing with the photographers or others that might be on the set. This is the last footage ever shot of Garbo, and she records gloriously in all three tests.

The team started assembling in Rome in early September 1949. *La duchesse du Langeais* was scheduled to begin shooting on September 15 at the Scalera Studios

outside Rome. Garbo, accompanied by the ever-present Schlee, was staying at the Grand Hotel, having fled the Hassler, where she felt she could not have any privacy. On September 5 Wanger, Garbo, and Ophuls met together at the hotel. This might have been the moment when Wanger shared the news that he was having difficulties finalizing the financing from his potential Italian partners. Garbo was asked to meet with them. Apparently this was not a happy moment for either the actress or the investors. Garbo must have resented being put on view, so insisted the meeting take place in a dimly lit room at her hotel. This must have annoyed the investors. Wong Howe arrived in Rome the same day, but there was no sign of James Mason, who was waiting in California, insisting that his salary be put into escrow before he started the long journey to Italy. Late that day the Italian investors pulled out of the deal.

Wanger tried to find new financing in Italy and then left the next day for London with the same mission in mind. Finally, on September 8, James Mason notified Wanger he would not make the film. For a moment Wanger seemed to have new backers at hand, but when Garbo heard that Mason was not available, she told her producer she would not work with anyone else. The prospect of making the film in Rome ended. On the ninth Garbo, Schlee, and Wanger left for Paris in the hope that the film might be salvaged in a new location with a different group of investors and potentially a new costar. Nothing more came of *La duchesse du Langeais*. Ophuls's last word on the subject, "A pity forever." [28]

The sad tale of the aborted film might have simply been a footnote in the Garbo chronology of unrealized projects had the three test footages not been rediscovered. Today we can look at the film shot in anticipation of her working again. During her Hollywood period, 1925–1941, Garbo had had two distinct stages. She was the glorious youthful beauty of *Flesh and the Devil* and *The Mysterious Lady*, and audiences watched her face and acting evolve into Hollywood's great dramatic star of the 1930s in films such as *Queen Christina* and *Camille*. The tests made in 1949 show that there was a third phase waiting, had film projects come together satisfactorily and Garbo wished to resume working. No less beautiful than she was before, we have a glimpse of a mature face that could have continued to thrill moviegoers of the postwar era. It was not to be.

CHAPTER NINE

Myth

WHILE GARBO, WANGER, AND OPHULS WERE IN ROME TRYING TO salvage *La duchesse de Langeais*, another film was commencing production back in Hollywood. Billy Wilder, along with Charles Brackett, had written a script about a former silent screen actress, "the greatest star of them all," who lived in gloomy but splendid isolation in her enormous Roaring Twenties mansion, surrounded by many of the accoutrements of the first era of motion picture stardom. There was the ballroom, cathedral-like and fitted with an organ, where Valentino danced. The actress's Hispano-Suiza limousine had leopard-skin upholstery. A tuxedo-clad butler continued to serve her every whim. For a pet, there was a monkey. And, of course, there was a swimming pool in the walled garden. This script became the film *Sunset Boulevard*, which Wilder also directed, and which has come to be regarded as one of Hollywood's supreme films. The story concerns the fictional Norma Desmond, whose career abruptly ended with talking pictures, but the vast riches she accumulated from a queenly salary allowed her to close the door on the past and enshrine her legend in a tarnished-gilt capsule. Wilder claimed he wrote the script with Mae West in mind;[1] if this is true, the picture was saved when she refused the part. After considering Mary Pickford and Pola Negri, he found the ideal Norma Desmond in Swanson, one of the greatest casting coups in movie history. For it was Swanson who most closely embodied the high-living glamour goddess as recalled from the pre–studio system era, and during her reign she might well have been "the greatest star of them all." Swanson was fifty when she played Desmond, and the tale concerns Desmond's quest to make a comeback and to work once again with her old friend and former director Cecil B. DeMille. She befriends a young screenwriter, Joe Gillis, played by William Holden (who was nineteen years Swanson's junior). The unlikely pair develop a writing partnership and attempt to turn a screenplay that Desmond had been working on for years— based on one of her silent hits—into a contemporary talking picture. Soon they embark on a brief, doomed love affair. But when Swanson finally comprehends

her screen return is a fantasy, and the romance an impossibility, she descends into madness. Along the way Wilder and his acting team serve audiences a captivating story documenting the decline of a once-great star, a casualty of the demise of the silent screen. Wilder scripts many of the best lines ever uttered by an actress on film, and Swanson delivers each perfectly.

To entertain the young writer, Desmond screens one of her early films. In a brilliant touch, Wilder uses an actual Swanson film, *Queen Kelly*, that was directed back in 1928 by her *Sunset Boulevard* costar Erich von Stroheim. Watching the film with Gillis, Desmond exclaims, "Still wonderful, isn't it? And no dialogue. We didn't need dialogue. We had faces. There just aren't any faces like that anymore. Maybe one—Garbo. Oh, those idiot producers. Those imbeciles. Haven't they got any eyes? Have they forgotten what a star looks like?"

Garbo was only six years younger than Swanson, but she was of a completely different generation, arriving in Hollywood in 1925 at the dawn of the studio system. When Swanson filmed *Queen Kelly* back in 1928, a project that was never completed, she had been working for fifteen years and had attained the summit of fame as one of early cinema's most bankable goddesses. Alas, by the late 1920s her career was mostly over, and Swanson worked only sporadically in the next two decades. *Sunset Boulevard* was the triumphant return that Norma Desmond imagined but that Gloria Swanson achieved. And Swanson even had the chance to work again with DeMille, who made a cameo appearance in the film. For Garbo, there would not be a return to acting. When Wilder included the reference to Garbo, was he assigning her to the realm of cinema history? Swanson's line, spoken in the present tense, suggested that Garbo remained the one great face in the movies. Why couldn't that one go on making movies? Swanson's return was proof that successful comebacks were possible. In the end it was up to Garbo to decide, but after the Roman fiasco she may never have seriously considered working again, although projects continued to be offered. She understood intuitively that the Garbo brand as a working motion picture actress was finished. Maybe she looked at Norma Desmond and saw that being reduced to having a screen lover two decades younger would be humiliating. Or, even worse, she realized that roles for middle-aged women generally depicted them as vulnerable, as mothers, as crazy or irrelevant.

Hepburn, Crawford, and Bette Davis worked regularly in the 1950s, still stars to be sure, but now playing "interesting" characters and no longer being offered the electrifying roles that defined their early careers. All three had strong parts in the mid-1950s, but would Garbo have considered playing an autumnal spinster in Venice as Hepburn did in *Summertime* (1955), or re-create an historical character in later middle-age, as Davis did portraying Elizabeth I (again) in *The Virgin Queen* (1955)? She might have made a convincing Vienna in *Johnny Guitar* (1954), a role played by Crawford, but it is hard to imagine Garbo as a western

After living and working in the United States for twenty-six years, Garbo became an American citizen in February 1951. An unidentified photographer made sure the occasion was recorded.

saloon keeper who gets her man in the end, albeit in a desert hideout with bullets flying overhead.

Instead, Garbo continued her routine of dividing her time between North Bedford Drive in Beverly Hills and hotel suites in New York City. She also made regular visits to Europe, often in the company of Schlee. Did she hope with the passing of time she would finally be accorded the privileges that she had so long sought: privacy and anonymity? Without studio press agents working on her behalf, no new film projects announced, and no public appearances, what about Garbo could possibly fascinate the public?

Garbo's last MGM portrait session took place in October 1941, just after *Two-Faced Woman* finished its principal photography but before the retakes demanded by the Legion of Decency. The session with Beaton had taken place in the spring of 1946. Perhaps she got the posing itch every five years, for in 1951 she decided it was time to be photographed again. The lucky photographer was British Antony Beauchamp, son-in-law to Winston Churchill and a well-known and well-regarded portrait artist in the 1950s, though he's hardly remembered in the twenty-first century.

Beauchamp met Garbo on her forty-fifth birthday, September 18, 1950, at the Los Angeles home of Harry Crocker, another bachelor in her inner circle of admirers who kept stone-silent about their friendship. Like Bob Reud, Crocker was an improbable friend, as he too was a publicist, as well as a former actor; he also wrote a celebrity column, "Behind the Makeup," published in the Hearst papers. Crocker had been a good friend to John Gilbert, probably stemming from the years when Crocker played bit parts at MGM in the late 1920s. During the 1930s he was a regular escort for Marion Davies. What might have appealed most to Garbo, along with his dark good looks and discretion, was that he was a scion of the famous San Francisco Crocker banking family, socially prominent and financially independent. Garbo and Crocker were neighbors on North Bedford Drive. To ward off the curious who might learn of her whereabouts, Garbo regularly used his address for her correspondence. And she often took refuge in his home as a place away from prying eyes. Along with the host, the birthday dinner included only two guests, Beauchamp and his wife, Sarah Churchill, who was an actress.

Beauchamp's mother, "Viviennne" (Florence Vivienne Entwistle), also a prominent London photographer, undertook the publication of her son's memoirs, *Focus on Fame*, which he completed shortly before his death by suicide in 1957. Beauchamp wrote of his encounters with many illustrious sitters, but he singled out two for special praise: "In the world of cinema there exist today only two living legends to whom the word greatness can be truly applied, Greta Garbo and Charlie Chaplin."[2] "There she sat under the illumination of a single flickering candle—the perfect Garbo of the legend," Beauchamp wrote, recalling his first sight of Garbo waiting alone at the small table set for four in Crocker's garden.[3] Soon after the dinner, Beauchamp told Crocker of his desire to photograph her. The surprising response was that his host had wanted a new picture of his friend, and it turned out Garbo was willing. Was the evening planned to bring about the prospect of her working with Beauchamp? Whether strategy or kismet, he was invited by Crocker to make some pictures. And was it a coincidence that Beauchamp was working on a project for *McCall's* magazine and had been commissioned to take color photographs of Hollywood's ten most beautiful women? Could Garbo still make the list ten years after *Two-Faced Woman*? Both men thought so, and Garbo must have agreed as well.

Beauchamp contacted his editor and asked if *McCall's* would like a new Garbo portrait for the cover of the upcoming issue. "Don't be silly . . . you know perfectly well Garbo won't pose for a picture," was the predictable response.[4] Crocker offered his house for the session, as he felt she would be most comfortable working in his sitting room. Six o'clock was the hour appointed; Beauchamp came over early and arranged the lights and equipment. Garbo appeared promptly, and a cocktail was served. "The lens of a camera," Beauchamp wrote later, "seemed to fascinate Garbo as the eye of a snake does a rabbit."[5] By eight she was ready to go home, but she was also hungry for dinner. No photographs had been taken. They

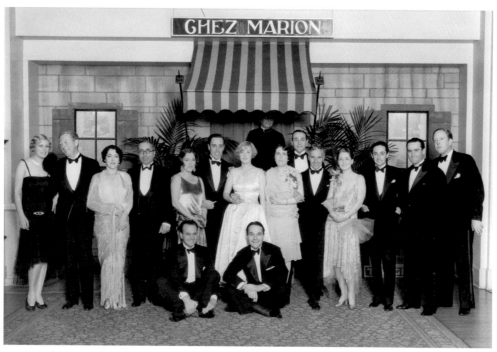

Harry Crocker is seated at left next to William Haines at a 1928 party for Marion Davies at Los Ange-les's Ambassador Hotel. Joining the festivities, from left: Lorraine Eddy, Matt Moore, Aileen Pringle, Louis B. Mayer, Gloria Swanson, Harry d'Arrast, Marion Davies, Louella Parsons, Ricardo Cortez, Charlie Chaplin, Norma Shearer, Irving Thalberg, Harold Lloyd, and Robert Z. Leonard. Courtesy John Kobal Foundation

decided to eat, and Garbo promised to return the next day. Yet again she refused to be photographed, though once more she agreed to return the following day. By then Crocker had to leave Los Angeles but told the two they were welcome to continue using his sitting room as a studio. "And for the next ten evenings there were identical repeat performances—all ended with me having dinner alone with Garbo without getting a single picture." Finally Beauchamp had to return to New York. He told Garbo he was leaving in two days, with or without her photograph. Tomorrow, she promised—and she did consent to his taking her picture. All were in color. "Thank heaven that's over," she told him when he finished, "That is definitely the last picture I shall ever have taken."[6]

Beauchamp made six exposures, all of Garbo in close-up. She seems to be lying back on a sofa wearing a light-beige-colored turtleneck sweater under a black coat, one time smiling, another eyes closed—the one *McCall's* selected for the June 1951 issue, printed in black and white. It had been a decade since a new Garbo portrait had appeared on a magazine cover. Inside, Garbo led the series of "Hollywood's Ten Most Beautiful Women," and her photograph, now in color, is the largest. The other beauties were Elizabeth Taylor, Arlene Dahl, Jean Sim-mons, Gene Tierney, Ethel Barrymore, Hjördis Pauline Tersmeden (married to

Garbo met British photographer Antony Beauchamp at a small dinner hosted by Harry Crocker to celebrate her forty-fifth birthday. Garbo agreed to be photographed for the first time in five years. To no one's surprise, the new images quickly were featured on magazine covers around the world.

David Niven), Janice Rule, Constance Smith, and Ava Gardner. "Garbo's Greatest Film Roles" was the feature that followed: "Here are the scenes that made Greta Garbo the most glamorous legend in America motion picture history." Stills from ten films were included, looking back to *Flesh and the Devil* (with Gilbert) and ending with Ninotchka laughing. "Although she is 45 and has not made a film in 10 years," the last line of the story read, "millions still consider Garbo the most

fascinating woman in the world and hope that someday she will find another script worthy of her talent."[7]

Beauchamp starting selling the images to important magazines but was careful not to overexpose his subject. One of the first was the Italian magazine *Epoca* (January 1952), which reproduced Garbo on the cover and in color. Later that year the Swedish magazine *Alt* (September 1952) acquired the rights and followed suit—again on the cover and in color. *Paris Match* had its turn on April 2, 1955, with the caption: "Le récit dont tout le monde parle: l'énigme Garbo" (The story the whole world is talking about: the Garbo enigma). How canny Garbo had been to allow Beauchamp to photograph her and in color. These new photos helped keep her squarely at the center of 1950s fame. She was no longer a movie star with a devoted following, like mid-1950s cinema giants Taylor, Marilyn Monroe, Grace Kelly, or Audrey Hepburn. But, when any magazine put Beauchamp's Garbo on its cover, it was a reminder that she was the most brilliant of cinema's prewar goddesses.

Garbo may have insisted to Beauchamp that she was finished with the camera, but before the end of the year she was posing again. Again, in need of a new passport photo, she turned to her friend George Hoyningen-Huene, the Russian-born photographer on the staff of *Harper's Bazaar*. In a brief session, she allowed him to expose several negatives in addition to the headshot she needed for the passport. This time the results were not as good; the half-dozen or so photographs lack glamour or joy, and they were rarely reproduced. Hoyningen-Huene did send one to his magazine, and it was published in April 1952. It did not make the cover.

During and after the war, the Ritz Tower on Park Avenue was Garbo's most common stopping place in New York, although for a time in the early fifties she was the regular guest of heiress Alice Tully, who had purchased and combined the five apartments on the twenty-seventh floor of the Hampshire House on Central Park South to create a splendid palatial residence. Tully carved out a four-room suite for Garbo with open park views.[8] Garbo lived there until 1953, when she finally purchased her own apartment, not surprisingly in the same building as her friend George Schlee and his wife, Valentina. They had been longtime residents of the Beekman Campanile overlooking the East River at the end of Fifty-Second Street, and when a full floor became available, Garbo finally had a permanent home in New York City. The relationship among the three has never been adequately explained. In particular, what did Valentina think of the long stretches when her husband was off vacationing with Garbo? The Schlees stayed married, and when in New York together they continued to entertain as a couple, so whatever arrangement was made, it suited them.

Garbo continued to favor the company of successful, wealthy, and famous men and remained close to Max Gumpel from Stockholm days. John Gilbert was her first American conquest, but his insistent ardor had proved too stultifying. Her professional success and, of course, her beauty had given her an entrée into high

society. Statesmen, industry leaders, and European royals visited MGM in the 1920s, and all wanted to meet the attractive players. Although officially Garbo met none, early photographs reveal otherwise. Back in 1928, when Garbo made her first voyage home, she was photographed dining shipboard with Swedish prince Sigvard, who was returning after a family wedding in America. It was on the same trip that she met Count and Countess Wachtmeister and the countess's nephew Wilhelm Sörensen. Although Garbo often traveled alone during her working years, it became increasingly obvious that unwanted attention would follow her everywhere she went. By the late 1930s, she was usually accompanied by a distinguished man who could ward off the curious, affording Garbo some degree of protection and privacy. The Stokowski relationship has been well documented, less so her friendship with Harry Crocker. Gayelord Hauser, as we have seen, became a frequent escort and introduced her to many American tycoons who were glad to entertain her at their homes and at fashionable resorts. But of all her friends and traveling companions, the one most often at her side, and who most successfully guided Garbo into the upper reaches of 1950s café society, was George Schlee.

Garbo and Schlee regularly traveled together to Europe. In the summer of 1953, they made a trip to the south of France and the Italian Riviera. While in Cannes the pair rented the yacht *Glen Tor* and sailed to Portofino, a tiny, picturesque fishing village just south of Genoa that had become a stopping point for many cultivated and wealthy British and American vacationers, who often arrived by boat. Actors Rex Harrison and Lilli Palmer had built a home in the hills above Portofino, and they became hosts to distinguished visitors. One evening they were entertaining the Duke and Duchess of Windsor for dinner when Schlee called from the village below, telling Palmer that he and Garbo would like to come up for a drink. Palmer asked the duke if he minded; he did not, noting that he had never met Garbo. More than twenty years later, Palmer wrote about the evening. The diners were elegantly dressed, Wallis Windsor "in something white and exquisite, with what were probably fabulous jewels around her neck." Garbo appeared at the house "in old blue slacks and a faded blouse . . . Greta's brown hair hung straight and shapeless, matted from seawater . . . Wallis . . . traveled with her own hairdresser." The Windsors were staying on a yacht called the *Sister Anne* belonging to Singer heiress and socialite Daisy Fellowes. Wallis invited the gathered party to join her and the duke for dinner shipboard the next evening. "I have no dress," was Garbo's response to the royal invitation. "Then it will be an informal party," the duchess answered. The next evening Harrison and Palmer motored out to gather Garbo and Schlee from *Glen Tor*, anchored just off the Portofino harbor; "photographers and reporters circled the yacht in rowboats and dinghies." If Garbo gave the reporters a few minutes' time, Palmer suggested, "perhaps they will leave you alone." After a quarter of a century's experience, it was "no use," she answered; "they won't go away. I've tried everything." The boat "was

When making summer visits to Italy, Garbo sometimes visited Rex Harrison at his home in the hills above Rapallo on the Italian Riviera. The actor reflexively raises a protective hand, although here Garbo seems amused by the intrusive cameras. Photograph by United Press.

tied up at night at the farthest, stinkingest end of the harbor, where they hoped, in vain as usual, to escape notice . . . The harder she tried, the more persistently the press and the general public pursued her." Garbo told Palmer, "I only know the rear entrances of the hotels I stay in . . . I always have to climb over garbage cans and hampers full of dirty linen and sneak up to my room on foot or in the service elevator." [9] More than a decade after Garbo had made her last picture, the frenzy continued.

The Academy of Motion Picture Arts and Sciences honored Garbo in 1955 with an honorary Academy Award. She was forty-nine. An old friend, director Jean Negulesco, was that year's producer of the occasion, and he may have lobbied

the Academy finally to grant Garbo an Oscar. She did not attend and declined to designate someone to pick up the award in her stead. On March 10, 1955, from the stage of the RKO Pantages Theatre in Hollywood, screenwriter Charles Brackett presented a special Academy Award to Greta Garbo, "for her luminous and unforgettable screen appearances." A film clip from *Camille* was screened. Strangely, the camera then cut to another camera at the NBC–New Century Theatre in New York City, where Nancy Kelly, who had recently won the Tony Award for her performance in *The Bad Seed*, accepted the Oscar on Garbo's behalf. Garbo had no connection to Kelly, so the decision to have the statuette presented in New York might have been in the hope that Garbo would decide at the last minute to attend. Legend has it that Garbo did not see her Oscar for two years and that it was finally delivered to George Schlee by Minna Wallis, wife of producer Hal Wallis. Schlee reportedly kept the Oscar at his villa at Cap d'Ail near Monaco, which Garbo visited each summer. Later it was displayed on a bookshelf in the living room of her New York City apartment.

Garbo did not mark her Academy Award with a portrait session, and although producers continued to offer her scripts, she remained immune to the call to return to acting. Press snaps at airports and coastal villages were about all the public saw of her. She might have faded finally into the quiet retirement she claimed to desire. But suddenly a new generation of writers emerged, taking Garbo as their subject in thoughtful musings published in prestigious magazines and books.

Kenneth Tynan was a leading British theater critic when in 1954 he wrote an essay titled simply "Garbo" for *Sight and Sound* that began with the now-fabled first line, "What, when drunk, one sees in other women, one sees in Garbo sober." A new sort of cinema criticism arguably began with this remarkable sentence. For it was not only that Tynan was taking the measure of Garbo's entire career—that had been done before—but that, as readers today can see, he was thinking seriously about her motivations personally and professionally, and in a context that considered the sweep of nascent film history. He was often critical of his subject, but in a carefully analytical way that in the end highlighted her abilities. A fan magazine writer might have suggested that Garbo was afraid to work again. Tynan puts it more elegantly: "It is likely that too many volumes have been read into and written about her, and that every additional adulatory word reinforces the terror I am sure she feels at the thought of having to face us again and measure up to the legend." He describes her films as "musk-scented tin lizzies" but adds, "During the decade in which she talked to us, she gave signs that she was on the side of life against darkness." Or, more to the point, "Round the militant bluster of MGM dialogue she wrapped a Red Cross bandage of humanity." Tynan claims that "except physically, we know little more about Garbo than we know about Shakespeare." Musing about her repertoire of screen characters he synthesized accurately what earlier critics described as a "sameness" in her roles; "In most of the characters she played," he writes, "the only discernable moral imperative

is loyalty, an animal rather than a human virtue—that 'natural sense of honour' which, as Shaw says, 'is nowhere mentioned in the Bible.'" Did Tynan mean this positively or critically? Read sixty-five years later, his words both accurately describe Garbo's performances and underscore why they retain a freshness and vitality despite being packaged under the heavy weight of the studio system's banality and morality. Tynan concludes frankly, "So it looks as if we're never to know whether or not she was a great actress . . . We must acclaim a glorious woman who exhibited herself more profoundly to the camera than any of her contemporaries: but the final accolade must, if we are honest, be withheld."[10] History gives us a perspective unavailable to Tynan in 1954. He wished Garbo had played "Hedda, Masha, or St. Joan." She did not, but when the dust settled on the history of twentieth-century motion pictures, it was enough that she had played Maria Walewska, Marguerite Gautier, and Anna Karenina.

In 1957, in his book *Mythologies*, French philosopher Roland Barthes included "Garbo's Face," a five-paragraph reflection on his memory of seeing the actress at work. He begins by reminding his readers of a moment in cinema's past when audiences "literally lost themselves in a human image as in a philtre, when the face constituted a kind of absolute state of the flesh, which one could neither attain or abandon." Three years after Tynan's essay, Barthes knew for certain that Garbo's career was sealed when he wrote, "Her nickname Divine probably intended to express less a superlative state of beauty than the essence of her corporeal person, descended from a heaven where things are formed and finished with the greatest clarity . . . The Essence must not degrade, her visage could never have any other reality than that of its intellectual perfection, even more than its plastic one." Garbo as an actress and face was now a memory, and she needed to participate in preserving her screen illusion. "The Essence has gradually dimmed, progressively veiled by dark glasses, hooded capes and various exiles; but it has never altered."[11] The face of Garbo, he suggested, no longer belonged to a mortal woman but had entered the realm of myth, and belonged to the poets and philosophers who would interpret forever its meaning. When Clarence Bull superimposed Garbo's face on the head of the sphinx in 1930, he was conveying in image what Barthes gave us in words twenty-five years later.

Garbo turned fifty on September 18, 1955, and whether or not it was an anniversary she wished to acknowledge, it was a newsworthy event. Writer John Bainbridge wrote a biography, *Garbo*, marking the half centenary, and *Life* magazine published his three-part tribute to the former actress that appeared in consecutive weeks beginning in January of that year. The famous 1928 Edward Steichen photograph of Garbo with her hands on her head was used on the cover of the issue launching the series. In early spring, Doubleday brought out Bainbridge's tribute, the first full-length consideration of her career by an American writer since Rilla Page Palmborg's book more than two decades earlier. On the dust jacket, two of Antony Beauchamp's 1951 photographs were used—Garbo smiling with

her eyes open on the front cover, closed on the back. Palmborg felt Bainbridge had plagiarized her earlier biography and sued Time, *Life*'s parent company for $710,000 in damages (how she fared was never reported).

In his opening sentence, Bainbridge quotes Balzac writing about George Sand: "She was gifted with genius, and led one of those exceptional lives which cannot be judged by ordinary standards."[12] He wrote a balanced portrait highlighting Garbo's acting career but also revealing something about her private life, especially the ten years following the war. He resisted much critical interpretation of her acting skills but occasionally gave readers an interesting insight that he must have garnered from interviewing those who worked with her. After *Two-Faced Woman*, for example, he wrote that Garbo believed "malevolent forces were at work to bring about her downfall."[13] If she actually thought this, it would have contributed to her decision to scrutinize further projects carefully and, ultimately, accept none at all.

Bosley Crowther reviewed the book for the *New York Times*. "It is likely that more has been written about Greta Garbo, the moody movie star, than any other performer of the stage or screen that has ever lived," he wrote. Crowther agreed with Bainbridge that Garbo "has probably had a greater influence on the appearance of women today than any other person." But he also appeared to judge her: "This book is a fascinating look-in upon a strange artist's personality and its banging around in a community with which it obviously never came to spiritual terms."[14] But isn't that simple truth part of what made Garbo successful? She played the Hollywood game only to the point where it gave her a platform to make her films. She rejected almost all the other trappings of Hollywood movie stardom yet became motion pictures' greatest product. If anything can be stated with some certainty about Garbo, it is that while Hollywood never accepted her "spiritual terms," audiences did, through the magic that radiates from the screen every time her films are shown in theaters or on television.

The glamorous Art Deco Normandie Theatre on East Fifty-Third Street in New York, with a seating capacity of six hundred, revived *Camille* in March 1955. Crowther reviewed for the *Times* and touted the nineteen-year-old film and the new audience's positive reaction.[15] Arthur Knight, reviewing Bainbridge's book for the *Saturday Review*, noted that in its revival *Camille* "played to the best business the house had ever known." MGM went on to reissue the film nationally. Like so many others, Knight agreed that Garbo possessed the "face of the century." In Beauchamp's cover photographs, "the delicate nose, the arched brow, the high, firm cheekbones, the wide expressive mouth—all seem unchanged, youthful, indestructible. But it is a mask, passive, without animation, almost without life."[16] These pictures were still relatively new when Knight wrote, and he was considering her face in light of the images he remembered from her working days. Seventy years later we look at Beauchamp's photographs as the conclusion of a perfect twenty-five-year arc in the presentation of Garbo's face to the public. Yes, one

might claim that certain of her portraits have a masklike quality, but her photographs were never without life. Inscrutable though her face might be, we continue to wonder what it is that remains beguiling and captivating.

No reports have survived of Garbo's response to this sudden flurry of attention—the Oscar, the new biography, the film revivals and fancy literary tributes. Through it all she attempted to remain invisible despite the ubiquitous paparazzi who still managed to spot her when traveling, often with Schlee at her side, and frequently to visit someone rich and famous. The peripatetic pair befriended Aristotle Onassis in the mid-1950s, and they were photographed boarding his famous yacht *Christina* at one or another Mediterranean port. Garbo might have wished to shun publicity, but Onassis enjoyed the attention provided by his famous visitors, who also included Winston Churchill, Maria Callas, and later, of course, Jacqueline Kennedy. Schlee might not have liked the flashing bulbs of press cameras whenever he and Garbo traveled through airports, but he must have enjoyed the added social exposure that escorting her provided. It did not seem to matter to his hosts that he left his wife back home in New York.

Schlee died on October 3, 1964, in Paris when he and Garbo were traveling together, occupying adjoining suites at the Hôtel de Crillon. Reporting on his death, the *New York Times* wrote, "Mr. Schlee was about 65 years old. His age, like much about him, was shrouded in what one of his friends termed 'a romantic and pleasant air of mystery.'"[17] Schlee's body was returned to New York, where there was a funeral service on October 7. Garbo did not attend. Valentina lived until 1989, and for twenty-five years after the death of her husband, she and Garbo lived in the same apartment building, although all reports suggest they were never friends.

One photograph taken as Garbo disembarked from the plane carrying her back from Paris after Schlee's death shows her carrying protectively a package that is likely a small painting. An enthusiasm begun in 1942, art collecting continued to interest Garbo, and in the 1960s she put together a remarkable collection of paintings by the Russian Expressionist artist Alexej von Jawlensky. She also added masterpieces by artists such as Robert Delaunay (*Woman with a Parasol*) and Chaïm Soutine (*Woman with a Puppet*) to the Renoirs and Bonnard she had acquired earlier. One hallmark of the collection was its extremely high quality. She liked paintings with bright, intense palettes and strong painterly techniques. In a sun-drenched apartment with its open eastern and southern exposures, Garbo lived in an exhilarating kaleidoscope of pattern and color.

Garbo may rarely have entertained at home (or anywhere else), but she lived in a kind of splendor befitting a former movie queen. Long-time *Vogue* editor Babs Simpson recalled that Billy Baldwin, the leading society decorator of his day, chose the furniture and fabrics for Garbo's apartment in 1953 but was asked to not mention his famous client to anyone.[18] The living-room furniture included important eighteenth-century French pieces upholstered in sumptuous Scalamandré

A photographer captured Garbo in October 1964 disembarking in New York following the death of her friend George Schlee in Paris. The package she carries looks to be a painting she acquired on her trip abroad. Photograph by Wide World.

silks. Garbo designed her own carpets, also in a bright modernist palette, and her bedroom walls were lined in a handprinted Fortuny fabric called Ashanti in bittersweet (rusty-pink) and gold. Such luxury notwithstanding, she retained her thrifty ways. Marty Jennings, who still has a small shop on First Avenue selling electrical products and lightbulbs, recalled that Garbo regularly came in to buy eight feet of cord and a plug so she could rewire lamps herself rather than paying him ten dollars apiece to do the job.

After the death of Schlee, Garbo continued her nomadic lifestyle and made regular visits to Salka Viertel in Switzerland, Cécile Rothschild in Paris, and Cecil Beaton in England. She and Beaton eventually had a falling-out, although she paid him a visit shortly before his death in 1980 and kept a portrait painting of him in her collection. Her intense on-again, off-again friendship with Mercedes de Acosta, which survived for almost three decades, was finally irreparably broken when de Acosta published her memoirs, *Here Lies the Heart*. For a book published in 1960, de Acosta is surprisingly frank about her lesbianism, and she implies that she and Garbo had been romantically involved. No reader would be able to come away from the book thinking otherwise. Whatever the true nature of their relationship, Garbo was not interested in having this period of her life so frankly dissected, and shut the door. De Acosta died six years later in New York, having sold her papers and letters to the Rosenbach Library in Philadelphia. There is plenty of correspondence from Garbo, but little of it illuminates their tempestuous history.

A better chronicler of Garbo was Raymond Daum. When they met in 1963 at actor Zachary Scott's apartment in the Dakota apartment house in New York, Daum was working at the United Nations and was a neighbor of Garbo's on Beekman Place. Another in her long line of devoted bachelors, Daum became a walking companion and they traveled hundreds of miles of New York streets together. He also kept scrupulous notes about their conversations and wrote a book, *Walking with Garbo*, that came out shortly after her death in 1990. His memories provide a firsthand account of her moods in the 1970s, and the pages of his book are filled with anecdotes relating to the banalities of Garbo's life wandering about New York, thoughts about people she passed on the street, what she liked to eat, and her "bachelor existence."[19] There are occasional insights into her motivations: "Don't ever ask me about the movies, especially why I left them," he quotes her as saying. "I'm sorry for a lot of things, for quitting things. But I've always lived my own peculiar way, willy-nilly. I'm sort of a free-going spirit, otherwise I can't exist. Actually, I've been out of order for years."[20]

As the 1950s turned in to the 1960s, interest in Garbo should have subsided. No longer did she titillate the press or her fans with a new portrait session or hints of an upcoming film project. It was the decade before the nostalgia craze began, and the warhorses from cinema's golden age were largely unseen unless they appeared on television, or on stage, or for the unfortunate few, in the horror movies that drew former top-tier stars in need of a paycheck or one more chance in front of the camera. It is arguable whether Joan Crawford and Bette Davis were wise to costar in *What Ever Happened to Baby Jane?* (1962). The picture was critically acclaimed at the time, but it was an ignominious twilight for two of cinema's biggest stars. Henceforth roles offered to them, and their peers who continued working, were more often than not horror stories. Davis continued with *Hush . . . Hush, Sweet Charlotte* (1964) with Olivia de Havilland and Mary

Astor. Astor shrewdly stopped acting in films, but De Havilland descended further into camp with *Lady in a Cage* the same year. Gloria Swanson could not resist a final close-up and agreed to a small role in the disaster movie *Airport 1975.* How prescient Garbo was to bring down the curtain on her career after the failed attempt to get the funding for *La duchesse de Langeais.* She avoided the horror and disaster movies, and she never answered the call to go on stage, where so many of her contemporaries played in road company revivals of *Hello, Dolly!* and *Mame.*

The early 1960s saw perhaps the biggest single change in the dynamic between motion picture stars and audiences since the advent of sound. The mighty foundation of motion picture stardom, carefully built in the silent picture days and promoted by the moguls back in the 1920s and 1930s, was about to be replaced, or more accurately subsumed by, an equally potent paradigm, the culture of celebrity.

By the time Elizabeth Taylor signed a contract in late 1960 to star in *Cleopatra* for Twentieth Century-Fox, the studio system was sputtering its last gasps. *Butterfield 8* (1960) had been her final commitment to MGM, and now Taylor, free from a long-term contract, could accept the offer of $1 million to play the Egyptian queen. She had come of age in the MGM glamour factory and, over nearly two decades beginning when she was still a child, rose to become the world's most famous movie star. Filming of *Cleopatra* began in the winter of 1961 with Rouben Mamoulian directing and a budget of $5 million. By the time it was released in the summer of 1963, the final cost exceeding $30 million was the highest of any Hollywood film. The production delays and the soaring expenses were largely attributable to Taylor. She became ill shortly after filming began in London, which caused the production to be shut down for months. When it started again anew, now in Rome, she had different costars, most notably Richard Burton replacing Stephen Boyd as Mark Antony. Predictably, she fell in love with the married Burton, and what might have been just another Hollywood romance erupted into an enormous scandal that affected not only the lives of the stars but the film itself. For now *Cleopatra* was not just another movie but the stage on which the world's most visible illicit affair was playing out and in real time. The international press descended and followed the couple's every move. It is impossible to overestimate how dominant the Taylor-Burton affair was in the press of the early 1960s. They provided the public with a filmland romance of a magnitude not seen since Garbo and Gilbert, but now without the brakes and filters so deftly applied by the studio's publicity apparatus. Movie stardom was being transmogrified into celebrity, a category that did not rely upon actually appearing on screen and thrived instead on gossip, scandal, conspicuous consumption, and a glamorous "lifestyle." With *Cleopatra* Taylor became as famous as Gloria Swanson or Mary Pickford had been in the 1920s, or Garbo in the next decade. But unlike the others, her sensational and combustible private life held more interest than anything she had ever done before, or would do again, on screen. She was now an international celebrity.

Just before *Cleopatra* went into production in Rome, Federico Fellini released *La dolce vita* (1960). One of his characters was an independent press photographer whom Fellini named Paparazzo, which translates from the Italian as "swarming insect." Garbo knew well the type, and Taylor would soon become its latest and perhaps most notorious victim. Stars' lives were no longer managed (and protected) by the studios. Instead, they were perceived as public property. The gauzy screen that had insulated the stars of yesteryear and sanitized their behavior had suddenly become transparent. In the insatiable quest to know everything about a star, movie fans were no longer content with formal portraits of their favorites. Rather, let's see Liz and Dick caught in awkward situations. Wronged wives and aggrieved husbands were now also vulnerable to assault. The camera had become a weapon, and no performer—actor or celebrity—would be protected from the vicious onslaught.

At a time when Garbo's star should have waned in the twilight sky of the golden age of Hollywood, the increased clamor by magazines and newspapers for images of the famous, even those long retired, made her face once again a sought-after commodity. The world's press decided, as though a message had been broadcast globally, that Garbo's was still among the most coveted faces, and that new snaps could be sold for a good price to editors across America and Europe. If a photo could be taken that showed the once-glorious face in less-than-ideal circumstances, so much the better. The fascination was in part because she abandoned her career at its height but also because she never chatted about the old days with Merv Griffin, Mike Douglas, or Dick Cavett. As with so many of Garbo's characteristics, here again she was unique. The allure she had worked so diligently to promote on screen was wholly resurrected twenty years after her last picture was released. Her image, no matter its vintage, was still one of the most desirable on the planet.

Garbo attended a matinee of the 1964 Broadway production of *Funny Girl* starring Barbra Streisand, accompanied by her friend the producer William Frye. At intermission, Frye recalled, members of the audience started to recognize the famous face seated quietly; "an audible buzz began . . . people walked down the aisle and crossed the row in front of us, staring and talking and pointing." They stayed for the second act, but real problems began when they left the theater and admirers started to become insistent. One woman even tried to get into their car. "I'd been in public with any number of stars," he later wrote, "including Tallulah Bankhead, Bette Davis, Rosalind Russell, and Joan Crawford, but I'd never witnessed anything approaching the frenzy we had just gone through." [21]

Garbo sightings became something of a sport among New Yorkers beginning in the 1960s. Just to spot her and report the location was enough to start a conversation. One young mother back in the late 1960s took her infant in her stroller to Central Park, where in the late spring she would sit on a bench and read magazines, passing an hour quietly. One day a well-dressed older woman joined

her on the bench and engaged playfully with the baby for a few minutes. With a polite "good morning," the woman went off. The next day the young mother was back in the same place and again was visited by the same woman. Both sat quietly; only the baby drew any attention. This time, after the woman departed, several passersby ran up breathlessly and exclaimed as one, "Do you know who that was?" It was Garbo, of course, and it was a story still being recounted fifty years later. Tim Wallach was a young man in the mid-1970s when, riding on the uptown Madison Avenue bus, an older woman sat down next to him. "Could it really be Garbo?" he wondered. Continuing looking forward, he quietly uttered, in German, "Sind Sie?" (Is it you?). No answer for thirty seconds, but finally a single word—"Ja." Cecil Beaton wrote in his diary, "It must be a very peculiar sensation to know that almost everyone one sees knows one by sight."[22]

It was something of a comedown, necessitated by a desperate need for a paycheck, when Joan Crawford agreed to narrate an hour-long television documentary about Garbo for the BBC in 1969. Crawford, photographed mostly in close-up, tells an abbreviated version of Garbo's life and career, illustrated by early photographs and with clips from Garbo's films. How difficult it must have been for one of cinema's legends and most thrilling beauties to have to quote Mauritz Stiller describing her MGM rival: "You only get a face like that in front of a camera once in a century."[23]

Four years later, in 1973 when Katharine Hepburn appeared on *The Dick Cavett Show*, the host asked her frankly: "Everybody says that Garbo had something that no one had before or since. I'm willing to believe that this is not true." Hepburn's response, "No, this is true." Bette Davis also described Garbo as unique: "Her instinct, her mastery over the machine, was pure witchcraft. I cannot analyze this woman's acting. I only know that no one else so effectively worked in front of a camera."[24] Fellini claimed Garbo "was the only movie star to achieve the status of a religious icon . . . the founder of a religious order called the cinema."[25]

Garbo's anniversaries were followed in the press. *Look* magazine featured Garbo on the September 8, 1970, cover that proclaimed, "Garbo is 65: A surprising portrait of the most mysterious woman of our time." The 1928 Steichen photograph was used—by 1970 it had become the iconic Garbo image. John Bainbridge wrote the accompanying article, which coincided with the publication of a new, heavily illustrated, large-format edition of his 1955 biography. Fifteen years later public interest in Garbo had not diminished. Neither had her beauty. Screenwriter and novelist Irwin Shaw had lunch with her in 1970 and afterward proclaimed, "She is so beautiful, so beautiful it is incredible."[26] Gore Vidal was more succinct, "At sixty-five, Garbo was still very beautiful—that is, she still looked like Garbo."[27]

Billy Wilder evoked her a second time on screen in his 1978 film *Fedora*, based on a novella by Tom Tryon. Fedora, the most radiant and glamorous star of her era, had retired decades before, when still young and at the top of her career, and now lived in quiet exile at her splendid villa on a private Greek island. Awarded

LOOK

50 CENTS · SEPTEMBER 8, 1970

GARBO

IS 65

A surprising portrait of the most mysterious woman of our time

Special Booklet:
HANK STRAM'S
GUIDED TOUR OF
PRO FOOTBALL'S
DAZZLING
NEW PLAYS

Senator Ribicoff:
DO MOST
AMERICANS
SECRETLY
WANT
SEGREGATION?

Steichen's classic 1928 photograph was the magazine's choice as the image to document and to celebrate Garbo's sixty-fifth birthday in 1970.

an honorary Oscar, she agreed to accept the statuette but only if delivered to her island refuge late in the afternoon as the sun was setting, and with only the Academy president and a lone photographer present. The presentation was made, photographs were taken, and suddenly Fedora was back, as magnificent as before. Or was she? Wilder did not need to mention Garbo as the story's inspiration. The myth was so well established by 1978 that the character of Fedora, with her large floppy hats, trousers, flat shoes, and sunglasses, could only have been based on Garbo. The Garbo myth was further enshrined on film when Sidney Lumet directed *Garbo Talks* in 1984. The story follows a young man's quest to track down the elusive actress in New York and try to convince her to visit his dying mother. Like Don Quixote's impossible dream, the film follows for two hours the quest for

Barthes's ideal or Bull's sphinx. It is a movie, so audiences are given a satisfactory ending—mother and actress meet—though Garbo remains inviolate.

Garbo was introduced to a new generation when Andy Warhol included her in his 1981 painting *Myths*, a compendium of ten portraits, including his own, that is a provocative selection of twentieth-century signal figures. Garbo was an idol of the artist,[28] and besides them the only two other actual people included are Margaret Hamilton as the Wicked Witch of the West and George Reeves flying through the air as Superman. Other subjects were Mickey Mouse, Santa Claus, Howdy Doody, Mammy, Dracula, and Uncle Sam. The same year Warhol also made a series of ten silkscreen prints, based on the images included in the painting. The series was also titled *Myths*, with a separate image devoted to each of his ten subjects; Garbo's was titled *The Star*. Collector and film historian John Kobal provided him with a photograph by Clarence Bull from *Mata Hari*, from which the Garbo image was taken. Warhol's fame has only increased since his death in 1987, and his work is collected avidly and exhibited widely, helping to ensure that the faces of Garbo—along with Marilyn, Jackie, and Liz—remain beacons of twentieth-century popular culture.

By the time Warhol was celebrating Garbo, her travel rhythms had changed noticeably. Although she continued to make frequent visits to Europe, after the deaths of Hörke Wachtmeister in 1976 and Salka Viertel two years later, she was as likely to venture with new friends to South America and made regular visits to the Caribbean with her niece, Gray Reisfield. Finally old age caught up with Garbo. In her last years, New York was home, and for as long as possible she walked the streets observing the citizens of her adopted city, as she had for more than four decades. Pedestrians still gawked when she passed by, and one photographer, Ted Leyson, haunted her final years with his intrusive camera. Yes, a few bucks still could be made delivering to the tabloids an image of this elderly woman who really did just want to be left alone.

Garbo died on Easter Sunday, April 1990. The next day the world's papers carried news of her death and, of course, her photograph. The *New York Post* and *Daily News* both gave her the entire front page, using images that had been taken at MGM in the 1930s. Forty-nine years had lapsed since a theater marquee in Times Square or in downtown Los Angeles had announced a new Garbo film. Leyson's cruel photographs taken days before her death were also published. She remained, even at her death, Hollywood's greatest movie star, and, however unwillingly, a late-twentieth-century celebrity. Garbo had spent most of her life trying to live outside of the public eye, but she was never successful. As her health failed, she was not even accorded the privilege of being allowed to spend her last days privately, with the dignity accorded most of us. The camera that had made her a star, then a legend, and finally a myth never left her alone.

What is Garbo's legacy in the twenty-first century? She was the perfect product of the Hollywood studio system. In the MGM cocoon, her image was refined,

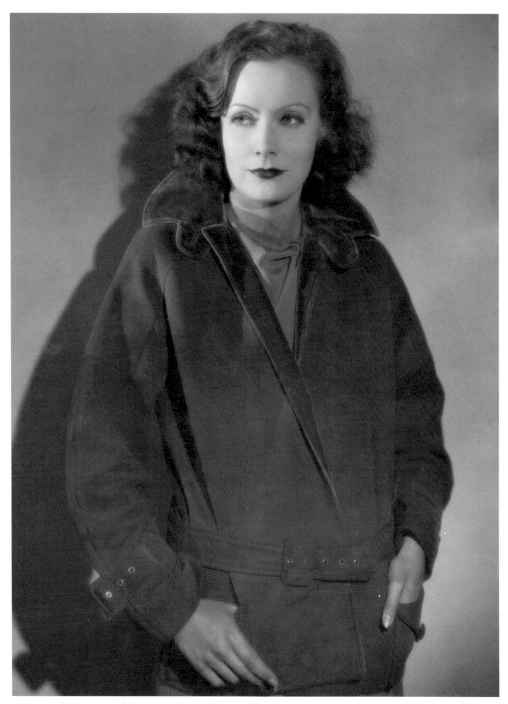

Garbo quickly became a fashion icon whose style was widely imitated. Couturier Adrian, one of Hollywood's greatest fashion figures, worked with Garbo for the first time in *A Woman of Affairs*, and he designed a series of smart outfits that supported her modern image. Photograph by Ruth Harriet Louise (1928).

her career flourished, and she rose to become the most thrilling of all motion picture stars. Garbo plotted a unique course for herself as she assumed greater control of her work, and by the late 1920s she dictated the terms over virtually every aspect of her films: scripts, cast, directors, writers, and cinematographers. She made a tremendous amount of money for MGM, and while she was working, Garbo was the highest-paid performer in Hollywood. In fact, with the exception of Louis B. Mayer and a few other industry moguls, hers was the highest salary in the movie business. Cole Porter underscored Garbo's financial preeminence in a lyric from the song *You're the Top*, from his 1934 musical *Anything Goes*, when he wrote: "You're the Top . . . You're Garbo's salary." Rising to the pinnacle of her industry, Garbo was undeterred by the traditional male-dominated Hollywood game. Katharine Hepburn parroted Garbo in style and dress but never had the income or control over her films, although she managed to convince us that she was Hollywood's original independent. Garbo's beauty might be argued, but it doesn't much matter today, as classical beauty has little clout in Hollywood. Still, regardless of what one thinks, her face is enshrined among the monuments of the last century, and many Garbo photographic portraits are considered signal works of art. Few dispute her abilities as an actress, and there is a strong consensus that her performance in *Camille* might be Hollywood's finest ever. No actor before or since has had such a magical relationship with the camera, moving or still. Garbo redefined the screen image of women. All of her characters had ambivalent relationships with men. Romance might have been the main course, but it was served on her own terms. She was rarely married in her films, and if so, typically unhappily. On screen and off, she had complete sexual self-determination. Garbo the actress and Garbo the woman both influenced fashion in profound ways. Arguably, she had more influence over the last century upon the way women look, how they dress and wear their hair, than any other person.

Look around today, Garbo is everywhere.

ACKNOWLEDGMENTS

Jonas Kasteng shared with me his remarkable correspondence between Garbo and Robert Reud and graciously allowed me to reproduce the photograph in his collection signed by Garbo to Reud.

Scott Reisfield, Garbo's great nephew and coauthor of *Garbo: Portraits from Her Private Collection*, made family documents available, corrected my errors, and provided photographs.

Simon Crocker, chair emeritus of the John Kobal Foundation, assisted in many ways and allowed me to make new prints from many of the negatives in the foundation's collection. Thanks as well to Liz Jobey and Michael Mack, cochairs of the foundation, and to trustee Terence Pepper.

While this book was under way, the photographic archive of the John Kobal Foundation was acquired by the Hood Museum of Art at Dartmouth College. John Stomberg, the museum's director, and Kathy Hart, curator, aided this project and allowed me access to the rich photo collection.

Barbara Dau and Larry Nichols alerted me to the mosaics by Boris Anrep in the National Gallery in London.

Over the years many friends have shared Garbo stories and sightings, and I thank especially Janice Oresman and Tim Wallach, and the late Johnny Nicholson and Babs Simpson.

The late Karen Sinsheimer, former curator of photography at the Santa Barbara Museum of Art, was my curatorial partner on several exhibitions devoted to the art of Hollywood photography, including *Garbo: Portraits from Her Private Collection*.

Bruce Robertson and I collaborated on *Ruth Harriet Louise and Hollywood Glamour Photography*, and, good-naturedly, he is always ready to assist my later forays into motion picture history.

Prudence Crowther read the manuscript and made suggestions as to how the book could be better.

Robert Loper read this book at every stage and has my gratitude for his keen observations that improved both content and style.

NOTES

CHAPTER ONE

1. In 1925 Famous Players-Lasky set up an acting school at the Astoria Studios in New York. The venture was not considered a success and closed after a year. During the 1930s most of the top Hollywood studios set up some sort of program to nurture new talent.
2. Louise Brooks, *Lulu in Hollywood* (New York: Knopf, 1982), 88.
3. "A Swedish Enchantress," *Picture-Play*, August 1926, p. 55.

CHAPTER TWO

1. *Motion Picture News* 16, no. 11, 1766.
2. An early indication of the influence of movie stars in popular culture is seen in the 1917 short film *All Star Production of Patriotic Episodes for the Second Liberty Loan*, in which President Woodrow Wilson is joined by Mary Pickford, Douglas Fairbanks, William S. Hart, and others to promote the sale of war bonds. The film is available on YouTube.
3. Charles Chaplin, *My Autobiography* (New York: Simon & Schuster, 1964), 215.
4. William J. Mann, *Tinseltown: Murder, Morphine, and Madness at the Dawn of Hollywood* (New York: Harper's, 2014); Sidney D. Kirkpatrick, *A Cast of Killers* (New York: Dutton, 1986); Bruce Long's tribute to Taylor, and the circumstances around his murder, may be found at www.taylorology.com.

CHAPTER THREE

1. Sven Broman, *Conversations with Garbo* (New York: Viking, 1992), 37.
2. Henry Albert Phillips, "Greta Garbo—Home-Town Girl," *Screenland*, March 1935, pp. 22–23, 78–79. Phillips recounts his journey to Sweden in quest of the barber shop where Garbo worked as a girl. The locals told him the barber was Mr. (Arthur F.) Ekengren, now retired. Phillips met a woman, Märtha Thörrnland, who claimed to have worked with Garbo. It is an attractive story about this moment in Garbo's childhood, and parts are probably true.
3. Robert Payne, *The Great Garbo* (New York: Praeger, 1976), 43.
4. Alexander Walker, *Garbo* (New York: Macmillan, 1980), 183.
5. Walker, *Garbo*, 183.
6. To view the film, go to www.Filmarkivet.Se, *Sverige och svenska industrier*.
7. The Swedish Film Database does not list Garbo in either film.
8. John Bainbridge, *Garbo* (Garden City, NY: Doubleday, 1955), 35.
9. Fritiof Billquist, *Garbo* (New York: G. P. Putnam's Sons, 1960), 31. The cost of the film is reported to be 15,000 Swedish crowns.
10. Ruth Biery, "The Story of Greta Garbo," *Photoplay*, April 1928, p. 78.

11. Karen Swenson, *Greta Garbo: A Life Apart* (New York: Scribner's, 1997), 47.

12. Bainbridge, *Garbo*, 38.

13. Frederick Sands and Sven Broman, *The Divine Garbo* (New York: Grosset & Dunlap, 1979), 47.

14. Barry Paris, *Garbo: A Biography* (New York: Knopf, 1995), 82.

15. Sven Hugo Borg, *The Private Life of Greta Garbo* (London: Amalgamated Press, Ltd., 1933) (supplement to *Film Pictorial*; digitized by www.greta-garbo.de). The *Film Pictorial* date is January 13, 1934.

16. Sands and Broman, *Divine Garbo*, 49.

17. Bainbridge, *Garbo*, 50.

18. Billquist, *Garbo*, 61.

19. Billquist, *Garbo*, 63.

20. Irene Mayer Selznick, *A Private View* (New York: Knopf, 1983), 60.

21. Åke Sundborg, "That Gustafsson Girl, Part 2," *Photoplay*, May 1930, p. 42.

22. Paris, *Garbo*, 83.

23. Bainbridge, *Garbo*, 65.

24. Billquist, *Garbo*, 70.

25. Swenson, *Greta Garbo*, 78.

26. A copy of the original contract is in the collection of Scott Reisfield.

27. According to the Swedish Line's passenger list for June 26, 1925, Stiller and Garbo traveled in "Cabin Class" and are listed under "Tillägg," which translates as "addition" or late booking.

28. Letter from Garbo to Mimi Pollak dated March 9, 1925, courtesy Scott Reisfield.

CHAPTER FOUR

1. Kaj Gynt appeared in Metro Pictures' *The Eternal Mother* (1917), starring Ethel Barrymore.

2. Hubert Voight as told to Gurdi Haworth, "I Loved Garbo," *New Movie*, February 1934, pp. 30–31, 87–90.

3. Faith Service (Gladys Hall), "Greta Garbo: Find," *Movie Magazine*, September 1925, pp. 15, 90–91.

4. W. Adolphe Roberts, *Motion Picture*, November 1925, p. 53.

5. Walker (*Garbo*, 35) describes the expenses incurred by Garbo and Stiller on their journey from Sweden to Hollywood, and how these costs were allocated to each when contracts were signed.

6. Arnold Genthe, *As I Remember* (New York: Reynal & Hitchcock, 1936), 165–68.

7. "A Swedish beauty named Gretta [*sic*] Garbo arrived with her manager the other day, was met by a populace waving banners and cheering and conducted to the Biltmore where a reception was tendered her." *Moving Picture Stories*, October 20, 1925, p. 8.

8. Billquist, *Garbo*, 96.

9. Reported in "Murray's Column," *Exhibitors Herald*, October 24, 1925, p. 68.

10. "William Daniels," in Charles Higham, *Hollywood Cameramen* (Bloomington: Indiana University Press, 1970), 67.

11. Charles Affron, *Lillian Gish: Her Legend, Her Life* (New York: Scribner, 2001, 204–5).

12. Paris, *Garbo*, 93.

13. Contract between Famous Players-Lasky and Metro-Goldwyn-Mayer, dated November 11, 1925. This contract was formerly offered for sale by Houle Rare Books & Autographs, Palm Springs, California.

14. Sven-Hugo Borg, "Garbo's Untold Story," *Screen Play*, September 1933 (reprinted in Peter Haining, *The Legend of Garbo* [London: W. H. Allen, 1990], 103).

15. Marguerite Tazelaar, "The Garbo as Seen by Her Cameraman," *Queenslander*, July 25, 1935, p. 3.

16. Ruth Beiry, "The Story of Greta Garbo, Chapter III," *Photoplay*, June 1928, p. 65.

17. Review of Ibañez's *Torrent*, *Motion Picture*, May 1926, p. 65.

18. Mordaunt Hall, *New York Times*, February 28, 1926, p. 4.

19. Walker, *Garbo*, 41.

20. *Variety*, January 27, 1926, p. 28.

21. Original negatives, dated, at the John Kobal Foundation, London.

22. Teet Carl, "The Young Swedish Girl Was Scared," *Hollywood Studio Magazine*, November 1971, p. 10.

23. Carl, "Young Swedish Girl Was Scared," 10.

24. "Gossip of the Camera Coasts," *Motion Picture*, July 1926, p. 74.

25. Mordaunt Hall, *New York Times*, February 28, 1926, p. 4.

26. "Chatter from Hollywood," *Screenland*, July 1926, p. 86.

27. "Chatter from Hollywood," p. 86.

28. In a negative dated April 24, 1926, and numbered MGM-774 in the Kobal Foundation archive, Stiller is shown on location with his crew working on *The Temptress*.

29. *Moving Picture World*, May 22, 1926.

30. Walker, *Garbo*, 54.

31. Reproduced in Norman Zierold, *Garbo* (New York: Stein and Day, 1969), pl. 6.

32. Mordaunt Hall, *New York Times*, October 11, 1926, p. 18.

33. Borg, "Garbo's Untold Story," in *Private Life of Greta Garbo* by Borg, supplement to *Film Pictorial*, January 13, 1934.

34. Rilla Page Palmborg, "The Mysterious Stranger," *Motion Picture*, May 1926, p. 76.

35. Frederica Sagor, interview with the author, New York, May 2000.

36. Kevin Brownlow, *The Parade's Gone By . . .* (New York: Knopf, 1968), 146.

37. Interview with Boardman in David Gill and Kevin Brownlow, *Hollywood*, season 1, episode 12, "Star Treatment," first aired March 26, 1980, Thames Television.

38. Letter quotation courtesy collection of Scott Reisfield.

39. *Film Daily*, September 2, 1926, p. 10; *Moving Picture World*, September 4, 1926, p. 36.

40. Edmund Goulding was set to direct, and Garbo's costar was to have been Pat O'Malley, according to a mention in *Exhibitors Herald*, November 13, 1926, p. 34.

41. "Gilbert-Garbo in Studio Tilt with MGM," *Film Mercury*, November 12, 1926, p. 3.

42. Paris, *Garbo*, 126.

43. "Records Are Smashed," *Hollywood Topics*, week ending Saturday, February 12, 1927, p. 3.

44. Helen Unity Hunter, "Society," *Hollywood Topics*, week ending Saturday, February 12, 1927, p. 12.

45. *Hollywood Topics*, week ending Saturday, February 12, 1927.

46. Borg, "Garbo's Untold Story," pp. 122–23.

47. Walker, *Garbo*, 68.

48. Released in 1927 under the title *Adam and Evil*, costarring Lew Cody and Aileen Pringle.

49. Ruth Biery, "The Story of Greta Garbo, Chapter III," *Photoplay*, June 1928, p. 145.

50. Pauline Hammer, "Little Studio Journey, *Hollywood Topics*, week ending Saturday, January 29, 1927, p. 26.

51. "Garbo Refuses to Sign 5 Year Pact with Metro-Goldwyn," *Exhibitors Herald*, February 26, 1927, p. 10.

52. "New Blood in Motion Pictures," *Hollywood Vagabond*, February 17, 1927, p. 3.

53. Fred W. Fox, "Making and Breaking Contracts," *Hollywood Vagabond*, April 28, 1927, p. 4.

54. "News of the Camera Coasts," *Motion Picture*, June 1927, p. 67.

55. Dorothy Calhoun, "They Learned about Women from Her," *Motion Picture Classic*, August 1927, pp. 36, 80.

56. Eugene Nifford, "I Gave Garbo Her First Chance on Film," *Motion Picture Monthly*, May 1937 (reprinted in Haining, *Legend of Garbo*, 77–83).

57. King Vidor, *A Tree Is a Tree* (Hollywood: Samuel French, 1981), 136–37.

58. Vidor, *Tree Is a Tree*, 64.

59. Matthew Kennedy, *Edmund Goulding's Dark Victory* (Madison: University of Wisconsin Press, 2004), 67.

60. Mordaunt Hall, "Greta Garbo's Intelligent Acting," *New York Times*, December 4, 1927, p. 7.

61. "White Washing the Payers," *Film Mercury*, July 29, 1927, p. 9.

62. "Exhibitors Misled on Cost of Pictures," *Film Spectator*, October 29, 1927, p. 5.

63. Paris, *Garbo*, 569. Paris, in his filmography, lists the cost and profit/loss for each of Garbo's American films.

64. Margaret Chute, "Hollywood's Girl Photographer," *Modern*, August 4, 1928, p. 806.

65. *Screenland*, March 1928, p. 45.

66. "Can't Get Away with a Fool for a Heroine," *Film Spectator*, June 9, 1928, pp. 8–9.

67. Mordaunt Hall, "Review of 'The Divine Woman,'" *New York Times*, January 22, 1928, p. 7.

68. Passenger list as reported in *New York Times*, December 9, 1928.

69. Martin Martin, "What Size Glory," *Screenland*, January 1928, p. 48.

70. Swenson, *Greta Garbo*, 166.

71. Lawrence Reid, "The Mysterious Lady," *Motion Picture News*, August 11, 1928, p. 477.

72. *Film Daily*, August 12, 1928, p. 6

73. *Motion Picture News*, August 4, 1928, p. 341.

74. *Motion Picture News*, October 27, 1928, p. 1267.

75. "Harry Rapf Sees Sound as Advance in Entertainment," *Exhibitors Daily Review*, August 10, 1928, p. 3.

76. "39 Sound-Talkie Features . . . ," *Exhibitors Daily Review*, September 12, 1928, p. 1.

77. "Use Made of Television in Talking Short," *Motion Picture News*, November 3, 1928.

78. Edward Steichen, *A Life in Photography* (Garden City: Doubleday, 1963), ch. 8, n.p.

79. "A Woman of Affairs," *Variety*, January 23, 1929, p. 18.

80. Earl J. Hudson, "A Woman of Affairs," *Motion Picture News*, November 3, 1928, p. 1338.

81. Margaret Reid, Greta—As She Is," *Picture Play*, December 1928, pp. 74, 112.

82. Mette Hjort and Ursula Lundquist, *A Companion to Nordic Cinema* (Wiley-Blackwell, 2016), 400.

83. Victor Seastrom, "The Man Who Found Garbo," in *Legend of Garbo* by Haining, 92.

84. Seastrom, "Man Who Found Garbo," 92.

85. *Jewish Daily Bulletin*, November 18, 1928, p. 3.

86. Rilla Page Palmborg, *The Private Life of Greta Garbo* (Garden City, NY: Country Life Press, 1931), 78.

87. Letter from Joseph Buhler to Garbo dated March 7, 1929. This letter is part of an extensive collection of correspondence between Robert Reud and Garbo in the collection of Jonas Kasteng.

88. Palmborg, *Private Life of Greta Garbo*, 81.

89. Swenson, *Greta Garbo* (184–89), describes Garbo's return to Sweden.

90. Broman, *Conversations with Greta Garbo*, 64.

91. Broman, *Conversations with Greta Garbo*, 189.

92. Bainbridge, *Garbo*, 132.

93. *Variety*, December 18, 1928, p. 5.

94. "Joseph Kennedy and Schenck Contested Gilbert Contract," *Exhibitors Daily Review*, September 8, 1928, p. 2.

95. "Joan Crawford to Be Starred," *Exhibitors Daily Review*, October 15, 1928, p. 3.

96. Palmborg, *Private Life of Greta Garbo*, 94.

97. Telegram from Harry Edington to Robert Reud dated March 17, 1929. Collection of Jonas Kasteng.

98. Voight, "I Loved Garbo," p. 31.

99. *New York Times*, May 10, 1929, p. 31.

100. "The Single Standard," *Variety*, July 31, 1929, p. 17.

101. Walker, *Garbo*, 184.

102. Among the earliest use of "Swedish Sphinx" to describe Garbo is Ralph Wheelright, "The Swedish Sphinx Speaks," *Screenland*, September 1929, pp. 45–46, 95. Later it was among the most common sobriquets used to describe Garbo.

103. Clarence Sinclair Bull and Raymond Lee, *The Faces of Hollywood* (South Brunswick, NJ: A. S. Barnes, 1968), 23.

104. Allan Jordan, "Photographing Garbo," *Movie Mirror*, July 1932, pp. 46–47, 100–101.

105. John Kobal identified another Garbo double known only by her first name, "Chris." He includes her portrait taken by Clarence Sinclair Bull in his book with Terence Pepper, *The Man Who Shot Garbo* (New York: Simon & Schuster, 1984), pl. 82.

106. Lois Shirley, "The Girl Who Played Greta Garbo," *Photoplay*, August 1929, pp. 29, 108.

107. Paul Gallico, *The Revealing Eye* (New York: Atheneum, 1967), pp. xix–xx.

108. *Variety*, October 9, 1929, p. 41.

109. Frederick James Smith, "What to Expect in 1930," *New Movie Magazine*, February 1930, p. 51.

CHAPTER FIVE

1. Charles Bickford, *Bulls, Balls, Bicycles and Actors* (New York: Eriksson, 1965), 239.

2. Bickford, *Bulls, Balls, Bicycles and Actors*, 252.

3. Bickford, *Bulls, Balls, Bicycles and Actors*, 252.

4. "Fox Buys Loew's-MGM; Assets Now 230 Million; Industry's Largest Deal," *Exhibitors Herald-World*, March 9, 1929, p. 17.

5. "Chase and Others Buy 660,900 Loew Shares," *Motion Picture Herald*, December 23, 1933, p. 39.

6. Wilhelm Sörensen, "The Day That Garbo Dreaded," reprinted in Haining, *Legend of Garbo*, 145.

7. "Anna Christie," *Film Daily*, February 9, 1930, p. 12.

8. Robert Herring, "London Looke Backe," *Close Up*, June 1930, p. 462.

9. Palmborg, *Private Life of Greta Garbo*, 119–20.

10. Palmborg, *Private Life of Greta Garbo*, 240.

11. Palmborg, *Private Life of Greta Garbo*; Parson, *Los Angeles Examiner*, February 16, 1930, quoted in Swenson, *Greta Garbo*, 226.

12. Palmborg, *Private Life of Greta Garbo*, 241.

13. Rilla Page Palmborg, "Greta Garbo Goes Home," *Motion Picture Classic*, February 1929, p. 21.

14. Palmborg, "Greta Garbo Goes Home," 208.

15. Sörenson's article for the *Sunday Express*, June 5, 1955, is reprinted in Haining, *Legend of Garbo*, 139–45.

16. Rilla Page Palmborg, "The Man Who Tried to Elope with Garbo," *Photoplay*, September 1931, pp. 33, 114–15.

17. Palmborg, *Private Life of Greta Garbo*, 131.

18. Palmborg, *Private Life of Greta Garbo*, 271; speaking with the press in New York on May 4, 1936, as she returned from Stockholm, Garbo told reporters, "I will not speak on the radio" (*New York Times*, May 4, 1936, p. 9).

19. Cecil Beaton as told to Rose Reilly, "Fantastic Hollywood," *Screenland*, May 1931, p. 128.

20. Hugo Vickers, *Cecil Beaton: A Biography* (New York: Donald I. Fine, 1985), 130.

21. Vickers, *Cecil Beaton*, 131.

22. Phil M. Daly, "Along the Rialto," *Film Daily*, March 1, 1931, p. 3.

23. Palmborg, *Private Life of Greta Garbo*, 228.

24. Palmborg, *Private Life of Greta Garbo*, 230.

25. Palmborg, *Private Life of Greta Garbo*, 233.

26. Palmborg, *Private Life of Greta Garbo*, 235.

27. John Loder, "A Year in the Life of Garbo," *Film Weekly*, March 25, 1932, reprinted in Haining, *Legend of Garbo*, 146–53.

28. Palmborg, *Private Life of Greta Garbo*, 194.

29. "News and Gossip of the Studios," *Motion Picture*, September 1931, p. 94.

30. Palmborg, *Private Life of Greta Garbo*, 241.

31. Salka Viertel, *The Kindness of Strangers* (New York: New York Review of Books, 2019), 142; originally published New York: Holt, Rinehart & Winston, 1969.

32. Ronald Bergan, *Sergei Eisenstein: A Life in Conflict* (Woodstock, NY: Overlook Press, 1999), 196.

33. "Cal York's Monthly Broadcast from Hollywood," *Photoplay*, December 1931, p. 92.

34. Palmborg, *Private Life of Greta Garbo*, 257.

35. Palmborg, *Private Life of Greta Garbo*, 267.

36. Dorothy Calhoun, "You Worship the Stars, but Hollywood Says 'Oh Yeah?,'" *Motion Picture*, August 1931, p. 53.

37. Palmborg, *Private Life of Greta Garbo*, 253.

38. Adela Rogers St. Johns, "The Heart of Greta Garbo," *New Movie Magazine*, July 1930, pp. 82–84, 106, 108.

39. *Variety*, April 26, 1930, p. 24.

40. "Romance," *Variety*, July 26, 1930, p. 4.

41. Helen Louise Walker, "Dressing Glamorous Garbo," *Movie Mirror*, April 1932, p. 26.

42. "Romance," *Inside Facts of Stage and Screen*, July 26, 1930, p. 4.

43. "Romance," *Modern Screen*, November 1930, p. 83.

44. Leonard Hall, "Garbo-Maniacs," *Photoplay*, January 1930, p. 60.

45. Whitney Stine, *The Hurrell Style* (New York: John Day, 1976), 16.

46. Stine, *Hurrell Style*, 20.

47. Stine, *Hurrell Style*, 20.

48. *Exhibitors Herald-World*, June 7, 1930, p. 78.

49. "The Hole in the Wall," *Photoplay*, April 1931, 134.

50. "Building up the Mystery Woman," *Film Daily*, October 25, 1930, p. 3.

51. Palmborg, *Private Life of Greta Garbo*, 275.

52. Katherine Brown, "Did Brown and Garbo Fight?" *Photoplay*, March 1931, p. 33.

53. Brown, "Did Brown and Garbo Fight?".

54. Gwenda Young, *Clarence Brown: Hollywood's Forgotten Master* (Lexington: University Press of Kentucky, 2018), 120.

55. "Garbo Draws Top Figure . . . ," *Inside Facts of Stage and Screen*, February 21, 1931, p. 3.

56. "Inspiration," *Film Daily*, February 8, 1931, p. 10.

57. Ruth Waterbury, "What Is This "Box Office?" *Photoplay*, February 1931, p. 69.

58. "Inspiration," *Bioscope*, February 18, 1931, p. 35.

59. Elinor Hughes, *Famous Stars of Filmdom* (Boston: L. C. Page, 1931), pp. 201–21.

60. Correspondence in the Robert Reud archive offers evidence that he was serving as in intermediary in an attempt to arrange a Garbo-Reinhardt collaboration. Collection of Jonas Kasteng.

61. Jack Jamison, "Five Little Stories of Garbo," *Movie Mirror*, October 1932, p. 18.

62. Waterbury, "What Is This "Box Office?," 68.

63. *Silver Screen*, April 1931, p. 19.

64. Another example is found in Ellery Queen's novel *Four of Hearts* (New York: Lippincott, 1938): "Hasn't been done since Garbo gave her last interview to *Screen Squeejees*," said the agent gleefully. "Telling Butch where he gets off! Now we're getting somewhere."

65. Viertel, *Kindness of Strangers*, 146.

66. "F. W. Murnau Killed in Coast Auto Crash," *New York Times*, March 12, 1931, p. 32.

67. Lotte Eisner, *F. W.Murnau* (Berkeley: University of California Press, 1973), 222.

68. *Film Daily*, April 19, 1931, p. 4.

69. Warren G. Harris, *Clark Gable* (New York: Harmony Books, 2002), 77.

70. "Susan Lenox, Her Fall and Rise," *Film Daily*, October 18, 1931, p. 10.

71. Mordaunt Hall, "Trouble, Trouble, Trouble," *New York Times*, October 17, 1931, p. 20.

72. "Sterns Made Deal with Magazine to Distribute Photos," *Motion Picture News*, December 19, 1931, 66.

73. Mercedes de Acosta, *Here Lies the Heart* (New York: Reynal, 1960).

74. De Acosta, *Here Lies the Heart*, 214.

75. De Acosta, *Here Lies the Heart*, 217.

76. De Acosta, *Here Lies the Heart*, 219.

77. De Acosta, *Here Lies the Heart*, 222.

78. Cal York, *Photoplay*, December 1931, p. 34.

79. Allan R. Ellenberger, *Ramon Novarro* (Jefferson, NC: McFarland, 1999), 112.

80. Ralph Wheelright, "When Nordic Met Latin," *Photoplay*, February 1932, p. 102.

81. Wheelright, "When Nordic Met Latin," 102.

82. "The Story of Greta Garbo in 'Mata Hari,' with Ramon Novarro, told in Pictures," *Screenland*, March 1932, pp. 34–50.

83. "News and Gossip," *Motion Picture*, May 1932, 36.

84. Dorothy Manners, writing in *Motion Picture* (March 1932, p. 44), titillated readers with an article titled, "Has Novarro Fallen in Love with Garbo?—and Did Garbo Fall in Love with Novarro?" but she had the good grace to conclude that they were only good friends.

85. Katherine Albert, "How Garbo's Fear of People Started," *Photoplay*, March 1932, p. 28.

86. Ruth Biery, "Hollywood's Cruelty to Greta Garbo," *Photoplay*, January 1932, p. 29.

87. Walker, *Garbo*, 124.

88. Ruth Biery, "The Lion Tamer," *Photoplay*, July 1932, p. 32.

89. Swenson, *Greta Garbo*, 270 (*Picturegoer Weekly*, June 18, 1932).

90. "Cal York's Monthly Broadcast from Hollywood," *Photoplay*, November 1932, p. 94.

91. Gene Fowler, *Good Night, Sweet Prince* (New York: Viking, 1944), 340.

92. Alma Power-Waters, *John Barrymore: The Legend and the Man* (New York: Julian Messner, 1941), 180.

93. The photo in its entirety is produced in Walker, *Garbo*, 125.

94. A photograph of Garbo and Barrymore on the set of *Grand Hotel* with the blindstamp of Clarence Sinclair Bull was offered at Heritage Auctions, Dallas, Texas, on February 17, 2019, sale 161907, lot 53163. It is possible that the short session Garbo and Barrymore had with Bull on the set was in lieu of a formal portrait session as was typical at each film's conclusion.

95. Melvyn Douglas and Tom Arthur, *The Autobiography of Melvyn Douglas* (New York: University Press of America, 1986), 88.

96. "Garbo Is Actually a Remarkable Person," *Philadelphia Inquirer*, July 3, 1932. An abbreviated version of this newspaper article published in the *Cincinnati Enquirer*, October 30, 1932, attributes the quotes to Georg Wilhelm Pabst.

97. *Film Daily*, June 3, 1932, p. 1.

98. Mordaunt Hall, "The Screen: Miss Garbo's Last Film," *New York Times*, June 3, 1932, p. 32.

99. "Hollywood Bandwagon," *New Movie Magazine*, September 1932, p. 74.

100. *Film Daily*, June 30, 1932, p. 2.

101. "Another Bank Blows," *Variety*, June 7, 1932, p. 3.

102. De Acosta, *Here Lies the Heart*, 235.

103. De Acosta, *Here Lies the Heart*, 235.

104. "To Hell with Depression," *Motion Picture Herald*, June 4, 1932, pp. 12–13.

105. Walker, *Garbo*, 132.

106. Walker, *Garbo*, 132.

107. "Was the Great Greta Garbo a Visitor Here Yesterday?" *Bronxville Press*, July 26, 1932, p. 1.

108. "Greta Garbo Visits Her Lawyer," *New York Times*, July 30, 1932.

109. Greta Garbo to Salka Viertel, telegram dated July 28, 1932 (Greenwich, Conn.), part of the collection of sixty-five letters from Garbo to Viertel offered Swann Galleries, October 10, 2019, sale 2519, lot 38.

110. Dorothy Calhoun, "The Inside Story of Garbo's Great Success!" *Motion Picture*, June 1932, p. 81.

CHAPTER SIX

1. Joel W. Findler, *The Hollywood Story* (New York: Crown, 1988), 286–87.

2. "A Bill of Divorcement," *Photoplay*, November 1932, p. 56.

3. Viertel, *Kindness of Strangers*, 173.

4. Viertel, *Kindness of Strangers*, 173.

5. Viertel, *Kindness of Strangers*, 174.

6. De Acosta, *Here Lies the Heart*, 251.

7. Vickers, *Cecil Beaton*, 159.

8. De Acosta, *Here Lies the Heart*, 240.

9. Vickers, *Loving Garbo* (New York: Random House, 1994), 58–61.

10. Label on the back of an Associated Press photo of Garbo and her brother dated Aug. 20, 1932 (author's collection).

11. Billquist, *Garbo*, p. 192.

12. International News Services, "Garbo, Disguised by Black Wig and Dark Glasses, Visits London without Discovery," *Houston Chronicle*, November 13, 1932.

13. Roly Young—The Show Shop, "Garbo Visits London Incognito," *Toronto Star Weekly*, November 13, 1932.

14. Swenson, *Greta Garbo*, 291.

15. Billquist, *Garbo*, 199.

16. "Garbo Pursued as Black Wig Disguise Fails," *Syracuse Herald*, November 20, 1932.

17. Billquist, *Garbo*, 195.

18. Walker, *Garbo*, 133.

19. Letter from Garbo to Salka Viertel dated (Stockholm) December 31, 1932, Swann Galleries, October 10, 2019, sale 2519, lot 38.

20. "Hollywood Day by Day," *New Movie Magazine*, August 1933, p. 7.

21. "Garbo's Romance on Shipboard," *Movie Mirror*, July 1933, 32.

22. *Variety*, April 11, 1933.

23. Letter from Garbo to Salka Viertel dated (Stockholm) December 31, 1932, Swann Galleries, October 10, 2019, sale 2519, lot 38.
24. "Garbo's Romance on Shipboard," p. 33.
25. *Variety*, May 9, 1933, p. 58.
26. "Hollywood Day by Day," *Movie Mirror*, August 1933. p. 7.

CHAPTER SEVEN

1. "Our Boulevardier," *New Movie Magazine*, July 1933, p. 94. Signaling the end of Prohibition, on March 22, 1933, President Roosevelt amended the Volstead Act to allow the manufacture and sale of beer. Full repeal came on December 5.
2. *Variety*, May 23, 1933, p. 2.
3. Allan Jordan, "The Man behind Garbo," *Movie Mirror*, September 1932, p. 30.
4. *Variety*, April 25, 1933, p. 2.
5. "Garbo in New York This Week," *Hollywood Reporter*, March 9, 1933.
6. Walker, *Garbo*, 133.
7. *Hollywood Reporter*, May 4, 1933.
8. "Garbo, She Stay Home," *Variety*, May 9, 1933.
9. Walker, *Garbo*, 133.
10. *Hollywood Reporter*, May 16, 1933, p. 1.
11. *Hollywood Reporter*, May 12, 1933, p. 2.
12. *Hollywood Reporter*, May 23, 1933, p. 2.
13. *Hollywood Reporter*, June 2, 1933.
14. Butterfield's, May 10, 2001, Sale 7231, lot number 3124; typed letter signed by Greta Garbo, dated August 2, 1933, on MGM letterhead.
15. Walker, *Garbo*, 134.
16. *The Dick Cavett Show*, season 7, episode 53, original air date January 24, 1973, ABC.
17. Gloria Swanson, *Swanson on Swanson* (New York: Random House, 1990), 427.
18. Gladys Hall, "John Gilbert's Confession," *Modern Screen*, November 1933, p. 114.
19. Hall, "John Gilbert's Confession," p. 14.
20. Walker, *Garbo*, 134.
21. Eve Golden, *John Gilbert* (Lexington: University Press of Kentucky, 2013), 252.
22. "The Screen," *New York Times*, December 27, 1933, p. 23.
23. Paul Rotha, *Cinema Quarterly* 2, no. 3 (Spring 1934): 185.
24. "Berlin Communique," *New York Times*, August 4, 1935.
25. Kirtley Baskette, "Guessing Time for Garbo, *Photoplay*, September 1934, p. 86.
26. Nemo, "Hollywood Day by Day," *New Movie Magazine*, October 1933, 56–57, 68.
27. Jimmy Hazlewood, "Kiddies," *Hollywood Filmograph*, May 20, 1933, p. 7.
28. Golden, *John Gilbert*, 271.
29. "The Low Down," *Hollywood Reporter*, September 8, 1933.
30. De Acosta, *Here Lies the Heart*, pp. 254–55.
31. *Hollywood Reporter*, January 24, 1934.
32. Swenson, *Greta Garbo*, 318.
33. Swenson, *Greta Garbo*, 318.
34. The *Hollywood Reporter* announced on January 3, 1934, that Mamoulian was under consideration to direct *The Painted Veil*. *Motion Picture Daily* reported on March 16, 1934, that the studio had cooled on the idea.
35. Helen Quinn, "Not That It Matters," *Hollywood Reporter*, June 8, 1934, 3.
36. "Goldwyn Salary Figures Start Hollyw'd Buzzing," *Hollywood Reporter*, February 14, 1934, p. 1.
37. Harold Weight, "Hollywood Lacks Real Fortune Tellers," *Hollywood Filmograph*, December 23, 1933, p. 29.
38. Viertel, *Kindness of Strangers*, p. 197.
39. "De Vinna off Again," *Hollywood Reporter*, May 29, 1934, p. 12.

40. Cal York, "Hollywood Goings-On!," *Photoplay*, August 1934, p. 39.

41. Thomas Doherty, *Hollywood's Censor: Joseph I. Breen & the Production Code Administration* (New York: Columbia University Press, 2007), 67.

42. Delia Ormiston, "WHAT ABOUT George Brent and Greta Garbo?," *Movie Mirror*, March 1935, p. 34.

43. Rosalind Shaffer, "Ssh! Brent Woos Garbo in Silence," *Omaha Herald*, November 25, 1934.

44. Otis Wiles, "What It's like to Work with Garbo," *Photoplay*, November 1934, p. 90.

45. Swenson, *Greta Garbo*, 329.

46. Delight Evans, "An Open Letter to G.G.," *Screenland*, February 1935, p. 3.

47. Andre Sennwald, "The Screen," *New York Times*, December 7, 1934.

48. "The Painted Veil," *Variety*, December 11, 1934, p. 19.

49. "Seen and Heard," *Hollywood Filmograph*, November 4, 1933, p. 2.

50. The letter is quoted in full in Swenson, *Greta Garbo*, 332–33.

51. Swenson, *Greta Garbo*, 334.

52. See "Garbo 'Steps Out' and Gasps Are Heard in Hollywood," *Newark Sunday Call*, January 27, 1935; "Who Snubbed Who, Is Puzzle," *Minneapolis Journal*, January 27, 1935.

53. Viertel, *Private Life*, 198.

54. "Anna Karenina," *Variety*, September 4, 1935, p. 14.

55. "Anna Karenina," *Photoplay*, September 1935, p. 69.

56. Andre Sennwall, "The Screen," *New York Times*, August 31, 1935.

57. Alistair Cooke, "Anna Karenina," *Garbo and the Night Watchman* (London: Jonathan Cape, 1937), 143.

58. "Greta Garbo's 1935 Salary," *Motion Picture Daily*, January 28, 1937.

59. "Critics Pay Honor to Film Favorites," *New York Times*, March 2, 1936.

60. "Mussolini Cup Goes to New Garbo Film," *New York Times*, September 8, 1935.

61. Adrian, "Adrian Answers 20 Questions on Garbo," *Photoplay*, September 1935, pp. 36–37, 76.

62. William Stull, "Garbo's Cameraman Talks at Last," *Hollywood*, October 1935, pp. 26–27, 72.

63. Gunilla Bjelke, "Garbo Talks for Publication," *Movie Classic*, October 1935, pp. 35, 77–79.

64. Letter from Garbo to Salka Viertel dated Tistad, 10th July, 1935, Swann, Galleries, October 10, 2019, sale 2519, lot 38.

65. Letter from Garbo to Salka Viertel, undated (late summer 1935), Swann, Galleries, October 10, 2019, sale 2519, lot 38.

66. De Acosta, *Here Lies the Heart*, 269.

67. De Acosta, *Here Lies the Heart*, 271.

68. De Acosta, *Here Lies the Heart*, 271.

69. Letter from Garbo to Salka Viertel, undated (Fall 1935?), Swann, Galleries, October 10, 2019, sale 2519, lot 38.

70. Letter from Garbo to Salka Viertel, undated (Fall 1935?), Swann, Galleries, October 10, 2019, sale 2519, lot 38.

71. Walker, *Garbo*, 148.

72. "Greta Garbo Back, a Bit Less Aloof," *New York Times*, May 4, 1936, p. 9.

73. Gavin Lambert, *On Cukor* (New York: Capricorn Books, 1973), 108.

74. Swenson, *Greta Garbo*, 352.

75. Lambert, *On Cukor*, 109.

76. Patrick McGilligan, *George Cukor: A Double Life* (New York: St. Martin's Press, 1991), 108.

77. Walker, *Garbo*, 50.

78. Jane Ellen Wayne, *Robert Taylor: The Man with the Perfect Face* (New York: St. Martin's Press, 1989), 52.

79. Broman, *Conversations with Greta Garbo*, 148.

80. Lambert, *On Cukor*, 93.

81. Swenson, *Greta Garbo*, 360.

82. Swenson, *Greta Garbo*, 360.

83. Broman, *Conversations with Greta Garbo*, 162.

84. Cal York, "Cal York's Gossip of Hollywood," *Photoplay*, February 1937, p. 27.

85. Broman, *Conversations with Greta Garbo*, 162.

86. "Garbo's Draw," *Hollywood Reporter*, August 6, 1936.

87. "On the Sets with the Stars," *Motion Picture*, November 1936, p. 66.

88. Jack Larson, "Outtakes of a Life," *Washington Post*, April 22, 1990.

89. Topper, "Camille," *Hollywood*, March 1937, p. 44.

90. "Camille," *Motion Picture Review Digest*, March 29, 1927, pp. 15–17.

91. Ida Zeitlin, "Garbo Is Still Queen," *Motion Picture*, August 1936, p. 37.

92. "A Modern Children's Crusade to Hollywood," *Film Daily*, November 19, 1937, p. 8.

93. Viertel, *Kindness of Strangers*, 214.

94. Viertel, *Kindness of Strangers*, 214.

95. Viertel, *Kindness of Strangers*, 215.

96. Norbert Lusk, "Soft and Sharp Focus," *Picture Play*, January 1938, p. 11.

97. C. A. Lejeune, "Marie Walewska," *World Film News*, April 1938, p. 34.

98. Ruth Waterbury, "Close Ups and Long Shots," *Photoplay*, January 1938, p. 9.

99. Richard Griffith, "No Awards for Garbo," *Picture Play*, March 1938, pp. 46–47, 72.

100. Swenson, *Greta Garbo*, 365, quoting, "Garbo a Different Girl, Studio Copper Declares," *New York Post*, October 30, 1937.

101. "Movie of the Week: Conquest," *Life*, November 8, 1937, pp. 40–41.

102. "What the Picture Did for Me," *Motion Picture Herald*, March 19, 1938, p. 57.

103. "What the Picture Did for Me," *Motion Picture Herald*, March 5, 1938, p. 52.

104. Glenn O'Brien and Lillian Gerard, "Anita Loos: Gentlemen Prefer Genius," *Interview*, July 1972.

105. Collection of Jonas Kasteng.

106. *Film Daily*, September 19, 1936, p. 4.

107. *Washington Post*, January 23, 1938.

108. "Stokowski Sails; Garbo Abroad, Too," *Philadelphia Inquirer*, February 6, 1938.

109. "Garbo, Stokowski Meet in Italy; Blissfully Happy; Wedding Seen," *San Francisco Call Bulletin*, March 1, 1938.

110. "Garbo, Stokowski Meet in Italy."

111. "Stokowski-Garbo Marriage Arrangements Disclosed," *Los Angeles Times*, March 6, 1938.

112. Bainbridge, *Garbo*, 193.

113. Bainbridge, *Garbo*, 198.

114. Collection of Jonas Kasteng.

115. "Greta Garbo, Stokowski Shaken as Car Overturns," *New York Times*, June 27, 1938, p. 19.

116. Broman, *Conversations with Greta Garbo*, 164.

117. "Regents' Unit Viewing Two Rejected Films," *Motion Picture Herald*, March 5, 1938, p. 22.

118. Chester B. Bahn, "Press Verdict . . . Clears the Stars," *Film Daily*, May 12, 1938, p. 1.

119. *Motion Picture Herald*, January 7, 1939, p. 34.

120. Ruth Waterbury, "Close Ups and Long Shots," *Photoplay*, December 1939, p. 14.

121. *Variety*, November 22, 1939.

122. Frank Nugent, "Ninotchka," *New York Times*, November 10, 1939.

123. "Ninotchka," *Variety*, October 11, 1939, p. 13.

124. James Dugan, "MGM Lays an Egg," *New Masses*, September 12, 1939, pp. 27–29.

125. "Lubitsch Skill Presents New Greta Garbo," *Box Office Digest*, October 9, 1939, p. 10.

126. Delight Evans, "Ninotchka," *Screenland*, January 1940, p. 53.

127. Swenson, *Greta Garbo*, 397.

128. Elizabeth Wilson, "Garbo in Love Again?," *Screenland*, November 1939, p. 25.

129. Wilson, "Garbo in Love Again?," p. 25

130. Hollis Alpert, "Saga of Greta Lovisa Gustafsson," *New York Times Magazine*, September 5, 1965, p. 51. Albert quotes Richard Griffith recalling Garbo's visit during late winter 1941 to the Museum of Modern Art accompanied by Gaylord Hauser and Erich Maria Remarque.

131. Duncan Underhill, "Garbo Goes on Forever," *Screen Book*, January 1940, p. 57.

132. Viertel, *Kindness of Strangers*, 242.

133. Viertel, *Kindness of Strangers*, 247.

134. The "old ladies," Garbo, Shearer and Crawford, might be screen queens with devoted legions of acolytes, but it was the new faces, Judy Garland, Lana Turner, Hedy Lamarr, and Greer Garson, among others, that were the most avidly promoted.

135. Howard Gutner, *Gowns by Adrian* (New York: Abrams, 2001), 101.

136. Hedda Hopper, *Los Angeles Times*, July 27, 1941, quoted in Gutner, *Gowns by Adrian*, 101.

137. Gutner, *Gowns by Adrian*, 101.

138. "Two-Faced Woman," *Variety*, October 22, 1941, p. 8.

139. "'Two-Faced Woman' Garbo Personality Puts Over Slim Farce," *Film Bulletin*, November 1, 1941, p. 4.

140. Delight Evans, "Two-Faced Woman," *Screenland*, January 1942, p. 52. Although the review appeared in the January 1942 issue, the film viewed was the original, unedited version.

141. HOTCHA GARBO DITTO AT B.O.," *Variety*, December 3, 1941, p. 3.

142. "Legion's Garbo Film Ban to be Cited in Churches," *Film Daily*, November 27, 1941, pp. 1, 7.

143. "Ban on 'Two-Faced Woman' Stirs National Attention to Standards," *Motion Picture Herald*, December 6, 1941, p. 13.

144. *Variety*, December 10, 1941, p. 7.

145. Bosley Crowther, "The Screen in Review" [*Two-Faced Woman*], *New York Times*, January 1, 1942, p. 37.

146. "Cinema: The New Pictures," *Time*, December 22, 1941.

147. Lambert, *On Cukor*, 156, 158.

148. "Not Only Alone, but Unique," *New York Times*, November 30, 1941, p. 5.

CHAPTER EIGHT

1. "Medicine: Garbo's Gayelord," *Time*, February 15, 1942.

2. Harry Evans, "Hollywood Diary," *Family Circle*, June 26, 1942, p. 10.

3. Hilton Tims, *Erich Maria Remarque: The Last Romantic* (London: Constable and Robinson, 2003), 126.

4. Tims, *Erich Maria Remarque*, 128.

5. *The Greta Garbo Collection*, Sotheby's, November 15, 1990.

6. Rita Reif, "Garbo's Collection and a van Gogh Are to Be Sold," *New York Times*, July 19, 1990.

7. Smithsonian Institution, Archives of American Art, Jacques Seligmann & Co. archive, box 185, folder 43.

8. Walker, *Garbo*, 165.

9. Viertel, *Kindness of Strangers*, 268.

10. Viertel, *Kindness of Strangers*, 268.

11. Viertel, *Kindness of Strangers*, 268.

12. Brownlow, *The Parade's Gone By . . .* , 147.

13. Swenson, *Greta Garbo*, 409.

14. Paris, *Garbo*, 371.

15. "George Hurrell," *International Photographer*, September 1941, p. 3; Robert D. Webster, "George Hurrell," *Bulletin of the Kenyon Country Historical Society*, November/December 2006, p. 3.

16. Swenson, *Greta Garbo*, 436.

17. Broman, *Conversations with Greta Garbo*, 197.

18. Cecil Beaton, *Cecil Beaton: Memoirs of the 40s* (New York: McGraw-Hill, 1972), 121.

19. Beaton, *Cecil Beaton*, 122.

20. "Garbo Is Going Home," *New York Times*, July 7, 1946, p. 29.

21. "Garbo Arrives Home," *New York Times*, July 18, 1946, p. 20.

22. "Greta Garbo Back, Not So Exclusive Now," *New York Times*, September 4, 1946, p. 20.

23. *Variety*, February 19, 1947, p. 18.

24. George Benjamin, "How Long Can You Stay Great?" *Modern Screen*, September 1948, p. 105.

25. Zierold, *Garbo*, 100.

26. Nathaniel Benchley, "This Is Garbo," *Collier's*, March 1, 1952, 15.

27. Benchley, "This Is Garbo," 15.

28. Lutz Bacher, "Captivated by Garbo: Max Ophuls' Roman Interlude with the Duchess of Langeais," *Cine-Action*, Spring 2002, pp. 45–53. Bacher describes in detail Ophuls's association with the ill-fated project.

CHAPTER NINE

1. Maurice Zolotow, *Billy Wilder in Hollywood* (New York: Putnam, 1977), 157.

2. Antony Beauchamp, *Focus on Fame* (London: Odhams Press, 1958), 146.

3. Beauchamp, *Focus on Fame*, 147.

4. Beauchamp, *Focus on Fame*, 148.

5. Beauchamp, *Focus on Fame*, 153.

6. Beauchamp, *Focus on Fame*, 156.

7. "Garbo's Greatest Film Roles: Here Are the Scenes That Made Greta Garbo the Most Glamorous Legend in America Motion Picture History," *McCall's*, June 1951, p. 32.

8. "Habitats: The Alice Tully Apartment," *New York Times*, September 18, 1994, p. 6.

9. Lilli Palmer, "Garbo and the Duke," *Esquire*, September 1975, pp. 103–5, 135–36, 138.

10. Kenneth Tynan, "Garbo," *Sight and Sound*, April–June 1954, pp. 187–190, 220.

11. The first edition is Roland Barthes, "Visage de Garbo," *Mythologies* (Éditions du Seuil, 1957); the edition used here is Roland Barthes, "The Face of Garbo," *Mythologies*, trans. Richard Howard (New York: Hill and Wang, 2012).

12. Bainbridge, *Garbo*, 11.

13. Bainbridge, *Garbo*, 217.

14. Bosley Crowther, "A Distant, Lonely Star," *New York Times*, March 27, 1977, p. 7.

15. Bosley Crowther, "Lady with a Lamp," *New York Times*, March 13, 1955, sec. 2, p. 1.

16. Arthur Knight, "The Divine Greta," *Saturday Review*, April 2, 1955, pp. 24–25.

17. "Schlee's Remains to Be Flown Here," *New York Times*, October 6, 1964, p. 39.

18. Babs Simpson (1913–2019), conversations with the author.

19. Raymond Daum with Vance Muse, *Walking with Garbo* (New York: Harper Collins, 1991), 144.

20. Daum, *Walking with Garbo*, 180.

21. William Frye, "The Garbo Next Door," *Vanity Fair*, April 2000, pp. 218, 220, 230–34.

22. Beaton, *Cecil Beaton*, 114.

23. *Garbo*, narrated by Joan Crawford, 1969, BBC TV, 50 minutes.

24. Annette Tapert, *The Power of Glamour* (New York: Crown, 1998), 222.

25. Swenson, *Greta Garbo*, 521.

26. John Bainbridge, "Garbo Is 65," *Look*, September 8, 1970, p. 48.

27. Gore Vidal, *Palimpsest: A Memoir* (New York: Random House, 1995), 299.

28. Blake Gopnik, *Warhol* (New York: Harper Collins, 2020), 321.

FILMOGRAPHY

Peter the Tramp, Petschler-Film (Stockholm); directed by Erik A. Petschler; filming dates: Summer 1922; released: December 26, 1922; with: Erik A. Petschler.

The Saga of Gösta Berling, Svensk Filmidustri AB (Stockholm); directed by Mauritz Stiller; filming dates: Part 1: September–October 1923, Part 2: December 1923–February 1924; released: Part 1: March 10, 1924, Part 2: March 17, 1924; with: Lars Hanson, Gerda Lundequist, Mona Mårtenson.

The Joyless Street, Sofar-Film (Berlin); directed by Wilhelm Pabst; filming dates: February–March 1925; released: May 18, 1925; portraits: Alexander Binder; stills: Curt Oertel; with: Asta Nielsen, Jaro Furth, Einar Hanson.

Torrent, MGM Production 254; directed by Monta Bell; filming dates: November–December 1925; released: February 8, 1926; portraits: Ruth Harriet Louise; stills: Buddy Longworth, Fred Morgan (stills 254: 1–146); with: Ricardo Cortez.

The Temptress, MGM Production 265; directed by Mauritz Stiller, Fred Niblo; filming dates: March–April (Stiller), June–August (Niblo); released: October 3, 1926; portraits: Ruth Harriet Louise; stills: Buddy Longworth (stills 265: 1–360); with: Antonio Moreno.

Flesh and the Devil, MGM Production 282; directed by Clarence Brown; filming dates: September–October 1926; released: December 26, 1926; portraits: Ruth Harriet Louise; stills: Buddy Longworth (stills 282: 1–160); with: John Gilbert, Lars Hanson.

Love, MGM Production 310; directed by Edmund Goulding; filming dates: April, June–July 1927; released: November 29, 1927; portraits: Ruth Harriet Louise, Clarence Sinclair Bull; Russell Bull; stills: William Grimes (stills 310: 1–202); with: John Gilbert.

The Divine Woman, MGM Production 332; directed by Victor Seastrom; filming dates: September–November 1927; released: January 14, 1928; portraits: Ruth Harriet Louise; stills: Milton Brown (stills 332: 1–154); with: Lars Hanson.

The Mysterious Lady, MGM Production 374; directed by Fred Niblo; filming dates: May–June 1928; released: August 4, 1928; portraits: Ruth Harriet Louise; stills: James Manatt (stills 374: 1–120); with: Conrad Nagel.

A Woman of Affairs, MGM Production 380; directed by Clarence Brown; filming dates: July–August 1928; released: December 15, 1928; portraits: Ruth Harriet Louise; stills: James Manatt (stills 380: 1–141); with: John Gilbert, Douglas Fairbanks Jr.

Wild Orchids, MGM Production 353; directed by Sidney Franklin; filming dates: October–November 1928; released: February 23, 1929; portraits: Ruth Harriet Louise; stills: James Manatt (stills 353: 1–138); with: Nils Asther, Lewis Stone.

The Single Standard, MGM Production 430; directed by John S. Robertson; filming dates: April–May 1929; released: July 27, 1929; portraits: Ruth Harriet Louise; stills: James Manatt (stills 430: 1–145); with: Nils Asther, Johnny Mack Brown.

The Kiss, MGM Production 440; directed by Jacques Feyder; filming dates July–August 1929; released: November 16, 1929; portraits: by Ruth Harriet Louise; stills: Milton Brown (stills 440: 1–135); with: Conrad Nagel, Lew Ayres.

Anna Christie, MGM Production 456; directed by Clarence Brown; filming dates: October–November 1929, released: February 21, 1930; portraits by Clarence Sinclair Bull; stills: Milton Brown (stills 456: 1–150); with: Charles Bickford, Marie Dressler.

Romance, MGM Production 489; directed by Clarence Brown; filming dates: March–May 1930; released: August 22, 1930; portraits by George Hurrell; stills: Milton Brown (stills 489: 1–106); with: Gavin Gordon, Lewis Stone.

Anna Christie (German language), MGM Production 476; directed by Jacques Feyder; filming dates: July–August 1930; released: March 27, 1931; portraits: Clarence Sinclair Bull; stills: Milton Brown (stills GR476: 1–97); with: Theo Shall, Hans Junkermann, Salka Viertel.

Inspiration, MGM Production 521; directed by Clarence Brown; filming dates: October–November 1930; released: January 31, 1931; portraits: Clarence Sinclair Bull; stills: Milton Brown (stills 512: 1–85); with: Robert Montgomery.

Mata Hari, MGM Production 579; directed by George Fitzmaurice; filming dates: October–November 1931; released: December 26, 1931; portraits: Clarence Sinclair Bull; stills: Milton Brown (stills 579: 1–133); with: Ramon Novarro, Lionel Barrymore.

Grand Hotel, MGM Production 603; directed by Edmund Goulding, filming dates: December 1931–February 1932, released: April 12, 1932; portraits: Clarence Sinclair Bull during session for *As You Desire Me*; stills: Milton Brown, Fred Archer, George Hurrell (stills 603: 1–128); with: John Barrymore, Joan Crawford, Lionel Barrymore, Wallace Beery.

As You Desire Me, MGM Production 615; directed by George Fitzmaurice; filming dates: March–April 1932, released: May 28, 1932; portraits: Clarence Sinclair Bull, stills: Milton Brown (stills 615: 1–63); with: Melvyn Douglas, Erich von Stroheim.

Queen Christina, MGM Production 688; directed by Rouben Mamoulian; filming dates: August–October 1933, released: December 26, 1933; portraits by Clarence Sinclair Bull; stills: Milton Brown (stills 688: 1–109); with: John Gilbert.

The Painted Veil, MGM Production 776; directed by Richard Boleslawski; filming dates: July–September 1934; released: November 23, 1934; portraits by Clarence Sinclair Bull; stills: Milton Brown (stills 776: 1–122); with: Herbert Marshall, George Brent.

Anna Karenina, MGM Production 815; directed by Clarence Brown, filming dates: March–May 1935; released: August 30, 1935, portraits: Clarence Sinclair Bull; stills: William Grimes (stills 815: 1–108); with: Fredric March, Basil Rathbone.

Camille, MGM Production 938; directed by George Cukor; filming dates: October–November 1936; released: December 12, 1936; portraits: Clarence Sinclair Bull; stills: William Grimes (stills 938: 1–168); with: Robert Taylor; Lionel Barrymore; Henry Daniell.

Conquest, MGM Production 983; directed by Clarence Brown; filming dates: May–August 1937; released: October 22, 1937; portraits: Clarence Sinclair Bull; stills: William Grimes (stills 983: 1–131); with: Charles Boyer.

Ninotchka, MGM Production 1100; director: Ernst Lubitsch; filming dates: June–August 1939; released: October 6, 1939; portraits: Clarence Sinclair Bull; stills: Milton Brown (stills 1100: 1–79); with: Melvyn Douglas, Ina Claire.

Two-Faced Woman, MGM Production 1190; director: George Cukor; filming dates: June–August, December 1941; released: November 30, December 31, 1941 (revised film); portraits: Clarence Sinclair Bull; stills: William Grimes (stills 1190: 1–175); with: Melvyn Douglas, Constance Bennett.

SELECTED BIBLIOGRAPHY

Acosta, Mercedes de. *Here Lies the Heart: A Tale of My Life*. New York: Reynal, 1960.

Arconada, Cesar M. *Leben der Greta Garbo (Roman)*. Giessen, Germany: Kindt & Bucher Verlag, 1930.

Aros (Alfred Rosenthal). *Greta Garbo: Ihr Weg von Stockholm bis Hollywood*. Berlin: Verlag Scherl, 1932.

Bach, Steven. *Marlene Dietrich: Life and Legend*. New York: Morrow, 1992.

Bachman, Gregg, and Thomas J. Slater, editors. *American Silent Film: Discovering Marginalized Voices*. Carbondale: Southern Illinois University Press, 2002.

Bainbridge, John. *Garbo*. New York: Doubleday, 1955.

Barthes, Roland. *Mythologies*. Translated by Richard Howard. Paris: Editions du Seuil, 1957 New York: Hill and Wang, 2012.

Beaton, Cecil. *The Face of the World*. New York: John Day, 1957.

Beaton, Cecil. *Memoirs of the 40's*. New York: McGraw-Hill, 1972.

Beauchamp, Antony. *Focus on Fame: The Autobiography of Antony Beauchamp*. London: Odhams Press, 1958.

Berg, A. Scott. *Kate Remembered*. New York: Putnam, 2003.

Bergan, Ronald. *Sergei Eisenstein: A Life in Conflict*. Woodstock, NY: Overlook Press, 1997.

Bickford, Charles. *Bulls, Bats, Bicycles & Actors*. New York: Paul S. Erickson, 1976.

Billquist, Fritiof. *Garbo: A Biography*. Translated by Maurice Michael. New York: G. P. Putnam's Sons, 1960.

Blei, Franz. *Die göttliche Garbo*. Giessen, Germany: Kindt and Bucher, 1930.

Brion, Patrick. *Garbo*. Paris: Chêne, 1985.

Broman, Sven. *Conversations with Greta Garbo*. New York: Viking, 1991.

Brooks, Louise. *Lulu in Hollywood*. New York; Knopf, 1982.

Brownlow, Kevin. *The Parade's Gone By . . .* New York: Knopf, 1968.

Bull, Clarence Sinclair, and Raymond Lee. *The Faces of Hollywood*. South Brunswick, NJ: A. Barnes, 1968.

Burr, Ty. *Gods Like Us*. New York: Pantheon Books, 2012.

Cahill, Marie, *Greta Garbo: Hollywood Portrait*. New York: Smithmark, 1992.

Carr, Larry. *Four Fabulous Faces: The Evolution and Metamorphosis of Garbo, Swanson, Crawford and Dietrich*. New Rochelle, NY: Arlington House, 1970.

Chaplin, Charles. *My Autobiography*. New York: Simon & Schuster, 1964.

Conway, Michael, Dio McGregor, and Mark Ricci. *The Films of Greta Garbo*. New York: Citadel Press, 1968.

Cooke, Alistair. *Garbo and the Nightwatchman*. London: Jonathan Cape, 1937.

Corliss, Richard. *Greta Garbo*. New York: Pyramid, 1974.

Crawford, Joan, with Jane Kesner Ardmore. *A Portrait of Joan*. New York: Doubleday, 1992.

Crowther, Bosley. *Hollywood Rajah: The Life and Times of Louis B. Mayer*. New York: Holt, Rinehart and Winston, 1960.

Curtiss, Thomas Quinn. *Von Stroheim*. New York: Farrar, Straus and Giroux, 1971.

Dance, Robert, and Bruce Roberson. *Ruth Harriet Louise and Hollywood Glamour Photography*. Berkeley: CA, 1990.

Danzinger, James. *Beaton*. New York: Viking Press, 1980.

Daum, Raymond, with Vance Muse. *Walking with Garbo*. New York: Harper Collins, 1991.

Davies, Marion. *The Times We Had: Life with William Randolph Hearst*. Indianapolis: Bobbs-Merrill, 1975.

Davy, Charles, editor. *Footnotes to the Film*. New York: Oxford University Press, 1937.

Doherty, Thomas. *Hollywood's Censor: Joseph I. Breen & the Production Code Administration*, NY. Columbia University Press, 2007.

Doherty, Thomas. *Pre-Code Hollywood: Sex, Immorality and Insurrection in American Cinema, 1930–1934*. New York: Columbia University Press, 1999.

Douglas, Melvyn, and Tom Arthur. *The Autobiography of Melvyn Douglas*. New York: University Press of America, 1986.

Dressler, Marie, as told to Mildred Harrington. *My Own Story*. Boston: Little, Brown, 1934.

Durgnat, Raymond, with John Kobal. *Greta Garbo*. New York: Studio Vista/Dutton, 1965.

Eyman, Scott. *Ernst Lubitsch: Laughter in Paradise*. New York: Simon & Schuster, 1994.

Eyman, Scott. *Lion of Hollywood: The Life and Legend of Louis B. Mayer*. New York: Simon & Schuster, 2005.

Findler, Joel W. *The Hollywood Story*. New York: Crown, 1988.

Flamini, Roland. *Thalberg: The Last Tycoon and the World of MGM*. New York: Crown, 1994.

Fountain, Leatrice Gilbert, with John R. Maxim. *Dark Star*. New York: St. Martin's Press, 1985.

Fowler, Gene. *Good Night, Sweet Prince*. New York: Viking, 1944.

Frewin, Leslie. *Blond Venus: A Life of Marlene Dietrich*. London: MacGibbon & Kee, 1955.

Gabler, Neal. *An Empire of Their Won: How the Jews Invented Hollywood*. New York: Crown, 1988.

Gallico, Paul, *The Revealing Eye: Personalities of the 1920's in Photographs by Nickolas Muray*. New York: Atheneum, 1967.

Gemünden, Gerd, and Mary R. Desjardins. *Dietrich Icon*. Durham: Duke University Press, 2007.

Genthe, Arnold. *As I Remember*. New York: Reynal & Hitchcock, 1936.

Gill, Brendan, and Jerome Zerbe. *Happy Times*. New York: Harcourt, Brace Jovanovich, 1973.

Golden, Eve. *John Gilbert*. Lexington: University Press of Kentucky, 2013.

Goodman, Ezra. *The Fifty-Year Decline and Fall of Hollywood*. New York: Simon & Schuster, 1961.

Gopnik, Blake. *Warhol*, New York: Harper Collins, 2020

Greer, Howard. *Designing Male*. New York: Putnam, 1951.

Gutner, Howard. *Gowns by Adrian*. New York: Abrams, 2001.

Haining, Peter. *The Legend of Garbo*. London: W. H. Allen, 1990.

Harris, Warren. *Clark Gable*. New York: Harmony Books, 2002.

Harrison, Rex. *Rex: An Autobiography*. New York: William Morrow, 1975.

Harvey, James. *Watching Them Be: Star Presence on the Screen from Garbo to Balthazar*, NY: Faber and Faber, 2014.

Haskell, Molly. *From Reverence to Rape: The Treatment of Women in the Movies*. New York: Holt, Rinehart and Winston, 1974.

Higham, Charles. *Hollywood Cameraman: Sources of Light*. Bloomington: Indiana University Press, 1970.

Higham, Charles. *Merchant of Dreams: Louis B. Mayer, MGM and the Secret Hollywood*. New York: Donald I. Fine, 1993.69.

Holden, Anthony. *Laurence Olivier*. New York: Atheneum, 1988.

Hughes, Elinor. *Famous Stars of Filmdom (Men)*. Boston, L. C. Page, 1932.

Hughes, Elinor. *Famous Stars of Filmdom (Women)*. Boston: L. C. Page, 1931.

Irwin, Will. *The House That Shadows Built*. Garden City, NY: Doubleday, 1928.

Isherwood, Christopher. *Diaries: 1939–1960*. New York: Harper Collins, 1996.

Kennedy, Joseph, editor. *The Story of the Films*. New York: A. W. Shaw, 1927.

Kennedy, Matthew. *Edmund Goulding's Dark Victory*. Madison: University of Wisconsin Press, 2004.

Kennedy, Matthew. *Marie Dressler*. Jefferson, NC: McFarland, 1999.

Kiesling, Barrett C. *Talking Pictures: How They Are Made and How to Appreciate Them*. New York: Johnson, 1937.

Kobal, John. *The Art of the Great Hollywood Portrait Photographers, 1925–1940*. New York: Knopf, 1980.

Kobal, John. *Hollywood Glamour Portraits*. New York: Dover, 1976.

Kobal, John. *People Will Talk*. New York: Knopf, 1985.

Krefft, Vanda. *The Man Who Made the Movies: The Meteoric Rise and Tragic Fall of William Fox*. New York: Harper Collins, 2017.

Kühn, Richard. *Greta Garbo: Der Weg einer Frau un Künstlerin*. Dresden: Carl Reissner-Verlag, 1935.

Laing, E. E. *Greta Garbo: The Story of a Specialist*. London: John Gifford, 1946.

Lambert, Gavin. *Norma Shearer*. New York: Knopf, 1990.

Lambert, Gavin. *On Cukor*. New York: G. B. Putnam's Sons, 1972.

LaSalle, Mick. *Complicated Women*. New York: St. Martin's Press, 2000.

Leff, Leonard J., and Jerold L. Simmons. *The Dame in the Kimono*. New York: Doubleday, 1990.

Lernet-Holenia, Alexander. *Greta Garbo: Ein Wunder in Bildern*. Berlin: Höger-Verlag, 1938.

Lernet-Holenia, Alexander. *Greta Garbo: Ideal des Jahrhunderts*. Wiesbaden: Limes Verlag, 1956.

Livio, Robin. *Greta Garbo*. Paris: Denoël, 1972.

Maas, Frederica Sagor. *The Shocking Miss Pilgrim: A Writer in Early Hollywood*. Lexington: University Press of Kentucky, 1999.

Makin, William J. *Greta Garbo*. Private Lives of the Film Stars, no. 1. London: L. T. A. Robinson, [1934].

Mann, William J. *Behind the Screen*. New York: Viking, 2001.

Mann, William J. *Tinseltown: Murder, Morphine, and Madness at the Dawn of Hollywood*. New York: Harper, 2014.

Marx, Samuel. *Mayer and Thalberg: The Make-Believe Saints*. New York: Random House, 1995.

Mayer, Arthur. *Merely Colossal: The Story of the Movies from the Long Chase to the Chaise Longue*. New York: Simon & Schuster, 1953.

McGilligan, Patrick. *George Cukor: A Double Life*. New York: St. Martin's Press, 1991.

Moore, Colleen. *Silent Star*. New York: Doubleday, 1968.

Muir, Robin. *The World's Most Photographed*. London: National Portrait Gallery, 2005.

Nerman, Einar. *Caricature*. New York: American Studio Books, 1946.

Nourmand, Tony, and Phil Moad. *Hurrell*. London: Rare Art Press, 2012.

Osborne, Robert, editor. *The Life and Legend of Greta Garbo*. Hollywood Legends, vol. 1, no. 1. Covina, CA: Collectors Publications, 1967.

Palmborg, Rilla Page. *The Private Life of Greta Garbo*. Garden City, NY: Doubleday, 1931.

Paris, Barry *Garbo*. New York: Knopf, 1995.

Paris, Barry. *Louise Brooks*. New York: Knopf, 1989.

Payne, Robert. *The Great Garbo*. New York: Praeger Press, 1976.

Pepper, Terence. *Beaton Portraits*. London: National Portrait Gallery, 2004.

Pepper, Terence, and John Kobal. *The Man Who Shot Garbo: The Hollywood Photographs of Clarence Sinclair Bull*. New York: Simon & Schuster, 1989.

Power-Waters, Alma. *John Barrymore: The Legend and the Man*. New York: Julian Messner, 1941.

Quigley, Martin. *Decency in Motion Pictures*. New York: Macmillan, 1937.

Reisfield, Derek, and Robert Flynn Johnson. *Sven Gustafson: Colorist*. San Francisco: Baker Beach Books, 2001.

Reisfield, Scott, and Robert Dance. *Garbo: Portraits from Her Private Collection*. New York: Rizzoli, 2005.

Rifkind, Donna. *The Sun and Her Stars*. New York: Other Press, 2019.

Riva, Maria. *Marlene Dietrich*. New York: Knopf, 1993.

Robinson, David. *Garbo*. Cologne: Taschen, 2007.

Roston, Leo C. *Hollywood: The Movie Colony, The Movie Makers*. New York: Harcourt, Brace, 1941.

Rotha, Paul. *The Film till Now*. New York: Funk & Wagnalls, 1949.

Sands, Frederick, and Sven Broman. *The Divine Garbo*. New York: Grosset & Dunlap, 1979.

Schanke, Robert A. *"That Furious Lesbian": The Story of Mercedes de Acosta*. Carbondale: Southern Illinois University Press, 2003.

Selznick, David O. *Memo from David O. Selznick*. Edited by Rudy Behlmer. New York: Viking Press, 1972.

Selznick, Irene. *A Private View*. New York: Knopf, 1983.

Semback, Klaus-Jürgen. *Greta Garbo Portraits: 1920–1951*. New York: Rizzoli, 1985.

Sjölander, Ture. *Garbo*, New York: Harper & Row, 1971.

Slide, Anthony. *Inside the Hollywood Fan Magazine*. Jackson: University Press of Mississippi, 2010.

Soares, André. *The Life of Ramon Novarro*. New York: St. Martin's Press, 2002.

Souhami, Diana. *Greta & Cecil*. New York: Harper-Collins, 1994.

Steichen, Edward. *A Life in Photography*. London: W. H. Allen, 1963.

Steiger, Brad, and Chaw Mank. *Garbo*. Chicago: Merit Books/Camerarts, 1965.

Sternberg, Josef von, *Fun in a Chinese Laundry*, New York: Collier Books, 1965.

Stine, Whitney, and George Hurrell. *The Hurrell Style*. New York: John Day, 1976.

Sundborg, Åke. *Greta Garbos saga*. Stockholm: Albert Bonniers Förlag, 1929.

Swanson, Gloria. *Swanson on Swanson*. New York: Random House, 1981.

Swenson, Karen. *Greta Garbo: A Life Apart*. New York: Scribner's, 1997.

Swindell, Larry. *Charles Boyer: The Reluctant Lover*. New York: Doubleday, 1983.

Tapert, Annette. *The Power of Glamour*. New York: Crown, 1998.

Thomas, Bob. *Joan Crawford*. New York: Simon & Schuster, 1978.

Thomas, Bob. *Thalberg: Life and Legend*. New York: Doubleday, 1969.

Thorp, Margaret. *America at the Movies*. New Haven: Yale University Press, 1939.

Tims, Hilton. *Erich Maria Remarque: The Last Romantic*. New York: Carroll & Graf, 2003.

Tyler, Parker. *The Three Faces of the Film*. New York: Thomas Yoseloff, 1960.

Vance, Jeffrey, *Douglas Fairbanks*. Berkeley: California, 2008.

Vickers, Hugo. *Cecil Beaton*. New York: Donald I. Fine, 1985.

Vickers, Hugo. *Loving Garbo*. New York: Random House, 1994.

Vidal, Gore. *Palimpsest: A Memoir*. New York: Random House, 1995.

Viertel, Salka. *The Kindness of Strangers*. New York: New York Review of Books, 2019. Originally published New York: Holt, Rinehart & Winston, 1969.

Walker, Alexander. *Garbo: A Portrait*. New York: Macmillan, 1980.

Walker, Alexander. *Sex in the Movies*. New York: Penguin Books, 1968.

Walker, Alexander. *The Shattered Silents: How the Talkies Came to Stay*. New York: William Morrow, 1979.

Walker, Alexander. *Stardom: The Hollywood Phenomenon*. New York: Stein and Day, 1970.

Williamson, Alice M. *Alice in Movieland*. New York: Appleton, 1928.

Zierold, Norman. *Garbo*. New York: Stein and Day, 1969.

Zolotow, Maurice. *Billy Wilder in Hollywood*. New York: G. P. Putnam's Sons, 1977.

INDEX

Page numbers in **bold** indicate illustrations.

ABOUT THE AUTHOR

Robert Dance is author of *Hollywood Icons* and *Glamour of the Gods* and coauthor of *Garbo: Portraits from Her Private Collection* and *Ruth Harriet Louise and Hollywood Glamour Photography*.